ART AND POWER

Renaissance Festivals
1450–1650

ART AND POWER

Renaissance Festivals
1450–1650

ROY STRONG

University of California Press
Berkeley Los Angeles

© Roy Strong 1973, 1984

Published in 1984 in the United States of America
by the University of California Press,
Berkeley and Los Angeles, California

This book was designed and produced in Great Britain
by the Boydell Press, an imprint of Boydell & Brewer Ltd.

ISBN 0-520-05479-2
Library of Congress Catalog Card Number 84–040613

Contents

Part One *The Study of Magnificence*

Part Two *Pageantry and Politics*

List of Illustrations

1. *Scene from the ballet 'Hercole e Amore', 1640*. Drawing. Biblioteca Nazionale Universitaria, Turin, B.R.N.1437. (Photo: A. C. Cooper)

2–3. *Pageant arches for the entry of Charles V as Count of Flanders into Bruges, 1515*. Illuminations from Remy du Puys, *La triumphante et solenelle entrée faicte sur le joyeux advenement de tres hault et trespuissant prince Monsieur Charles prince des Espagne, Archiduc d'Austrice, en sa ville de Bruges*. Vienna, Oesterreichische Nationalbibliothek, Cod. 2591. (Photos: Bildarchiv der Oesterreichische Nationalbibliothek)

4–5. *Pageants for the entry of François I into Lyons, 1515*. Illuminations. The Ducal Library, Wolfenbuttel, Cod. Guelf. 86.4. (Photos: Weidenfeld and Nicolson)

6. *Scene from René of Anjou's 'Traité de la Forme et Devis d'un Tournoi', 1489*. Illuminations. Paris, Bibliothèque Nationale MS.Fr.2692. (Photo: Bibliothèque Nationale)

7. *Section from the Great Tournament Roll of Westminster, 1511*. Drawing. London, College of Arms. (Photo: College of Arms)

8. *Torchdance at a feast, early 16th-century*. Illumination from a Flemish calendar for February. British Library Additional MS.24098 f. 19v. (Photo: British Library)

9. *The Gallic Hercules*. Woodcut from Alciati, *Emblemata*, Augsburg 1531.

10. *The arch at the Porte St. Denis in Henri II's entry into Paris, 16th June, 1549*. Woodcut from *C'est l'ordre qui a este tenu . . .*, Paris 1549.

11. *Obelisk in Henri IV's entry into Rouen, 1596*. Woodcut from *Discours de la Ioyeuse et triomphante entree . . .*, Rouen 1596. (Photo: The Warburg Institute)

12. *Impresa of Henri II*. Engraving from G. Ruscelli, *Le Imprese Illustri . . .*, Venice 1580. (Photo: The Fotomas Index)

13. *The Assyrian Apollo*. Engraving from Vincenzo Cartari, *Le Imagini dei Dei degli Antichi . . .*, Venice 1571 edn. (Photo: The Fotomas Index)

14. Giorgio Vasari, *The chariot of Apollo in 'La Genealogia degli Dei', 1566*. Drawing. Gabinetto di Disegni e Stampe, Uffizi, Florence. (Photo: Weidenfeld)

15. *The Demon Mountain in 'Le Ballet de la Délivrance de Renaud', 1617*. Woodcut from *Discours au vray Ballet . . .*, Paris 1617. (Photo: Bibliothèque Nationale)

16. *The enchanted garden in 'Le Ballet de la Délivrance de Renaud', 1617*. Woodcut from *Discours au vray ballet . . .*, Paris 1617. (Photo: Bibliothèque Nationale)

39. Inigo Jones, *Design for the main setting for the Barriers*. Drawing, 1610. Trustees of the Chatsworth Settlement. (Photo: Courtauld Institute)

40. Artist unknown, *Panorama of the tournament 'L'Isola Beata'*. Drawing, 1569. Ferrara, Biblioteca Civica. (Photo: Biblioteca Civica)

42–3. The Teatro Farnese. (Photos Alinari 15492, 15493)

44. M. Grueter, *View of the horse ballet, La Giostra dei Venti, 1608*. Etching from Camillo Rinuccini, *Descrizione delle Feste fatte nelle Reali Nozze di Serenissimi Principi di Toscana . . .*, Florence 1608.

45. Jacques Callot, *View of the tournament the 'Guerra d'Amore'*. Etching, 1616.

46. Stefano della Bella, *Equestrian ballet in the Boboli Gardens*. Etching, 1637. (Photo: Victoria and Albert Museum)

47. Jacques Callot, *The first intermedio of 'La Liberazione di Tirreno'*. Etching, 1617.

48–9. *Two pages with ballet figures*. Woodcuts from *Ballet de Monseigneur le Duc de Vendosme . . .*, Paris 1610.

50. *Emblematic lake dug for the entertainment at Elvetham, Hampshire, 1591*. Woodcut from John Nichols, *Progresses of Queen Elizabeth*, London 1823.

51. *Arch for the entry of Henri IV into Rouen, 1596*. Woodcut from *Discours de la Ioyeuse et triomphante entrée de . . . Prince Henri IIII . . . en sa ville de Rouen . . .*, 1599. (Photo: The Warburg Institute)

52. Antoine Caron, *Augustus and the Sibyl*, c.1575–80. Painting. Paris, Musée du Louvre. (Photo: Service photographique des musées nationaux)

53. *Arch for the entry of James I into London, 1604*. Engraving by William Kip from Stephen Harrison, *Arches of Triumph*, London 1604. (Photo: Victoria and Albert Museum)

54. Perino del Vaga, *Arch for Charles V's entry into Genoa, 1529*. Drawing. London, the late Anthony Blunt. (Photo: Courtauld Institute)

55. Giulio Romano, *Column for Charles V's entry into Mantua, 1530*. Drawing, Albertina, Vienna. (Photo: Bildarchiv der Oesterreichische Nationalbibliothek)

56. Artist unknown, *Arch for Henri II's entry into Lyons, 1548*. Woodcut from (Maurice Scève), *La Magnificence de la superbe et triumphante entrée de la noble antique cité de Lyons faicte au Tres-chrestien Roy de France . . .*, Lyons 1549. (Photo: The Warburg Institute)

57. Artist unknown, *Arch for Henri II's entry into Paris, 1549*. Woodcut from *C'est l'ordre qui à este tenu à la novelle et joyeuse entrée, que . . . le Roy Treschrestien Henry deuzieme de ce nom à faicte en sa bonne ville & cité de Paris . . .*, Paris 1549. (Photo: The Warburg Institute)

58. Polidoro da Caravaggio, *Project for a decoration for the entry of Charles V into Messina, 1535*. Drawing. Berlin, Kupferstichkabinett, K.d.Z. 26451. 79 D 34. (Photo: Jörg P. Anders)

59–60. Attributed to Jacomo Melinghino formerly to Baldassare Peruzzi, *Two arches for Charles V's entry into Rome, 1536*. Drawings from the Siena Sketchbook. (Photo: The Warburg Institute; Grassi, Siena)

61. Artist unknown possibly after Giulio Romano, *Arch for Charles V's entry into Milan, 1541*. Woodcut from Giovanni Alberto Albicante, *Trattato del'intrar in Milano di Carlo V.C. . . .*, Milan 1541. (Photo: The Fotomas Index)

62. Artist unknown, *Arch for Prince Philip's entry into Ghent, 1549*. Woodcut from F. van Velde, *Arcus triumphales Quinque a S.P.Q. Gand. Philippo Austrie Caroli imp. principi . . .*, Ghent 1549. (Photo: Weidenfeld)

63–5. Artist unknown, *Arches for the entry of Prince Philip into Antwerp, 1549*. Woodcuts from Cornelius Scribonius, *Spectaculorum in Susceptione Philippi Hisp. Princ. Antverpiae aeditiorum mirificus apparatus . . .*, Antwerp 1550. (Photo: The British Library)

66–7. Artist unknown, *Two festivals at Binche, 1549*. Drawings. Brussels, Bibliothèque Royale, Albert Premier. (Photo: Service photographique, Bibliothèque Royale)

68. J. and L. van Duetecum, *Allegorical ship for the obsequies of Charles V in Brussels, 1558*. Engraving from *Magnifique et somptueuse Pompe funèbre faite aux obsèques et funerailles de tres victorieus emperour Charles V . . .*, Antwerp 1559. (Photo: The Fotomas Index)

69. Circle of Bernardo Buontalenti, Catafalque for Cosimo I, Grand Duke of Tuscany, 1574. Drawing. Florence, Biblioteca Nazionale Centrale, MS Nuovi Acquisti n. 1025, c.15. (Photo: Bibliotheca Nazionale)

70. Inigo Jones, *Catafalque for James I, 1625*. Drawing. London, Royal Institute of British Architects. (Photo: Courtauld Institute)

71. *Festival at Bayonne*. Tapestry (Galleria Uffizi, Florence). (Photo: Alinari 29156)

72. *Festival at Fontainebleau*. Tapestry (Galleria Uffizi, Florence). (Photo: Alinari 1758)

73. Attributed to Antoine Caron, *Running at the quintain*. Drawing (Witt Collection, The Courtauld Institute of Art, University of London). (Photo: Courtauld Institute)

74. Attributed to Antoine Caron, *Festival at Bayonne*. Drawing (Pierpont Morgan Library, New York). (Photo: Pierpont Morgan Library)

75. Attributed to Antoine Caron, *Tournament at Bayonne*. Drawing (Witt Collection, Courtauld Institute of Art, University of London). (Photo: Courtauld Institute).

76. *The arch at Pont Nostre Dame for Charles IX's entry into Paris, 1571*. Woodcut from Simon Bouquet, *Bref et sommaire recueil . . .*, Paris 1572.

77. *The arch at Pont Nostre Dame for Elizabeth of Austria's entry into Paris, 1571*. Woodcut from Simon Bouquet, *Bref et sommaire recueil . . .*, Paris 1572. (Photo: The Fotomas Index)

78. *Serlian perspective in Charles IX's entry into Paris, 1571*. Woodcut from Simon Bouquet, *Bref et sommaire recueil . . .*, Paris 1572.

79. *The Ballet of the Provinces of France, 1573*. Woodcut from Jean Dorat, *Magnificentissimi spectaculi a regina Regnum matre in hortis suburbanis editi*, Paris 1573.

80. Domenico Zenoni, *Arch and loggia at the Lido by Palladio erected in honour of Henri III, 1574*. Engraving (Museo Correr, Venice, inv. stampe Gherro, 1741). (Photo: Museo Correr)

81. *The Salle de Bourbon at the opening of the 'Balet comique', 1581*. Engraving from *Balet Comique de la reyne . . .*, Paris 1582. (Photo: British Library)

82. *The Fountain chariot in the 'Balet comique', 1581*. Engraving from *Balet comique de la reyne . . .*, Paris 1582. (Photo: The Warburg Institute)

83. *The sirens in the 'Balet comique', 1581*. Engraving from *Balet comique de la reyne . . .*, Paris 1582. (Photo: The Warburg Institute)

84–5. Orazio Scarabelli, *Two arches for the entry of Christina of Lorraine into Florence, 1589*. Engravings. New York, Metropolitan Museum of Art, Prints Dept., Dick Fund (31.72.5). (Photo: Metropolitan Museum)

86. *Part of the decoration outside the Palazzo Vecchio for the entry of Christina of Lorraine into Florence, 1589*. Engraving from Raffaello Gulaterotti, *Descrizione del Regale apparato per le Nozze Della Serenissima Madama Cristina di Lorena . . .*, Florence 1589. Engraving. (Photo: Freeman)

87. Cesare Lisi, *Conjectural reconstruction of the groundplan of the 'Teatro Mediceo'*. From *Il Luogo Teatrale a Firenze*, exhibition catalogue, Palazzo Medici Riccardi, 1975, (8.2).

88. Bernardo Buontalenti, *Design for the first intermezzo in 'La Pellegrina': the Harmony of the Spheres, 1589*. Drawing. (London, Victoria & Albert Museum). (Photo: Victoria and Albert Museum)

89. Epifanio d'Alfiano after Bernardo Buontalenti, *The second intermezzo in 'La Pellegrina': the contest of the Pierides and Muses, 1589*. Engraving.

90. Agostino Caracci after Bernardo Buontalenti, *The third intermezzo in 'La Pellegrina': Apollo slaying the Python, 1589*. (Florence, Gabinetto Diseigni e Stampe deglu Uffizi. n. 100838). (Photo: The Courtauld Institute)

91. Epifanio d'Alfiano after Bernardo Buontalenti, *The fourth intermezzo in 'La Pellegrina': the Inferno, 1589*. Engraving.

92. Epifanio d'Alfiano after Bernardo Buontalenti, *The fifth intermezzo in 'La Pellegrina': the Rescue of Arion, 1589*. New York, Metropolitan Museum of Art, Prints Dept., Dick Fund (31.72.5). (Photo: Metropolitan Museum)

93. Bernardo Buontalenti, *Design for the sixth intermezzo in 'La Pellegrina': the Assembly of the Gods, 1589*. Drawing. London, Victoria & Albert Museum. (Photo: Victoria and Albert Museum)

94–5. Orazio Scarabelli, *Entry of the Duke of Mantua with Don Pietro de'Medici and part of the entry of Don Virginio in the 'sbarra', 1589*. Engravings. New York, Metropolitan Museum of Art, Prints Dept., Dick Fund (31.72.4). (Photo: Metropolitan Museum)

96. Orazio Scarabelli, *The 'naumachia', 1589*. Engraving. New York, Metropolitan Museum of Art, Prints Dept., Dick Fund (31.72.5). (Photo: Metropolitan Museum)

97. Artist unknown, *Festival in honour of Marie de'Medici at the Villa Valfonda: corso al saracino, 1600*. Fresco. Florence, Palazzo Giuntini. (Photo: Alinari 35028)

98. Bernardo Buontalenti, *Design for the Prologue to Caccini's 'Il Rapimento di Cefalo', 1600*. Drawing. Victoria & Albert Museum, London. (Photo: Victoria and Albert Museum)

99. Matthias Grueter, *The 'Argonautica' on the river Arno, 1608*. Engraving from Camillo Rinuccini, *Descrizione delle Feste fatte nelle Reali Nozze de'Serenissimi Principi di Toscana . . .*, Florence 1608. (Photo: British Library).

100. Remigio Cantagallina after Giulio Parigi, *The first intermezzo in 'Il Giudizio di Paride', 1608*. Engraving. (Photo: Victoria and Albert Museum)

101. Giulio Parigi, *Design for the fourth intermezzo in 'Il Giudizio di Paride', 1608*. London, Theatre Museum. Victoria & Albert Museum. (Photo: Victoria and Albert Museum)

102. Giulio Parigi, *The sixth intermezzo in 'Il Giudizio di Paride': the Temple of Peace, 1608*. Engraving. (Photo: Courtauld Institute of Art)

103. *Interior of the Whitehall Banqueting House*. (Photo: National Monuments Record)

104. John Webb, *Groundplan of the stage and scenery in 'Salmacida Spolia', 1640*. Drawing. London, The British Library, Department of Manuscripts, Lansdowne MS.1171, ff. 31–4. (Photo: British Library)

105. John Webb, *Elevation of the stage in 'Salmacida Spolia', 1640*. Drawing. London, The British Library, Department of Manuscripts, Lansdowne MS.1171, ff. 1b–2. (Photo: British Library).

106. Inigo Jones, *Sketch for the sea triumph in 'Love's Triumph through Callipolis', 1631*. Drawing. The Trustees of the Chatsworth Settlement. (Photo: Courtauld Institute of Art)

107. Inigo Jones, *Venus in a cloud machine in 'Love's Triumph through Callipolis', 1631*. Drawing. The Trustees of the Chatsworth Settlement. (Photo: Courtauld Institute of Art)

108. Inigo Jones, *Opening scene in 'Chloridia', 1631*. Drawing. Trustees of the Chatsworth Settlement. (Photo: Courtauld Institute of Art)

109. Inigo Jones, *Costume for Henrietta Maria in 'Chloridia', 1631*. Drawing. The Trustees of the Chatsworth Settlement. (Photo: Courtauld Institute of Art)

110. Inigo Jones, *Opening scene in 'Coelum Britannicum', 1634*. Drawing. The Trustees of the Chatsworth Settlement. (Photo: Courtauld Institute of Art)

111. Inigo Jones, *Atlas in 'Coelum Britannicum', 1634*. Drawing. Trustees of the Chatsworth Settlement. (Photo: Courtauld Institute of Art)

112. Inigo Jones, *Costume design for Charles I in 'Coelum Britannicum', 1634*. Trustees of the Chatsworth Settlement. (Photo: Courtauld Institute of Art)

113. Inigo Jones, *Scene of a princely villa in 'Coelum Britannicum', 1634*. Drawing. The Trustees of the Chatsworth Settlement. (Photo: Courtauld Institute of Art)

114. John Webb after Inigo Jones, *The final scene in 'Salmacida Spolia', 1640.* Drawing. The Trustees of the Chatsworth Settlement. (Photo: Courtauld Institute of Art)

115. Artist unknown, *The 'Salle du Palais Cardinal'*. Painting, 1641. Paris, Musée des Arts Decoratifs.

Preface

The origins of this book lie in the Ferens Lectures in Fine Art which I was asked to deliver at the University of Hull in 1971–72. Subsequently I expanded and adapted them for an earlier version of the present book which was published in 1974 entitled *Splendour at Court. Renaissance Spectacle and the Theatre of Power*. Both lectures and book set out to introduce to a wider audience the complex subject of renaissance festivals. To achieve such an introduction successfully is no less a complex task, which is why I have returned to it again a decade later. Virtually all of the first part of the present book is new. The second part has been substantially rewritten and I have been able to include important new research both in the chapters on Valois as well as Medici festivals. In contrast, little of significance has appeared on either the Emperor Charles V or on Charles I.

The second decision was to footnote the book, thus providing a quarry for those who wish to take any topic further. I make no apology for the fact that what follows is often a synthesis of other people's research (including my own), although I hope that in that very process I have been able to draw out forcefully the main issues and developments, which are all too quickly obscured in the innumerable individual studies of isolated festival events. Indeed this is a subject that exists virtually entirely in article form. *Art and Power* is designed as a point of departure and a basic work of reference for anyone who needs to study renaissance festivals, whether their concern is with the history of politics, theatre, art or ideas.

This book would never have been written without the pile of books and articles fed to me by Stephen Calloway or the admirable typing of Pauline Cockrill. To both I owe a deep debt of gratitude.

ROY STRONG
August 1984

PART ONE

THE STUDY OF MAGNIFICENCE

I have met with those
That do cry up the machine, and the shows;
The majesty of Juno in the clouds,
And peering forth of Iris in the shrouds;
Th'ascent of Lady Fame which none could spy,
Nor they that sided her; Dame Poetry,
Dame History, Dame Architecture too,
And Goody Sculpture, brought with much ado
To hold her up.

Ben Jonson, *Expostulation with Inigo Jones*

1

I

THE MEDIEVAL INHERITANCE

February 10th 1640 was the birthday of Madame Royale, the Duchess Christina of Savoy, sister of Louis XIII and widow of Duke Victor Amadeus I, ruler of a then independent state buttressed between France and the duchy of Milan. That year it was celebrated at the castle of Chambéry by a ballet entitled *Hercole e Amore*, invented by her counsellor and devoted friend, Count Filippo Aglié. There is a marvellous pictorial record of this princely spectacle, as indeed of all Savoy fêtes, from 1640 to 1681, preserved in a series of twelve volumes written and illuminated by Tommaso Borgonio (d.1691), secretary to two dukes in succession.[1] In the ballet Duchess Christina saw her own son, the little Duke Charles **1** Emmanuel, play the part of Love, attired in a wonderful costume of cloth of gold and silver, with diminutive wings sprouting from his shoulders, an absurd head-dress of multi-coloured ostrich plumes, a bandeau of flowers and clutching a tiny bow and arrow. Not only did she have the delight of seeing her son dance for her, but her eleven-year-old daughter arrived later in the ballet in a ship, along with other court ladies dressed as Cypriots, having voyaged from that island, the haven of Love, to pay tribute to the duchess and offer her greetings on her birthday. The setting was of rocks backed by a distant seascape and port, onto which sailed a ship with flags fluttering in the wind and with Cupid aiming his arrow perched on the poop.

By 1640 spectacles of this sort were part of the repertory of entertainment at every European court. The twelve volumes of text and illuminations of Savoy court fêtes give us a wonderful glimpse into this lost world at its apogee. Before our eyes unfold ballets, tournaments and courtly banquets to celebrate birthdays, marriages, saints' days and

carnival time. Knights in exotic costume vanquish sea monsters in the Piazza Castello to mark the marriage of Christina's daughter, Adelaide, to Ferdinand of Bavaria (1650); Madame's own birthday is celebrated by a patriotic banquet followed by a ballet (1645), a feast in which each course took place in a different room decorated to evoke the provinces of Savoy; at an earlier date (c.1640), she and her husband had boarded the Ship of Felicity in the midst of the *salle des fêtes* to the roar of cannons, to watch a marine entertainment. Looking through the drawings, engravings and illuminations of these endless festivities, we enter a world of fantastic allegory, for these fêtes were not only for enjoyment but were meant to be read, in the words of Ménestrier, the seventeenth-century theorist of the court fête, as '*Allegories de l'Estat des temps*'. They are crammed with contemporary comment, but in a language that is today virtually incomprehensible as a means of presenting a programme of political ideas.

Christina's devoted minister and servant Count Filippo Aglié (1604–1667) occupied a key role at the Savoy court, devising these spectacles for a period of over thirty years. Menestrier himself describes Aglié as a man 'versed in the knowledge of history, antiquity, politics, and every sort of *belles lettres*, [he] could compose excellent Latin, Italian and French verse, could play all sorts of instruments and compose music'. Year after year Aglié presided over these entertainments, inventing the themes, writing the verses, composing the music, supervising the vast teams of designers, artists, sculptors, actors and singers which made up each spectacle. He himself was celebrated throughout the Europe of his day as a brilliant choreographer. Aglié's qualifications fitted him for the role exactly, for he possessed a wide literary and artistic knowledge aligned to a detailed grasp of contemporary politics as one of the ducal counsellors of state. Who better could devise '*Allegories de l'Estat des temps*'? Even though his ballet of *Hercole e Amore* lives on for us today as little more than a delightful archaic spectacle, a remote ancestor of the Russian imperial ballet, with its charming flat painted side wings and backcloth, its richly attired aristocratic performers, its touches of humanity in the appearance of the duchess's own children, the ballet was devised and understood by the audience at the time as having a quite specifically political connotation.

It is some measure of how far we have lost this way of thinking that politics is the last aspect that would cross our minds when examining these glittering performances three hundred years later. In her birthday ballet of 1640, Madame Royale saw danced before her the hopes and fears of the moment. Let us try to recapture some of those hopes and fears and to experience, even if only a little, its true meaning. To grasp a fraction of the ballet's impact at the time we have to reconnoitre back in time. Christina's husband, Victor Amadeus I, duke of Savoy, had unfortunately died in

1637, leaving a young child as his heir. His two brothers, disputing Christina's claim to the regency, had promptly allied themselves with Spain, and two years later Spanish forces actually invaded Piedmont and besieged Turin. Christina fled to France and at Grenoble entered into humiliating transactions with her brother, Louis XIII, and his minister, Cardinal Richelieu. It was Filippo Aglié who saved the duchess from virtual surrender to France, a surrender which included the handing over of her infant son to be educated at the French court. Aglié's ballet *Hercole e Amore* celebrated, therefore, the return of Madame Royale to her exiled court and her reunion with her beloved children. The ballet danced by her son, the infant duke, and her daughter, together with many of the greatest nobles of the Savoy court, was a reaffirmation of loyalty at a crucial moment in the country's history. The plot, invented by Aglié, told how the duchess's subjects, the 'Alpine heroes', had been seduced from their allegiance by two wicked enchantresses, Urganda and Melissa (Spain and France), and how this disturbance would alone be quelled and reduced to calm by the Alpine Hercules (the deceased Duke Victor Amadeus) sending Love (the little Duke Charles Emmanuel) to restore concord to her divided peoples. Surprising though this may seem to us, in 1640 this was a perfectly normal means of expressing such a political reality.

But the ingredients that purveyed this political allegory were still novel in 1640: a castle hall, a nascent permanent court theatre, with a proscenium arch built at one end concealing machinery which could, by the withdrawal and projection of side wings and back shutters, change location. This machinery included in its repertory traction devices to enable the descent and ascent of celestial beings. Candles placed behind glasses filled with coloured water accentuated both the mystery and the glory of such a performance. But the true focal point of this totally artificial environment was not the stage at all but the enthroned duchess who sat at the opposite end of the hall. From her eyes radiated the lines of vision fulfilled in the serried ranks of side wings in the peepshow and towards her all the action on stage was directed. The courtiers and others privileged enough to be admitted to this elitist gathering had to make of the vision what they could, ranked as they were on either side along the walls of the room. By 1640 this arrangement was emerging as the norm, precisely because it enabled a manipulation of visual and aural experience perfectly attuned to the ideological demands of the courts of baroque Europe. No one, however, could have prognosticated that the basic elements of this formula, which were initially the products of Florentine humanism in its republican phase in the early quattrocento, would have ended up two centuries later as the ideal vehicle for the exponents of absolutism. How this came about is the central theme of this book.

By the middle of the seventeenth century such expressions in the

language of court spectacle were a natural part of the apparatus of the Baroque monarch. But this apparatus was initially a creation of the medieval and even more of the Renaissance mind. To a great extent the court fête and its context represented one of the most profound philosophical positions taken up by Renaissance writers and artists, who genuinely believed in the importance of the role of art and letters in the service of the state. All over Europe poets, architects, painters, sculptors and musicians united to create these ephemeral spectacles. In Venice, in 1574, Tintoretto and Veronese collaborated to decorate an arch and loggia designed by Palladio for the entry of Henri III en route from Poland to France; in England, in 1533, Holbein designed a pageant of the muses for the coronation entry of Anne Boleyn into London; earlier, Leonardo da Vinci had devised spectacular machines for entertainments at both the Milanese and French courts; Inigo Jones was to expend forty years of his life in supervising the court festivals of the Stuart kings; and the entry of the Archduke Ferdinand into Antwerp in 1635 was made under the artistic direction of Peter Paul Rubens. Writers involved ranged from Ben Jonson and Torquato Tasso to Pierre Ronsard and Jean Dorat; and musicians from Orlando di Lasso to Claudin Le Jeune, and from John Dowland to Claudio Monteverdi. No other art form demonstrates so fully the passionate belief in the union of the arts held during the Renaissance. The court fête could express philosophy, politics and morals through a unique fusion of music, painting, poetry and the dance, all terrestrial manifestations of that overall cosmic harmony which they believed governed the universe and which the art of festival tried so fervently to recreate on earth. Few things, therefore, can give us such a vivid insight into the workings of the Renaissance mind.

But by 1640, the date of our example from Savoy, we are at the tail end of this tradition, whose assumptions and forms have already for the most part been fully developed. We are in fact at the stage where the Renaissance festival is evolving into the Baroque, an evolution which forms the conclusion to this book. What concerns us is the Renaissance festival. What was it and why was it different from what preceded it? Like every other aspect of the Renaissance its roots lay in a rich medieval inheritance which it overlaid and transmuted with images and ideas derived from its rediscovery and study of the art, literature and thought of the classical world. To understand just how revolutionary that change was we shall need to get our initial bearings by considering that heritage. In order to do so, we shall have to simplify a subject which is likewise enormously complex. Let us start, therefore, by looking at the main types of festival form which the Renaissance took over from the middle ages — the royal entry, the tournament and the indoor mascarade or

entertainment — and the changes that overcame these forms during the century and a half of the Renaissance.

The Royal Entry

The royal entry, when a ruler made his solemn *entrée* into and took possession of a city or town, was the most public of these three major festival forms.[2] The *entrée* itself remained relatively simple until the middle of the fourteenth century: clergy, town officers, bourgeoisie and members of the guilds would meet the ruler at the city gate and conduct him into the town. By the close of the fifteenth century, however, the *entrée* had developed into a ritual which embraced the whole of the society concerned, together with its institutions. It incorporated in one gigantic spectacle its judicial, economic, political, religious and aesthetic aspects in a format which reflected vividly not only the rise to prominence of the urban classes but also the increasing power of the prince. It always opened with a gesture of fealty, the arrival of the ruler at the city gate and the formal handing over of keys. This, however, was complemented by exchanges of gifts; and the prince in his turn guaranteed the rights and privileges of the citizens, a gesture re-enacted later in the entry when he performed the same rite for the clergy on his arrival at the principal church or cathedral. The entry procession itself emphasised such mutual obligations, for in one mighty sweep the onlookers saw pass before them, in microcosm, the whole of society as they knew it: the king beneath a canopy attended by his principal officers of state, the nobility, gentry and knights at arms, the clergy in the form of bishops, priests and the religious orders, the third estate made up of officials and representatives of the guilds and confraternities. This medieval processional form, with its concern for rank and for the reciprocal duties of the various classes of society, never changes and continues on through the Renaissance into the Baroque period.

By the close of the fourteenth century, however, this rudimentary welcome began to be elaborated by the introduction of street pageants. These were usually organised by the guilds, and were almost always on religious subjects: scenes from the Passion, the life of the Virgin or lives of the saints. Gradually these tableaux developed, through the fifteenth and into the sixteenth century, into a repertory of archways and street-theatres which presented variants of a remarkably consistent visual and iconographical vocabulary. The same compilation of castles, genealogical

7

trees, tabernacles, fountains and gardens peopled by the same groups of allegorical personages — in the main personifications of the virtues together with biblical and historical *exempla* — appear all over Europe. These ingredients were deployed to remind both king and subject of a number of set topics, which reappear (under different guises and in varying sequence) in entry after entry over a century and a half. They always somehow emphasised the legitimacy of the monarch, both in terms of his own sanctity, due to the act of coronation and anointing with sacred oil, and in those of his descent of the blood royal as the rightful heir of his dynasty. Without exception, they presented to the ruler himself images of those virtues to which he should aspire and for this the whole tradition of the *speculum principis* or 'mirror of princes' from St Augustine to John of Salisbury and to the *De Regimine Principum* was drawn upon. These treatises described the virtues which the ideal Christian ruler should cultivate, although as a literary form their roots went back to antiquity: hence their vigour during the Renaissance. The street pageants demonstrated to the prince the benefits that would flow to his subjects from his possession and practice of these virtues, fruits expressed in the form of trees bursting into leaf, flowery bowers and gardens or flowing fountains. And the city would usually make allusions to itself and its particular needs from the visiting prince. In a way, the ceremonial *entrée* as a form was more closely allied to the act of coronation than at first glance it would seem. Any examination of its underlying ideas shows that its focus is continually on the eternal myths that were essential to the concept of *les rois thaumaturges*, the mystical sacred rulers who were venerated and regarded as a race set apart in the Europe that preceded the age of enlightenment. In this way the key reference becomes the king as Christ entering the new Jerusalem.

We can elaborate on this with some examples. In 1431 the fifteen-year-old Henry VI of England made his state entry into London after his coronation as king of France in Paris.[3] The pageantry presented expressed the political aspirations of the decade that followed the treaty of Troyes, in which the heirs born of Henry V and his queen, Catherine of France, were to rule over the two kingdoms. The citizens of London, no doubt with prompting from the court, devised a spectacle that dwelt on the nature of kingship but which reiterated the legitimate right of their young ruler to wear two crowns. This view was made clear from the start at the city gate, where a shield bore the arms of both countries. In the middle of Tower Bridge the king encountered three empresses, Nature, Grace and Fortune who bestowed upon him 'science and conyng', 'strength and fairness' and 'prosperite and Richnesse'. All this stems from the *speculum principis* tradition, and the pageant went on to elaborate the point with fourteen maidens, seven of whom represented the Gifts of the Holy Ghost and the

rest the Gifts of Grace. The theme was taken up again in a pageant in the middle of which sat a king

> Whom to governe, there as ffigured tweyne,
> A lady, Mercy, satte upon his Riht syde;
> And on his lyffte hand, yff I shall nat ffeyne,
> A lady, Trouthe, his Domes to provyde;
> The lady Clemens aloffte dydde abyde . . .[4]

Before the king sat two judges and seven sergeants-at-law. The fruits of such ideal virtuous kingship followed at Cheapside, represented by a fountain running wine and a cluster of trees laden with fruit 'so cunnyngly wrought, that to many they aperyd naturall trees growynge'. Next came an affirmation of the legitimacy of Henry's descent, a vast genealogical tree which sprang up from St Louis and St Edward the Confessor and met in his father, Henry V, the sanctity of which was reinforced by its being doubled by a biblical Tree of Jesse. The series came to its close with a reminder of the divine nature of monarchy, set apart by anointing with holy oil and the ritual of crowning, in the form of a stupendous paradise in which the throne was surrounded by a heaven complete with hierarchies of angels and from which God the Father spoke to the king.

Dynasty, sanctity, mystery, virtue, cast within visionary and often apocalyptic terms, provide us with the thought context of late medieval kingship, themes which were not to be lost, but rather reinforced, during the Renaissance. Over half a century later in April 1485 the themes evoked in Charles VIII's entry into Rouen were basically identical.[5] This time the sequence was different, for it opened with a tableau on the *speculum principis* tradition entitled 'Repos Pacifique', in which the king sat enthroned with Justice and Strength behind him, Prudence and Temperance at his side and Peace at his feet. Inscriptions interconnected the virtues, whose fruit was peace while below the dais stood seven more regal attributes whose initials made up the king's name:

C onseil loyal
H aut vouloir
A mour populaire
R oyal pouvoir
L ibéralité
E sperance
S apience

As in 1431, a ruler saw represented in abstract the nature of his government, his role as the imposer of Peace and Justice by Strength leavened by Temperance and Prudence. In the second tableau came the customary parallel of the government of heaven to that of earth: an angel

pointed out to St John the Divine the apocalyptic vision of God in Majesty seated on a rainbow surrounded by the symbols of the four Evangelists and attended by the twenty-four Elders. This was a celestial prefiguration of the kingdom of France entitled 'Ordre politique' and the four evangelists were equated with the four estates of the realm: clergy, nobility, burghers and commonalty. Subsequently a tableau entitled 'Uncion des rois' cast Louis XI as David, designating Charles VIII as Solomon his heir, and ordering the high priest to anoint him, after which a crown mysteriously descended upon his head and he was suddenly elevated into the air while figures representing France and her provinces appeared to chorus *Vivat rex Salomon*. Finally came a further chiliastic burst, the equation of Charles VIII with the Emperor Constantine defeating Maxentius by the power of the Cross, a tableau rich in allusions to French claims to world empire by reason of their descent from the imperial house of Troy and from Charlemagne. This lineage cast the French monarchy into a potentially messianic imperial role, as the dynasty destined to produce the 'emperor of the last days' who would subdue the infidel and offer up his crown in Jerusalem.

Although these two entries stand half a century apart, and although they also bear within their scenarios the aspirations of rival countries and rival monarchies, their assumptions about kingship are of a type that occur all over northern Europe in the late medieval and early modern period. They are rooted in a view which is almost wholly biblical, in which the king as Christ or one of his scriptural prototypes, takes possession of the New Jerusalem, in which the earthly state is directly presented as a mirror of the heavenly. The use of typology, the foreshadowing of present by past events, becomes a central means of maintaining the argument. Moving on into the next century, we can trace this format used to a relentless extreme in the young Charles V's entry into Bruges in 1515 in the role of viscount of Flanders.[6] A vast series of street pageants appealed to the young prince to restore the prosperity of the city as it sank in the face of the rivalry of Antwerp. In one, Charles assisted Merchandise to depose Chierté from Fortune's wheel and replace her with Bruges, an event paralleled by Artaxerxes promising to restore Jerusalem. In another Louis of Nevers granting privileges to the city was compared to Moses delivering the Tables of the Law. The equation of Jerusalem with Bruges, of the Brugeois as a second Chosen People and hence Charles as Christ entering his Holy City recurs as an underlying theme in them all. In the same year François I entered Lyons[7] with a programme not so different from that of Charles VIII thirty years before: the baptism of Clovis, the first Christian king of France, recalled the sanctity and descent of the royal family; their legitimacy was further emphasised in a giant *fleur de lys* in which stood François I flanked by *Grace de Dieux* and France, while everywhere there

were the virtues of the *speculum principis* tradition. Neither of these entries, for which we have contemporary illuminated manuscripts, show virtually any trace (save for the contribution of the Italian community at Bruges) of the forms and themes which were soon to arrive from south of the Alps.

The medieval entry showed surprising vitality and endurance. Because cultural fashions moved only gradually across Europe, it continued untouched until the close of the sixteenth century in countries such as England and Scotland. There, somewhat surprisingly, it could even survive the change of religion. Elizabeth I's entry into London (1559) was a triumph for the Protestant Reformation and yet in style it was wholly a child of the preceding Gothic ages.[8] Stripped of its Catholic trappings, the remnants of the archaic repertory were made use of: the legitimacy of descent appeared in the usual form of a tree, this time the family rose tree of the houses of York and Lancaster culminating in the Tudors; the virtues of the *speculum principis* tradition were re-worked to a Protestant ethic, with a tableau of biblical beatitudes and a triumph of virtue over vice; the typological tradition was deployed to depict the young queen as Deborah, 'the judge and restorer of the house of Israel'. Catholic cosmic apocalyptic visions gave way to monarchy cast as Old Testament kingship revived.

England had to wait until 1604 to have its first state entry in the Renaissance manner, for James I. It was a change which the French had already begun to assimilate in the 1530s and which they adopted fully in 1550 on the occasion of Henri II's *entrée* into Rouen. What needs to be stressed is that although the Renaissance was to change the outward face, imagery and style of the medieval entry, it did not dislodge its thought-premises. Indeed, as we shall see, it reinforced them. Nor should we view the medieval entry as a primitive forebear. Within its own terms of reference, it was as coherent and complex as any of the most elaborate Renaissance entries.

The Tournament

The royal entry was essentially a vehicle for dialogue between a ruler and the urban classes. The tournament fulfilled a very different function in late medieval society. It expressed in festival form the role of the monarch both as liege lord of his knights and as the fount of those two supreme chivalrous qualities, honour and virtue. Again, as in the case of the royal entry, the Renaissance was not to replace but to transmute and extend these fundamental ideas, a fact reflected in the change of structure and

11

purpose of feats of arms as a part of the ritual of court life.[9] All recent scholarship has emphasised the continuity and vitality of the chivalrous ideal through the sixteenth century, its adaptability to the changing demands of the new national monarchies and to new ideals of aristocratic behaviour.

The tournament from its origins performed a military function, training knights in the handling of sword and lance, teaching them to fight in groups and instilling into them the virtue of prowess.[10] From the bloody pitched battles of the twelfth century, it had evolved by the late middle ages into three set forms of combat, the joust, the *mêlée* or *tournoi* and the foot combat. All three forms could be united for a *pas d'armes*, a festival form which united the arts of war and peace by overlaying onto an exercise designed to train knights for battle the trappings of allegory, plot, poetry, ceremonial and music. These latter elements must not obscure the fact, however, that until well into the seventeenth century the tournament continued to be regarded with all seriousness as a training for war. This was certainly true for the whole of the first half of the sixteenth century, when the Italian wars (1494–1559) were still fought by heavy cavalry for whom training in handling the lance was absolutely essential. The new standing armies of France, Burgundy, Brittany, Venice and Milan in the late fifteenth century depended on such cavalry, outmoded though it in fact already was. Nor was the advent of firearms such an immediate threat to knightly prowess as we might suppose. Indeed Louis de Bruges, Lord of La Gruthuyse, a bulwark of Burgundian chivalry, chose a bombard with the motto *Plus est en vous* for his *devise*, anticipating the canonball *impresa* of the condottiere Este Dukes of Ferrara.

It was actually not until the last quarter of the sixteenth century that the gun was to drive the lance from the battlefield. It was then and only then that J. R. Hale's observation became an established fact: 'The indiscriminate death by shot and ball ruined war as a finishing school for knightly character.'[11] That that flower of Elizabethan chivalry, Sir Philip Sidney, should have been shot down makes the point precisely. The relationship of actual war to the spectacle of the tournament is therefore an essential background to any discussion of the latter during the late medieval period. The growth in theatricality, which was to be the most pronounced feature of the tournament's development during the fifteenth and into the sixteenth centuries, must not be taken as evidence of decline and decadence. Certainly no one saw it as such at the time. The new theatrical element reflected rather the ability of the form to respond both to the evolution of the aristocrat as courtier and to the demands of nationalistic chivalries, which focussed the loyalty of knights on the ruling dynasty, be it Valois, Habsburg or Tudor.

Knights were capital for a medieval king in time of war, so that it is

hardly surprising that the tournament quickly developed safeguards in the distinction between jousts of war (à outrance) and those of peace (à plaisance) in which the lances were rebated and fitted with coronals. In addition, about 1420, a barrier was introduced which divided one knight from another as they charged towards each other with their lances. And increasingly it was this form of combat, the joust as against the tournoi, which gained currency, epitomising the new stress on individual display in combat. This in turn was soon to merge into the renaissance concept of fame as achieved by heroism in battle. The purpose of joustes à plaisance was to splinter as many lances as possible, with additional points being scored for good strokes. These late medieval accomplishments were to be carried into the renaissance period as the attributes of any accomplished courtier. Castiglione, eulogising Guidobaldo, Duke of Urbino (1472–1508), wrote:

> ... the greatnesse of his courage so quickened him, that where hee was not in case with his person to practise the feates of Chivalrie, as he had done long before, yet did he take verie great delight to behold them in other men ... And upon this at Tilt, at Tourney, in playing at all sorts of weapon, also in inventing devices, in pastimes, in Musicke, finally in all exercises meete for noble Gentlemen, every man strived to shew himselfe such a one, as might deserve to bee judged worthie of so noble assembly ...[12]

In this we pass from the medieval knight to the renaissance courtier; but the end remained identical, to be 'well seene in armes'.

Tournaments began as events inimical to civil order. In England they were banned by Henry II and later subject to royal licence. As the middle ages drew to their close, however, they were staged more and more often under the auspices of government; and what had been a warlike private pursuit became a festival ritual of homage and service to the crown. The introduction of an element of disguise went back as far as the thirteenth century with the 'Round Table' tournaments, and in the fourteenth century this was developed still further.[13] In 1343 the challengers at a tournament at Smithfield came dressed as the Pope and his cardinals. Forty-three years later Richard II looked on to see knights led in by silver chains held by ladies mounted on palfreys. These modest beginnings were to be substantially elaborated in the fifteenth century under the aegis of the courts of Anjou and of Burgundy.

René of Anjou (1409–1480), scholar, poet, artist, architect, courtly lover and valiant man at arms, maintained a brilliant and influential court. Not only was he the author of the most meticulous treatise on tournament ceremonial ever written, the Traité de la Forme et Devis d'un Tournoi, but he also presided over several fantastic feats of arms.[14] One was the Emprise de la Gueule du Dragon (1447) in which knights guarded a pas

6

near Chinon where their shield adorned a column topped by 'un Dragon furieux'. Another was the *Chasteau de la Joyeuse Garde* (1448), a fête which lasted forty days and included a tournament whose main feature was the procession to the lists in which walked Turks leading lions by silver chains. Even more extraordinary was *Le Pas de la Bergière* at Tarascon in 1449. Reflecting the preoccupation of his court with the literary affectation of idealised rusticity, the gallery this time was a thatched cottage. At one end of the list there was 'une gente pastourelle' tending with her 'houette' her 'brebiettes', beneath a tree upon which had been hung the shields of two challengers, black and white, *tristesse* and *liesse*. They, of course, arrived attired as shepherds attended by 'deux gentilz escuiers pastoreaux'. René of Anjou's territorial authority was fragile and such public demonstrations of wealth and power through the cult of chivalry were aimed at keeping a nobility loyal to the crown. The same deliberate development of a glamorous court to meet the same ends was even more true of the dukes of Burgundy.

The financial resources of the Burgundian court were infinitely greater than those of René of Anjou, and it was there that chivalrous exercises took on a form that was to have a decisive influence right into the second half of the sixteenth century.[15] So complex were their tournaments that I shall allude briefly to the ingredients of only one, the famous *Pas de l'Arbre d'Or*, staged to celebrate the marriage of Margaret of York to Charles the Bold in 1468. It began with what became a standard ingredient, a cartel giving the allegorical framework. In this the lady of the *Ile Cellée* begged the Bastard of Burgundy, who had recently rescued a lady, to undertake an enterprise, one condition of which was that he should decorate a golden tree with the arms of famous warriors. The lady placed at the Bastard's disposal her pursuivant, *Arbre d'Or*, a dwarf, and also the giant of the *Fôret douteuse*, whom she held captive. The tournament, which took place in the market-place at Bruges, lasted several days. Opposite the gallery, in which the ladies of the court sat, there was a vast golden tree, and each knight arrived with his own separate device within the overall plot of the festival. It would be pointless to describe at length the exoticism and fantasy of every knight and one will suffice. Cartellieri's lush prose encapsulates the mood exactly:

> Anthony of Luxembourg, Count de Roussy and Brienne, on his part had also prepared an unusual entry. A dwarf from Constantinople, belonging to the English King, rode in behind trumpeters. In his right hand he held a paper after the fashion of a petition; a key was tied to his arm as if to add a suggestion of mystery. A stately counterfeit citadel was then rolled in, the walls being of black stone, having four towers at the corners, and one in the centre. Within the citadel, by command of an unknown lady, the Count of Roussy was held a captive. Having reached the ladies' presence, the dwarf

read his petition aloud. *Danger*, it ran, possessed the key to this prison and had entrusted it to him, *Petit Espoir*, his servant. The knight would only gain his liberty and take part in the *Pas* by the intercession of the noble ladies assembled here, for not even *Danger* could refuse such a request. The ladies having signified their approval, the dwarf flung open the great gate and out sprang the Count of Roussy in armour. His motto was inscribed in gold letters on his horses' trappings, which were of white satin.[16]

Pure theatre although this may seem, it is to be remembered that the lords who decorated the tiltyard at Bruges were the very same who rode into battle alongside their liege, the duke of Burgundy.

The influence of this type of tournament was to be enormous. The emperor Charles V inherited Burgundian chivalry along with the Burgundian lands, and Burgundian chivalry certainly did not perish on the battlefields of Morat and Nancy. Catherine de'Medici in her *magnificences* was also to attempt to emulate the tradition, while in Italy the court at Ferrara was to marry this northern inheritance with the new ideals and forms of renaissance humanist culture. But nowhere was the Burgundian tradition to be stronger than in England, where, due to Edward IV's exile in the Low Countries and the translations of Caxton, the two civilisations shared a common literature. This tradition was to bear its richest fruit in the reign of Henry VIII, the first twenty years of which were devoted to using the tournament in its Burgundian form as a means of presenting the king to the world as the Tenth Worthy. There, in the aftermath of the Wars of the Roses, the problem was not so different from that of Anjou and Burgundy: the use of the cult of chivalry in blunting a powerful aristocracy in service to the crown.

The tournament held in celebration of the birth of a son to Katherine of Aragon in January 1511 is not only very fully documented but has been the subject of an important scholarly study by S. Anglo.[17] It neatly sums up the strength of the Burgundian tradition following the format exactly, although one is struck by its provinciality in comparison. It opened as did its predecessors with a letter of challenge which outlined the allegorical setting. Queen *Noble Renome* of the land called *Ceure noble* had heard of the birth of the royal child, and had sent four knights to honour the event with feats of arms. They were *Ceure loyall* (Henry VIII) attended by three courtiers as *Vaillaunt desyre, Bone voloyr* and *Joyous panser*. On February 12th the queen and her ladies assembled in the tilt gallery. The tournament was prefaced by a huge pageant car which wended its way slowly towards them. It was preceded by wild men, who led a golden lion and a silver antelope on whose backs rode ladies. These in turn drew a forest nine feet in height which included 'hawthornes, okes, mapylles, hasylles, byrches, broom, fyrs, with bestes and byrds in bosyd [embossed] of svndry facyn'. On it were two foresters and in the middle there was a golden castle,

7

15

within which there was a lady with a garland of silken roses for the queen. Inside this mobile forest were hidden the four challengers, whose shields bearing their *devise* were suspended from trees at the corners. On arrival before the queen, the foresters blew their trumpets and the king and his companions revealed themselves. As in the case of the *Pas de l'Arbre d'Or* there was a whole series of allegorical entries. On the second day the king's brother, Charles Brandon, Duke of Suffolk, came in a tower which was unlocked and out of which he stepped dressed as a pilgrim. A letter was carried to the queen seeking permission to run at tilt; which granted, he threw off his disguise and stood revealed fully armed. How reminiscent of the Count of Roussy's entry nearly half a century before in the market-place at Bruges!

So the tournament as an expression of courtly chivalry was essentially a northern festival form, although there was, of course, a vigorous Italian tradition. It drew for its imagery on Arthurian legend and medieval romances. In contrast to the royal entry, the transmutation into its renaissance guise was not to be so dramatic. In this instance it might be argued that the influences worked in reverse from north to south, as opposed to the more usual south to north. As it was fundamentally the expression of an aristocratic society, it was only when Italy moved away from republicanism to the autocracy of the new dynasties established through the Italian wars that it began to be cultivated as a festival form expressive of a new order of things.

Entertainments

Tournaments in the late middle ages were more often than not a daytime manifestation of a festival event that continued in the evening and went on into the night with feasting and revelry in the great hall of the palace. On the evening of the tournament that celebrated the birth of a son to Henry VIII in 1511, there was a banquet followed by an 'interlude' with songs and then a court ball. In the midst of this the king disappeared and 8 dressed himself for a 'disguising'. Four torchbearers entered the hall, preceding a pageant car on wheels which stopped at first behind an arras curtain hung across the hall. A gentleman then went up to the queen and explained to her:

> howe in a garden of pleasure there was an arber of golde, wherin were lordes and ladies, moche desirous to shew pleasure and pastime to the Quene and Ladies, if they might be licenced to do so.

The queen spoke on behalf of all present in bidding them enter, at which point the arras (ancestor of the theatre curtain) 'was taken awaye'

revealing 'the golldyn arber in the arche yerd of plesyer'.

The arbour was made up of gilded pillars entwined with golden grapes and within it arose an orchard of pomegranate, apple and olive trees. Spring flowers surrounded the benches beneath the trees, on which sat six lords (three of whom had been amongst the challengers at the tournament) and six ladies attired in white and green, the Tudor colours, thickly overlaid with letters of heavy gold embroidery which were later to be rifled by the onlookers. The lords and ladies were flanked by eight minstrels and, at the front, on the steps leading down to the hall floor, stood more people; while at the summit of the pageant six choristers burst into song. The lords and ladies then descended and performed to the ministrels' music what must have been a series of choreographed dances, however rudimentary in form.[18]

This is an instance from provincial England of a type of entertainment which was common currency at any European court by the close of the fifteenth century. The basic ingredient was the arrival of aristocratic persons in disguise, either on foot or riding on a pageant car, who danced before the assembled company and who subsequently joined with them in a court ball.[19] Dancing presupposed the attendance of musicians and this could entail the addition of song, of attendant actors and increasingly the introduction of a plot giving substance to the 'disguise', which called for elucidation by speech. The latter entailed work for the court poet, and in England the earliest surviving instances are by John Lydgate providing an allegorical framework for the simple mummings staged to entertain King Henry VI.[20] But by far the greatest elaboration of such secular indoor entertainments was reached at the Burgundian court by the middle of the fifteenth century.

As in the case of the tournaments, so complex and rambling were these events that I shall confine myself to describing just a few elements which made up one of their most famous spectacles, that inspired by the capture of Constantinople by the Turks in 1453, the Feast of the Pheasant staged at Lille on Sunday February 17th, 1454.[20] I shall pass over the *entremets* (the allegorical set pieces that were exhibited on the banqueting table), the fact that the various courses (none of which was less than forty dishes) were let down by cranes in litters from the ceiling, and the preliminary interludes that included the Adventures of Jason at Colchis, in allusion to the ducal Order of the Golden Fleece, in favour of the main entertainment of the evening. This began with the entry of a Saracen leading an elephant with a tower on its back, in which sat Holy Church with a black mantle of mourning cast over her. Holy Church declaimed her woes in a dirge addressed to the duke: *Lamentatio Sanctae matris ecclesiae Constantinopolitanae.* Heralds of arms now appeared headed by Golden Fleece King-at-Arms, bearing a live pheasant wearing a bejewelled collar.

He was followed by two ladies and two knights of the Golden Fleece. The herald addressed the duke, reminding him that 'it is and was ever customary to present a peacock or other noble bird at great feasts before the illustrious princes, lords and nobles, to the end they might swear expedient and binding oaths, now I, with these two ladies, am here to offer to you this noble pheasant . . .' The duke arose, presented a scroll to the herald and swore an oath to fulfil what had been written on it. This stated that Duke Philip would accompany his lord the king of France on a crusade, should he proclaim one, and that he was prepared to engage the Sultan in single combat.

Holy Church, having rendered thanks, retreated from the hall on her elephant and the great nobles pressed forward to take the oath. There then entered a lady in the role of God's Grace. She was preceded by torchbearers and musicians, and attended by twelve knights bearing torches in crimson and black with golden masks, who led in twelve ladies whose faces were veiled. The ladies wore jewelled collars and on a leaf on their left shoulder was inscribed their identity as one of the twelve Virtues. God's Grace proceeded to introduce herself to the duke to whom she handed a letter. This was read out aloud and recorded the joy of both God and the Holy Virgin at the response of the Burgundian court and went on to say that they sent these Virtues that the venture might be brought to a glorious conclusion. One by one the Virtues were presented to the assembled company after which God's Grace departed, leaving the knights and Virtues, ladies and gentlemen of the court in disguise, to take part in the ball that followed.

At the Burgundian court, as this instance demonstrates, such disguisings and pageantry within the palace walls could be deployed for a highly political purpose. As Maurice Keen demonstrates, the Feast of the Pheasant was not empty extravagance but a precursor in late Gothic guise of the renaissance alliance of pageantry and politics. Both Philip the Good and his father were devoted to the crusading cause. In the 1440s Burgundian ships were in the Mediterranean and the plans for the crusade meandered on with all seriousness until 1456. The etiquette and ceremonial of Burgundy were indeed to be European in their influence. Through the Emperor Charles V they were taken up by both branches of the Habsburg family, in Spain and in the Empire. Through both dominion and marriage they were also to be adopted in the Italian peninsula. These entertainments, however, still belong firmly to the middle ages. Their imagery is religious and romantic. They are rambling and episodic, and although elementary machinery and scenery was used, it was unsophisticated. Such entertainments were appendages to the basic ingredients of any festive evening, feasting and dancing. The notion of a separate *salle des fêtes*, let alone of a court theatre did not exist. That idea

in itself embodied a major boundary which was to divide the renaissance festival from its medieval predecessors.

Conclusion

This brief survey of the medieval inheritance shows how piecemeal it was. The ideologies that were to radically transform the disparate elements that made up these events were scarcely in evidence. The true focus of medieval symbolic pageantry had been religious, the liturgy of the Church, mirroring a world picture which centred directly on God and in which the place of man, whether ruler or peasant, was still basically on the periphery. This is vividly reflected in the splendours of religious ceremonial at Easter or Corpus Christi and its secular expression in processions and mystery plays. The greatest spectacles of the medieval *rois thaumaturges* were not their state entries but their stupendous religious rites in which they were exhibited to their people in the solemn rituals of a royal coronation or funeral, healing by touch for the king's evil or washing the feet of the poor in imitation of Christ each Maundy Thursday. What is more, the escalating ceremonial surrounding late medieval kingship could actually stem from the adaptation to a secular purpose of a format that was in origin religious. Thus the introduction of a canopy carried over the French monarch in the late fourteenth century was almost certainly a transference to the king of a ritual used in honour of the Sacrament in the Corpus Christi procession. In this way the royal entry in France evolved out of the liturgy.[21] Although by 1500 secular court festivals were much more prominent, the balance was still heavily in favour of religion and of the Church. By 1600 that had changed. In countries that remained Catholic, ecclesiastical pomp in its new counter-reformation guise was to be complemented by what can only be called a liturgy of state which centred on the ruler. In the case of Protestant countries, there was not even a question of complement. It was one of total reversal. The liturgy of state ruthlessly replaced that of the medieval church; for the new reformed churches had abolished religious images and ceremonial. In Elizabethan England, for example, the Accession Day of the monarch was promulgated as an official holy day of the Established Church, its festivities replacing those of the old medieval saints' days.[22] The medieval religious plays gradually ceased to be performed giving way to a new type of secular mystery, entertainments staged in homage to the Virgin Queen as she wended her way through her kingdom.[23] A tremendous revolution had taken place, in which, under the impact of renaissance humanism the art of festival was harnessed to the emergent modern state as an instrument of rule.

II

REMOVED MYSTERIES

Ben Jonson, publishing the text of one of his most recondite
entertainments for the Stuart court, was moved to do so because otherwise
'the glory of all these solemnities had perished like a blaze and gone out in
the beholders' eyes'. Then follows a sentence which brilliantly and
conveniently encapsulates for us what set the renaissance festival apart
from its medieval precursor:

> This it is hath made the most royal princes and greatest persons, who are
> commonly the personators of these actions, not only studious of riches and
> magnificence in the outward celebration or show, which rightly becomes
> them, but curious after the most high and hearty inventions to furnish the
> inward parts, and those grounded upon antiquity and solid learnings; which,
> though their voice be taught to sound present occasions, their sense doth or
> should always lay hold on more removed mysteries.[1]

Festivals, Jonson tells us, relate to princes and great persons. They are
expressions of 'riches and magnificence'. They are vehicles for 'high and
hearty inventions', stemming not only from a profound study of classical
antiquity but deep scholarship and learning. And, although they admirably
reflect the current needs of any event, beneath the surface lurked for
perception by the erudite 'removed mysteries'. Jonson's sentence is in fact
dense with ideas, ideas that establish that a revolution has indeed taken
place and a series of assumptions has been established by the opening of
the seventeenth century. It will be the concern of this chapter to elucidate
what exactly these assumptions were.

'The most royal princes and greatest persons': the idea of magnificence

Renaissance festivals focussed on the prince. In a Europe dominated by the problem of rival religious creeds and the breakdown of the universal Church, the monarch not only established himself as the arbiter in religious matters but gradually became adulated as the sole guarantor of peace and order within the State. Before the invention of the mechanical mass media of today, the creation of an 'image' of a monarch to draw people's allegiance was the task of humanists, poets, writers and artists. During the sixteenth and seventeenth centuries, therefore, the most profound alliance developed between the new art forms of the Renaissance and the concept of the prince. This proliferated into every field of artistic endeavour. These were the centuries of palace building: the Louvre and Fontainebleau by the Valois, Whitehall and Nonsuch by the Tudors, and the Escorial by the Habsburgs. Simultaneously the state portrait, together with its multiplication by studio assistants and engravers, became a vehicle for dynastic glorification. This was reflected in many alliances between ruler and painter: Charles V and Titian, Henry VIII and Holbein, Charles I and Van Dyck. Such a systematic proliferation of monarchical imagery found further expression in the cult of the medal. Every great event in the life of a prince was to be enhanced by recondite allegory on the reverses of medals struck in his honour. Not only did such attitudes affect the visual arts, but they also affected the world of letters. The great Renaissance epics, Ronsard's *Franciade* or Spenser's *Faerie Queene*, were written for the glory of princes. Each celebrated the reigning dynasty by perceiving its members through the mythical history of their legendary forbears. At the same time court historians, under the impact of Renaissance historiography, recast national history within dynastic terms. For Edward Hall, the whole of English history was but a prologue to the accession of the house of Tudor and, in particular, to the most magnificent reign of King Henry VIII. For a chronicler of the arts like Vasari, the development of painting to perfection was somehow aligned to the rise of the Medici to absolute power within the city of Florence.

The importance attached to tournaments, ballets, state entries, firework displays, water spectacles, alfresco fêtes, intermezzi, masques and masquerades is reflected in the vast corpus of literature printed to commemorate these events. These describe to us, in minute detail, what might at first glance seem essentially trivia: the architecture, paintings and decorations, the sculptures, allegorical devices, scenery and costumes that made up such occasions. These descriptions and their commentaries were to enable those who were not there to savour the transitory wonder and to grasp its import from afar. Commemorative books, with their elaborate illustrations printed under official auspices, were designed to pass to

posterity as monuments of princely magnificence. The significance attached to this is, as I shall demonstrate, reflected in the emergence of such a literature. By 1550 it had established itself as a literary genre. By 1600 no major festival went unrecorded in print, the publications were on a lavish scale and illustration became the norm. The coincidence of this development with the emergence of absolutism and in the quest for messianic rulers around the year 1600 cannot be accidental.

It is magnificence, however, which is the key word. The very idea of it was to be of central importance both to the Renaissance and Baroque court.[2] Prodigal expenditure on achieving splendour was certainly not a medieval virtue, but it came to be one through the humanist revival of a Thomist-Aristotelian philosophical position. The praise of magnificence arose through the defence by Florentine humanists of the building projects of Cosimo il Vecchio. In doing this they looked first to St Thomas, who had classified magnificence as a virtue, and through him to Aristotle who, in the *Nicomachean Ethics*, had been even more precise: '. . . great expenditure is becoming to those who have suitable means to start with, acquired by their own efforts or from ancestors or connexions, and to people of high birth and reputation, and so on; for all these things bring with them greatness and prestige'. Magnificence thus became a princely virtue. A prince must be seen to live magnificently, to dress splendidly, to furnish his palaces richly, to build sumptuously. No other philosophy could otherwise explain the vast sums of money expended by Henry VIII on the Field of Cloth of Gold, Mary of Hungary on the fêtes at Binche, or Catherine de'Medici on her sets of 'magnificences'. In the case of a Catherine de'Medici or a Charles I, the importance of court spectacle as a demonstration of regal 'magnificence' was such that their greatest creations came during periods when the crown was not only heavily in debt but almost bankrupt.

'Antiquity and solid learnings': emblems, 'Imprese' and the mythological manuals

The Renaissance court festival, unlike its medieval forbears, stemmed from a philosophy which believed that truth could be apprehended in images. Its approach can be summed up in the words of Prospero conjuring up the marvels of the masque in *The Tempest*: 'No tongue! all eyes! be silent.'[3] Fêtes speak to the visual sense in a lost vocabulary of strange attributes which we can no longer easily read, but which, by the

22

close of the sixteenth century, was a perfectly valid silent language within the make-up of the educated Renaissance mind. Our guide to it is a vast tract of literature, books of emblems and *imprese* and mythological manuals.[4]

These compilations were an extension and elaboration, under the impact of Florentine Neoplatonism, of the inherited tradition of hidden meanings. Both Greek and Latin apologists had argued that the pagan philosophers had had glimmerings of the Christian truth and revelation. Although these texts were known to the middle ages, they were studied with renewed fervour during the renaissance, when scholars examined them to recover a lost history or secret wisdom, pre-dating the Christian revelation, that was passed down through Moses and the Egyptian priests by way of Hermes Trismegistus to the Greeks. The massive extension and revitalisation of allegory during the renaissance owed much to this impulse, which was reinforced by the efforts of antiquarians to explain the surviving monuments of antiquity. It was also reinforced by the similarities between Platonism and Christianity. The acceptance of a pagan theology that descended from Zoroaster through Hermes Trismegistus to Orpheus, Pythagoras and Plato enabled Renaissance man to assimilate the whole heritage of classical mythology and history. The imagery of Renaissance festivals reflects this vividly.

In this tradition of secret wisdom, the Egyptians occupied a seminal postion and the emergence in 1419 of a book supposedly written by a priest, Hor Apollo, provided the renaissance not only with an Egyptian Book of Creatures (to assimilate into the existing tradition of Christian bestiaries) but also with further confirmation that hidden meanings were indeed to be discovered in the lost records of the ancients. First printed in 1505, the *Hieroglyphica* was to run through thirty editions by the close of the century. In it the reader could learn, for example, that the Egyptians used the phoenix in their inscriptions to represent the soul and the eternal renewal and restoration of all things. Or they could discover that a swan symbolised a musical old man. As sight was the primary sense in the Neoplatonic hierarchy, great store was laid on the cult of hieroglyphs and emblems, which, it was believed, not only visually symbolized an abstract idea but somehow by these ancient attributes partook of its very essence. The principles of the *Hieroglyphica* were translated into more popular form by Andrea Alciati, whose *Emblemata*, first published in 1531, had run into innumerable editions by the close of the sixteenth century. Although these began as epigrams, the addition by the printer of illustrations established the caption-figure-epigram formula. In this way a swarm of bees making a helmet in a hive symbolized *Pax*, or two white men scrubbing a coloured one epitomized *Impossible*, or Aeneas carrying his aged father, Anchises, depicted *Pietas*. More obscure are the ones

stemming back to the *Hieroglyphica*, such as the serpent devouring its own tail which represents Time.

Alciati's *Emblemata* was the fount of a whole series of emblem books in every European language, all of which copied and repeated each other as they welded together the same sources, a combination of Egyptian pseudo-science, Hellenic mythography, Pythagorean metaphysics, medieval heraldry, alembicated Petrarchism and Ficinian Neoplatonism. The most important and influential of these was the *Hieroglyphica sive de sacris Ægyptiorum aliarumque gentium literis* (1556) by Piero Valeriano. This ran into nine editions down to 1626 and was also translated into French and Italian. Valeriano's huge dictionary added to the Egyptian hieroglyphs the symbolism of medieval lapidaries and bestiaries and that of animals stemming from the *Physiologus*. It immediately became a veritable mine of information for organisers of court festivals.

Let us take some examples. One of the most extraordinary emblems in Alciati's *Emblemata* depicts the hero Hercules, club in hand, with chains issuing from his mouth to the ears of a crowd of people and the motto:

9 *Eloquentia Fortitudine praestantior.*[5] The image goes back to Lucian, who identified the Celtic god, Ogmius, with Hercules. Lucian attributed to this god powers of eloquence such as would enslave the listener. This image, one unknown to the middle ages, was enshrined in Alciati, and presented an emblem ideal for application to monarchs bent on subduing their subjects by the civilising powers of persuasion. Its appeal to French humanists was immediate, and the rudimentary version in Alciati was taken up and developed into a complex mythology in which the monarch

10 was cast as the Gallic Hercules. In 1549 Henri II made his entry into Paris, a spectacle designed to demonstrate to Europe French power and prestige in the face of the might of Charles V's empire. The entrée opened with an arch surmounted by the Gallic Hercules 'dont le visage se rapportoit singulierement bien à celuy du feu Roy Francois'. From his mouth extended golden chains to figures personifying the four estates of the realm, vanquished by the wisdom and power of this humanist prince. Its meaning was to be even richer for Henri IV who, in the aftermath of the savage wars of the Catholic League, needed all his powers of persuasion to reconcile a kingdom divided by religion. In 1595 he made his entry into Lyons where Chancellor Bellièvre made use of the theme; while the year after, in Rouen, an obelisk was erected covered with scenes (including

11 Alciati's famous image from an edition of 1549), celebrating Henri as Hercules and one face of which was inscribed *Hercules Gallicus*. Four years later the Jesuit André Valladier devised a complete programme for the reception of the king's bride, Marie de'Medici, into Lyons on the subject including, amongst its by now extremely complex ramifications, aspirations to empire and universal peace, Alciati's original emblem. The

same author in his funeral oration for the king wrote: 'Le feu Roy en ses devises n'avoit rien de plus commun que la massue d'Hercules, dépeinte en ses galeries, brodée aux bocquettons de ses gardes, gravée en ses médailles, esmaillée sur ses armes, comme le grand Alexandre imitoit tant qu'il pouvoit Hercules!'

Valeriano was on every scholar's bookshelf. The entry of Anne of Austria into Segovia in 1570 was largely based on it;[6] it was plundered by the compilers of Elizabeth of Austria's entry into Paris the following year.[7] Ben Jonson constantly had it to hand when he devised the masques for the Stuart court. In 1605 he staged the first of these, the *Masque of Blackness*, in which Anne of Denmark and her ladies arrived disguised as Aethiopians come to pay tribute to James I. To him they yielded their fans on which were painted 'a mute hieroglyphic, expressing their mixed qualities'. 'Which manner of symbol,' he continues, 'I rather chose than *imprese*, as well as for strangeness, as relishing of antiquity . . .' The third pair of masquers presented 'A pair of naked feet in a river', an image which meant 'the purifier' and Valeriano gave its source as the *Hieroglyphica* of Horus Apollo.[8]

This cult of emblems was complemented with exactly what Jonson refers to, a preoccupation with personal devices or *imprese*, a Neoplatonic revamping of the devices of medieval chivalry.[9] An *impresa* is something quite distinct from, if interconnected with, an emblem; and these too provoked a vast outpouring of literature in which learned authors debated at length the rules which framed them. Such an argument was a crucial one, for it focussed on a problem central to late Renaissance or mannerist court culture, that of expression. Although *imprese* were said to have been a fashion taken north by the armies of Charles VIII, they were in fact a reworking in terms of Renaissance thought of the old medieval *devise* which a knight bore in honour of his lady. As the sixteenth century progressed they extended out from their original basis within the ambience of chivalrous love-etiquette and became vehicles for the most recondite speculations of the academies. In general an *impresa* consisted of 'the body', the picture, and a motto, 'the soul', both of which were interdependent and expressed the aspirations of the bearer. As in the case of emblems, they lent themselves readily to the strongly hermetic currents typical of the age; the treatises all present them in a haze of historical mythology with a lineage which included the Egyptians, the Bible, the Greeks and Romans. Their obscurity also reflected this obsession with the hidden and arcane, and their adoption by crowned heads and courtiers again emphasised the hierarchical divisions of society. For monarchs, *imprese* became an essential expression of their ideals; they were used in the decoration of their palaces and public buildings and even on the most menial items of their everyday life — book-bindings, fabrics, silver, glass

and costume. Layers of abstruse meaning could be extracted from a device such as Henri II's crescent-moon with the motto *Donec impleat orbem,*

12 which combined prophecies of French imperial expansion and religious aspirations, together with a compliment to his moon-goddess mistress, Diane de Poitiers.

Imprese formed an essential part of the language of festival, vividly intertwining the language of knightly love with that of loyalty to the crown.[10] Such, for instance, were the devices used for the great carrousel staged in 1612 in Paris to celebrate the marriages of Louis XIII and Anne of Austria and Elizabeth of France with the Spanish Infante.[11] The most important band of aristocrats came as the *Chevaliers du Soleil,* all of them carrying shields decorated with sun *imprese*: in splendour, banishing clouds, opening the leaves of flowers or hovering above an eagle or phoenix. These reflected the new emphasis on sun imagery that was to become such a marked feature of French court life as the monarchy moved towards the absolutism of Louis XIV. Over the following forty years the imagery of these sun *imprese* was to recur until, in 1663, he finally adopted the sun as his personal *impresa* with the motto: *Nec pluribus impar.* These were expressions of an increasing political reality. In a post-Copernican universe the planets actually revolved around the sun.

The emblem books were complemented by the mythological encyclopaedias, which were so prominent in the middle years of the sixteenth century. In these the re-discovered pantheon of pagan antiquity was conveniently synthesised, presenting writers, scholars and artists with a series of indispensable handbooks.[12] In them were described the basic myths and fables, the appearance and attributes of both gods and abstractions and, central to their use, their symbolic meaning within the three main strata of interpretation, moral, historical and according to natural philosophy. Often what may appear as a pyrotechnic display of erudition by the compiler of a court festival will in fact be revealed as having been pirated wholesale from one of these books. The four in question are: Lilio Gregorio Giraldi's *De Deis gentium varia et multiplex historia* (1548), Natale Conti's *Mythologiae* (1551), Vincenzo Cartari's *Le*

13 *Imagini colla sposizione degli dei degli antichi* (1556) and, much later, Cesare Ripa's *Iconologia* (1593). All four ran into many editions, often profusely illustrated, and were translated into Italian, French, German and English. They remained standard source books until well into the Baroque period and as sources for unravelling the meaning of festivals of the mannerist era, when allegory entered its most obscure phase, they are fundamental.

Giraldi and Cartari were used, for example, for one of the most spectacular of the fêtes staged to celebrate the marriage of the Emperor Ferdinand's daughter, Joanna, to the son of Cosimo I, Duke of Florence in

1565–66.[13] The *Genealogia degli Dei* was the last but one *fête* designed to impress both the bride and the whole of Europe with the richness, power, splendour and artistic taste of the Medici court. Vincenzo Borghini was a humanist in the service of Cosimo whose role was to devise the allegorical programmes for such festivities. Vasari supervised their visual realisation, in the case of the *Genealogia* designing twenty-one triumphal chariots **14** besides hundreds of costumes for those who walked in the procession. The theme was that of Olympus come down to earth in homage to the bride and groom, and with these encyclopaedias to hand, author and artist compiled a spectacle of mind-boggling erudition. The more abstruse the image the more it appealed to Borghini, so that through the Florentine streets there meandered a bizarre assembly of figures that included the Demogorgone of Boccaccio, the Juno of Martianus Capella and the Assyrian Apollo of Macrobius.

Forty years later Ben Jonson found these works equally indispensable as he wrote the masques for the court of James I. One instance here too will suffice. In 1608 he wrote the *Haddington Masque* to mark the marriage of Viscount Haddington to a daughter of the Earl of Sussex.[14] The plot was a graceful eulogy of the marriage, making use of a dramatization of a poem by Moschus known as *Amor Fugitivus*, in which Venus describes her runaway son, Cupid. In the masque this was a preface to a vision of Vulcan's forge in which the court saw a 'curious peece', a golden celestial sphere — the 'heauen of mariage' — bearing the masquers as the zodiacal signs who invoked the blessings of Venus' star on the 'perfection' of the alliance. The description of Venus, her swans and doves, and of Vulcan, lame, dirty and soot-stained, all came out of Cartari. From Cartari too he learnt that Vulcan wore a blue pointed cap which symbolised the heavens where pure fire, of which Vulcan was god, was to be found. Interpreting this within the light of natural philosophy, Jonson then turned to Conti, a prime source for the interpretation of fables *ad physicam*, where he found a whole series of references including one to Vulcan as *facifer in nuptiis*. This association of the god of fire with marriage because he was heat and light, enabled Jonson to construct his masque around Vulcan and Venus, in her role as 'Praefect of Mariage', as being the two essentials to procreation.

Both in Borghini's and in Jonson's case there were bitter complaints by spectators who, understandably, could not take in what they were seeing. In 1566 it was reported 'The festival procession displayed such a wealth and variety of figures that in the short span of time available to the observer they could not be grasped by everyone, and this gave rise to criticism'.[15] Jonson roundly declared that the object of such spectacles was 'to declare themselves to the sharpe and learned; And for the multitude, no doubt but their grounded iudgements did gaze, said it was fine, and were

satisfied'.[16] Such a view did not reflect so much distasteful academic snobbery as something more profound, the pleasure and delight that a Renaissance audience took in enigmas and mysteries.[17] Indeed the philosophical assumptions of the Renaissance hermetic tradition are never far away from the study of festivals in their most esoteric, courtly guise as in the Florentine *apparati* or the Stuart court masques.

Festivals offer one aspect of a phenomenon that is central to both the sixteenth and the seventeenth centuries, the allegorical tableau whereby ideas were conveyed by a combination of more or less naturalistic pictorial representations on the one hand with, on the other, some kind of organisation in space which is not naturalistic but artificial, schematic or diagrammatic.[18] Festivals were aggregates of symbolic images held together by words, spoken or written, which were an essential part of the visual statement and without which it became virtually meaningless. Although hieroglyphics were initially exploited in the service of Renaissance Neoplatonism, such a concern with images was also shared by Aristotelians. For them, thought consisted of forms which are received by the mind as images. There was, therefore, no essential divide, in that, to both, every picture was a symbol whose true importance lay in its meaning; and that was expressed in symbolic or allegorical terms by way of words. Only in the significance attached to images would they have parted company. These diagrams, therefore, as Walter Ong has described, may be said to have occupied a position midway between the aural and visual worlds of communication for two centuries. Such an attitude accounts for the enormous vitality of the festival tradition as a valid means of expression during the same period.

'High and Hearty Inventions'

Sir John Harington, in the preface to his translation of Ariosto's *Orlando Furioso*, usefully defines the layers of meaning which, under the impact of such humanist thought as that encapsulated in the encyclopaedias, governed a Renaissance court spectacle in the same way as they formed the basis for the composition of a poetic epic. Both were concerned not only with giving delight and pleasure but also in purveying matter for contemplation by the learned:

> The Ancient Poets have indeed wrapped as it were in their writings diverse and sundry meanings, which they call the senses or mysteries thereof. First of all for the literall sense ... they set downe in manner of an historie the acts

28

and notable exploits of some persons worthy of memorie: then in the same fiction, as in a second rime and somewhat more fine, as it were nearer to the pith and marrow, they place the Morall sence profitable for the active life of man, approving vertuous actions and condemning the contrarie. Many time also under the self same words they comprehend some true understanding of Naturall Philosophie, or sometimes of politik government, and now and then of divinitie: and these same sences that comprehend so excellent knowledge we call the Allegorie, which Plutarch defineth to be when one thing is told, and by that another understood.[19]

The Renaissance court fête, as it finally evolved during the second half of the sixteenth century into the set forms of entry, *ballet de cour, intermezzi,* court masque and exercise of arms, was increasingly patterned on these thought assumptions.

Ben Jonson's masques provide some of the most accessible instances of esoteric allegorical structure in the texts, in which he not only gives his sources but goes on to unravel the meaning for the uninitiated. His attitude to the latter, it might be added, was at best a disdainful one. Jonson had little time for those whom he regarded as stupid. 'And for the allegory', he wrote in the case of his masque *Hymenaei,* 'though here it be very clear, yet because there are some, must complain of darkness, that have but thick eyes, I am contented to hold them this light'.[20] This he wrote in a passage in which he elucidated part of his entertainment to mark the marriage of the young earl of Essex to Frances, daughter of the earl of Suffolk, in 1606. In it he used an archaeological reconstruction of Roman marriage rites as a vehicle for the celebration of ascending levels of union, from the particular dynastic alliance of two great aristocratic houses to the ideal one of James I and his Queen, and from a contemplation of the political union wrought by the King in joining Scotland and England to that union wrought by God in the world through love.

Central to the onlookers' experience was a series of visual images based on the microcosm-macrocosm principle. These began with a globe 'figuring Man' which revolved to disgorge from its hollow interior a turbulent group of eight men as the Humours and Affections. Reason descended from the top of the globe to take them into order, an action symbolic not only of the triumph of the rational mind within the individual but also mirroring the wider perspective of the subjection of civil insurrection within the body politic by means of the establishment of order through reason. The latter was acted by a venerable lady, 'her garments blue, and semined with stars . . . fill'd with arithmetical figures . . . Alluding to that opinion of Pythagoras; who held, all reason, all knowledge, all discourse of the soul to be meer number'. What the viewer saw was a mobile representation of the Pythagorean-Platonic tradition as

revivified by Renaissance Platonism and Jonson's references here are to Plutarch and Macrobius on number. Within this thought-context the marriage-union allegory could naturally progress to a celebration of the ineffable one of the Neoplatonists, the *unitas*, the source of all number, a thread that leads on to a paean not only of God as the One but more particularly the king as his image on earth. The initial emblematic diagram was taken a stage further when clouds parted to reveal Juno and, above her, Jove, an allegorical tableau which moved from microcosm to macrocosm by way of a goddess who is also air and a god who is heaven. The action was completed when Juno sent eight women as her powers or functions who, joining the men under the direction of Order and Reason, embarked on a series of geometric dances culminating in a grand chain depicting the Platonic structure of the universe in which an endless chain stretches down from God embracing all and uniting everything in mutual indissolvable links. Finally the dancers cast themselves into a circle which, in the words of D. J. Gordon, summed up the whole entertainment:

> The union of marriage consummated in love typifies the harmonious ordering of man's nature and man's society that follows when reason is obeyed; this is perfection. Nor can man and the elements that go to make him be separated from the world of nature, man from the globe, the *orbis terrarum*, microcosm from macrocosm. In both microcosm and macrocosm right order has been established by the Divine Reason, and perfection, right order, is achieved and maintained when the dispositions of reason, human and divine, are admitted and accepted. The circle is eternity, perfection, God. The orb is globe and sky and eternity. The circle is also the girdle of Venus: marriage that is a bond of union through love . . . Venus is also that power of the *Anima Mundi* which under Divine reason gives life and shape and unity to created things.[21]

Le Ballet de la Delivrance de Renaud danced at the French court in 1617 might be taken as second, somewhat cruder instance of such a method.[22] Based on an episode in Tasso's *Gerusalemma Liberata*, the ballet opened with a mountain in which twelve demons (one of which was played by Louis XIII) kept the knight Renaud prisoner. The demons celebrated their conquest with a dance, after which the location changed to a garden in which a nymph who arose from a fountain attempted to seduce two soldiers. Renaud appeared and the soldiers, in turn, appealed to him, but he only exulted in what he believed to be his god-like existence. This was followed, however, by the knights causing Renaud to look at himself in a crystal shield which they carried. As a result of this he was filled with a revulsion against himself and, moving towards the middle of the room, tore off the jewels, flowers and other ornaments that epitomized his voluptuous enslavement. In the following scene the enchantress, Alcina, into whose hands Renaud had fallen, summoned her demons, who

15

16

appeared in the form of monsters. Alcina touched these with her wand and they changed into ridiculous old people who executed a grotesque and eccentric dance. On to the stage next came a pageant car carrying a wood, behind every tree of which stood a soldier of the crusader Godefroy's army. These celebrated the escape of Renaud in a dialogue with a hermit:

> Enfin la raison de retour
> Se voit en luy triomphes de l'Amour.
> Ce tiran n'est plus son vainqueur,
> Ses feux ne brule [sic] plus son coeur.

The ballet came to its close with a vision of Godefroy enthroned, together **17** with his knights, in a pavilion of cloth of gold; after which they descended to dance the grand ballet.

Far less sophisticated and complicated than Jonson's masque of a decade before, the layers are more easily perceived and disentangled. The literal sense is the story, as it was lifted from Tasso, of Renaud and his deliverance from the enchantress, Alcina. In its moral context, Renaud was the waywardness of youth saved by self-realisation (the moment when he saw himself in the crystal shield) and through knowledge (the hermit sent by Godefroy). But these were preliminary skirmishes, because its central message lay in the allegory which, in Harrington's words quoting Plutarch, is 'when one thing is told, and by that another understood'. This was political, for the ballet was performed during a crucial period in which the government was in the hands of the king's mother, Marie de'Medici, and her favourite Concini, and when the king himself was still under the sway of the duc de Luynes. The background to the ballet was the unrest that marked the autumn of 1616, months in which Concini fled from Paris on a wave of unpopularity, in which the king arrested the prince de Condé and the other princes who had taken up arms, while in the south the Huguenots were verging on revolt. All this resulted in a ballet whose central idea was that of a strong king. Louis danced two roles, that of a demon of fire and that of Godefroy. Fire was the most important of the elements, and the ballet elaborated its virtues: '*Epurer les corps impurs*'; '*Reunir les choses Homogenees et semblables*'; it separated gold from silver and achieved that ultimate in royal policy: '*Rapeler tous ses sujets a leur devoir, et les purger de tous pretextes de desobeissance*'. At the close, in the figure of Godefroy, the king appeared as the absolute monarch triumphant over vices and enemies. Shortly after this performance Louis carried out a *coup d'état* in which the maréchal d'Ancre was assassinated and his own mother confined to Blois.

These two instances illustrate how quickly the study of renaissance festivals becomes the study of individual events, in which the broad principles I have tried to outline were applied to a particular occasion. All

over Europe humanists and writers used the same repertory of images and sources to mean something quite different according to time, place and circumstance. Exactly the same mythological characters and symbolic images could mean totally different things as they were endlessly re-cast to meet each new situation. In general, however, the imagery of festivals may be said to reach its most esoteric phase in the mannerist period typified in Italy by the Medici *intermezzi*, in France in late Valois court spectacles and in England by the early masques. By about 1630 these extremes of obscurity of allusion were in retreat, giving way to a bolder, more easily read repertory. It cannot be a coincidence that this happened simultaneously with another development, the abandonment of a complex polycentric vision, which allowed for other viewpoints and readings, in favour of a unified monocular one which had no room for alternatives.

The advent of artificial perspective

The emergence of the illusionistic stage was the most important development in the princely festivals of the sixteenth century and as a subject it has evoked a vast outpouring of scholarly literature.[23] What I give here is no more than a rudimentary outline necessary not from the point of view of its importance for the history of drama (which is outside the scope of this book) but from that of the prince. Whatever the complexities of the emergence of the illusionary stage there is no doubt that as the century drew to its close, the preference became more and more for indoor spectacles where visual effects could be easily controlled and where the eyes of the spectators could almost be forced to look at things in a certain way. And that certain way was monocular perspective, which by the 1630s had become the norm throughout the European courts. But this was the climax of a revolution which had its roots in early *quattrocento* Florence and took almost two centuries to be adopted on the outer fringes of northern Europe. Perspective scenery did not arrive in England, for example, until 1605.[24]

The origins of artificial perspective, both in painting, relief sculpture and theatre, lay in architecture. In the middle ages it had antecedents in the siting of public buildings. The Piazza del Battistero and the Piazza della Signoria in Florence were two complementary open spaces in which monumental buildings were placed deliberately to be viewed as expressions of an order within the republic in respect of both its citizens and clergy. Springing out of this and various strands in the history of

optics in the late middle ages under the aegis of the Franciscans as well as the impact of the 'optical' cartographic methods arising from the reception of Ptolemy's *Geographia*, it was the architect, Filippo Brunelleschi, who invented in 1425 artificial perspective of the type which was later absorbed into festivals.[25] He it was who painted the first two documented views of buildings in perspective, seen as from a single viewpoint and based on a geometry of space. Brunelleschi's obsession with perspective sprang from his desire to create a new architecture, to which a concept of space in terms of mathematics based on the macrocosm-microcosm principle was fundamental. This new ideal of beauty through the harmony of parts expressed in the notion of proportion was reached through geometry, which is the basic ground of scientific perspective. By this revolutionary invention, Brunelleschi reduced medieval Romano-Gothic polycentricity to a few elementary rules by which space was conquered practically and theoretically by means of the centric ray, by which the picture plane became the intersection of the visual pyramid. The harmony thus achieved emphasised man's moral responsibility within God's geometically ordered universe.

For Brunelleschi the quest was an architectural one, a means whereby the architect sought to rationalise the diversity of the medieval city and impose on it a single module related to man. In Alberti's *Della Pittura* (1435) the new theory of artificial perspective was codified and made available to artists, who quickly adopted it. By this means painting was raised to the status of a liberal art through the use of geometry. More particularly the new system of spatial order enhanced both the painting and meaning of *istorie*. Its application to festivals, however, went hand in hand with another revival from the antique world, that of the classical theatre. The humanist theatre, arising out of a revaluation of the texts of the plays of Terence and Plautus, looked for its staging towards Vitruvius, who had written:

> There are three kinds of scenes, one called the tragic, second, the comic, third, the satyric. Their decorations are different and unlike each other in scheme. Tragic scenes are delineated with columns, pediments, statues, and other objects suited to kings; comic scenes exhibit private dwellings, with balconies and views representing rows of windows, after the manner of ordinary dwellings; satyric scenes are decorated with trees, caverns, mountains, and other rustic objects delineated in landscape style.[26]

They would also have learned from Vitruvius that the art of *scenographia*, the painting of stage backdrops, was concerned with perspective.

Although humanist interest in the ancient theatre sprang from a belief in its role as an expression of civic *humanitas*, it was in fact the princely courts that mounted the first important experiments in re-creating these settings, although perspective was not an initial ingredient. Pelligrino

Prisciano (born after 1435 — d.1518), a humanist at the Este court at Ferrara, describes the three types of setting in his *Spectacula*, written between 1486 and 1501. In 1508 the term *prospettiva* is used to describe a setting for Ariosto's *La Cassaria* at Ferrara designed by Pelligrino da Udine (1476–1547). Five years later Gerolamo Genga (1476–1551) designed a city setting with beautiful buildings for the Cardinal Bibbiena's play *La Calandria* (1513) at the Montefeltre court at Urbino. If the dating c.1496–97, postulated by scholars for a page in the Codex Atlanticus of

18 Leonardo da Vinci, is correct, we have the earliest surviving sketch of an attempt to recreate the Vitruvian scene, preceding by about two decades Baldassare Peruzzi's famous synthesis of the tragic and comic scene in the Uffizzi.[27] What we are witnessing is not only the arrival of the artificial perspective setting but its appropriation into the precincts of the palace as an *instrumentum regni*. It is ironic that these visions of ideal cities in the new harmonious classical style which began as so pure an expression of humanist civic values, soon became a divisive cultural formula in which an enclosed area of a palace was transformed into an auditorium in which an elite few contemplated Neoplatonic visions re-affirming their right to rule.

It has been suggested that three pictures which depict such ideal cities in monocular perspective record settings for plays staged in the Palazzo

19 Medici on the occasion of the marriage of Lorenzo, Duke of Urbino in 1518.[28] One was a scene for Macchiavelli's *Mandragola* which put on stage an idealised view of the new piazza planned for San Lorenzo. Whether this is true or not, it is only a short step from this picture to the earliest surviving designs for stage settings deliberately attempting to recreate antique theatre. A drawing of a street setting generally dated about 1530–1535 is one of the earliest known extant instances of a set using artificial perspective.[29] It is generally attributed to Antonio da Sangallo the Elder (1453/55–1534).

It is his nephew Aristotile da Sangallo (1481–1551) who is crucial for the development of perspective spectacle in the service of the prince but in

20 another way.[30] From 1539 onwards he was called upon to provide scenery for the annual comedy performed during carnival time before the court of the Medici duke, Cosimo. These were prefaced by working on the festivals to mark the eighteen-year-old prince's marriage to Eleonora of Toledo, a milestone in the establishment of the dynasty's hegemony over Tuscany.[31] The setting for Antonio Landi's comedy *Il Commodo* (1539) was a watershed in the evolution of a court theatre of a type which conquered Europe. Although the Este court at Ferrara had already developed the practice of *intermezzi*, it was the Medici who were to elaborate this form to its highest pitch by means of a series of Vitruvian architect-engineers, one teaching the other in succession: Sangallo, Giorgio Vasari, Bernardo Buontalenti and Giulio Parigi.

The auditorium for *Il Commodo* was to be a prototype. Sangallo transformed the rectangular palace courtyard by covering it with a *valerium*, a combination of antique allusion with the practicality of a screen from the sun of a type seen in any Florentine piazza. The *gradi* or seats in tiers that surrounded three sides of the courtyard again combined references both to the antique theatre and to arenas for tournaments in the middle ages. Although there was no curtain, there was a nascent proscenium arch with columns and statues once more linking medieval precedent in the form of 'mansions' with the *porta regia* of the classical amphitheatre. The setting was a *prospettiva* of Pisa with its campanile and baptistery cupola towering above palace facades alternating with street vistas. Significantly, its lines of perspective radiated from the ducal throne, foreshadowing the alliance of perspective and absolutism that was to be the potent reason for its adoption later by the Bourbon kings of France and the Stuart kings of England. Vitruvius wrote of the centre of the circle of his amphitheatre where all lines of vision met but the place was left unoccupied. In both temporary and permanent renaissance re-creations of antique theatres for courts this inevitably was appropriated for the royal box, an innovation that had no archaeological precedent.

Approached from another angle, this solution was a logical outcome of the long tradition of princely homage that formed the choreographic motivation of any group of characters in space in a court entertainment. Both allegorical chariots and participants always wound their way towards the throne to render tribute. The new perspective decor, which identified the characters, was the old mobile decor writ large but achieving an infinitely stronger emphasis on the princely onlooker.[32] Sangallo's set for *Il Commodo* marks a convenient point at which we can pause. Six years later this type of setting became available through the publication of Sebastiano Serlio's *Archittetura* (1545) in which he discusses the three types of fixed setting and prints the famous woodcuts of the tragic, comic **21, 22** and satyric scene. But *Il Commodo* was notable for something else, stage machinery. The performance began with a sunrise. A crystal sphere filled with distilled water and placed in front of a lantern in which two torches burnt was slowly drawn in a huge arc by means of a winch across the scene. The 'sun' set as the play closed. It was the union of artificial perspective with the development of such engineering feats that was to make up the mainstay of the baroque theatre. The roots of the latter, too, lay in *quattrocento* Florence; to which we must now return.

Festivals and engineering[33]

As in the case of perspective, it is Brunelleschi who offers a starting point for a consideration of another element fundamental to the Renaissance festival, the development of moveable scenery. In this instance it was the architect's contribution, born of his knowledge of the mechanics necessary for building projects on a colossal scale, to the Florentine tradition of *sacre rappresentazioni*. These were religious interludes with spectacular scenic effects that were installed as permanent fixtures in some of the Florentine churches and were used on important occasions such as the arrival of Charles VIII in 1494. Brunelleschi, as the prototype Renaissance artisan-engineer knowledgeable in all forms of mechanical devices described by Vitruvius, was called upon to apply this knowledge to achieve new scenic wonders.[34] It is only necessary to describe one of these to realise that we are tapping a line of development that leads directly down to their secular counterpart in the next century, the *intermezzi* that celebrated the autocratic rule of the Medici Grand Dukes. That at S. Felice was a contrivance whereby God the Father sat enthroned while twelve boys dressed as angels were secured by iron struts to a huge revolving iron circle which was concealed by cotton wool to look like clouds and interspersed with lights as stars. By means of a small windlass a second revolving iron ring was let down, to which were attached by iron rings eight more boys dressed as angels. This hovered in mid-air, while a mandorla made of copper with perforations that contained candles descended to the ground. From this stepped the Angel of the Annunciation who delivered his message to the Virgin, returning to his mandorla to ascend along with the swirling angels to heaven again. The mandorla was constructed so that the lights could be concealed and revealed by means of straps as the Angel left and returned to it. Vasari restored this vision of a Dantesque cosmology on the occasion of the marriage of Francesco de'Medici to Joanna of Austria in 1566, when it was moved to the church of S. Spirito. What more is needed to affirm that these engineering feats in churches, which began in the 1420s, were a potent source for the later theatrical spectacles as *instrumentum regni* within the closed walls of the palace?

Leonardo da Vinci belongs to that tree of Florentine Vitruvian artisan-engineers, stemming directly down from Brunelleschi, who played such a crucial part in the application of these principles to court festivals.[35] In 1493 he was praised for his 'grande ingegno & arte' in the spectacle he devised in honour of the Duchess Isabella at the Sforza court at Milan. The *Festa del Paradiso* was staged on the occasion of the marriage of Gian Galeazzo Maria Visconti to Isabella of Aragon in 1490. It is one of the earliest instances we have of a court spectacle in a totally enclosed

specially created environment in which an aristocratic audience was subject to a series of calculated visual and aural effects. The decor of the room associated nature, in the form of trees with their branches entwined, with a dynastic glorification of the Sforza family, the portraits of whose ancestors were suspended as a garlanded frieze. The audience was placed around the room in tiers with the ducal family set apart as the focus of Leonardo's 'teatro della sorpresa'. This was a mobile representation of the Ptolemaic universe in the form of a half oval with lights arranged to depict the stars and zodiacal signs. The planets were personified, paying tribute to the duchess, and the heavens opened to reveal musicians and singers in a manifestation of cosmic harmony. It concluded with Apollo presenting the *libretto* to the young duchess and her praises being sung by the Graces and the seven Virtues. The heavenly astrological aspect of the entertainment could indicate that one of its purposes was talismanic, an effort to draw down the good influences of the heavens on the nuptials. No drawings survive for this festival but fragmentary sketches exist for two others. The first gives some indication of his work on a production of Baldassare Taccone's *Danae* for the Conte de Cajazzo six years later. One **24** identifiable section of the sketch is a celestial appearance of a deity in the clouds and the text of the play assumes a whole series of ascents and descents. Other drawings make it clear that Leonardo was fully cognisant of Brunelleschian devices of the type used to achieve the descent of the Angel of the Annunciation. A second group of sketches may relate to a production of Poliziano's *Orfeo* either at the Castle of Marmirolo in 1490 **25** or as performed for the French governor of Milan, Charles d'Amboise, in 1506/7. We have no evidence that this actually took place but the decor was a mountain that opened to reveal the underworld of Pluto with the deities this time arising from below stage.

Brunelleschi and Leonardo are touchstones indicating how a vigorous medieval tradition[36] that made use of engineering to achieve scenic and mechanical effects in the liturgy and in mystery plays began to be expanded and developed under the impact of the study of the texts of classical antiquity. It was known from Vitruvius that the classical theatre had not only three types of setting but that it also had changeable scenery in the form of *periaktoi*. In 1569 Vasari introduced these on stage for a comedy at the Medici court[37] and in 1583 the problem of *periaktoi*, with **26** diagrams as to how they worked, was discussed by Ignazio Danti in his *Le Due regole della prospettiva pratica di M. Iacomo Barozzi da Vignola*. In 1605 Inigo Jones made use of them for the plays he presented before James I at Oxford.[38] More important from the point of view of festivals was the discovery and study of the mechanics of the School of Alexandria, in particular the works of Hero. These enabled the Renaissance architect to fulfil a role ascribed to him by Vitruvius but never elaborated, of providing

machinery for festivals. Book X of Vitruvius is devoted to such machines, not only because of their practical use in building but because the architect has to use them in festivals 'to please the eye of the people'.[39] Hero's work, however, released them from the straitjacket of the three Vitruvian settings by means of a whole series of scientific theorems presented in the form of *automata* whose additional allegorical significance had a potent appeal.[40]

The mechanical wonders of the school of Alexandria gave the Renaissance Vitruvian architect engineer the source he needed, for example, for garden automata; for the texts, particularly of Hero's *Pneumatics*, dealt largely in terms of spectacular effects obtained by means of hydraulics. Hero, however, wrote a second work, also known to the Renaissance, on the use of automata in the theatre. In this he describes three-dimensional automata as well as those that had to be viewed from a particular angle by the onlooker. The text provided information as to how to achieve automatic changes in scenery for a five-act play and instructions how to construct a mechanical apotheosis of Bacchus. These works were published in Latin by Lorenzo Valla in 1501 and in 1589 they appeared in Italian translated by Aleotti and Baldi.

The same year as these appeared, the Medici court, as we shall see, staged those landmarks in theatrical history, the intermezzi of 1589, in honour of the marriage of the Grand Duke Ferdinand, in which the picture frame stage, aligned to painted perspective sets and with elaborate mechanical effects in the way of changes, ascents and descents, reached a new perfection.[41] It is important to recognise that although we can look at this event through eyes as varied as the history of politics or the development of the stage, they can also be viewed as documents in the history of science. Hero's theorems which demonstrated the use of winches, pulleys and weights (the fundamental ingredients of all the visual effects of the baroque theatre) were always in the form of machines with human and animal forms, such as Hercules slaying the dragon. For the Renaissance mind such a machine would not only demonstrate a physical theorem, but illustrate a myth which also had an allegorical significance for any educated person. The same can be applied to machines in Renaissance festivals. Although we have learnt to look at them in terms of theatre and allegorical content, we tend to forget that an audience would also have appreciated them in scientific ones, as instances of the miraculous mechanical achievement of classical antiquity revived. In this aspect the Renaissance festival contributed directly to developments from which the experimental science of the seventeenth century was to emerge.

The Theory of Spectacle: wonder and power

The *intermezzi*, with their accent on spectacular scenic devices which left the audience 'stupiti', were also expressions of the Renaissance exaltation of 'wonder' as an experience. Renaissance theorists based their development of spectacle on a passage in Aristotle's *Poetics*, where they read that 'the fearsome and the piteous may arise from spectacle'.[42] For Aristotle, wonder is the end of poetry, and as drama is a form of poetry its end too is to evoke wonder in the minds of the onlookers.[43] So in the hands of Renaissance dramatic theorists wonder expressed in terms of sheer visual spectacle gradually assumed an important place in drama, something aided by the knowledge, through Vitruvius, that stage scenery had been used in the threatres of classical antiquity.

As we have noted, this concern with machinery and engines was taken a stage further by Sebastiano Serlio in his *Architectura*, published in 1545, which apart from including the celebrated wood cuts of three types of play setting, the tragic, comic and satyric, also contained important passages on the theory of spectacle:

> Among all the things that may bee made by mens hands, thereby to yeeld admiration, pleasure to sight, and to content the fantasies of men; I think it is placing of a Scene, as it shewed to your sight, where a man in a small place may see built by Carpenters or Masons, skilfull Perspective work, great Palaces, large Temples, and divers Houses, both neere and farre off; broad places filled with Houses, long streets crost with other ways: tryumphant Arches, high Pillars or Columnes, Piramides, Obeliscens, and a thousand fayre things and buildings, adorned with innumerable lights ... There you may see the bright shining Moone ascending only with her hornes, and already risen up, before the spectators are ware of, or once saw it ascend. In some other Scens you may see the rising of the Sunne with his course about the world: and at the ending of the Comedie, you may see it goe downe most artificially, where many beholders have been abasht. And when occasion serveth, you shall by Arte see a God descending downe from Heaven: you also see some Comets and Stars shoot in the skyes ... which things, as occasion serveth, are so pleasant to mens eyes, that a man could not see fairer with mens hands.[44]

Serlio also cast stupendous scenic effects with a powerful political and social role, for these things were manifestations of the virtue of magnificence:

> Thus have I seene in some Scenes made by Ieronimo Genga, for the pleasure and delight of his lord and patron Francesco Maria, Duke of Urbin; wherein I saw so great liberalitie used by the Prince, and so good a conceit in the workeman, and so good Art and proportion in things represented, as ever I saw in all my life before. Oh good Lord, what magnificence was there to be seene ...[45]

When these calculated visions were based on such an ideology, it is hardly surprising that their engineers and designers came to occupy so important a place in late sixteenth- and early seventeenth-century courts. Such a theory of wonder, based on the idea of spectacle as essential to drama, and aligned to a celebration of magnificence and liberality as regal virtues, required persons able to realize these princely toys. The Renaissance architect trained in the science of the Vitruvian disciplines was a mathematician and a geometrician able to express in his work the harmonies of the universe as found in man the microcosm. His activity was a perpetual realization of such images of harmony.

But what kind of harmony? It was one which centred on political power being a reflection of a geocentric universe. Festivals were an art whereby society could be persuaded and transformed to meet these ideals.[46] They, therefore, occupied a crucial educational role, fully justifying in the thought-context of the period the vast sums expended upon them, because they cast the leaders of society into precisely the heroic roles they should occupy. Not until well on into the seventeenth-century is there any serious criticism that such events were in any way frivolous, or that they were a scandalous waste of money. Far from it; they were essential vehicles in a ritualistic and symbolic society whereby *les rois thaumaturges* led their courts in a celebration of order and virtue. It can hardly be a coincidence that the evolution of the court theatre, the development of the illusionistic stage and the huge escalation of princely festivals went hand in hand with the intensification of the mystical aura that surrounded crowned heads as the sixteenth century drew to its close. It can hardly also be a coincidence that it was the new rulers of the petty states of Renaissance Italy, whose absolute rule had replaced the vigorous republicanism of the middle ages, who took up and developed to its highest pitch the art of festival. Above all, they created the theatre of the Neoplatonic idea in which the abstract virtues of their rule were conjured up to vanquish any opposition. Flattery these spectacles may seem to us, but that would be to misread them entirely; for they were expressions of a political reality that recognised monarchs and princes as a semi-divine race set apart from ordinary mortals. Such apotheoses constantly made exactly that point, as the ruler was allegorised in terms of intellect, control and power.

If I had to define the Renaissance court fête in relation to the prince, I would say that its fundamental objective was power conceived as art. The fête enabled the ruler and his court to assimilate themselves momentarily to their heroic exemplars. For a time they actually became the 'ideas' of which they were but terrestrial reflections. The world of the court fête is an ideal one in which nature, ordered and controlled, has all dangerous potentialities removed. In the court festival, the Renaissance belief in man's ability to control his own destiny and harness the natural resources

of the universe find their most extreme assertion. In their astounding transformations, which defeat magic, defy time and gravity, evoke and dispel the seasons, banish darkness and summon light, draw down even the very influences of the stars from the heavens, they celebrate man's total comprehension of the laws of nature. The Renaissance court fête in its fullness of artistic creation was a ritual in which society affirmed its wisdom and asserted its control over the world and its destiny.

III

THE SPECTACLES OF STATE

The pressures of the new humanist ideas were inevitably to transform the festival traditions of medieval Europe. The renaissance was in essence a revival of the antique world; so one of its quests was also to be the re-creation of the lost festival forms of classical antiquity. This search for ancient forms led to the revival of the *naumachia* or water festival, to the development of state entries as lineal descendants of Roman imperial triumphs and to the introduction of the horse ballet in emulation of the ancient Greeks. In addition, it led, as we have already seen, to the archaeological pursuit of the ancient stage and speculation as to its Vitruvian machinery, which resulted in the invention of the proscenium arch theatre and its perspective settings. Finally, humanist preoccupation in France and Italy with the reconstruction of ancient music and dancing produced the forebears of our modern opera and ballet.

Renaissance festivals were enormously inventive and fertile in their sheer variety of construction. In spite of this, a permissible oversimplification of a complex theme will enable us to get our bearings. In broad terms, it would be true to say that there were three main developments during the period 1450–1650 which radically changed existing festival forms. The first was the transformation of the royal entry into an absolutist triumph in emulation of those of imperial Rome. This involved not only a change in its physical appearance, but also in its ideological structure, as any lingering possibilities of its use as a vehicle for dialogue with the middle classes vanished. The second was also a consequence of this general move towards autocratic dynastic rule, the revival of chivalry. Although the feudal realities of medieval chivalrous society had gone, the patterns of its behaviour and mythology lived on, and were indeed revitalised in the new

court life evolved by Tudor, Valois and Habsburg. At the instigation of the Italian courts, inherited chivalric attitudes and values were overlaid by a fashionable Neoplatonic gloss, traceable, for instance in handbooks of courtly behaviour, typified above all in Castiglione's *Il Cortegiano*. Romances of chivalry enjoyed an enormous vogue, from the *Amadis de Gaule* to Ariosto's *Orlando Furioso*, from Tasso's *Gerusalemme Liberata* to Spenser's *Faerie Queene*. In the court fête this was manifested in the continued vitality of the tournament as it was deliberately developed into a form perfectly expressive of the subservience of once warlike aristocrats to the crown, the *tournoi à thème*, in which any fighting was reduced to almost balletic proportions in the midst of scenarios whose whole purpose was to make the ruler or his heir apparent the hero and focus of every legend and romance of chivalry.

The latter epitomised another development that was typical of the late renaissance, the dominance of the court and its architectural setting, the palace and its surrounding formal gardens. In the case of the royal entry, courtly themes began to extend across the townscape of the city in the form of highly symbolic propaganda programmes by court humanists and poets. Tournaments were not only relocated away from the city squares or open spaces of the middle ages but were deliberately brought within the closed architectural complex of the palace, firstly into the courtyard and later into indoor arena theatres. This reflected the development of accesibility as an index of social status, a movement promoted actively by the new princely dynasties of Italy as part of their refeudalisation of society.

And this leads to the third major thrust, the gradual creation of permanent court theatres for presentation of forms of spectacle whose common pattern, whether in Medici Florence or in Stuart England, was the moving emblematic tableau in which the harmonious structure of the cosmos was conjured up as a mirror of the absolutist state and extended outwards to embrace its onlooking audience through dance. The *ballet de cour* with its roots in Italy, is without doubt the major new art form to emerge in the festivals and the one most essentially reflective of renaissance ideals, the evocation by means of art — visual symbol, allegory, music and movement — of the macrocosm-microcosm analogy and through that the tuning of the aspirations of earth to the harmonies of heaven.

The Royal Entry: antique triumph and absolutism

While the royal entry in the north entered its most complex phase in the fifteenth century, it remained within the mainstream of medieval tradition. But in Italy it took a quite different direction. By the close of the fourteenth century, under the impact of early humanism, there had already developed an appreciation of the classical triumph whose essence lay not in a series of the *tableaux vivants* but in the procession itself, which was developed into a highly symbolic vehicle.[1] Its lasting monument was the permanent classical triumphal arch accorded to the victor through which such processions made their ceremonial way. These aspects were to have a radical effect, transforming both the content and the visual appearance of the royal entry north of the Alps in the sixteenth century.

The Italian entry during the *quattrocento* was influenced not only by the humanist rediscovery and ultimately publication of the key texts describing Roman triumphs, above all that in Book XXX of Livy's *Historia Ab Urbe Condita*, but by literary evocations of allegorical processions in which onto the classical form was grafted the contents of mythologies, both Christian and chivalrous, of subsequent centuries. These were Petrarch's account of the triumph of Scipio Africanus in his epic *Africa*, his poem *I Trionfi*, in which those of Love, Chastity, Death, Fame, Time and Eternity pass by in processional style and Boccaccio's description of a triumph in his poem *Amorosa Visione*. In the hands of painters and illustrators these triumphs were conceived in terms of pageant cars carrying allegorical figures, known as *trionfi*. During the first half of the *quattrocento*, cassone chests began to be adorned with decorative panels depicting classical triumphs in the International Gothic manner but with an overlay of *à l'antique* detail.[2] Even more influential must have been the long series of illustrated editions of Petrarch's *I Trionfi*.[3]

Simultaneously, elements of the form began to be used for victorious *condottieri* and rulers. Castruccio Castracane entered Lucca in 1326 as a Roman *imperator* standing in a chariot, prisoners being driven before him through the streets. In 1443 Alfonso the Great declined the wreath of laurel prepared for him to wear during his solemn entry into Naples, although he entered it in true classical style through a breach made in the walls.[4] Laurana in his sculpture over the gateway to the castle in Naples records the occasion with considerable accuracy. Alfonso was enthroned upon a car drawn by six white horses, a canopy of cloth of gold borne over him by twenty nobles. Cavaliers on horseback attended him, together with a series of allegorical figures and *trionfi*, including one of Alexander the Great standing upon a revolving terrestrial globe. Ten years later Duke Borso d'Este entered Reggio in even more elaborate style. At the city gate he was welcomed by St Prospero, the patron saint of the town, who was

seen floating on a cloud with angels supporting a *baldacchino* above his head. Below rotated a circle of cherubims, two of whom received the sceptre and keys from the saint, which they promptly delivered to the duke while angels sang his praises. At this point the first of three pageant cars made its appearance. Drawn by hidden horses, a car bearing an empty throne appeared, behind which stood Justice attended by a Genius. At the corner of the chariot sat grey-headed lawgivers encircled by angels and banners. Justice and Genius addressed the duke, after which there followed a ship pageant and finally a car drawn by unicorns bearing *Caritas* clasping a burning torch. Further on along the route Julius Ceasar presented the seven Virtues to Borso, and the triumph ended with the duke reviewing once more the chariots from a golden throne placed before the cathedral, after which three angels flew down from a nearby building to present him with branches of victorious palm.[5] As a visual point of reference for this kind of *trionfo*, those by Piero della Francesca on the reverse of the portraits of Federigo da Montefeltre, duke of Urbino and his wife, Battista Sforza (after 1472) epitomise this revival of an antique form and its assimilation within a Christian-chivalrous society. The duke receives his crown of laurel from an angel and he is attended by the Cardinal Virtues. The duchess is attended by the Theological Virtues and her chastity is alluded to in the pair of unicorns that draw her chariot.

By the close of the *quattrocento* this transformation into a Roman imperial triumph, caught in nascent form in Borso's entry, was so complete that in 1501 the triumphs of Julius Ceasar, Paulus Aemilius and Scipio Africanus Major could be staged in Rome on the occasion of the marriage of Alfonso d'Este to Lucrezia Borgia.[6] When Louis XII entered Cremona eight years later, he was received with

> ... *arcs triumphans a modes antiques* ...
> *Enrichez de dictz Rethoriques*
> *Exaltans la gloire du Roy.*

The reception of Louis XII into Milan, in which Leonardo da Vinci is likely to have had a hand, was even more strictly classical. It is recorded as having been done 'selon l'ancienne coustume des Romains', and its climax was a triumphal car on which there was a seat of Victory supported by Fortitude, Prudence and Renown. The procession passed beneath a magnificent triumphal arch decorated with paintings depicting Louis XII's victories and surmounted by an equestrian statue of the king.[7] By the opening phases of the French wars in Italy at the close of the fifteenth century, the transformation of the royal entry into an antique triumph had been accomplished. Indeed, it was these wars that gave a reality to the military triumph as a festival form.

One more publication was also to have a significant impact, the

45

Hypnerotomachia Poliphili, an archaeological romance by Francesco
Colonna published by Aldus Manutius in 1499.[8] The novel takes the form
of a dream which includes altars with classical inscriptions, obelisks
bearing Egyptian hieroglyphs, columns, pyramids, triumphal arches,
temples, antique religious ceremonies, and *à l'antique* props of all sorts,
30 including a series of triumphal processions. One bearing Europa and the
bull is drawn by six lascivious centaurs, another with Leda and the Swan is
pulled by elephants:

> This tryumphant Charyot, was drawen by sixe white Elephants, coupled two
> and two together ... Their furniture & traces of pure blewe silke, twisted
> with threds of golde and silver ... Uppon them also, did ride ... sixe
> younge and tender Nymphes ... Over this stately Chariot tryumphant, I
> behelde a most white Swanne, in the amorous embracing of a noble Nymph
> ...[9]

The book enjoyed enormous popularity and ran into four French editions
before 1600 and was incompletely translated into English in 1592.

The *Hypnerotomachia Polyphili* was a popular manifestation of the
serious achievements of *quattrocento* antiquarian scholarship. At the court
of Mantua this reached its most influential visual manifestation in the
series of nine life-scale paintings, the *Triumphs of Caesar* by Andrea
Mantegna.[10] These summed up a lifetime's experience of an artist who, at
the same time, was one of the most perceptive antiquarians of the century.
No one has satisfactorily dated these paintings, but we know that the
project was under way by 1486 and was still incomplete in 1492 and the
likelihood is that they may have been begun as early as c.1474–78 under
the patronage of Marchese Lodovico Gonzaga. The significance of these
canvases is that they represent the first attempt at an accurate visual
31, 32 representation of a Roman triumph. Mantegna not only had the resources
of the Gonzaga library at his disposal, but knowledge at first or second
hand of a whole range of antique sources from gems, coins and medals to
the momuments of Rome. In addition, by 1475 all the main classical texts
— Livy, Appian, Plutarch and Josephus — had been printed. There were
also two major antiquarian books which included lengthy sections on
triumphs which he certainly drew upon: Flavio Biondo's *Roma
Triumphans* (1457–59) and Roberto Valturio's *De Re Militari* (1460).
Mantegna's procession consists of less than seventy figures, and yet he
purveys the impression of teeming thousands: trumpeters, standard-
bearers, youths carrying paintings of vanquished cities, prisoners bowed in
chains, banner- and trophy-bearers, huge urns erupting treasure,
culminating in the figure of Caesar himself, turned in imperial profile,
solemnly drawn upon a triumphal chariot.

It is conceivable that more canvases were originally planned, for the

victor comes, inaccurately, at the end of the triumph and not in the middle of it. Knowledge of the exact contents of these canvases was not to be widespread, however, until 1598–99 when the whole series was engraved by Andrea Andreani. Their influence was felt instead through a series of woodcuts by Jacopo da Strasbourg which were issued in Venice in 1503. 33, 34 These were only very loosely derived from Mantegna and were pirated, probably five years later, by Simon Vostre. Their influence on the development of the French royal entry into its classical phase was decisive, for these woodcuts formed the direct source utilised by the organisers of Henri II's *entrée* into Rouen in 1550, when he was presented with a 35, 36 complete re-enactment of a Roman imperial triumph.

Following the surrender of Boulogne by the English, this entry came at the apogee of the reign.[11] The procession began with a chariot laden with trophies and bearing the figure of Death chained at the feet of Fame. Next came fifty-seven of the king's ancestors crowned and wearing splendid robes, figures on horseback who were to act as *exempla* to the present monarch. There followed a chariot drawn by unicorns on which stood Vesta, the goddess of Religion, attended by Royal Majesty, Virtuous Victory, Reverence and Fear. This alluded to the king's religious policy of restoring peace and unity, in particular the reunion of the Catholic Church, an aim referred to in the church held aloft by Vesta. Next marched six bands of military men carrying models of forts won by the king in the area of Boulogne and banners depicting landscapes of the Scottish lowlands won from the English. After these ambled elephants and then figures in chains, alluding to the sad parade of prisoners that had taken place before the beleaguered Boulogne. Flora and her nymphs gaily scattering flowers ushered in the final chariot bearing 'un beau et elegant personnage' representing Henri II, with his four children at his feet, and to whom Fortune proffered an imperial diadem. Created under the guidance of local humanists, this entry drew on sources of this sort and was a deliberate attempt to excel a festival form of antiquity. The chariots were 'à l'imitation expressé des Romains triumphateurs' and as a whole the spectacle was 'Pareil triumphe à tous ceulx des Caesars'. The Rouen entry is also an early instance of an illustrated royal entry book. Its appearance is seemingly recorded in a series of woodcuts, whose relationship to those published in Venice should establish how we should view the visual material in such publications. What we are called upon to study in these elaborate accounts of royal entries, with pictures of the arches and other decorations, is an idealisation of an event, often quite distant from its reality as experienced by the average onlooker. One of the objects of such publications was to reinforce by means of word and image the central ideas that motivated those who conceived the programme.[12]

What spread across Europe was the notion of the entry as a triumph in

terms of the monarch as hero, reflecting exactly the change in political climate as the nation states of early modern Europe developed their identity by focussing a people's loyalty on the cult of a dynasty. As a result the entry gradually ceased to be a dialogue between ruler and ruled and developed instead into an assertion of absolute power with a corresponding expression of subservience by the urban bourgeois classes.[13] There can be few clearer demonstrations of this than the Medici in Florence, home of a vigorous republicanism until well into the sixteenth century, from the *entrata* of Pope Leo X in 1515 onwards.[14] So successful were they in establishing and emphasising their autocratic rule that by 1589, when Christina of Lorraine made her entry as the bride of the Grand Duke Ferdinand, the street festival had become entirely an extension of the programme devised for the closed world of the ducal court.

The Medici control of a state entry epitomised the extremes of megalomania to which a new dynasty bent on exalting itself and suppressing any lingering republican traditions could go. The result was that any entry into an Italian princely city became an *instrumentum regni* devised and designed under the aegis of the court poets, humanists and artists. It took much longer for the same position to be reached north of the Alps. There the desire by city authorities to make their case to the monarch in question led to the gradual disappearance of the separate guild decorations that were the essence of the medieval entry. Rouen in 1550 is already an instance of this. Increasingly, city authorities, who went to great expense to employ humanists, poets and artists to produce decorative schemes combining a suitably splendid tribute to a visiting prince with a statement of their own immediate needs and longer term aspirations, became irritated by extraneous matter presented by independent guilds or resident foreigners that upset and obscured the message of their carefully planned programme.

Nowhere is this development more strongly in evidence than in the long series of Flemish *blijde inkomsten* in which successive rulers of the Low Countries were received into its cities only on swearing a complicated oath to guarantee traditional municipal rights.[15] Time and again, until well into the seventeenth century, there is an attempt to use these occasions to drive a wedge of legally credible ceremony into the thick armour of the absolute regal power of the Spanish monarchy. We can trace this vividly in the series of entries into Antwerp of successive Spanish governors subsequent to 1585. In that year the city fell to the forces of the Duke of Parma and the Dutch blockaded the river Scheldt, the source of the city's maritime wealth. Thereafter every entry was used by the city fathers to combine increasingly eulogistic celebrations of their Habsburg rulers with tableaux to remind them of the commercial ruin over which they presided. In 1594

the Archduke Ernest saw a tableau in which nymphs released the
recumbent river god, the Scheldt, from his chains, an action which caused 37
water to flow from his urn, flooding down to alleviate a scene of
dereliction painted below. Nearby in a fully rigged ship sailors unfurled
sails in readiness for a voyage. Five years later the motif was re-staged for
the two new governors, Albert and Isabella; this time the marine deities
Neptune and Tethys were attended by the riches of the sea, followed by a
chariot bearing Neptune again who predicted the victory of the archdukes
over the waters, and the new golden age to come in the next century,
which was literally only weeks away from the date of the entry.

Even with the Twelve Years truce in 1609 and the consequent lifting of
the Antwerp blockade, there was no real return to prosperity, for the
Spanish put an embargo on trade with heretics and with the Indies. The
blockade returned in 1621 with the resumption of the war, and by the
time Rubens was called upon to decorate the streets in 1635 for the arrival
of the Cardinal Archduke Ferdinand, its economic ruin was even more
imminent. Bravely, the city fathers decided to accompany their eulogy of
the new governor with a deliberate attempt to 'montrer l'état actuel
d'appauvrissement du pays et de la ville, afin d'obtenir de Son Altesse qu'il
y partât remède'. After a series of apotheoses two arches came as a finale
and more than something of a shock. This time the arrival of the Prince
produced no golden age, no immediate happy reversal of misery as if by
magic. Instead he saw the lady Antwerp turned in supplication to him, as 38
the god of commerce was about to fly away and leave her, this time
forever. Two sleeping figures, a sailor and the river Scheldt, elaborated the
theme while on either side the alternative futures were presented to him:
Abundantia and *Opulentia* as opposed to *Paupertas*. Beyond, in an arch
Rubens designed for the Antwerp Mint, the Cardinal saw the fabulous
South American mount Potosi, the richest and most famous of all the New
World silver mines, symbol of that source which (even though by 1635 it
was reduced to a trickle) still maintained the declining structure of the
Spanish Habsburg empire. What a contrast! The poverty of Antwerp was
set against the glittering wealth of her mistress. There was not one
reference to the city on that vast money mountain, as if to emphasise the
fact that the coinage which came from Antwerp's mint sprang no longer
from the rich commercial activities of its citizens, but from Spain. But
what is being said in the language of festival is that here is a way forward;
for the implication is not only that Philip IV's brother should revive
commerce and avert the final flight of Mercury, but that Antwerp should
share in the vast treasure of the Spanish New World trade. The message
did not go unheeded and in 1640 Ferdinand obtained from his brother the
long sought for authorization to trade in the East Indies. Alas, it was too
late. The city's fate was sealed in the Treaty of Munster in 1648, when

Spain agreed to the permanent closure of the river Scheldt.

The glorious *Pompa Introitus* of 1635 represents the sad end of a vigorous tradition, the last lingering of a belief that an entry was a dialogue between ruler and ruled, between the prince and the bourgeois classes. In the age of absolutism which had already emerged elsewhere in Europe, that dialogue had vanished.

The revival of chivalry: the 'tournoi à thème'

The tournament underwent a very different but just as dramatic transformation as the royal entry as it entered its renaissance phase. Contrary to all that one would expect, particularly in view of the advent of firearms, the medieval tournament, far from going into decline, did exactly the opposite. The reasons for this were partly political and partly social. Fighting was an essential attribute of the ruling classes; for the new dynasties, the tournament in the dramatic form, particularly as evolved by the dukes of Burgundy, fulfilled this need, while at the same time blunting its aggressive potentialities into an expression of dynastic loyalty. Tournaments were increasingly stage-managed to ensure that the monarch or heir apparent was always the victor. The pattern of these prestige spectacles, in which the myths of medieval romance were deliberately harnessed to the crown, was followed both by the Emperor Maximilian I and by the young Henry VIII. In this sphere, the legendary Field of Cloth of Gold in 1520 offers the most staggering example of conspicuous consumption to no avail, although it was motivated by a genuine belief that the political problems of Europe would be solved if only monarchs met over a conference table and reduced their wars to chivalrous sports.[16] In the second half of the century the momentum did not decline, although there was a further diminution in the actual fighting in such events, caused by the death of Henri II at a tournament in 1559. 'Running at tilt is a generous and a martiall exercise', wrote Henry Peacham in 1634, 'but hazardous and full of danger, for so many hereby (even in sport) have lost their lives, that I may omit *Henry* the French king, with many other princes and other noble personages of whom history is full'.[17] The result of this was the *tournoi à thème* with its predetermined plot set amidst the most complex of *mises-en-scène*. This became a standard vehicle for expressing princely magnificence, whether, for instance, to celebrate a treaty of alliance in France or to mark a great marriage in Savoy. That Louis XIV could still deploy himself as a knight on horseback, the hero of

a spectacular tournament, in 1662 gives some indication of the vitality of the chivalrous tradition within Europe during the Renaissance and the Baroque periods.

The reign of Elizabeth I witnessed one of the most remarkable post-medieval revivals of chivalry centring on the cult of the Virgin Queen.[18] In a society split by the divisions of Catholic, Anglican and Puritan, the ritual of chivalry cut right across the religious barriers. Under the inspiration and guidance of her Master of the Armoury, Sir Henry Lee, the Queen presided over a spectacular series of tournaments held each year on the anniversary of her accession to the throne, November 17th. These were spectacles to which the public, for a small sum, were admitted. Nobles and gentlemen broke their lances in her honour at tilt, arriving in fancy dress, each one weaving a romantic story round his disguise in complement to the Queen. The military connotation was strong. The lords and knights who tilted were identical with those who fought in the wars in the Low Countries, France and Ireland in the 1580s and 1590s. A visting German gives a vivid if bemused account of the tournament of 1584:

> Many thousands spectators, men, women and girls, got places, not to speak of those who were within the barrier and paid nothing. During the whole time of the tournament all those who wished to fight entered the lists in pairs, the trumpets being blown at the time and other musical instruments. The combatants had their servants clad in different colours; they, however, did not enter the barrier, but arranged themselves on both sides. Some of the servants were disguised like savages, or like Irishmen, with the hair hanging down to the girdle like women, others had horses equipped like elephants, some carriages were drawn by men, others appeared to move by themseves; altogether the carriages had a very odd appearance ... When a gentleman with his servants approached the barrier ... one of his servants in pompous attire ... addressed the Queen in well-composed verses or with a ludicrous speech, making her and her ladies laugh.

The surviving speeches evoke a picture that is wholly romantic in sentiment. One is spoken by the Damsel of the Queen of Fairies on behalf of an Enchanted Knight, who cannot tilt because 'his armes be locked for a tyme'. There is a sonnet on behalf of a Blind Knight, who has been overcome by the queen, 'best flower of flowers, that grows both red and white'. Another introduces the Black Knight and his companions, the Wandering Knights, who have been cast into melancholy because they were unable to attend the previous year's tournament (evidence that these shows unfolded a continuous narrative), but who now return 'to make short payment of the debts of our harts for the honoring of this day'. Evidence suggests that these tilts were serious expressions of the political fabric of the reign. After Sir Philip Sidney's death in 1586 his horse was solemnly led, draped in black, across the tiltyard. Was there, we may

wonder, a tearful pause while the queen and her subjects remembered Philisides, her shepherd knight?

This deliberate use of romantic chivalry to draw knights in allegiance to the crown stretches into the new reign. Around James I's eldest son, Henry, prince of Wales, there similarly centred a chivalrous revival.[19] Again it had a military connotation, for the Prince's political interest centred on the warlike ambitions of European pan-Protestantism. Ben Jonson's *Barriers* of 1610 deploys the prince within a dramatic scenario as the reviver of chivalry. Amid the ruins of the House of Chivalry King Arthur appeared and lowered down from the sky a shield for the prince, known in his tournament guise as Meliadus. Immediately this was hung up on his tent, Lady Chivalry stirred herself within her trophy-hung cave and exclaimed:

39

> ... O could I gaze a day
> Upon his armour that hath so reuiu'd
> My spirits, and tels me that I am long liu'd
> In his apparence. Breake, you rustie doores,
> That haue so long beene shut, and from the shores
> Of all the world, come knight-hood like a flood ...

Even when exercises of arms of this sort were finally abandoned at the close of James I's reign, the mythology of chivalry was assimilated into that of the court masque.

This vividly evokes the extremely important political connotations of the chivalric revival. Simultaneously, the tournament form itself was evolving; and nowhere is this better demonstrated than in Italy,[20] where the Medici were leaders in promoting the tournament in Florence, as the city gradually abandoned its republican traditions and moved towards an aristocratic society. With the advent of the Medici as dukes, the tournament became a norm of festival art, and an ideal vehicle whereby to express the new order of things. It was, however, in Ferrara under the late Este dukes that the tournament was developed to its highest form of elaboration as the old format of *defi par cartel* gradually gave way to the *tournoi à thème*.[21] The Este court had always been open to northern influences, and was the fountainhead from whence flowed chivalric practice in its new renaissance guise. Ferrara, too, was seminal for the marriage of the ingredients of a Greco-Latin humanist culture to the mythology of romance civilisations from north of the Alps. During the 1560s under Duke Alfonso II, a series of *tournois à thème* were staged; in these, sustained plots, carefully conceived in philosophical and symbolic terms under the supervision of the leading poets of the day, were adorned with complex stage machinery, a range of literary forms embracing verse, dialogue and monologue besides sung and instrumental music, all on a

scale which anticipated not only the equestrian set pieces of the baroque age, but also opera.

The tournaments concerned were *Il Castello di Gorgoferusa* (1561), *Il Monte di Ferronia* (1561), *Il Tempio d'Amore* (1565), *L'Isola Beata* (1569) and *Il Mago rilucente* (1570). All of these were of a type of which *Il Tempio d'Amore* may be singled out for more detailed consideration. The tournament marked the apogee of the fêtes to celebrate the marriage of Duke Alfonso to Barbara of Austria and its *thème* was almost certainly devised by Torquato Tasso, directly reflecting his glorification of chivalrous honour and love in terms of knightly exploits by *diversi erranti* in a manner which occurs in his *Rinaldo*. It was staged in a courtyard garden of the palace with the *gradi* for the huge number of spectators in tiers in a hemicycle at one end, facing across an open arena towards a towering mountainous set. This owed something to Serlio's satyric scene; but, more important, it anticipated in temporary form the *Teatro Farnese* in Parma, which was built to house entertainments of exactly this type. The plot centred on access to the Temple of Love by those who wished to reach it by way of Honour and Virtue. Access to the Temple had been denied to six ancient sorceresses, who in revenge vowed to impede knights who wished to approach it. In order to achieve this they took on a youthful, seductive aspect and conjured up the rival palaces of Pride and Voluptuousness. At the opening they enslaved the Knights of Glory, turning them into rocks only to release them to become their defendants against a vast cavalcade of challengers who each arrived in a different form of *trionfo*. These not only included varieties of combat but were fully fledged allegorical and dramatic incidents related to this main *thème* whose ingredients were mobile scenery, knights in disguise and a train of actors and musicians. Whatever the outcome of these conflicts they always ended with the sorceresses triumphing and relegating yet another group of assailants either to a labyrinth or a wood. Eventually, of course, the Knights of Honour and Virtue arrived who vanquished with their superior force, not only of arms but also of morals, the evil enchantments. The Temple of Love, which had initially been seen at the opening of the tournament but which was concealed throughout its progress, reappeared in even more glorious form, and one of the Graces stepped forth to address the new duchess in her own language on the powers of virtuous love. Although in the individual combats the elements of chance still remained, nothing else impeded the progress of a plot in which concepts of Neoplatonic love were inset into a dramatic action which was a hybrid drawing on classical antiquity and the medieval romance tradition and fusing them to pay homage to the house of Este.

The visual evidence for this tournament is of importance forming a direct line of descent leading to the *Teatro Farnese*. The surviving

groundplan and elevation of the setting show the curved lines of the courtyard and the extension of its façades in perspective to form almost a proscenium arch framing the Temple. The latter was subject to scene change, clouds being pushed on from either side to conceal and later reveal it. G. B. Aleotti, who was to be the architect of the *Teatro Farnese*, began his career working for Cornelio Bentivoglio, one of the key figures connected with this series of tournaments. If it had not been for the eclipse of the Este in 1597 the *Teatro Farnese* should have more logically been constructed in Ferrara rather than Parma.

In any account of the tournament in Italy the court of Savoy must be included. There, due to its proximity to France, that fount of the northern chivalrous tradition, and to the aristocratic structure of its society under its dukes, the tournament tradition was even more vigorous and of greater longevity than in Ferrara. Under Duke Charles Emmanuel (1580–1630) the form rapidly evolved into the renaissance format of the *tournoi à thème*.[22] From 1618 onwards these form perhaps the most heavily documented and illustrated sources for the tournament as it developed out of its mannerist and into its baroque phase. And, as in the case of the ballets, from 1640 down to 1681 these are recorded in the great series of volumes by Tommaso Borgonio. Carrousels at the court of Savoy worked to a set format in which the piazza or palace courtyard was transformed by temporary structures and in which the action was facilitated by the 40 entry of allegorical chariots. *Gli Hercoli Domatori de Mostri et Amore Domatore de gli Hercoli* was staged to celebrate the marriage of the Princess Adelaide to Ferdinand of Bavaria on December 15th 1650. If we look at the illustration we can see the ducal party looking down onto the piazza from the palace balcony. Before them is a hexagonal structure surmounted by Cupid, the Palace of Love. In the distance there is a mountain dedicated to the Alpine Hercules surmounted by a temple while at the opposite end, and therefore out of sight, was the palace of Hercole Ercinio encompassed by woods. The Palace of Love is surrounded by exotic monsters — whales, hydras, harpies, bulls and lions — which splendidly attired cavaliers on horseback are attacking. This combat involved different types of weapon: lance, club, pistol and sword. The thirty-two knights came as heroes of classical mythology in the train of a huge rocky pageant car bearing the arms of Savoy with Hercules standing on top, whose virtue and prowess were evoked as prototypes of the dukes of Savoy with as much monotony as they had been for Henri IV. Following a familiar theme these monster-vanquishing cavaliers were in their turn subjected by sixteen knights who personified the attributes of Love. The fête closed with a grand parade around the arena and homage to the onlooking ducal party with a choir lauding the triumph of Love with madrigals and epithalamiums. With this carrousel we are almost a

century on from *Il Tempio d'Amore* and yet the latter with its move towards concentrating the scenery opposite the spectators was already in advance of Savoy whose tournaments tended to be old-fashioned and fixed in format. That of 1650 included only one new ingredient that took it beyond Ferrara a century before, a horse ballet of great complexity danced by the knights in the service of Love. The importance of Savoy resides in the vitality and quantity of its tournaments which stretch in a huge series down to the close of the seventeenth century. It cannot be said, however, to be a centre for any major developments in its form.

As we cross into the seventeenth century and the age of the principalities, *tournois à thème* increase in number, exactly reflecting this vast refeudalisation of society. Florence, Parma and Ferrara were in the vanguard in developing the tournament into its next logical phase, the *opera torneo* in which the fighting took place in an arena, often indoors, against a proscenium arch stage.[23] The latter, fully equipped with painted perspective sets and machinery, unfolded a dramatic production along the lines of early opera, disgorging combatants on cloud machines who descended to fight in the arena below. Combat was reduced to a series of set pieces that assisted the development of the mythological story in honour of the reigning house which was being unfolded on stage in terms of scenery, song and instrumental music.

With the official inauguration of Giovan Battista Aleotti's Teatro Farnese (1618–19) in Parma in 1628 the *tournoi à thème* can be said to have entered its Baroque phase.[24] This prototype Baroque theatre framed the tournament in a permanent court *salle des fêtes* which combined elements from a *sbarra* in the *cortile* of a palazzo, the curved horseshoe of the *gradini* and arcading from the auditorium of the theatre of the academies with the proscenium arch and machinery of the Teatro Mediceo. *Mercurio e Marte* by Claudio Achillini (with music by Monteverdi played by up to as many as five orchestras) celebrated the marriage of Odoardo Farnese to Margherita de'Medici and presented the young duke as being wooed from the pursuit of letters to that of arms. This familiar *topos* was a vehicle for transformation scene after transformation scene, culminating in the arena itelf being flooded for a final water triumph (the theatre was on the second floor). In the concluding assembly of the gods on stage, up to a hundred people seemed to be suspended in the clouds. At the time it was recorded: 'there has never been a grander tournament, one employing a greater number of machines'.

Spectacles of this kind finally removed the tournament into the closed world of the palace complex, away from the town piazza or square where it still remained accessible to the populace. In Florence the same thing happened.[25] The *Guerra d'Amore* and the *Guerra de Bellezza* (both 1616) **45** had taken place in the Piazza Sta Croce; but eleven years later in 1637 the

46 equestrian ballet to celebrate the marriage of Vittoria della Rovere to Ferdinando II was staged in the Boboli Gardens of the Pitti Palace. *Il Mondo Festiggiante* in 1661 which marked the marriage of Marguerite Luisa d'Orleans to Cosimo III also took place there.[26]

As in the case of the royal entry a vast change had taken place. For most of the sixteenth century, tilting, however thickly overlaid with drama and spectacle, was still the essence of these events, and they were still closely linked to the training of men at arms in service of the ruler. By the 1630s fighting in a tournament called more upon a courtier's acting ability than his combative skills. Whereas the court tournament had been a means of maintaining the abilities of a warlike aristocracy in loyalty, in the absolutist age which followed they were merely deployed as elements in an esoteric allegorical drama, whose cosmic claims for the powers of the prince were as insubstantial as the painted sets on stage.

The effect of the recovery of antiquity on the royal entry is only too readily traceable in the change in its physical appearance alone. It is easily forgotten, however, that the revival of chivalry and the *tournoi à thème* could be seen by humanists in exactly the same light. Ménestrier's *Traité des Tournois, Ioustes, Carrousels, et autres Spectacles Publics* (1669) is still imbued with the thought-premises of the renaissance. He opens his book by tracing the origins of tournaments back to antiquity in which such spectacles combined the rites of religion with military exercise and learned allusions. He goes on to discuss Roman circuses and combats and the symbolic nature of such tournaments, above all the choreographed carrousel in which the movements of horses and riders echoes the courses of the heavens.[27] This revival of the antique horse ballet was to become a major preoccupation of the mannerist period and was pioneered by the Medici court in virtually every set of festivals from 1608 onwards. In that year one was staged in the Piazza Sta Croce to celebrate the marriage of Cosimo de'Medici to Maddelena of Austria and the etching by Grueter shows precisely what such an extraordinary spectacle looked like: three

44 concentric circles of riders revolve, evoking exactly Ménestrier's description.[28] The *Ballo e Giostra de Venti* was the first of a series choreographed by Agniolo Ricci. Andrea Salvadori, who wrote the libretto for the *Guerra d'Amore* (1616), was perfectly well aware of their archaeological aspect stating that such a tournament 'Rinnouellarsi gli antichi spettacoli di Roma, e di Atene'.[29] Jacques Callot's etching corroborates this, for in the rectangular piazza an oval amphitheatre has been erected. The horse ballet was used to just such an emblematic effect as Ménestrier indicates and in the etching a *trionfo* of Mars and Venus is about to enter the arena and drive a wedge between the battle raging in the centre. A madrigal sung by Venus to the grand duke's *loge* signalled an

harmonious resolution in the equestrian ballet which immediately followed. Twenty years later Ricci was the choreographer for an even more highly developed equestrian ballet, on the occasion of the marriage of Vittoria della Rovere and Ferdinando II.[30] This time the etching is by Stefano della Bella, and it goes on to give fifteen of the figures executed by the horses and their riders in the margin. As in 1616 the ballet expressed the restoration of harmony and the triumph of virtue. Amor Pudico fired an arrow at the castle of the wicked enchantress Armida, releasing the knights who executed the geometric figures recorded in the left-hand margin of the etching.

The same humanist impulse that was turning the tournament into a ballet in Italy also occurred in France under the influence of the Academies. The Joyeuse *magnificences* of 1581 included 'des balets aussi à pied & à cheval, prattiquez à la mode des anciens Grecs, & des nations qui sont auiourdhuy les plus eloignées de nous'.[31] The tradition survived the wars of religion; one of Henri III's equerries was Antoine Pluvinel who was to stage an equestrian ballet in the Palace Royale in 1613.[32] What is interesting but hardly surprising is that to Ménestrier there was absolutely no difference between a ballet *à cheval* and one *à pied*: 'Car comme dans le Ballet ordinaire il y a trois choses, l'Air, les temps de l'Air, & la Figure'.[33] Images of cosmic harmony brought down from heaven to earth being the constant and obsessive preoccupation of the renaissance court fête, it was inevitable that it should have led to the dramatic development and spread of totally new festival forms ideally expressive of these ideals, not only the equestrian carrousel but the *ballet de cour*. Agniolo Ricci who was the choreographer of the Medici horse ballets was also the choreographer of the ballets *à pied* which were included as an essential element of the *intermezzi* in the early seventeenth century.

The rise and spread of ballet de cour

One of the ballets Ricci created came as one of the climaxes to an entertainment to mark the marriage of Ferdinando Gonzaga, Duke of Mantua to Caterina de'Medici in 1617, *La Liberazione de Tirreno e d'Arnea, autori del sangue toscano*.[34] It was staged in the Teatro Uffizi and was a typical hybrid mingling classical mythology, characters from Ariosto's *Orlando Furioso* and Florentine history in a celebration of Medici power and prestige. It is also virtually unique because there is an 47 etching of it by Jacques Callot showing a ballet in action. The moment

THE STUDY OF MAGNIFICENCE

depicted came early on in the entertainment. The scene is that of the *Primo Intermedio*, the island of Ischia with a mountain in the middle. Callot conflates the action and depicts three different moments in the performance simultaneously. The earliest is the appearance of an Olympian chorus, including Jove, who descended on a cloud machine. The second records the appearance of the twenty-two dancers, male and female with hands linked, as they were about to descend into the auditorium. The male dancers were headed by the Grand Duke Cosimo as his mythical ancestor, Tirreno, together with ten companions; the female by the Grand Duchess Caterina as his beloved Arnea with her ten handmaidens. The third phase records the twenty-two dancers arranged in a figure in the auditorium with the grand duke and duchess in the centre. Subsequently this vision of harmony was disrupted by an inferno which led to fighting at the barriers; harmony was re-established in a grand final ballet.

The geometric or 'horizontal' dance reserved for court performances which we see here is without doubt the most important new form of festival to emerge during the renaissance.[35] It was indeed Italian dancing masters who began to develop choreographed dances in the *quattrocento*, but the systematic development into *ballet de cour* was to be the work of the late Valois court under the impact of the French academies and their quest to revive 'ancient' dancing. Its practical fulfilment was due to an Italian, Balthasar de Beauxjoyeulx. But this is to anticipate a major theme of the chapter on Catherine de'Medici. It is sufficient to grasp at this point that the *Balet Comique de la Reyne* danced in 1581 was a landmark in this evolution, closing with a ballet danced by Louise of Lorraine and her ladies of no less than forty figures, squares, triangles, circles and mixed figures: 'and so dexterously did each dancer keep her place and mark the cadence that the beholders thought that Archimedes himself had not a better understanding of geometrical proportions than these princesses and ladies showed in the dance'. As Frances Yates wrote:

> The Pythagorean-Platonic core of the Academy — that all things are related to number, both in the outer world of nature and in the inner world of man's soul — perhaps found in the marvellous accuracy of this measured dancing one of its most perfect artistic expressions ... The dance of the nymphs represents the two eternities, the eternity of matter and the eternity of spirit. On the one hand the figures of the dance, constantly forming, breaking, and re-forming in a new figure, are the endless succession of birth and death in the transmutation of the elements and the passage of the seasons. On the other hand these geometrical figures stand for the eternal truths, echoed by the spiritual side of man through moral choice and the right direction of desire.[36]

Ballet is the most elusive of all Renaissance festival forms to recapture, stemming as it does from an age that had no form of choreographic

notation. Scenery and costumes are recorded in engravings and designs; music, poetry and prose lives on in printed form; but dance virtually eludes evocation.

Its importance, however, is reflected in the fact that it spread rapidly, in one form or another, across Europe. Henri IV's sister, Catherine de Bourbon, took *ballet de cour* to the court of Duke Charles III of Lorraine.[37] In 1600 the first ballet was danced at Nancy, the ladies entering on a chariot like a garden from which they descended to dance. Three years later she honoured her brother with one: 'Madame de Bar fit danser une fois un ballet dont toutes les figures faisoient les lettres du nom du Roi'. In 1606 the dancers came as twelve goddesses led in by Cupid to celebrate the marriage of Marguerite Gonzague-Mantoue to Henri de Lorraine. Descending from a triumphal chariot they danced two and two 'avec une telle grace et allegresse que chacun en avoit contentement'.

In 1619 Henri IV's daughter, Christina, Madame Royale, married Victor Amadeus, heir to Duke Charles Emmanuel I of Savoy.[38] The court at Turin was one of the most splendid in Europe and Savoy geographically occupied a bridgehead between France and Italy. The arrival of Christina reinforced a vigorous existing tradition and she quickly established ballet as *the* festival form above every other until her death in 1663. In this she was served by the man of genius whom we have already encountered, Filippo d'Aglié, whose talents included those of being a brilliant choreographer. Ménestrier records that no less than thirty-two ballets were danced at the Turin court between 1606 and 1657.

In 1638 the Chancellor Axel Oxenstierna summoned a French dancing master to Sweden who introduced *ballet de cour* there.[39] The most notable contributor must have been Réné Descartes who was involved in the ballet *La Naissance de la Paix* with which Queen Christina celebrated the Treaty of Westphalia in 1648. The French dancing master was a certain Antoine de Beaulieu who up until 1638 had been in England, where another daughter of Henri IV, Henrietta Maria, had been instrumental in bringing the influence of the French *ballet de cour* to its English counterpart, the Stuart court masque.

The court masque emerged simultaneously with the *ballet de cour*, taking a definitive form in 1605, when the team of Ben Jonson and Inigo Jones inaugurated the long series of spectacles which spanned four decades down to the outbreak of Civil War in 1642.[40] The masque was to prove the ideal vehicle for the Stuart kings to exhibit their divinity to their court in a series of emblematic tableaux, in which the masquers as various personifications of neoplatonic *ideas* vanquished all opposition to the crown and its policies. Dance always formed the climax to any of these occasions, both the initial figured dances by the masquers themselves and the general dancing in which they drew into the ideological chain the

onlooking aristocratic community. In Samuel Daniel's *Vision of the Twelve Goddesses* (1604), James I's queen, Anne of Denmark and her ladies celebrated peace with Spain with a symbolic masque in which they bore gifts to a Temple of Peace. After having performed this ritual they danced 'with great majesty and art ... motions circular, square, triangular, with other proportions exceeding rare and full of variety'.[41] Fourteen years later an Italian described Prince Charles descending from the stage into the auditorium in Jonson's *Pleasure Reconciled to Virtue* (1617): 'these all descended from the scene together in the figure of a pyramid, with the Prince alone always at the apex'.[42] The masquers in *Beauty* (1608) performed 'a most curious dance full of excellent device and change, ended it in the figure of a diamond'.[43]

Choreographed dances as the apogee of indoor court entertainments are therefore a European phenomenon of the later mannerist period leading into the early Baroque. Dance was, of course, a social accomplishment, a virtuous and moral exercise.[44] Within the context of a festival choreography of this kind was able to emphasise social gradation. More even than that, dancers were meant to be read by the onlooking audience who looked down on the patterns from above. Order, who led the dancers in Jonson's *Hymenaei*, as we have seen, wore a garment 'painted full of arithmetical and geometrical figures'.[45] In the *Ballet de Monseigneur le Duc de Vandosme* performed at the French court on January 17th–18th 1610 the main masquers at the climax danced what is described as the Druid's alphabet.[46] The ballet text uniquely provides us with a groundplan of the various figures. There were twelve in all including an arrow-shaped formation signifying 'Constance Esprouvée', a spray as 'Pein agréable', a diamond set into a square as 'Vertueux dessein', culminating in an enormously complex figure, 'Pouvoir Supresme', with intersecting triangles within a square encompassed by a circle: 'ceste dernier figure marque du plus parfaict caractere'. It has been argued that it would have needed ribbons held by the dancers to have followed these patterns, but the diagram can also be read as including the movements made by the dancers tracing a figure as well as their final position *en tableau*.

Now let us return to the grand duke and grand duchess in *La Liberazione*, with whom this section began. They stand in the centre of two circles of dancers. This formation must have been meant to have been read by the audience in some way similar to Jonson's use of the circle in *Love's Triumph through Callopolis* (1631) in which he celebrates Charles I's love for his queen, Henrietta Maria, in neoplatonic terms and images. The king as Heroic Love finds himself at the centre of a circle of heroic lovers:

Where love is mutual, still
All things in order move;
The circle of the will
Is the true sphere of loue.[47]

It cannot surely be a coincidence that choreographed dance as the focal point of great entertainments rises to prominence precisely during a period when the unity of Christendom was shattered by the divisions in religion resulting in war. The dance represents part of that obsessive quest particularly in the years in the aftermath of the wars of religion but prior to the outbreak of the Thirty Years War, for a new unity, a new harmony, a new world structure. Ménestrier gives us the thought-context which animated these moving geometrical hieroglyphs in which courtiers formed symbolic figures and by their movement mirrored the order of an hermetic universe:

> Les Egyptiens qui furent des Sages reglez jusqu'aux plus petites choses, firent les primiers de leurs Dances des hieroglyphiques d'action, comme ils avoeint des figures pour exprimer leur Mysteres. Platon qui fut leur Disciple & leur admirateur, en put assez louer l'esprit de celuy, qui le premier mit en Concert & en Dance l'Harmonie de l'Univers & tous les mouvemens des Astres, & conclud qu'il devoit être un Dieu, ou un homme Divin. Les Interprètes de Sophocle, d'Euripide, & d'Aristophane, nous ont découvert ces Mysteres que Platon n'a pas expliqué. Ils disent que toutes les Dances que faisoient les Egyptiens, representoient les mouvemens celestes & l'Harmonie de l'Univers.[48]

The thought-context is that of 'removed mysteries', the dance as the image of cosmic harmony and order as handed down within the hemetic tradition.

Conclusion

That I should end on this note of universal harmony and order is appropriate. It is indeed the central theme which unites all Renaissance festivals.[49] If I had to select a word to describe the nature of these transmuted festival forms it would be 'aspiration'. The iconographic programmes devised by humanists, composers, poets, architects and painters for royal entries, *tournois à themes* or *ballets de cour* encapsulate aspirations that through a particular ruler, treaty or alliance, earth might approximate more to the perfection of heaven. So those forms most expressive of this quest gain currency and develop in a passionate search

for 'ancient music' and 'ancient dancing', which are allied to a use of the newly recovered images and hieroglyphs of antiquity, with their deep hidden truths and mysteries as passed down from Moses to the Egyptian priests and, by way of the Thrice Great One, Hermes Trismegistus, to the Greeks within the hermetic tradition. Festivals could only ever have developed and escalated on this gigantic scale within an atmosphere of pervasive neoplatonism, in which man the microcosm was re-cast into a position of hitherto unknown power within a magical universe full of occult influences to which he would attune himself. These influences ranged through music reflecting the celestial harmony of the spheres; architecture in the new classical style based on number and geometrical ratio embodying a Platonic-Pythagorean view of the structure of the universe; the evocation of the images of the gods and goddesses of antiquity or *ideas* reinvested through the recovery of their old attributes with all their ancient 'power'; to the movement of the dance mirroring the planets and stars in their courses. All these visions, conjured up time and again in the festival world, carried an additional intensity in an era which witnessed the breakdown of the old medieval world picture, the shattering of the Universal Church by the Reformation, the expansion of the earth's surface to include the New World, and the discoveries of Copernicus which were eventually to dislodge a geocentric world picture. For the reader four centuries later the aspirations of festival speak of the greatest hopes cherished by Renaissance man and of their eternal betrayal.

PART TWO

PAGEANTRY AND POLITICS

Whereas all representations, especially those of this nature in court, public spectacles, either have been or ought to be the mirrors of man's life, whose ends, for the excellence of their exhibitors (as being the donatives of great princes to their people) ought always to carry a mixture of profit with them no less than delight . . .

Ben Jonson, *Love's Triumph through Callipolis*, 1631

I

THE IDEA OF MONARCHY

If the fundamental driving force that animated renaissance festivals was remarkably consistent, so too was the monarchical mythology that it sustained and propagated. In discussing this mythology, we are not dealing with the political reality of kingship, but with something much more intangible, the Idea of it. The Habsburg, Valois, Stuart and (by dint of marriages) the Medici dynasties, who will be the main subjects of the second part of this book, were all promoting remarkably parallel visions of autocratic rule in their festivals. The same ingredients assumed a European dimension as they were re-cast by organisers of fêtes to meet the demands of different dynasties and different politico-religious pressures. If I had to choose one theme, however, which provided a common thread it would be the one of empire.[1] This is less surprising than it would seem at first glance. The two greatest dynasties of Europe, Habsburg and Valois, were both descended directly from Charlemagne, and both the Holy Roman Emperor and the *Rex Christianissimus* were heirs to claims to dominion that were universal. In remote England the Tudor 'Empire' came as a result of the break with Rome but their successors, the Stuarts, re-created on their accession the ancient Empire of Great Britain. All three claimed direct descent from the ancient imperial stock of Troy. These claims enabled the poets and humanists who devised *fêtes de cour* to draw on a rich tradition that included not only the classicism of Roman antiquity and Augustan imperial rhetoric but also the chivalrous sagas of northern Europe. Both ingredients were built upon and expanded by the new dynasties of the sixteenth century.

At the opening of the century, when the Habsburg, Valois and Tudor dynasties were consolidating their power, nothing seemed further from

political reality than an imperial *renovatio*. With the Emperor Charles V, however, the Holy Roman Empire suddenly became a fact overnight again. For almost forty years the mythology of universal empire ran riot in relation to Charles V, having a profound effect on the development of the mythologies of the national monarchies.[2] For Charles the revival of Sacred Empire was enhanced by its coincidence with the spread of the Renaissance style *à l'antique*. More vividly than any emperor since antiquity, Charles was depicted as a Roman *imperator* in antique armour, his brow wreathed in laurel. To his court, moreover, were attached notable exponents of the theories of Sacred Empire. The imperial chancellor, Mercurino Gattinara, was one whose ideas stemmed from Dante's *De Monarchia* and who fervently supported the expansion of Charles's dominions to embrace new horizons. Another was the court preacher and historiographer, Antonio Guevara, whose book *The Dial of Princes* had a European influence and who repeated, amid a disquisition on imperial and royal virtues, the arguments that the rule of the One over the whole world was best. A third was the emperor's Latin secretary, Alfonso de Valdes, who wrote, following the Sack of Rome, a *Dialogue of Lactantio and an Archdeacon*, drawing on medieval defenders of imperial rights against papal encroachments and fusing them with attitudes which were Erasmian. In this treatise the notorious Sack was cast as a divine judgement, papal shame opening the way to the emperor asserting his right to summon a general council which would end the Lutheran schism and inaugurate ecclesiastical reform. Charles never actually wielded these powers, but for almost half a century he remained the focal point for those who believed that he would.

To the ethos of imperial myths and sagas revived can be added another ingredient. Three years before the spectacular *renovatio* of empire embodied in the imperial election of 1519, Erasmus dedicated a book to Charles which had a profound influence on the Idea of Monarchy throughout Europe.[3] The *Institution of a Christian Prince* recasts for the Renaissance the medieval *speculum principis* tradition. The ideal prince was now one who had received both a Christian and a humanist education. The heroes and heroines whose virtues he should pattern himself upon figure in the classical texts beloved by Renaissance humanists, in Plato, Cicero, Seneca and Plutarch. Educated in this manner, princes would be animated to act in concert and advance universal peace. The ideas embodied in this text find very vivid expression in the state entries staged not only for the Emperor Charles V, but also for monarchs throughout Europe: time and again figures representing the princely virtues were paraded for their contemplation, and examples of virtuous behaviour from antiquity were acted out, painted or sculpted for their edification. To take one extreme example: when Charles V and his

empress entered Seville in 1526 they progressed through a series of arches dedicated to the Virtues — Prudence, Fortitude, Clemency, Peace, Justice and Faith — that led them to Glory where they were crowned by Fame.[4]

Erasmus's book is one aspect of how the medieval cult of monarchy was affected and enhanced by the study of classical antiquity. Texts offered an abundance of material on the ceremonial cult of rulers in the ancient world and the impact of that on renaissance kingship has yet to be fully elucidated. Symptomatic of its dangers was the Inquisition's charge against Giordano Bruno that he had called Elizabeth I *Diva*, to which he replied that he addressed her thus 'not as a religious attribute but as the epithet which the ancients used to give princes'.[5] The cult of the royal image by way of painted portrait, sculpture, engraving and medal certainly overlay onto the existing sanctity of the royal image knowledge of the worship accorded effigies of Roman Emperors. Indeed in a Protestant country such as England, where religious images were thrown out as idolatry, the likeness of the monarch, his coat of arms and seal were the only ones accorded ceremonial deference.[6] An interesting specific instance of the humanist study of antiquity on the development of the cult of crowned heads is the French royal funeral ceremony. This can be pin-pointed to the humanist cleric who organised the funeral of François I in 1547 when, for the first time,[7] the late medieval exposition of the king's effigy was elaborated as a result of knowledge of texts describing the funerals of the Emperors Septimus Severus and Constantine.

> And it is to be understood and known that during the time the body was in the chamber next to the great hall, as well as while the effigy was in that hall, the forms and fashions of service were observed and kept as were customary during the lifetime of the king . . .[8]

In this instance a fully clothed life-sized effigy of François I was served with whole banquets, echoing the practice recorded by Herodian for the Roman Emperor. This practice in simplified form was already established at the close of the middle ages as reflective of the fact 'the king never dies' but at the funeral of 1547 it was given a fashionable *à l'antique* overlay in the same way that two years later the royal entry was to be transformed on a far more radical scale.

The imperial idea did not die with Charles V's abdication in 1555. The twin branches of Habsburg dominon, both in Austria and in Spain, were direct heirs to it and made full use of the panoply of Empire in the mythology of their court life. In the case of Philip II it became indivisible from a triumph of Catholicism.[9] Others were also indirectly heirs of the idea. In an age of nascent nationalism and lingering universalism, the imperial idea continued to have a tremendous appeal, particularly during

the second half of the sixteenth century when the wars of religion led to rulers becoming the focus for messianic hopes. This became blended with the nationalist philosophy stemming from the assertion defining the postion of the French kings in the later Middle Ages, that every monarch *est in patria sua imperator*, 'is emperor in his own land'.[10] The arguments put forward by those defending these new national 'empires' drew heavily on the texts used to defend universal empire. In this they added imperial mysticism to the already complex aura of sanctity that surrounded *les rois thaumaturges* who, in the case of both France and England, could, by dint of holy unction at their coronation, actually heal their subjects by the royal touch. Not even the Reformation was to diminish belief in this power, which continued unabated in its attraction until the third quarter of the seventeenth century. In the case of France, this was to revive with force in the figure of Henri IV in the aftermath of the wars of religion. There every effort was made to re-emphasise the sacred nature of kingship. André Duchesne, reflects this when, in 1609, he wrote that 'our great kings . . . have never been considered pure laymen, but have been held to be decked both with priesthood and with royalty, all in one'. The same attitude is to be observed amongst the English royalists in respect of Charles I.[11]

Imperial themes deriving from Charles V had an enormous impact on Elizabethan thought concerning the monarchy.[12] The position taken up by the crown in relation to the church of being its governor and defender was based directly on the arguments used by those who had supported the emperor against the pope in the never-ending struggles during the middle ages. As the pope had reduced the imperial power to nought, it was argued, his powers had devolved upon kings of individual countries. The famous Act in Restraint of Appeals of 1533, by which Henry VIII rejected papal authority, begins by stating that the realm of England was an 'empire' over which the Bishop of Rome had no authority. Bishop Jewel, the official apologist for the Anglican settlement of 1559, sums up the position of the English crown in the post-Reformation period exactly. Whereas in olden times the emperor had summoned councils of the church, it was 'now a common right to all princes, forasmuch as kings are now fully possessed in the several parts of the empire'. This formed the politico-theological basis upon which the Tudors built up their position as restorers of ancient purity to the polluted English church by reassuming the powers once rightfully enjoyed by emperors in the primitive church. The cult of Elizabeth I stems from this role as the just virgin of imperial reform, descended from the ancient imperial house of Troy, the embodiment of the Tudor *pax* by virtue of the union of the two roses of York and Lancaster. In her oft-sung role of Astraea, she is actually identified with the virgin of Virgil's prophetic *Fourth Eclogue*, whose advent foretells the Age of Gold and an imperial *renovatio*. Elizabeth

reigns, in the words of the dedication of Edmund Spenser's epic *The Faerie Queene*, published in 1590, as the 'most high Mightie and Magnificent Empresse', whose 'empire' extends beyond the bounds of her tiny island kingdom to embrace the colony of Virginia. The year after this, the imperial theme was stated with renewed vigour in the great entertainment given by Lord Hertford in celebration of her as 'Faire Cinthia the wide Ocean's Empresse'. A huge crescent-shaped lake had been dug as emblematic of

50

> . . . the rich increase
> Of all that sweet Elisa holdeth deare.

In this image the imperial moon symbolism of Henri II's famous *impresa* is adapted for the expanding Tudor Empire.[13]

The rhetoric of Golden Age falls as fast round Elizabeth I as it does around Valois or Habsburg. Gloriana, under which name Spenser celebrates the public aspect of his sovereign, is descended from the line of the Trojan Brutus, from whom spring kings and 'sacred Emperors'. In an imitation of Ariosto's prophecy in *Orlando Furioso* celebrating the empire of Charles V, Spenser used Merlin to foretell the advent of the Tudor dynasty and in particular of an imperial virgin:

> Thenceforth, eternal union shall be made
> Between the nations different afore,
> And sacred Peace shall lovingly perswade
> The warlike minds, to learne her goodly lore,
> And ciuile armes to exercise no more;
> Then shall a royal virgin reign . . .[14]

Occasional bursts of wild imperialism are part of the Eliza cult. It is glimpsed in the terrestrial globes that appear so frequently in her portraits, into one of which the crown of the Holy Roman Empire is even inserted. In direct reference to Charles V she is depicted, in the aftermath of the defeat of the mighty Armada, standing triumphant between the columns of Hercules which were his *impresa*. Like that of Charles V, too, Elizabethan imperialism draws to itself traditions of courtly chivalry intensified in the case of Elizabeth I as she combined the twin aspects of sovereign and romantic heroine. In emulation of the *Toison d'Or*, the Tudors placed renewed emphasis on the ancient Order of the Garter founded by Edward III in the fourteenth century. The celebration of St George's Day on April 23rd became a major festival of Elizabethan Chivalry when the queen and her knights in their splendid robes processed in public.[15] At the Accession Day Tournament of 1590, the British *Virgo* and her growing empire found dramatic expression in the erection within the tiltyard of Whitehall Palace of the Temple of the Roman Vestal Virgins. Certain of the virgins bore to

the queen splendid gifts from the altar, while before the temple stood a pillar bearing a crown embraced by an eglantine tree. On this hung a Latin prayer, ecstatic in its Eliza worship, stating that the queen had moved one of the pillars of Hercules and that now her mighty empire stretched into the New World.[16]

The rule of Elizabeth Tudor was a success. Across the Channel the last Valois struggled in the face of endless disasters; but what is so striking is that such catastrophes did not erode the essential Idea of Monarchy. Indeed, they might be said to have intensified it. The cult of Elizabeth reached its peak in the 1590s, when in fact the system was breaking down in the face of economic problems at home and unsuccessful campaigns abroad. This was equally true of the last Valois kings. The failure of the French monarchy did not in the least erode a fervent belief in its destiny to bring peace, justice and expanding empire. Few works of art from the period so neatly synthesise the late Valois Idea of Monarchy than Antoine Caron's *The Tiburtine Sibyl*.[17] Caron (c.1527–1599) was the designer of the festivals for the wedding of the Protestant Henri of Navarre to Marguerite de Valois (1572), those for the election of Henri III as king of Poland (1573) and the ones for the marriage of the duke de Joyeuse (1581). In the picture we find ourselves in the garden of Catherine de'Medici's Tuileries Palace looking across to the Seine on the right in the distance. It is a composite view of Paris in the mid-1570s but what is so revealing is the layers of image and metaphor applied to it. The city has been transformed, as it so often was by the art of festival, into *Nova Roma*, with antique galleys on the river, a classical obelisk, temples and other temporary buildings in the antique style. A courtly audience in the middle distance watches a tournament in progress. What we see are typical elements of Valois court fêtes in celebration of the crown but they form a backcloth to the idea that dominates the foreground. The Emperor Augustus (an idealised Charles IX?) kneels as the Tiburtine Sibyl shows him a glimpse of the Christian revelation to come. This is the Roman Empire sanctified, of which the *Rex Christianissimus* was heir by descent from the ancient Trojan line. Behind, on a plinth, rise the two twisted vine columns of the Temple of Solomon crowned and bearing the motto, *Pietas Augusti*. It is a variant of the *impresa* of Charles IX (derived from that of Charles V) whose pillars embodied the attributes in his motto: *Pietate et Justitia*. In this one image of Paris *en fête* we have so many threads central to the Idea of late Valois monarchy: Old Testament kingship, the Trojan imperial descent, the cult of chivalry and over and beyond, strange visions of universal dominion.

At the close of the century such ideas of *renovatio* found their focus in Henri of Navarre, whose extraordinary career and conversion to Catholicism presaged to many a remarkable destiny. Henri was heir to this

52

rich tradition that cast the French monarchy in potentially universalist terms.[18] Humanists hopes of a solution to the divisions of Christendom, which had formerly found their nodal point in hoped-for actions by the Emperor Charles V, crystallized yet again round Henri IV.[19] The French king's conversion to Catholicism, it was believed by many, opened the door to some universal religious solution. The French monarchy, as descendants themselves of *sacrum imperium* from Charlemagne and as guardians of Gallican liberties, had always attracted imperial mysticism. Even in the midst of the terrible wars with the Catholic League, when it seemed that the French crown was about to slip into oblivion, the imperial mythology was revived in the imagery surrounding Henri IV. In the Rouen entry of 1596 he stands like an emperor astride a terrestrial globe, Opportunity and Fortitude crowning him. At the turn of the century in the fêtes to welcome Marie de'Medici as the new queen of France, the myth of imperial destiny is intensified. Echoing the prophecies of theologians, astrologers and pamphleteers at the turn of the century, the festivals to celebrate the marriage in Florence sing of Henri as a hero whose military prowess will bring empire and who will lead a new crusade and free the Holy Sepulchre from the infidel. In the solemn entries made by Henri's bride into Avignon and Lyons, the king, under the image of the heroic Gallic Hercules, is cast as a protector of the Faith whose mission of universal pacification augurs imperial power. The programme by the Jesuit André Valladier, the *Labyrinthe royale de l'Hercule Gaulois triomphant*, for the entry into the papal city of Avignon includes an arch dedicated to Henry as Apollo Economo, the god who '*gouverne tout l'Univers par ses rayons et occultes influences*', and in which the king appeared bearing up the celestial sphere, with, below, the inscription *Redeunt Saturnia regna*, the imperial Virgilian prophecy of the *Fourth Eclogue* of the ruler who will restore the reign of Saturn, the Age of Gold. In another arch the columns of Hercules bore up a papal tiara and the French crown supported by a sword and a sceptre respectively, with Henry's motto *Duo protegit unus* above, to show, explains Valladier, pleading also in his obscure allegories for the return of the Jesuits to France, that by his authority he not only governs his kingdoms but wields his sword in protection of the Church. Nothing reveals the vitality of the French imperial vision better than the modest *entrée* devised by the astrologer Nostradamus's son for Marie's entry into the small town of Salon. There the golden fleur de lys of France and the red fleur de lys of the Medici appeared entwined with the sun and moon above with an imperial crown. An octave expressed the hope that from the union of this Mars and Pallas, this Sun and Moon would be born: 'Maint Astre et Maint Phoenix ... qui de tout l'Univers puissent avoir un iour les Empires divers'. In this way, the humanist dreamland of *renovatio* embodied in the messianic literature and imagery surrounding

51

Henri of Navarre becomes gradually transmuted into the creation of absolutist monarchy. It is a line of descent that leads directly from the Emperor Charles V to *le Roi Soleil.*

In England the arrival of the Stuarts intensified the theme of *imperium.* The entry of James I into London in 1604 endowed him with the Elizabethan imperial heritage enriched by James's own re-creation of the Empire of Great Britain by virtue of his descent from the Trojan Brutus.[20] As in the case of so many renaissance entries, London is *Nova Roma* and the Thames the Tiber receiving her Augustus. On the first arch he could spy the British monarchy holding a globe inscribed 'Orbis Britannicus. Divisos ab orbe' alluding to the famous line in Virgil's *First Eclogue, Et penitus toto divisos orbe Britannos,* a phrase used by Giordano Bruno to celebrate England and her Virgin Queen presiding over sacred waters. Further on an arch dedicated to *Nova Foelix Arabia* made an unequivocal statement on the imperial inheritance:

53

> Great Monarch of the West, whose glorious stem
> Doth now support a triple diadem,
> Weighing more than that thy great-grandsire Brute
> That thou maiest make a King thy substitute,
> And dost besides the red rose and the white,
> With the rich flower of France thy garland dight,
> Wearing above Kings now, or those of old,
> A double crown of laurel and of gold.

'Arabia Brittannica' wore 'an Imperiall Crowne on her head, and a Scepter in one hand, a Mound in the other'. Subsequently, on a later arch, Astraea, the Maiden Justice, the role played so often by the old queen, was seen poised aloft 'as being newly descended from heaven, gloriously attirde; all her garments beeing thickely strewed with starres; a crowne of starres on her head: a Silver veile covering her eyes', and the whole was rounded off at Temple Bar with the inevitable Latin tag hailing the return of the Augustan age: 'REDEUNT SATURNIA REGNA. Out of Virgil, to shew that now those golden times were returned againe, wherein Peace was with us so advanced, Rest received, Libertie restored, Safetie assured, and all Blessednesse appearing.'

In this sense and in others, the Idea of Monarchy becomes the focus for imperial Utopian aspirations. Festivals indeed perpetually offer us such transitory Utopias and this is not as foolish as it at first sight would appear. The period leading up to the Thirty Years War was marked not only by the tragic clash of rival religious ideologies, about which we hear only too much, but also, in sharp contrast, by the continued vitality of earlier modes of undogmatic humanist thought, which in its intense magico-hermetic phase sought for new universal solutions to a broken Christendom. There was the great examination and codification of the

physical world in the work of the geographers, explorers, botanists, and astronomers, in the hope that some new universal pattern would emerge to replace that so recently shattered and lost. Although this practical investigation was to contribute to the scientific modes of thought of the seventeenth century, it was still conducted within the framework of the old cosmology. Parallel with these enquiries, others coped with the problem of universal solutions in a manner equally typical of the age, seeking them through a belief in the occult and the spirit world, through astrology and prophecy.[21] These were Utopian visionaries of the type of Guillaume Postel, Francesco Patrizzi, Giordano Bruno and Tommaso Campanella. As R. J. W. Evans has written, the unifying element of their thought is 'that they actually viewed the state as one aspect of a magical cosmology'. The political programmes that any of these thinkers offered in the late renaissance period cannot be disentangled from their obsession with occultism, magic, chiliasm and pansophic wisdom. Their intellectual framework often provides a thought-context into which late Renaissance festivals would seem to fit naturally, both in the sense of the ideas they purvey and in their cultivation of mystical monarchy. Their work certainly dispels any notion that the contents, claims and hopes put forwards in these festivals were in any way abnormally fantastic.

The wild visions of universal empire in the programme for Charles IX's queen entering Paris in 1571 have their exact counterpart in the prophecies of the Cabalist Guillaume Postel, who believed in the sacred imperial destiny of the *Rex Christianissimus* as a world ruler. The universal destiny predicted for Henri IV in the marriage festivals in Florence in 1600 reflect the aura of prophecy encircling his rise to power. The increasingly autocratic visions of Charles I on stage, in which he cast himself as sacred and set apart from ordinary mortals whose very presence could banish evil opposition, reflects to the letter James I's words of advice to him: 'he [i.e. God] made you a little God to sit on his Throne and rule over other men'.

The rise and decline of the Renaissance court fête in its political sense coincides exactly with this reinforcement and expansion of the medieval idea of kingship. It also depends upon the re-creation in our minds of a lost and alien ethos, that of the despotic myth. Post-war scholarship has been understandably more attracted to that political myth as it was created by renaissance humanists in its republican forms and less to its princely manifestation, the alliance of a people and a dynasty as a cause. W. L. Gundersheimer, in his discussion of the Este dukes of Ferrara, sums up well these intangibles:

> . . . the dynasty must have its own mythology. This requires an account of its origins, designed to manifest its nobility, antiquity, and its claims to political legitimacy; second, it requires emphasis on the traditional virtues

fostered by the dynasty through a long line of rulers and other heroes; finally, at any particular moment it needs to be associated with an individual, the reigning prince of the moment. Here, particular qualities or abilities have to be dramatized, which is another way of saying that the propagandist has to build upon whatever virtues he can find in a particular ruler. If the ruler actually possesses such strengths, the task is greatly simplified.[22]

Thus rulers are depicted as noble exemplars of their dynasty and its inherited virtues. The preoccupations of the humanists in the case of the Este family in the *quattrocento* were to become a European phenomenon by the close of the *cinquecento*, the systematic cult of the family through literary and visual panegyric. Festivals are one aspect of this alliance between humanism and rulership in propagating a cumulative myth of dynasty.

It is now time to turn and examine just how that extension and escalation was achieved and used in the case of four rulers, the Emperor Charles V, Catherine de'Medici, the Grand Duke Ferdinand of Tuscany and Charles I. In the first half of this book I outlined the revolution in festival forms and ideas. In the second I shall show how those forms and ideas were used by four very different rulers whose aims and aspirations were widely divergent. For all of them, festivals were no mere peripheral activity, but a central instrument of government. Although I shall discuss their artistic implications, it is the political and ideological ones on which I shall concentrate, and which are indeed crucial to establishing the study of festivals within the mainstream of the history of ideas. I shall begin with a figure of European dimensions, the Emperor Charles V, whose long reign not only covers virtually the whole of the first half of the sixteenth century but whose unceasing peregrinations ensured the dissemination of the revived imperial mythology in its recast humanist guise throughout the known civilised world. Charles V was the first to use it on a gigantic scale supported by all the resources of what were then modern methods of promotion: printing and pageantry.

II

IMAGES OF EMPIRE

Charles V and the Imperial Progress

On June 29th 1539 Eleanora of Toledo, daughter of the Viceroy of Naples, made her solemn entry into the city of Florence as its future duchess.[1] The bride was the choice of the Emperor Charles V, and the most important of the triumphal arches to greet her on arrival was one in his honour. The procession paused to admire an elaborate arch over which could be seen the figure of Charles himself, arrayed *à l'antique*, crowned with laurel and carrying the imperial sceptre, river gods at his feet, flanked, to his right, by the figures of Spain and New Mexico, followed by Neptune, to show 'that the Western Ocean is dominated by His Majesty', while to the left stood Germany, with shield and lance, together with Italy and Africa. This formidable array had beneath it the following inscription: AUGUSTUS CAESAR DIVUM GENS AUREA CONDIT SAECULA ('Augustus Caesar, the offspring of gods, founds a Golden Age'), a tag taken from the famous prophecy of imperial greatness in Book Six of the *Aeneid*. Such tableaux of imperial grandeur, enhanced by the forms of Renaissance classicism, were to be re-enacted all over Europe in the first half of the sixteenth century, not only within Charles's own vast dominions, but both in England and in France. By the time of his abdication in 1555, every educated person within Europe must have been familiar with the rhetoric and imagery of Sacred Empire.

It was ironical that the art of festival was to give its most exuberant expression in the first half of the sixteenth century less to nascent nationalism than to glorifying a dramatic and unexpected revival of the phantom of universal empire. The Emperor Charles V ruled over domains

of a richness and greatness beyond the dreams of the Romans. From his paternal grandfather, the Emperor Maximilian, came the hereditary Habsburg lands within the Empire; from his paternal grandmother, those within the area of the Low Countries, once ruled by the dukes of Burgundy; from his maternal grandparents, a united Spain. To these Charles was to add in 1519 the title of Holy Roman Emperor, and territorially, by conquest, war or discovery, most of Italy and the New World. His vast domains came to be symbolized by his personal *impresa* of the two columns of Hercules, boundaries of the antique world, and the motto *Plus Ultra*.

Through his own relentless policy of dynastic aggrandisement, most of the remainder of Europe came within his orbit by marriage at one time or another, from Denmark to Milan, from Hungary to England. During his lifetime Charles defeated and captured his rival, François I, at the Battle of Pavia in 1525, and two years later imperial troops sacked Rome. In the years following it seemed as though the whole known world was subject to One, and One who had not only been crowned by the Pope but had taken the faith to the New World, had defeated the Infidel and seemed on the brink of resuming imperial 'rights' by summoning a general council to reform the Church and end the Lutheran schism.

Charles V's fêtes were, therefore, great compilations of imperial mythology on a scale unknown since the Roman Empire: globes of the world, images of the cosmos, gods and goddesses, heroes and heroines, subject continents, rivers and peoples, all held together by Latin tags from authors celebrating Augustan grandeur. In short, the revival of Empire represented in the figure of the Emperor Charles V gave Renaissance humanists and artists at last a living vehicle to whom they could legitimately apply the whole rediscovered repertory of classical antiquity. As the inheritor of Sacred Empire, the use of classical architectural motifs and the re-creation of imperial triumphs in his honour have a meaning beyond that of mere empty rhetoric.

Scattered over four decades of the sixteenth century as well as most of the countries of Western Europe, the festivals of the Emperor Charles V may at first glance strike one as diffuse and lacking in coherence.[2] In some we seem to leap forward into the imagery and forms of the Renaissance in full flood, in others we are still back at the court of Burgundy in the fifteenth century. It would be tempting, therefore, not to treat them chronologically; but that would be misleading, because what is central to them all is that, regardless of style and form, either group of festivals could provide a coherent vehicle for the imagery of empire. And indeed the imperial revival of Charles V was seminal in the interplay between north and south because it was during his long reign that the revived antiquity of the renaissance in Italy travelled northwards while, simultaneously, the

ceremonial and imagery of northern chivalry began to be widely cultivated in the Italy of the princes. I shall deal with the festivals as they occur but ask the reader to bear these facts in mind as we move forwards and backwards. The festivals themselves may be spread over forty years but they in fact can be treated as three quite distinct blocks. The first is set in Italy and runs from 1529 to 1536, from the imperial coronation at Bologna to the progress through Italy after the defeat of the Turks in Tunis; the second relates to his heir, the future Philip II of Spain, in the long ceremonial journey he undertook through the Habsburg domains in 1548–49 which culminated in the spectacular entry into Antwerp; and the final group is the vast series of chivalrous fêtes given by Mary of Hungary at Binche.[3] And in the main we shall be dealing with transmutations in content and form of one festival form only, the royal entry.

In the moving speech that the emperor made at his abdication, he recalled to those present his peregrinations: ten times to the Low Countries, nine to Germany, seven to Italy, six to Spain, four times through France, twice into England and twice to Africa. This list alone conveys the supranational character of imperial rule, besides the geographical extent of his universal monarchy. It focuses attention, too, on the ceremonial progress as a political weapon in the hands of monarchs during the sixteenth century. Progresses consolidated support for a regime, popularised its attitudes, took them down to the roots of local government, and made concrete the abstract of the crown in the actual presence of the ruler. The sixteenth century was an age of royal progresses. Charles V was not alone in using this as a means of furthering dynastic power and focusing loyalty to the crown. As we shall see, Catherine de'Medici also knew the value of the ceremonial progress. In the pause that followed the first of the religious wars Charles IX was taken on a long tour of his dominions, the 'Grande Voyage de France', making formal entries into each of his major cities and framing the journey with two great series of 'magnificences', at Fontainebleau in 1564 and at Bayonne on the Spanish frontier the year after. The most legendary and most successful of all these exponents of the royal progress was Queen Elizabeth I. These endless peregrinations, which were so often the despair of her ministers, were the means by which the cult of the imperial virgin was systematically promoted. Those undertaken during the first twenty years of her reign were crucial for the success of her rule, taking her west as far as Bristol (1574) and east to Norwich (1578). No other monarch's travels in terms of sheer distance and geographical coverage, however, were to rival those of Charles V.

The imperial coronation at Bologna, 1530: the triumph of the antique style

The most significant spectacle of the reign was the coronation of the emperor at Bologna in 1530. The event represented the focal point of imperial ambitions ever since Charles had been crowned King of the Romans at Aix-en Chapelle on October 23rd 1520 and had asked the German princes for men and money to reopen the Italian wars and achieve an imperial coronation in Rome. The coronation was the outcome of long years of conflict between Charles and François I in Italy. In 1525 the latter was defeated and captured at the Battle of Pavia, and by the Treaty of Madrid agreed to abandon all French claims to Naples and Milan. Milan became an imperial fief and Naples was annexed to the Spanish crown. No sooner was the French king released than he disclaimed the treaty as having been made under duress and, much to the embarrassment of the emperor, concluded the Holy League of Cognac with Pope Clement VII, Florence and Venice on May 22nd 1526. The imperial troops crossed the Alps and laid siege to Bologna, and the pope, fearing the worst, made a treaty with Charles on March 15th, but all to no avail, for the army, undisciplined and unpaid, moved south and laid siege to Rome. The infamous Sack of Rome, unwanted by Charles, placed the pope virtually in imperial hands, although he subsequently escaped, first to Orvieto and subsequently to Viterbo. Once more a French army entered Italy, to be finally routed at Landriano on June 21st 1529. On June 29th pope and emperor signed the Treaty of Barcelona, ostensibly motivated by the need to unite against the Turk in Hungary. In this Charles recognised papal claims to Ravenna, Cervia, Modena, Reggio and Rubeira, and, in return, Charles was invested with the kingdom of Naples. Both were to unite against heresy, and the pope threatened excommunication against those who allied themselves with the Turk. Meanwhile the emperor's aunt, Margaret of Austria, Regent of the Netherlands, had negotiated a peace with the French king through his mother, Louise of Savoy. The result was the Ladies' Peace of Cambrai, signed on August 3rd 1529. By this the emperor renounced his claims to the lost Burgundian lands, and François in turn recognised Charles's right to Flanders and Artois and himself abandoned claims to Milan, Genoa and Naples. As a finishing touch, the emperor's sister, Eleanor, was to marry François I, and as part of this universal peace Clement VII was to crown the emperor. Late in July 1529 Charles left Barcelona for Italy and on November 5th made his solemn entry into Bologna.[4]

The procession itself was a formidable demonstration of imperial power. All such processions were deliberately stage-managed to demonstrate the multinationality of Charles's domains. The emperor was met at the Porta

San Felice by twenty cardinals attended by four hundred papal guards. The cardinals dismounted from their mules and saluted his imperial majesty courteously. Three hundred light horsemen opened the imperial procession, followed by a troop of Spanish lords bearing banners and standards. Next came three hundred knights in armour with red plumes nodding in their helmets. Ten great cannon mounted on chariots were wheeled through the streets ahead of fourteen companies of German *Landsknechte* playing fife and tabor with huge banners fluttering in the wind. Two lords on horseback carried the imperial and the Burgundian standards, one the outspread eagle, the other a red cross of St Andrew on a white ground. Squadrons bearing ordnance followed, together with the German cavalry, culminating in a group of Spanish grandees surrounded by a hundred of the emperor's personal bodyguard carrying halberds. Before Charles rode the Grand Marshal supporting the imperial sword, while the emperor himself was in complete armour with a golden eagle on his helmet, bearing a sceptre in his hand, his horse-caparisons of cloth of gold embroidered with jewels. Four knights on foot supported a magnificent canopy over his head, eight pages attended him, and he was accompanied by Cardinals Farnese and Ancona.

At the city gate Charles kissed the cross proffered him, while the imperial heralds casually tossed eight thousand ducats in gold and silver to the crowd. The pope, surrounded by the entire papal court, waited to greet him in the church of St Petronius. Charles travelled by a route which was decorated with arches that symbolically spelt out the role of emperor as it was conceived by the pope in 1529. The Porta San Felice was decorated with putti dancing and playing instruments, joyful at the emperor's coming. There was a triumph of Bacchus with nymphs, fauns and satyrs, and one of Neptune with tritons, sirens and sea-horses to show that Charles's sway extended over both land and sea. The town gate bore medallions of Caesar, Augustus, Vespasian and Trajan, and equestrian statues of Camillus and Scipio Africanus with effigies of other Romans famous as virtuous warriors and exemplars of the virtue of prudence. Two Latin inscriptions promised even greater glory to an emperor who combined the qualities of such pagan heroes with those of champion of the Faith and shield of Holy Church.

The route was adorned with two further arches in the Doric style which carried numerous scenes and effigies reminding Charles of those emperors who had been protectors of the Holy See and defenders of the Faith. There were statues of Charlemagne, the Emperor Sigismund, Ferdinand of Aragon and the Emperor Constantine, scenes from whose life included him presenting the imperial crown and sceptre to Pope Sylvester. These were rulers zealous in the Faith, active against heresy, the Jews and the Moors, extending the Church into the new worlds, above all obedient sons of the

papacy. In this way the pope defined the imperial role as the emperor advanced through the streets of Bologna. Charles, the heir of the Caesars, was to be the perfect medieval emperor, whose sword and sceptre were at the service of the pope. In its rigid insistence on the active propagation of the Faith, and on the destruction of heresy, it equally anticipates the themes of counter-reform. Charles was cast in the role of the virtuous young emperor who had offended the spiritual power and devastated Italy, but who yet now humbly waited to make amends by submitting to Holy Church. The creation of Charles as the Champion of Christendom was played out in a final spectacle, the imperial coronation, on February 24th 1530, in a ceremony rich in symbolic statements on the subservice of *imperium* to *sacerdotium*. There was yet another, perhaps even more splendid procession, and further triumphal arches. On that day there was the unique sight of Charles riding at the pope's right hand as the living embodiment of the dependence of *regnum* on *sacerdotium*.

There are no surviving designs for the emperor's entry into Bologna but the artists involved would certainly indicate that it was in the antique manner. The great event, however, was framed by two others for which a few drawings do survive which give us for the very first time an exact impression of the reality of the transformation of the royal entry into an *à l'antique* triumph. The arches designed by Perino del Vaga (1501–1547) for the emperor's arrival in Genoa on August 12th 1529 are in the antique style adorned with sculpture and chiaroscuro paintings simulating bas reliefs.[5] The column topped by Victory by Giulio Romano (1499?–1546) which stood in the Piazza San Pietro as part of the decorations for the emperor's entry into Mantua on March 25th is again in the antique manner, a variant in wood inspired by Trajan's column.[6] These designs offer the earliest visual evidence we have of the transformation of the physical appearance of the royal entry in Italy under the impact of humanism. It was not until 1548 that this was to reach France. Lyons had a large colony of Italian merchants and was seminal for the introduction of renaissance culture from the peninsula. It was Henri II's entrée in 1548 that saw for the first time the medieval *tableaux vivants* jettisoned in favour of mute arches bearing allegorical sculpture, paintings, emblems and classical inscriptions, part of a reception that included a Serlian perspective, a Roman gladiatorial combat and a *naumachia*.[7] The programme was by Maurice Scève and the strongly archaeological nature of the entry reflected the part played in it by his collaborator, the antiquary Guillaume du Choul, author of the widely influential *Discours de la Religion des Anciens Romains* (1556) and friend of the Mantuan antiquary, Strada. The year after, Jean Martin, the antiquary who was responsible for Vitruvius, Serlio, Alberti besides the *Horapollo* and the *Hypnerotomachia Polyphili* in French, supervised the king's entry into

54

55

Paris in the same manner.[8] The culmination of this development was the Rouen entry of 1550 which we have already discussed, in which the revival of antiquity was also applied to the actual entry procession.

Charles V's Italian entries do not only signal this consolidation and export of the renaissance entry north of the Alps: they pinpoint something else, the emergence of the Vitruvian architect-engineer as an essential adjunct of a civilised princely court. Giulio Romano was Raphael's favourite pupil and entered the service of the Marchese Federico II of Mantua in 1524; he was responsible for all the artistic endeavours at the Gonzaga court for over twenty years. He was thoroughly imbued with every aspect of antiquity, even recording the ancient treasures of the city of Rome. In addition he had a collection of antiquities which he gave to the marchese and was consulted as an authority on ancient sculpture and engraved stones. As painter, architect and designer he was responsible for the Gonzaga palaces and their decoration, for major public buildings, for the town planning of the city, and for all kinds of *apparati* for the court including state entries and the scenery and costumes for entertainments.[9] The northern courts as yet had no such equivalents and it is significant that it was one of Giulio Romano's pupils, Francesco Primaticcio (1504/5–70), who was to travel north in 1532 to serve François I and his successor in precisely this manner and whose studio was to be responsible for the earliest festival designs for the Valois court in the renaissance style.[10] The imperial entry into Bologna was worked on by another artist who was to come to occupy an analogous role, Giorgio Vasari (1511–1574). In 1554 he was summoned to Florence by Cosimo I and placed in exactly the same position in respect of the Medici dynasty including supervising their court festivals.

The entries of 1529–30 set the scene for further explosions of Italian pageantry in the same manner in tribute to Charles V. What I wish to stress is that these events were to be decisive in fixing the new form, its content and style. They were also decisive in the overt politicisation of an architectural style, for the revived imperialism of Charles V was symbolically expressed by classical architecture. It was a style whose political overtones were equally applicable to the French Monarchy as descendants of Sacred Empire from Charlemagne. A century later Inigo Jones was to introduce the style to England also as one especially appropriate to monarchs who were emperors and reigned over the Empire of Great Britain.

The Progress through Italy, 1535–36

For ten years the Emperor had wanted to visit his kingdoms of Sicily and Naples. This he now planned to do as an aftermath to a campaign against Barbarossa and the Turks in North Africa. On June 10th, 1535 a vast fleet of Portuguese and Spanish galleys, the Genoese fleet under Andrea Doria, German contingents, other Italian and papal troops and Maltese set sail for Africa. Five days later they rode at anchor at Carthage. The first object of Charles's attack was the fortress of La Goletta, which was stormed and taken with the whole of Barbarossa's fleet. Charles advanced on Tunis, where Christian slaves had seized the town in his name and into which he entered as victor. On August 17th he put to sea again and on the twenty-second he landed in his kingdom of Sicily.

Vasari's *Vite* are full of references to the vast preparations made for the reception of Charles V on his triumphal progress: 'Tornando sua Maesta dall' impresa d'Africa vittorioso, passo a Messina e dipoi a Napoli, Roma e finalmente a Siena'. His progress actually ended on April 29th 1536, when he made his solemn entry into Florence. Italian and in particular Florentine artists, who specialised in such *apparati*, moved from one city to another ahead of the Emperor, working at frenetic speed in wood, paint and stucco to raise temporary decorations with which to receive him. Vasari records that the entry into Messina[11] was designed by Polidoro da Caravaggio (c.1490/1500–1543?) who 'fece archi trionfali bellissimi', although the text describing the occasion makes it clear that the main feature was the extraordinary chariots that preceded the imperial cortège to the cathedral. On one six Moors were bound prisoner at the foot of an altar laden with trophies, on the second, larger car stood the four cardinal Virtues, while angels revolved two hemispheres bearing the constellations. Above, a globe of the world turned, on which there stood the emperor crowned and bearing a Victory in his hand. When the procession reached the cathedral the chariot carrying the prisoners stopped before the door from above which floated down twenty-four winged angels from a starry sky, who gathered up the trophies from the altar and ascended with them heavenward singing the emperor's praises. These visions of a crusading emperor were elaborated at a solemn mass the next day. Suspended above the nave of the cathedral was a model of Constantinople with the Turkish arms over it. After the Gospel had been read an amazed congregation saw an imperial eagle soar through the air and lead an attack on the city in the middle of which, when the Turkish arms had been vanquished, a cross suddenly appeared.

A month later, on November 25th, Charles entered Naples.[12] The main feature of the Neapolitan entry was the series of *colossi*, over-life-sized statues. Piero Valeriano in his *Hieroglyphica* explains that famous men of

58

antiquity were honoured by statues whose dimensions matched their merit. The *colossi* were prototypes of imperial grandeur or tributes to it: Jove wielding sceptre and thunderbolt, Victory proffering branches of oak and palm, Atlas sustaining the world, Hercules with the imperial columns, Mars, Fame and Faith. Here, for the first time, the emperor's Turkish victories were acclaimed in a series of canvases decorating a triumphal arch. The historical parallels which the taking of Goletta and Tunis and the flight of Barbarossa evoked were humanist ones of Scipio Africanus, Hannibal, Alexander the Great and Julius Caesar, and not those of medieval crusading rulers.

The new pope, Paul II, a Farnese, bestowed on the emperor a Roman imperial triumph, the route being that used in antiquity, the *Via Triumphalis*.[13] This was reflective of the poverty of the city in the aftermath of the Sack. It was decreed that the entry procession should be by way of the 'meraviglie della antiquitate' and both houses and churches were demolished to reveal to full advantage the ancient monuments, streets were widened to enhance the approach to them while the Piazza Capena, which contained both the arches of Constantine and Septimus Severus, was re-ordered. Charles passed beneath both as well as the arch of Titus, all suitably refurbished with paintings and appropriate Latin inscriptions. The emperor, it is recorded, was much moved by this and stopped and studied them. To these the pope had added other temporary arches under the overall supervision of Antonio da Sangallo the Younger, notably at the Porta S Sebastiano, where Battista Franco (c.1498–1561) had executed great canvases of the Triumphs of Scipio Major and Minor hailing Charles as the *Tertio Africano*. But surpassing all was the one at the Palazzo di San Marco. Vasari, whose career was so intimately bound up with providing *apparati* for the Medici, states that he had never seen a more superbly proportioned arch, which for its statues, paintings and other decorations deserved to rank among the wonders of the world. Sangallo had numerous artists working under him, including Francesco Salviati (1510–1563), who painted *storie di chiaroscuro*, and probably the young Flemish artist, Martin van Heemskerck. The arch was of the Corinthian order with silver pillars and golden capitals. On the top was the gigantic figure of Roma seated between the emperor's ancestors, St Albert, the Emperors Maximilian, Frederick and Rudolf. The paintings depicted the taking of Goletta and Tunis, the emperor releasing Christian prisoners, being crowned King of Tunis, and other allegories of the campaign. For those who dreamed of an imperial *renovatio* no other entry was to be as poignant.

Baccio da Montelupo, who had executed fourteen stucco statues for the Ponte di S Angelo, meanwhile rushed ahead to Florence, whither the imperial court made its way via Siena.[14] Until 1552 the latter managed to

maintain its independence as one of the few remaining republican states in Italy, and although it accorded a welcome to the emperor and his personal retinue the city refused to allow the army within its gates. Vasari states that the citizens of Siena had expected Charles some six years before and in readiness had commissioned an equestrian statue by Domenico Beccafumi (c.1486–1551). This was now brought into use and met the emperor at the city gate. The statue, descriptions of which vary, showed the emperor in antique dress, with three river gods being trampled beneath his horse's hooves. Beccafumi had designed a castle for it to stand on, which was wheeled in the actual procession to the Palazzo Signoria.

Six days later, on April 29th, Charles entered Florence.[15] Alessandro de'Medici, whom the emperor had imposed as duke, had already written from Naples giving instructions that he was to be received in the most sumptuous manner possible. Under the direction of a committee, a team of artists and sculptors, including Vasari, compiled what was to be the finale to the biggest explosion of symbolic pageantry that the peninsula can ever have witnessed. Unlike the Roman entry, no expense was spared by the Medici, whose programme reiterated and synthesised all the others which preceded it. At the Porta di San Piero Gattolini there was an arch consisting of the imperial column device with PLVS VLTRA above it. At the Canto alla Cuculia the statue of *Hilaritas Populi Florentini* (a mood far distant from that of the majority of its vanquished citizens) stood near an arch covered with paintings depicting the defeat of the Turks. In the Via Maggio there was Charles's entry into Tunis, the flight of Barbarossa and his coronation as its king. As he turned out of that street, a silver statue of Hercules made the inevitable comparison with the emperor who had likewise vanquished the hydra. River gods, African, Spanish and German, besides the Tuscan Arno, paid homage as he passed over the Ponte Sta Trinità; *Victoria Augusti* with crown and palm stood at the Loggia de Tornaquinci, Jason wearing the Golden Fleece at the Canti de' Carnesecchi, Prudence and Justice with a globe of the world and the imperial eagle in Via Martelli and a huge figure of *Pax* at the Medici Palace. In answer to Siena there was to have been an equestrian statue of Charles but being unfinished the horse alone was put on display, with a dedication to *imperatori Carolo Augusto victorissimi*. In a blaze of glory the imperial progress drew to its close.

Nothing on such a scale and covering such an enormous area of the peninsula had ever been seen before, and its impact at the time is measured by the printed pamphlets, relatively early instances of this new genre, dedicated to describing in detail the contents of each entry. They are not as yet illustrated, but both the descriptions and the few identifiable designs establish that this was not only a celebration of the imperial idea, it was also a celebration that linked its autocratic power with the new

renaissance architecture in the classical style. These entries embodied the systematic temporary transformation of the physical appearance of some of the most important Italian cities. And this metamorphosis, together with those of 1529–30, can be read in a number of ways which it is important for us now to consider.

The prince and the city

These imperial progresses through Italy ought to be placed in a broader context both in respect of their aesthetic and ideological content. They are the first major festival manifestation of the phase we generally categorize as mannerist. They were also staged in the aftermath of the Lutheran revolt in Germany, whose influence was spreading vigorously in the 1530s. This was a period of economic crisis in Italy, due to the opening of the Atlantic sea routes to the New World, to the huge sums of money exacted to finance the imperial armies and the resulting roaring inflation. It was, in addition, the turning point for the political re-structuring of the country which was to last until the Napoleonic wars. Already the kingdom of Naples and Sicily was ruled by an imperial viceroy. In 1529 Milan was restored to Francesco II Sforza but, on his death in 1535, it became a dependency of the Habsburgs. In 1529 the emperor created the Gonzaga Dukes of Mantua and two years later put the Medici into Florence, also as dukes. Lucca and Siena were not to survive much longer as republics, leaving Venice as the sole republican state. We are in the age of the princes who, almost without exception, owed their domains and their titles to the Holy Roman Emperor.

This political reality must have profoundly affected the eulogistic nature of these imperial entries. Their almost hysterical adulation of Charles V as *Dominus Mundi* catches not only the fawning flattery of the new petty rulers but also the ideological crisis of the times, the aspiration that some one ruler would provide a universal solution to the breakdown of the old European order. This was to be a recurrent theme in political thought into the next century, as aspirations focussed on figures as diverse as the Valois kings, Elizabeth I, Henri IV and the Winter King and Queen of Bohemia. Festival imagery returns again and again to such hopes, which initially centred on the Emperor Charles V. In these entries, following in the train of the one into Bologna for his coronation in 1530, the powers of universal empire, of a reborn Augustus Caesar, are fully celebrated in decor based on the researches of Renaissance humanists and antiquarians. In the North, in the Low Countries or in England, the royal entry

remained a dialogue between the prince and his subjects, who paid homage but respectfully reminded him of the virtues he should cultivate and the liberties of his subjects that he should respect. In sharp contrast the visual mythology of the Italian entries is that of total subservience to a supreme power, a *Dominus Mundi*.

No other entries embody so fully the aims, first formulated in the *quattrocento*, of re-creating the Roman imperial triumph of antiquity. Such visions were enhanced by the use of the whole rediscovered repertory of Renaissance classicism. There were no *tableaux vivants*, except in Sicily, but mock antique arches of wood painted as marble and stone, gold and silver, on which were placed cameo paintings together with stucco and plaster statues. Charles is always the Roman Emperor, crowned with laurel, his victories celebrated as emulating those recorded by Livy. Such decor for princes was part of the rhetoric of the mannerist court artist, whose role was to elaborate, under the direction of humanists and poets, the mythology of a ruling dynasty. Unlike the North there were no allusions to knightly chivalry, only to the *imperator*; the victories were of valiant Romans over Carthaginians, not of invading knights over infidel Turks. Attitudes are epitomized in the introduction, both in Siena and Florence, of that most significant of imperial images, the equestrian statue. This was an honour reserved in antiquity for the emperor alone. Four years later, in 1541, the theme was repeated when Charles entered Milan[16] in an arch designed by Giulio Romano with a Moor, a (Red) Indian, and a Turk falling under his horses's hooves while its final form was Titian's great canvas celebrating the defeat of the Lutherans at the Battle of Mühlberg (1547). Unlike his fellow countrymen, Titian sensitively manages to fuse classical allusion with traditions of northern heroic chivalry.

The imperial entries also vividly encapsulate something else central to the transformation, not only of the royal entry, but also of the urban environment of late renaissance Italy: their impact on and reflection of a revolution in town planning.[17] As I have said, these temporary decorations *à l'antique* were a cosmetic overlay on medieval cities, superficially changing them for a brief period into an urban complex articulated by an imagery of absolute rulership conceived in terms of a processional route. Such decorations highlighted the major buildings and ornamented them with the symbols necessary to draw them in as part of the overall schema. In terms of perspective, the decorations created vistas to triumphal arches and *piazze*, adorned with allegorical sculptured groups. These imperial entries anticipate exactly what was to happen during the coming decades to the once republican cities of Italy and also represent a significant moment in the evolution of renaissance architecture. The latter, of course, had its roots in the vigorous republicanism of *quattrocento* humanist

61

Florence, the Brunelleschian-Albertian tradition of harmony and proportion based on the microcosm-macrocosm analogy, in which perspective was an essential ingredient governing the relationship of man to buildings in space. It would take us too far off our path to trace the history of the *città ideale* through successive architectural theorists, but what happens in the late renaissance is that the principle governing city planning is still man the microcosm; but that man now happens to be, not the citizen, but the prince. The perspectives, actual and transitory, the temporary arches and decorations found their focus in him. He moved through urban space in terms of monocular perspective in the same way that, transferred indoors into the static scenery of the palace theatre, he was also to be the focus. The new antique style is forcefully promoted with its references to the autocracy of the Roman Empire; and the theme of the mythical origins of each Italian city recurs monotonously as part of any state entry, as the prince places himself as lineal heir to this power and somehow casts himself as a restorer of his chief city to its role as a *Nova Roma* to act as a theatre for his dynasty. The imperial entries of Charles V demonstrated for a temporary period the objectives of what were to become the aims of long term building, the subjection of once republican cities to a princely mythology by means of the palace, the princely villa, the offices of state, the dynastic church and funerary chapel and heroic arches and statues celebrating individual members and deeds of the ruling house. They were a dress rehearsal for what was to become a standard theme purveyed by artists such as Vasari, who were employed to deliberately create such settings for these new Caesars. Nowhere indeed can this subjection be better followed than in the transformation of Florence in the coming decades into an architectural backcloth for the Medici grand dukes in which even ancient buildings embodying the essence of the republican spirit could by means of an overlay of paint and sculpture be linked into a new autocratic mythology. The imperial progresses of Charles V offer a watershed in respect of the changing role of art in relation to power in the Italy of the princes.

The antique triumph in the Low Countries: Prince Philip's Progress and the Entry into Antwerp, 1548–49

In 1549 came the most splendid series of fêtes of the whole reign, those held to mark the recognition of Charles's eldest son Philip as hereditary ruler of the Low Countries. During the intervening years the emperor's

universal policy had broken down. There had been a disastrous expedition against Algiers, another war with France, and endless difficulties, both religious and political, within the empire itself. After seeking a religious compromise between Catholics and Protestants, an effort doomed to failure due to the intransigence of the theologians, the emperor finally took up arms on behalf of Catholicism and won a resounding victory over the Lutherans at Mühlberg in 1547. This was not a solution in any way to the religious differences rending his lands, and he still pressed hard for the Protestants to be heard during the opening sessions of the Council of Trent. The Low Countries' fêtes marked an important political decision on the future division of the Habsburg lands. Charles had finally decided that the Low Countries should henceforth be joined to Spain and that this should be secured within his own lifetime by the recognition by the Estates of his son as their ruler. This was linked to a project never to be realized, that Philip was to be recognised as emperor in succession to his father. Towards the close of 1548 Prince Philip, with a vast entourage in the manner of the old dukes of Burgundy, landed in Italy and proceeded in triumph by way of Genoa, Milan, Mantua, Trent and up through Germany to the Low Countries.

Each town vied with the other in the splendour of its reception of the prince.[18] The progress through the Low Countries began in Brussels and
62 continued by way of Louvain, Ghent, Bruges, Lille, Tournoi and subsequently the northern towns, but its climax was the most famous
63–5 entry of the century, the one made into Antwerp on September 10th. The imagery of the entries was both biblical and classical. The relationship of Charles and Philip was acted out in the stories of Abraham making Isaac his heir, Joseph visiting Jacob, or Solomon crowned King of Israel at the behest of his father David. Classical prototypes were Philip of Macedon and Alexander the Great, Coelus Adrian succeeding Trajan, Priam choosing Hector or Flavius Vespasian attended by his son Titus. Everywhere the imperial descent was celebrated, everywhere the labours of Hercules expressed Charles's conquests by land and sea, for Empire and Church, and everywhere the princely virtues, those Erasmian attributes of the Christian prince, were recommended for study by the heir apparent. The Ghent *entrée* was almost wholly based on the exposition of the cardinal virtues and their virtuous subdivisions, while at Lille the mighty Ship of State was seen bearing the emperor and his son towards the haven of the Temple of Felicity, manned by maidens as the Virtues. But the changing mood of the times found disturbing expression in tableaux of religion at Lille, where the themes of incipient counter-reform were manifest in a forthright statement. While Charles and Philip stood within the Temple of Virtue, below yawned a gaping hell-mouth inhabited by the figure of Martin Luther. Further on, the figure of the Catholic Church was

to be seen treading Heresy underfoot, attended by pope and emperor as the shield of the faith, while nearby Luther and Zwingli rubbed shoulders with Julian the Apostate, Simon Magus, Arius and Hus, as vanquished heretics. The tableaux anticipated the events of the rest of the century.

Nothing, however, was apparently to eclipse the glory of the Antwerp entry.[19] Its fame was European, and illustrated texts were issued in Latin, French and Flemish. Vast armies of workmen laboured in raising arches and street pageants: 895 carpenters, 234 painters, 498 other workmen. The city itself, then at its apogee, employed 421 carpenters, 37 painters, 16 sculptors and 300 labourers. Amongst the foreign contributors, the Genoese excelled all in magnificence, spending some 9,000 florins on their arch, which took seventeen days to build and upon which 280 men worked. The Antwerp entry reflects in heightened form the themes of the other entries, the tension between wealthy cities with their ancient rights and liberties and the pressure of a dynasty that wished to centralize power.

Ironically, the official texts commemorating the event avoided printing the truth, that in spite of all its magnificence the Antwerp entry was a scaled-down celebration of a political failure. It had been planned to welcome Philip as the next emperor, but the refusal of the Electors to grant Charles's wish meant that Philip entered Antwerp only as a future king of Spain and as Marquess of the Holy Roman Empire in Antwerp. Many decorations were left unfinished, including a bridge with thirty-foot-high obelisks and a round Temple of Victory outside the gate of St George. When the programme for the street decorations is analysed, it is possible to trace remnants of what was to have been the greatest imperial fête of the century. In the arches and street pageants, the realities of an existing political situation were paraded before princely eyes. As of old, the citizens of Antwerp offered no slavish adulation of an absolute monach, as did their Italian contemporaries, but loyalty and service to one who respected their ancient rights and privileges. The very acceptance of Philip as their future sovereign within his father's lifetime was a novelty. Two or three years earlier the emperor had considered the possibility of making the Low Countries into an independent kingdom and, as a first step, came the recognition of Philip as heir. Mary of Hungary received ready support from the states of Brabant and Malines but found those of Flanders recalcitrant, so much so that Charles himself summoned their deputies to Brussels. In order to achieve the pragmatic sanction whereby he could unite his hereditary lands, he was forced to make concessions and recognise 'toutes les constitutions et tous les privilèges accordés anterieurement par les seigneurs aux divers territoires'.

This settlement so rich in seeds of future discontent was vividly portrayed in the Antwerp entry. Time and again Philip was reminded of the vast riches made from the freedom of its trade. On one pageant stood

the god Mercury, protector of merchants, attended by Commerce together with the five nations who had communities within the city. On another, Peace stood with Liberty at her side. From these flowed Concord and Policy, whose hands stretched towards Ceres, together with Abundance and Money. The Latin inscription accompanying these figures began with the words *Dulcis libertas* and referred all blessings to this virtue. Another arch glorified *Moneta*, from which all human order and happiness flowed. In these *tableaux vivants* the young prince was reminded by his future subjects of the conditions upon which their prosperity depended. Arches on the old imperial themes of ancestry, the Golden Age, world dominion, those depicting imperial victories and imperial *pax* and, above all, the final arch in which God the Father, standing before a huge revolving heaven, flanked by Virtues, invested Prince Philip with sceptre and sword and placed a jewelled crown on his head must have been bitter reminders to Philip that he was not emperor elect.

64

The entries also reflect the reception of the renaissance style in the Low Countries.[20] The Bruges entry of 1515 had arches but only one, the Italian, attempted the antique. The artist who presided over the decorations of the Antwerp entry (apart from those erected by the foreign colonies) was Pieter Coecke van Aelst (1502–1550). He was much travelled, having visited Constantinople in 1533 and possibly took part in Charles V's Tunis campaign in 1535, before which date he was already *pictor imperatoris*. At the very beginning of his career, he had visited Italy to study antiquity and it is conceivable that he had actually seen an entry *à l'antique*. His prime role in the Low Countries was as a teacher who countered lingering Late Gothicism and paved the way for the academic mannerism of Floris and his school. In 1539 he published a summary of Vitruvius, *Die Inventie der Colummen*, and translated into Flemish, German and French the writings of Vitruvius and Serlio. Coecke, therefore, is a key figure in the promotion of the renaissance style in the Netherlands but tempered with concessions to local tradition. We can see this in the design of his arches, which embroider onto classical forms the strapwork, cartouches and other flourishes which were to become the hallmark of Antwerp mannerism. In addition there is no abandonment, as was happening in France absolutely simultaneously, of *tableaux vivants*, giving lively evidence of the powers of the Chambers of Rhetoric, and of the desire of the citizens of Antwerp to present their case in dramatic form to their ruler.

The Ghent entry, for which we also have a series of woodcuts, was
65 similarly animated by this urge to re-create antiquity and the five arches were built in the five different orders: Ionic, Doric, Corinthian and Composite. Unlike those of Antwerp, however, they eschewed all decorative excrescences. The architect was a certain F. van de Velde and

the text describing the event states the city's specific desire to emulate Rome: 'As the Romans had the custom of erecting triumphal arches for those of them who had distinguished themselves, the city of Ghent has thought good to do the same for Prince Philip, following in this the example of other great cities.' Everywhere the imperial triumph was seen to go hand in hand with the ascendancy of renaissance classicism.

The Festivals at Binche, 1549: chivalrous romance and the ruler

But the most spectacular and marvellous of all the fêtes that attended the recognition of Prince Philip as the emperor's successor were given by the Queen Dowager, Mary of Hungary, at her palace at Binche.[21] The setting itself was described by Brantôme as 'un miracle du monde', and the fêtes were on such a stupendous scale that they became proverbial: *más brava que las fiestas de Bains* ('more splendid than the festivals of Binche'). Nearly all the entertainments were chivalrous in character. There was a foot combat in which knights arrived disguised as German pilgrims with their wives, only to find themselves rudely interrupted by the entry of knights dressed as huntsmen, with their attendants letting live rabbits and cats loose in the enclosure. On another evening, wildmen interrupted the 66 progress of a court ball to seize ladies and carry them off as prisoners to a nearby fortress which was stormed the following day. The queen dowager brought the fêtes to a close with a banquet in an Enchanted Room. A table 67 descended in layers bearing sugared confections of extraordinary invention in vessels of glass and porcelain, while above there was a ceiling across which the planets and stars moved and from which comfits and perfumes rained down upon the feasters. But the most spectacular event of all took place on August 25th and 26th and was entitled 'The Adventure of the Enchanted Sword and the *Château Ténébreux*'.

The preliminaries had taken place some time before in Ghent when, towards the close of a banquet, a grief-stricken knight had entered the hall and, throwing himself on his knees before the emperor, had presented him with a letter and begged leave that he might fasten a cartel to the palace gate. The emperor, having read the contents, gave permission for this to be done and said that he and his court would journey to Binche soon to see the strange things described in the missive. The court actually arrived on August 22nd and two days after, during a court ball, another letter was delivered to Charles which was read to the assembled spectators. This was from the Knights Errant of Belgic Gaul, who begged the emperor's

assistance against an evil enchanter, Norabroch, who held various noble subjects of the emperor prisoner in a castle, the *Château Ténébreux*, which he had further encircled with clouds so that it would not even be seen. The good Queen Fadade, however, had planted nearby the *Ile Fortunée*, out of which arose three huge columns that would ultimately bring about the magician's ruin. One was of jasper and in it a bejewelled sword was embedded, while the two others bore a prophecy: the knight who could draw forth the sword from the column would be the one who would break the evil spells, release the captives and destroy the *Château Ténébreux*. Such a knight could further be destined to succeed in other great enterprises which would not at the present be revealed. Before, however, any knight reached the *Ile Fortunée*, he must pass through three forms of combat: one at the barrier of the *Pas Fortuné* with the *Chevalier au Griffon Rouge*, and the second at the *Tour Périlleuse* with the *Chevalier à l'Aigle Noir*, and the third with the *Chevalier au Lion d'Or*. Knights who failed at any of these points of combat fell prey to the magician Norabroch. Those who passed all three boarded a boat like a dragon whose captain guided them to the *Ile Fortunée*, where they were to reveal their true identity. There each knight was to attempt to dislodge the sword. Those who failed withdrew honourably from the quest until a knight who answered the prophecy broke the enchantment. On hearing this dramatic saga the prince and other knights of the court begged the emperor that on the morrow they should be allowed to show their prowess.

The tournament lasted two days and the knights arrived in many disguises. There were Hungarian knights, there were knights of the Sun, of the Moon, of the Stars. There was the Knight of the White Rose and the Knight of Death. The last entered the arena surrounded by singers in black velvet chanting funerary responses. The tempo of the proceedings was enlivened from time to time by other effects: rain fell suddenly from the sky or there were terrible cries from the *Château Ténébreux*. Great was the joy of the captain of the dragon ship on the second day when the *Chevalier Ebré* withdrew the sword from the jasper column, but such happiness was short-lived when the prophecy revealed that it was a prince alone who would end the adventure of the enchanted sword. As evening drew on a knight called Beltenebros arrived. Having successfully completed the three combats he crossed to the island and withdrew the sword amid huge claps of thunder and hideous cries from the *Château*. When the knight informed the captain of his true identity, he fell on his knees in homage and then led the chosen knight to the far point of the island. Suddenly the clouds lifted, revealing the castle of Norabroch. It was reached by a bridge over which there was a gate firmly shut, on which hung a flask and before which were mustered the magician's knights. The chosen knight, armed with the

enchanted sword, advanced over the bridge, vanquished the guards and smashed the flask, at which point the spell was immediately dissolved. The doors of the *Château* fell open, liberating the prisoners, who paid homage to their deliverer. Great was their joy when the knight revealed himself to be none other than Prince Philip.

The dramatic plot of this tournament drew its nourishment from one of the deepest and most primitive of folklore motifs, that of the initiation ceremony. Themes such as these are woven inextricably into virtually every form of medieval romance: the mystery of the sacred sword which could only be drawn by the right person, an act followed by one of fealty or recognition. Such enactments were part of the pattern of European chivalrous literature, familiar to everyone in sixteenth-century Europe. The pseudonym Beltenebros chosen by Philip was taken from the *Amadis de Gaule*, a widely popular romance which was translated into French, Italian and German. The *Amadis*, because of its combination of a higher chivalry with the new patterns of neoplatonic courtly love etiquette, enjoyed an enormous vogue all over Europe. As a source for tournament plots and pseudonyms it was to be frequently drawn upon in France, Spain and England. The *Château Ténébreux* occupies an important place in the evolution of the tournament form because of its international reputation. It is a lineal descendant of the *pas d'armes* of the Burgundian court but precedes the developments that were to occur in Ferrara in the 1560s. In one sense it is a *tournoi à thème* because its plot was totally predetermined, but it lacks the infusion of humanist classical imagery and the move towards perspective staging that was to happen at the Este court. In spite of this it made one enormously significant move, reflective of the change in political climate by the middle of the century. The prince had to be the victor. And in this case the political aims were clearly to present Prince Philip as the preordained ruler of the Low Countries. Those present would be familiar with the difficulties encountered by both his aunt and father in getting the various Estates to accept Philip as their ruler before the emperor's death. Away from the caveats of civic entertainments, with their concern for local liberties and privileges, in the milieu of the imperial court, the statement could be made more forcefully. The prince was uncompromisingly presented as a divinely ordained deliverer, defeating evil, breaking spells, rescuing the afflicted through his valour alone. Those who were to live through the next twenty years and the revolt of the Netherlands must have paused to reflect on the incredible optimism of pageantry.

The theme of the ruler as the deliverer, so highly developed within the context of chivalrous romance at Binche, was to be repeated again and again all over Europe in the late sixteenth century. It had an enormous effect, for instance, on French court fêtes. In 1564 at Fontainebleau, where

Catherine de'Medici staged the first of her sets of 'magnificences', Charles IX and his brother, as fulfillers of a prophecy, vanquished a giant and stormed an enchanted castle to release ladies. A year later this was reworked for the fêtes at Bayonne on the Spanish frontier. This time it was Charles IX alone who, as the promised knight who should banish spells and establish peace throughout Christendom, stormed past a giant and a dwarf into the spellbound castle.[22] Catherine's youngest son organised an entertainment at the English court on exactly the same lines in 1582. The magician's power could be broken this time only by the most excellent prince in the world, who happened to be most constant in the profession of his love to the most heroic and virtuous of princesses, that is, Queen Elizabeth I.[23] In the case of a female monarch such as Elizabeth, the power of her virtues alone had force to dispel all enchantments. When she visited old Sir Henry Lee at Ditchley in the autumn of 1592 she penetrated an enchanted wood in which knights and ladies were imprisoned in the trees, entered a hall hung with charmed pictures, construed their meaning and thus broke the spell, causing her host to awaken from an enchanted slumber and those released from the wood to sing her praises:

> Happie houre, happie daie
> That Eliza came this waie.[24]

Three years later the virtue of the queen was such that its force could release eight knights entrapped within an Adamantine Rock who danced in homage of their deliverance.[25] In 1613 James I's queen, Anne of Denmark, was equally able to dispel enchantments, on this occasion releasing knights imprisoned in pillars of gold, in the masque written for the marriage of the Earl of Somerset. Thomas Campion, its author, provides a gloss on his motives for using such romance material:

> ... our modern writers have ... transferred their fictions to the persons of enchanters and commanders of spirits as that excellent poet Torquato Tasso hath done, and many others. In imitation (having a presentation in hand for persons of high state) I grounded my whole invention upon enchantments and several transformations.[26]

This was written over sixty years on from the *Château Ténébreux*, which marks the beginning of this *leitmotif* in late renaissance festivals, coinciding exactly with the escalation of the cult of crowned heads which is such a dominant feature of the late sixteenth century. Time and again the ruler and his court acted out in allegorical form his role as the all-powerful deliverer. What is significant is how extremely useful the romance tradition, inherited from the middle ages, was for this new promotion of royalty. It fitted in neatly not only with the new humanist cult of the hero but was a natural extension of the powers of the ancient *rois thaumaturges* whose touch alone could heal. One of the reasons for

the enormous vitality of the tradition of romance literature must have been its usefulness to rulers who cast themselves as the living embodiment of its magical heroes and heroines. As a theme it was still vigorous in the fêtes of Charles V's ideological descendant Louis XIV, whose most spectacular series of court festivals at Versailles was entitled *Les Plaisirs de L'Ile Enchantée*.

'Pompe funèbre': Charles V's obsequies and their influence

Almost a decade later, on September 21st 1558, three years after his abdication, the emperor died in the monastic peace of Yuste. All over Europe, obsequies were held in his honour, but none eclipsed the splendour of those staged in Brussels on December 29th.[27] These were the subject of a sumptuous volume from the Plantin press illustrated with thirty four engravings by Duetecum after Hieronymus Cock (c.1507/10–1570) and Hans Vredeman de Vries (1527–1604?). No publication on a ruler's funeral on such a scale had ever been seen before and, as a result, its influence was to be considerable in accelerating and setting the style for the elaboration in royal obsequies that subsequently ensued. There was a vast procession in which walked representatives of every country over which the emperor had ruled. Dignitaries bore his helm, cloak, sceptre, sword, orb, crown and insignia of the Toison d'Or, his son walked attended by the Knights of the Golden Fleece. In the church of St Agatha a scaffold had been constructed in the form of a quadruple crown covered with innumerable tapers. From this arose an elaborate catafalque on which the emperor's crowns were arranged in an ascending order; the first crown, the largest, stood for all the lands over which he reigned, the second, the smallest, was the one that he had received at Milan, the third that from the imperial coronation at Aix-la-Chapelle, and the fourth, poised at the very summit, the imperial diadem itself. A coffin rested on the catafalque bearing further attributes of imperial power and the whole structure was ablaze with thousands of candles which must have resulted in an overwhelming theatricality of effect.

For those watching the huge procession wend its way through the streets there was one very unusual feature in the shape of an allegorical ship drawn by marine monsters. Adorned with the arms of all the countries over which he had ruled, it was richly decorated with scenes and inscriptions recording the emperor's triumphs. Before the central mast, on a stone labelled 'Christus', sat Faith bearing a cross, while Hope rode at

the prow and Charity navigated from the helm. Behind arose the two imperial columns on rocks in the midst of the sea. In this way the imperial motto, '*Plus oultre*', now celebrated Charles's conquest of a heavenly kingdom. For the last time the pillars of Hercules and the ship of Jason and the Argonauts, the emblems of the two heroes of the House of Burgundy, were used to pay tribute to an emperor whose piety now carried him to greater glory in the world to come.

Like so many aspects of the festivals of Charles V even these obsequies were destined to make a lasting impact. They were certainly studied in Italy. The Medici, of course, owed their status to the emperor, and when Cosimo I died in 1574 his funeral ceremony was directly inspired by the arrangements at Brussels.[28] A whole team of artists under the direction of Alessandro Allori (1535–1607) transformed the interior of the Medici church of San Lorenzo with a huge catafalque as the focal point borne up by shrouded herms and surmounted by recumbent allegorical figures bearing the Medici arms and, above, a towering pyramid of candles which was likened, giving it a humanist overlay, to the pyramid of Cestus. There was no float in the funeral procession but the ideas that were embodied in that extraordinary feature were instead translated into component parts of the decoration of the church walls: *imprese*, coats of arms, scenes from the life of the deceased together with religious symbols. This vast propaganda exercise on behalf of the *nouveau* grand dukes of Tuscany was to provide them with a format which was to be reworked several times into the next century, in honour, not only of members of the Medici family, but also of foreign rulers such as Philip II and Henri IV.

Medici *pompe funèbre* tended to be published and illustrated as part of their deliberate exercise in dynastic promotion, so it is hardly surprising that the format should have appealed to Inigo Jones *fiorentino* when he was put in charge of the decor for James I's funeral in 1625.[29] This was the first time that an allegorical overlay had been applied to an English royal funeral. Much, of course, had to be discarded in deference to Protestant susceptibilities (inevitably no candles) and the result was a domed *tempietto* covered with pennons and shields of arms surrounded by statues of the virtues. On the summit glittered the crown of the man who was the first emperor of Great Britain. There can be no doubt that, whether Catholic or Protestant in creed, the practice of introducing the secular pageantry of apotheosis into a ruler's funeral had its main roots in the stupendous obsequies of 1558 and the extraordinary ship that had passed through the streets of Brussels.

Conclusion

That we should end a chapter on Charles V in Stuart England gives some indication of the widespread and lasting effect of the imperial revival that dominated the first half of the sixteenth century on the mythology of monarchy. The festivals of Charles V, however, stand apart from those associated with the three other rulers I shall be discussing in the subsequent chapters. The difference lies in that they were evoked rather than sponsored by the emperor. This in a way is vividly reflective of their nature up to the middle years of the century. Until then festivals, although a part of court life of increasing importance, had not taken on the status of being an essential arm of government. That they were becoming so is reflected by the fact that around 1550 major books dedicated to festival events with lavish illustrations began to appear.[30] The real starting point for this development were the volumes dedicated to Prince Philip's entry into Ghent and Antwerp in 1549 and Henri II's entries into Lyons, Paris and Rouen in 1548, 1549 and 1550. These were the forerunners of the massive publications to come that are among the great monuments to renaissance printing. By the turn of the century and the entries of Albert and Isabella in the Low Countries these had developed into huge folio volumes. This dramatic escalation was to be the striking development of the second half of the century as *fêtes de cour* became expressions of a pervading neoplatonism based on the principle 'seeing is believing', and aligned to a political evolution in the direction of Divine Right and absolutism. These were to be the crucial factors in the creation of the theatre of power.

III

'POLITIQUE' MAGNIFICENCE

Catherine de'Medici and Valois Court Festivals

Some five months after the Ship of State rode through the streets of Brussels signalling the end of the age of Charles V, French, Spanish and English deputies assembled at a small French town called Câteau Cambrésis to negotiate a treaty. In this settlement France finally abandoned her ambitions within the Italian peninsula, only to be compensated by the acquisition of Calais from the English. The peace, as was customary, was sealed by dynastic alliances. Two French princesses were to be married, one to the duke of Savoy, the other to Philip II of Spain. Exhausted by a disastrous war, the French crown from now on had to concern itself with internal problems too long set aside and, in particular, with the spread of Calvinism, which had gained converts among a substantial section of the population, including members of the aristocracy. But before the full import of these issues was realized, two marriages were celebrated with elaborate splendour in Paris, that of Marguerite de Valois to the duke of Savoy and that of the dauphin François to Mary Queen of Scots. One of the fêtes to mark the event was a great tournament in which the king, Henri II, tilted against his captain of the guard. The result was a famous, fatal, accident for the captain's lance pierced the king's helmet and within a matter of hours Henri was dead and a child of thirteen ascended the French throne as François II.

This unexpected event was watched by the queen, Catherine de'Medici, whose grief was such that she never wore other than mourning for the rest of her life. As a consequence of this dramatic death, this intensely cultivated and artistic princess suddenly found herself pushed to the centre

of the stage. The history of festivals at the Valois court in the second half of the sixteenth century is so closely bound up with her that they can almost be written in biographical terms. For Catherine de'Medici court fêtes were an integral part of her political policy. These costly and magnificent spectacles were designed to demonstrate to foreigners, as Brantôme records, that the country was not 'si totalement ruinée et pauvre, à cause des guerres passées, comme il s'estimoit'.[1] Catherine was the moving spirit behind such occasions and the fête she gave was always acclaimed to be the most brilliant and original. It gave her pleasure, Brantôme recounts, to present such spectacles, saying that she wished to imitate the ancient Romans in giving her people entertainments, thus averting their more mischievous activities. Alas, for Catherine this policy was a delusion, but for over twenty years the periodic alignment of Catholics and Protestants in chivalrous fêtes, whose theme was ever that of loyalty to the French crown and the blessings of peace, was to be one of her major preoccupations.

Late Valois festivals: the background

Unlike Charles V's festivals, those at the Valois court during the period 1560–85 were the product of a quite specific set of political circumstances which provide both the setting and the motivation for their staging. The situation Catherine inherited in 1559 was a recurring one and provides the backcloth against which all her court festivals or 'magnificences', as they were called, were acted out. At the opening of the 1560s there were three main political alignments within France. The first group, in general Catholic, found its leaders among the powerful house of Lorraine, the Guise family. The second, mainly of Protestant or Huguenot persuasion, was led by representatives of the Bourbon or Châtillon families. In the middle stood the Crown, bankrupt and with a young, inexperienced king, not strong enough either to dominate or to stand aside from the main, rival, political religious groups. As a result, for thirty years the monarchy became dangerously isolated until, in the person of Henri of Navarre, it identified itself decisively with one side. Catherine's own constant support came from her secretaries of state, who dealt with her correspondence, undertook endless negotiations between rival parties, seconded her tireless efforts to achieve peace and, when this was accomplished, helped her organize the festivals in celebration. Her policy is epitomized in her personal *impresa*, a rainbow with a motto in Greek meaning: 'It brings

peace and serenity'. The difficulty she contended with was that one religious war always tended to lead to the next, that each side perpetually claimed to act in self-defence, and that the mutual fear this engendered resulted in a total breakdown of confidence between all the parties concerned. Catherine laboured away in the middle, faced with a bankrupt exchequer, a corrupt and unreformed Church, fearing the growing might of Spain on both borders, and coping with the problem of how to allow a religious minority to practise its faith without being molested. Her policy was always one of peace and moderation — later embodied in the expression '*politique*' — finds vivid artistic expression in her court festivals. Once, in 1572, in the midst of such a set of conciliatory fêtes, through panic, it broke down; the result was the Massacre of St Bartholomew. The terrible '*noces vermeilles*' of Marguerite de Valois and Henri of Navarre have obscured the central theme of Catherine's life and have cost her her place as a creative genius in the art of festival.

The visual evidence for Valois festivals

The *fêtes* of the last Valois are marvellously and misleadingly evoked in two sets of visual documents to which I shall be referring throughout this chapter. The most famous is the set of eight tapestries known as the Valois Tapestries, now in the Uffizi in Florence, probably by way of Catherine's adopted daughter and heir, Christina of Lorraine, Grand Duchess of Florence. The second is a series of Drawings usually attributed to Antoine Caron (c.1527–1599), six in number, which are related in subject matter to the Tapestries and were obviously drawn upon for the preparation of the cartoons, although the content is often far from being identical.

73–5 Recent research establishes that there is nothing in the content of the Drawings to prove that the artist was present at any of the events depicted.[2] The compositional formula is essentially one of synthesis, whereby what was often a sequence of events was combined into a single image and placed in front of a background which would likewise redound to the glory of the Valois dynasty. Four out of the six Drawings make use of this device, presenting us with a panorama of the château d'Anet, a vista across the lake towards Fontainebleau, the formal gardens of Catherine de'Medici's Tuileries and, in addition, a view of its courtyard. This emphasis on the Valois palaces is so strong that, for example, in the case of the ballet performed for the Polish ambassadors in 1573 the temporary room in which it took place, and of which there is a

contemporary woodcut, is completely dispensed with. In the same manner, the opening of Charles IX's progress through France has been made to start from Anet because it was grander than the minor château of St Maur. Similarly, what must be meant to be the opening tournament of the fêtes at Bayonne in 1565 has been lifted and placed before the facade of the courtyard of the Tuileries palace. The anthological character of these Drawings is in fact a completely new departure in the recording of festivals. It may be reasonably concluded that the Drawings originally made up a set of eight matching the Tapestries, but that two have been lost. One pertinent clue as to their dating is that the last event they depict, the ballet for the Poles, was staged in 1573.

This suite of Drawings must therefore be used with extreme caution as giving us anything other than a general retrospective impression of the appearance of Catherine de'Medici's festivals. What they do reflect is the idea that they were thought at the time to be significant and worthy of record. If caution must be applied to the Drawings, even more must be applied to the Tapestries.[3] Frances Yates attempted to make a case for these being sent as a present by William of Orange to Catherine de'Medici in the hope of influencing her and her son, Henri III, to support his brother, Anjou, in the Low Countries. She believed they were designed and woven in Antwerp (they in fact bear a Brussels mark) in 1582, and were sent to France with an embassy in 1584 or 1585. There is, in fact, no direct evidence to support this hypothesis.

If the Drawings are at a remove from the events that they depict, the Tapestries are even further away. Their most distinctive feature is the superimposition of recognisable full length portrait figures in the foregrounds. These include with certainty Henri III, his queen, Louise of Lorraine, Catherine de'Medici, her younger son, Anjou, his sister, Marguerite de Valois, and her husband, Henri of Navarre. Other identifications are more dubious. Henri III is clearly king, which dates the Tapestries after his succession in 1574. The evidence of the clothes they wear would also suggest a date earlier than 1582. Sleeves by then had vastly expanded in size and that most distinctive feature of late Valois dress, the drum-shaped farthingale was worn. Another fact which would push the Tapestries back into the late 1570s is the absence of any specific allusion to the 'magnificences' for the marriage of Anne, Duke of Joyeuse in 1581.

71, 72

Inevitably any account of Catherine de'Medici's festivals must make use of these two sources as illustration; but for the student of reality of renaissance festivals they must rank as dubious documents. They give the fêtes an aesthetic unity which they probably never had, and any examination of them side by side with the documentary and printed sources quickly dispels any pretensions as to their archaeological accuracy.

They are, however, tremendously atmospheric. They are also tangible monuments to the increasing importance attached to such transitory phenomena as the century progressed. Such events could not only be the subject of a series of drawings, perhaps executed with engraving in mind, but also of a major set of tapestries destined for palace decoration at its grandest.

The Academy and the Festivals

The Valois court *fêtes*, again unlike those of Charles V, are also significant for being animated by a single artistic policy, that of the revival of 'ancient music' and 'ancient poetry'.[4] Ronsard praised Mellin de Saint-Gelais for being the first French poet to marry poetry and music in the ancient Greek way, a movement which was to find concrete form in Jean-Antoine de Baïf's establishment of the Académie de Poésie et de Musique in 1570. The aims of the Academy were the union of music and verse as it had been in antiquity, and through this union the revival of the ethical effects of ancient music on the listener. Such a renewal of ancient metric modes, epitomised in *musique mesurée*, was believed to have enormous 'effects' on the audience. The most famous story of the success that this movement achieved occurred at just such a set of 'magnificences', those staged to mark the marriage of Henri III's favourite, the Duke of Joyeuse, in 1581. During a foot-combat a warlike Phrygian song caused one gentleman present to rise from his seat and begin to draw his sword for the fight, his martial ardour being forthwith soothed to calm by a sub-Phrygian air. This union of music and poetry also included attempts to re-create 'ancient dancing', based on the rhythmic principles of *musique mesurée*. The Academy arranged practical experiments of dances executed to *chanson mesurée*, thus unifying poetry, music and the dance. Choreographed dances were always Catherine de'Medici's especial contribution to any set of 'magnificences' and her preoccupation with choreography, together with the humanist aims of the Academy, led to the birth of a new art form, the celebrated French *ballet de cour*. The actual history of the Academy is obscure, but in 1577 either a replacement or an extension of it was founded, the Académie du Palais. Much concerned with philosophical debates and with aspects of Henri III's religious exercises, it still continued the traditions of musical humanism embodied in the original foundation. The festivals of Catherine de'Medici were always therefore influenced more or less directly by the programme represented in this academic movement.

Chenonceaux and Fontainebleau, 1563–64

Catherine summed up her own position admirably in a letter to her daughter Elizabeth: 'God ... has left me with three small children and a kingdom utterly divided, in which there is not one soul I can trust at all, who has not got some private purpose of his own.' Her eldest son François II died in 1560, and Catherine assumed the reins of government on behalf of the new king, Charles IX, then aged ten, with Anthony, king of Navarre, whom she could control, as lieutenant-general of the kingdom. Catherine's hopes for a solution to the religious divisions dividing the realm centred on the summoning of a new general council at which the Protestants would be heard. Failing this, she threatened to convene a national council of the Gallican Church which would reform its own house in defiance of Rome. All the queen mother ultimately obtained was a new session of the Council of Trent, where the liberal demands made by the French delegation were promptly rejected. In reply Catherine held a colloquy at Poissy attended by theologians of the two creeds, a meeting which ended in total failure. While these royal efforts at conciliation were happening, however, the rival parties had already coalesced: the duke of Guise, the constable Montmorency and the Maréchal de St André in the Catholic interest, and the king of Navarre together with the prince de Condé in the Huguenot. In January 1562 Catherine took matters into her own hands and issued an Edict of Toleration granting the Protestants certain rights to practise their faith. Four months later the soldiers of the duke of Guise massacred some Protestants worshipping in a barn, an event which precipitated the first religious war. This came to an end the year after, fortunately for Catherine removing most of the troublemakers: Navarre was killed at the siege of Rouen, the Maréchal de St André fell at the battle of Dreux and the duke of Guise was assassinated. In March 1563 Catherine celebrated the re-establishment of peace with the first set of her 'magnificences' at Chenonceaux.[5] Little is known about them, but they included a firework display, a water fête, a picnic and a masque. We know only details concerning the fête on arrival, when the royal party advanced up the tree-lined avenue to be met by singing sirens who were answered by nymphs from the nearby wood. Satyrs entered and attempted to carry off the nymphs but they were rescued by knights. These singing sirens were to be a standard ingredient of the mythology of every set of 'magnificences' for the next twenty years.

Chenonceaux reads like a dress rehearsal for Catherine's next set of conciliatory 'magnificences', which took place at Fontainebleau at the beginning of 1564. Here the court had assembled prior to the *Grande Voyage de France* to receive ambassadors from the pope and the Catholic princes come to ask that the French king publish the decrees of the Council

of Trent within his domains and unite in a campaign to exterminate heresy. The requests were swiftly declined as being contrary to the liberties of the Gallican Church, and it was in an atmosphere of the rejection of Tridentine Catholicism and of religious conciliation that the second set of 'magnificences' was staged. They also reflected Catherine's wish to create a brilliant court centring round her son during the four years she governed the kingdom as Regent.

We know considerably more about the Fontainebleau fêtes, although the text and description of one only, that given by Charles IX's brother, Orléans, was printed in full.[6] Our knowledge is, therefore, far from comprehensive. This means that the water combat in allegorical costume in which an island is stormed in the lake at Fontainebleau, which appears both in the series of Drawings and amongst the Valois Tapestries, could have been one of the events. We have, for instance, no information about the opening *festin* presented by Constable Anne de Montmorency. Nor do we have details of the combat on horseback sponsored by the Cardinal de Bourbon four days later. Catherine de'Medici's own contribution was an expedition to a pavilion in the nearby forest followed in the evening by a banquet and a play at the château. The last of the festivals was presented by Charles IX himself on February 15th, a tournament in which six companies of men-at-arms, each headed by a prominent aristocrat attacked a castle defended by the prince de Condé and five other knights. The castle was enchanted and its entrance was guarded by devils, a giant and a dwarf. The knight assailants made their entrance through a hermitage at the sound of the inmates' bell striking and the prize for the knights who successfully penetrated what Ronsard's cartel describes as 'le seul fort des fidelles amours' were six ladies of the court attired as nymphs.

However, the most complex of all the fêtes was staged on February 14th by the Duc d'Orléans. He had his own residence and this provided the setting for an elaborate series of alfresco encounters and events which anticipated the more subtle festival forms to come. On arrival the king entered the confines of a formal garden with two canals. On one floated three sirens, one of which recited to the lute a loyal song casting the new reign in pastoral terms. The siren sang how the reign of Henri II had been a golden age which his son, the shepherd, Carlin, is now about to revive, having already chased away the phantom of war which had caused the gentle deities of sea and land to hide themselves. Now they have reappeared to celebrate the glory of the French monarchy. Subsequently Neptune rode along the second canal in a sea chariot drawn by four sea horses, and a nymph was disclosed in a shell hidden within a rock. Later, after dinner, two troops of knights disguised as Greeks and Trojans displayed their prowess in the courtyard in honour of their ladies and the day closed with a spectacle in the genre of the famous *Château Ténébreux*.

A maiden appeared seeking the king's aid in releasing herself and two others held prisoner in a tower by a giant. They could only be rescued by two knights,

> Et qui sont filz tous deux du plus vertueux prince
> Et du plus accomply aux armes que jamais
> On n'ayt veu, ou que veoir on pourra desormais.[7]

The king and his brother were led by this maiden to a tower on an island which they attacked and, defeating the two guardians, released the prisoners, after which the tower went up in flames 'pour monstrer que les enchantemens du Tyrant qui l'avoit bastie, estoient finiz'.

The Fontainebleau 'magnificences' formed the pattern for those to come. They were always to consist of a series of fêtes spread over a number of days with intervals in between and various people giving the entertainments on the different days. By 1572, if not earlier, this included the whole court wearing a particular colour for each event as it happened. In general each set of 'magnificences' had two types of spectacle, the first being predominantly chivalrous. These included a barrier, running at the quintain, a tourney between two groups of knights or the storming of a fortress. As the reign progressed this was increasingly diversified with music and song within a framework of dramatic action. Under the influence of Catherine these martial sports were tamed and their importance was gradually lessened by her own contributions. These took a rather hybrid form, making use of pageant cars, water, feasting, singing and dancing, but knitted together to create something original. Brantôme records that the queen mother could always be relied upon to produce a new and beautiful experience. In the early stages the form was loose and processional but as the reign progressed it tautened. Out of it was to emerge that most distinctive form of French festival art, the *ballet de cour*.

The 'Grande Voyage de France' and Bayonne, 1564–65

At the close of the Fontainebleau 'magnificences' the court continued its two-year ceremonial progress through the provinces of France so that the young king could be displayed to his subjects, and support could thus be engendered for the crown.[8] Throughout the tour the Edict of Pacification was rigorously enforced. Each town received the king with a solemn entry in the manner accorded to his predecessors. Contemporary descriptions dwell on the poverty of these occasions, reflecting as they did a kingdom wasted through civil war and disturbance. The author of the account of

the king's entry into Rouen in August 1563, remembers the glory of former occasions and reflects sadly on present poverty, on how not even enough tailors remained to make the costumes for the customary formal procession with which the entry had opened. That at Lyons in June 1564 was recorded as being 'ny sumptueuse en habits, ny ingenieuse en apparat de Theatres & Perspectives'.[9] The ravages of war were vividly recalled. Discord was chained and the entry included the remarkable sight of Catholic and Protestant children walking in procession together. Apollo and the Muses optimistically sang of a new golden age:

> ... O Charles de Valoys,
> Mon Prince, ô Siecle d'Or, tu sois le bien venue.[10]

The furthest point the court reached on its progress was the Spanish frontier, where from June 15th to July 2nd took place the famous encounter of the French and Spanish courts known as the Bayonne Interview. Politically, the occasion was a disaster. Catherine had hoped that Philip II would come in person so that she could explain her religious policy. In the end Philip sent his wife, Catherine's daughter, Elizabeth, and as his own representative, the duke of Alva. They carried strict instructions to offer an alliance only to exterminate heresy, with further demands that Huguenot ministers should be banished, that Huguenots should be deprived of office, and that Catherine should see that the decrees of the Council of Trent were put into effect within her kingdom. The queen mother's optimistic belief that personal contact would enable her to persuade her son-in-law to reopen the question of a new General Council of the Church and of an agreement on further Valois and Habsburg marriages was met with a rude rebuttal.

The fêtes, therefore, celebrated a non-existent Hispano-French *entente*, providing a context and purpose for the festivals far different from the Fontainebleau 'magnificences'.[11] Bayonne was designed to project the French monarchy internationally as rich and splendid not only in financial but also in cultural terms. The four great fêtes were not given this time by private individuals, but were the result of prodigal government spending to ensure a series of events which would astonish the onlookers, as each eclipsed the other in a mounting crescendo of invention and ostentation. When they began on June 19th, it was with an elementary tournament to which knights came attired in costumes of the nations: Trojans, French, Moorish, Spanish, Roman, Greek and Albanian, selected to reflect the homage to Charles IX of the knights of both antiquity and of the modern nations. Further groups came dressed as wild Scotsmen, demons, Turks and nymphs demonstrating the monarch's power over savages and the realm of mythology. Two days later the knights of diverse nations reappeared to assail an enchanted castle in which Bellona held Peace

73

prisoner by the magic of Merlin. It re-enacted the final event of the Duc d'Orléans' fête of the previous year; this time the king alone possessed the valour and virtue needed to lay low the guardian knight, quell a bevy of demons, vanquish a giant and rescue lady Peace. Once more Charles IX was cast as the fulfiller of prophecies: '*ce gentil Chevalier, à qui ceste adventure estoit reservée, rendra la Chrestienté plus florissante que'elle n'avoit jamais esté . . .*'.[12] The final spectacle was a tourney between the Knights of Great Britain and Ireland, an allusion to the Britain and Ireland of Arthur and the Knights of the Round Table rather than the England of Elizabeth I. The tourney took place on June 25th and consisted of eight knights on either side defending Love and Virtue respectively. The cartels were sung to the lyre and each side was preceded into the arena by a chariot. The British knights had Heroic Virtue and four other Virtues with the nine Muses, and the Irish carried Venus, the three Graces and nine little Loves or Passions. The Muses and Passions mounted the tilt gallery, in which the ladies sat, and gave them medallions bearing the devices painted on the knights' shields. The official *Recueil* of these events contains engravings of them, and a number can be identified in the Valois Tapestry that depicts the occasion.

Catherine's water festival was the third of the series. The anonymous author of the official *Recueil* begins by a frank explanation of the queen mother's aims. He writes that she wished through this meeting to secure not only peace and the union of the two kingdoms, but through this '*le bien universal de toute la Chrestienté*'.[13] Embarking on a boat constructed like a castle the royal party sailed through a series of canals to an island upon which an octagonal banqueting house had been constructed. As they journeyed, they passed various set-pieces: firstly, there was an attack on a whale led by men in boats which lasted half an hour; secondly, a marine tortoise appeared, upon which sat six musicians as tritons, who struck up music at the sight of Charles IX; thirdly, there was Neptune in a car drawn by sea-horses. Both the Valois Tapestry and the Drawing show these incidents in detail recalling as they do elements of the Duc d'Orléans entertainment of the previous year. Neptune was followed by Arion on a dolphin's back and three sirens, again familiar elements, who combined in loyal songs, saying that now the time was propitious to greet Charles and his sister, the Queen of Spain. On landing there were dances by shepherds and shepherdesses, after which the party proceeded up a *grande allée* to be met by Orpheus and Linus together with three nymphs, who sang songs with verses that sum up the whole theme of the day's spectacle:

> . . . ie voy le François & L'Ibere
> Ioincts et unis, non point comme estrangiers,
> Mais tout ainsi que deux freres Bergiers.

74

107

> Tant que vivra Philippe & Ysabeau,
> Tant que vivra Charles & Catherine,
> Ny l'Espagnol ny le François troupeau
> Craindra le Nord ny sa froide bruine:
> Tant que seront ces quatre d'un accord,
> Entre Bergiers il n'y aura discord.[14]

The peace of France and Spain is celebrated in the terms of idyllic Golden Age pastoral life. After a banquet had been served by the shepherds and shepherdesses, six violinists entered and struck up the music for nine nymphs who entered on a luminous rock and danced a ballet, after which the royal party returned as they had come.

71
73–5
Three of the Drawings and two of the Valois Tapestries give us impressions of Bayonne. Impressions must be the word, for nothing appears in them that could not have been derived from the official printed *Recueil*.[15] For the purposes of the evolution of Valois court fêtes, the Drawings are the better source. The first day's tournament has been given the background of the courtyard of the Tuileries with the king's dwarf in the foreground. The knight running at the quintain is certainly Charles IX attired as a Trojan, with, behind him, his brother, Henri, disguised as an Amazon, wearing a skirt. The vast boat built like a château and carrying hundreds of people used in the queen mother's aquatic festival has been reduced in the Drawing to one with some twenty persons in it. The river Adour wends its way diagonally right to left, enabling the artist to place on it the encounters recorded in the *Recueil* with the attack on the whale occupying the foreground. The events on the island are similarly abridged with a banqueting house placed in the distance. Nonetheless the Drawing encapsulates pretty exactly the essence of this entertainment, with its constantly shifting viewpoint as the party made its way through water and

75
over land. In the Drawing of the final tournament, there is a similar synthesis in which the presentation of the medallions takes place in the distance while in the foreground the equestrian ballet with which the tourney ended is in progress, in which fireballs were tossed between the riders, who intermingled to demonstrate that Love and Virtue were compatible.

The component parts of the Bayonne fêtes were an elaboration on Fontainebleau. The whale on the journey symbolised war vanquished before the eyes of the on-looking voyagers — internal civil war and war between Habsburg and Valois. The monster once subdued, it became possible for the shy sea and land deities, as at Fontainebleau, to make their presence felt once more. Harmony was taken from water to land by the shepherdesses in their dances. This theme of innocent country pastimes restored in time of peace was repeated again and again during the *Grande Voyage de France*, for whatever region the king visited the local dances

always formed a part of the entertainment. Such a cultivation of peasant pleasures as symbolic of peaceful good government can be paralleled as much in the peasant *kermesse* paintings of Breughel as in the progress entertainments of Elizabeth I. In contrast to Fontainebleau there is a shift in content, with a hitherto unknown emphasis on the dance. Out of these dances performed in a field by shepherdesses in regional costume, and those by the nymphs at the close of the banquet, the *ballet de cour* was to emerge.

Peace and Empire: the entries of Charles IX and Elizabeth of Austria, 1571

During the intervening years war broke out twice, once in 1567, ending in the Treaty of Longjumeau the year after, only to break out again, this time ending in August 1570 with the Peace of Saint Germain. Both treaties ratified the enforcement of the Edict of Pacification and the latter went even further by granting the Huguenots certain *places de sûreté* for the exercise of their religion. The most documented festival event of these years, however, was the separate entries made into Paris in March 1571 by Charles IX and his bride, Elizabeth of Austria.[16] Both occurred immediately in the aftermath of the Peace, the programme for the king's entry being compiled during the autumn of 1570 and reflecting directly the incredible surge of optimism that at last a permanent pacification had been achieved between Huguenot and Catholic. Such a view was reinforced by the choice of bride, for Elizabeth was the daughter of the Emperor Maximilian II within whose domains toleration had been granted to Protestants, albeit only to those who were noblemen. And no one who witnessed either of these entries, which are so pure an expression of the aspirations of the moment, could ever have foreseen the terrible tragedy that was to come just over a year later in August 1572, ironically the year when the published account of the festivities made its belated appearance.

The alliance of court and city in this celebration was epitomised by the city fathers employing two royal poets, Ronsard and Dorat, who worked out the programme with one of the city aldermen, who was also both a humanist and a poet, Simon Bouquet. Dorat provided the Greek and Latin inscriptions, Ronsard those in French, while Bouquet acted as overall co-ordinator of both events.[17] Together they provided detailed instructions which were delivered for execution to the artists, again ones closely associated with the court, Germain Pilon (c.1535–1590), and Niccolò dell'Abate (1509/12–1571?) The king's entry focussed on the newly

established peace and deliberately suppressed any tendencies towards triumphalism. Parts of Ronsard's forthcoming epic, the *Franciade*, designed to be the *Aeneid* of the Valois dynasty, were printed with the *Recueil*, although none of it was used because of its war-like overtones. All was to be peace and harmony. So Catherine de'Medici figured as *Gallia* herself holding aloft a map of France in the role of the one who had 'soustenu et supporté la France renversée et dereglée au plus fort de son mal'.[18] Through her and her virtues the ancient imperial monarchy of France whose founders, Francus and Pharamond, graced the first arch that the king saw, was preserved to be revived to greater glories by her son, Charles IX. A huge painted perspective summed up the themes of the entry. On one side there were the twin columns of the king's device, not intertwined but straightened (in more direct allusion to Charles V's device) with the figures below of *Pietate et Iustitia*. On the opposite side there was an identical pair of columns, upon which was suspended the arms of France and Germany with *Felicitas et Abondancia*, a progression from a statement of internal peace and justice to a vision of a marriage of empires. *Felicitas*, however, was really *Pax* for she carried an olive branch and a captive lay bound at her feet. In the midst of this Serlian perspective scene sat *Magestas*. Even more interesting were the decorations on the arches at the Pont Nostre Dame. Here a painting showed warring bee-hives, representing Catholics and Protestants, who were becalmed by a hand let down from heaven sprinkling upon them a dispersing powder. Another figured a scene of sacrifice at an altar alluding to the inviolability of the Peace; and on the nearby arch Mars was seen chained to a laurel tree with Victory and her palm tied to an olive.

Elizabeth was ill when the king's entry took place — pregnancy was optimistically rumoured — so much was the consternation of the city fathers when a second entry was asked for, which took place three weeks later. Great was the panic and confusion of both artists and poets, who were faced with adapting the existing street decorations. What is striking, however, apart from the inevitable intellectual poverty of such a programme, is the ease with which an extant structure could be adapted for a wholly different schema. New statues were introduced but in the main the old ones were altered. This time they were polychrome and there was a lavish application of gold and silver to the temporary architecture which gave it all a surface glitter that detracted from the fact that basically everything was the same as before. Moving from the premise of her husband's entry, the themes of reconciliation and national solidarity were expanded into a prognostication that through the marriage of these two Troy-descended monarchs not only would Europe be united but a child born who would conquer the Orient and rule the world. Francus and Pharamond became Pepin and Charlemagne. The ship France, flanked by

Charles IX and Anjou as Castor and Pollux, was replaced by a nymph on 76
the back of a bull who was not Europa but Asia, the *Recueil* recounting 77
that the child of this marriage 'ravira l'Asie, et le reste du monde, pour
joindre à son Empire et soy faire Monarque de l'Univers'.[19] Universal
aspirations based on the descent of the kings of France from Charlemagne
were never far distant, in addition to which the compilers may have been
influenced by the writings of Guillaume Postel, who cast the French
monarchy in just such a tremendous role.

The queen's entry had an additional event, an allegorical banquet, in a
room decorated with twenty-four canvases by Niccolo and his son Giulio
Camillo dell'Abate, after an extraordinarily recondite programme by Jean
Dorat. These illustrated the story of Bacchus's son, Cadmus of Thebes, as
told by a fifth-century Greek poet, Nonnos of Panopolis. Its climax was
the central ceiling panel, in which Cadmus and his bride, Harmonia, rode
in a great ship with four other smaller ships, representing Religion, Justice,
Nobility and Merchandise, chained to it. In other words the vision was of
the royal couple guiding the ship of France, also emblem of the city of
Paris, to a happy haven of peace and imperial greatness. Alas, this was not
to be. Already the queen's entry with its spectacular banquet had offended
the Catholics because it had taken place during Lent. This was at once
commented upon as an indication as to just how much Huguenot influence
was gaining a hold over the young king's mind.

*Le Paradis d'Amour: The Wedding of Henry of Navarre and Marguerite
de Valois, 1572*

The marriage of Charles IX and Elizabeth of Austria reflected exactly
Catherine de'Medici's policy during this period which centred on matches
for her children. More or less simultaneously other projects proceeded:
Anjou and subsequently Alençon to Elizabeth I of England, and
Marguerite to Henri of Navarre. In these two marriages the queen mother
went a step further in moving from an alliance of liberal-minded rulers to
one of couples whose faith was actually of rival creeds. Through these
matches a pattern of conciliatory alliances would be formed throughout
Europe, a policy to be complemented by concerted efforts against Spanish
oppression in the Low Countries. In July 1570 William of Orange's
brother, Louis of Nassau, asked Catherine and Charles IX for a French
army in order to liberate the Netherlands. The result of this was a
rapprochement with the new leader of the Huguenots, Admiral Coligny,
who began to have an increasing influence over the king that Catherine

was later to regret. During these years, therefore, a pattern of anti-Spanish alliances was formed. In the spring of 1572 a treaty of peace was signed with England and marriage negotiations with Elizabeth began in earnest. Magnificent embassies were exchanged and splendid fêtes were given on both sides of the Channel. In England the occasion was marked by a brilliant midnight tourney at Whitehall Palace with the speeches in French on the theme of Peace, who arrived in a chariot, seeking succour at the hands of the queen.[20] But even more significantly on April 11th the contract of marriage between Henri of Navarre and Marguerite de Valois was sealed.

The 'magnificences' for the Navarre-Valois wedding the year after were planned as a series in the same way as their predecessors. No one attending the opening fêtes could have had any premonition that this gathering of Catholic and Protestant leaders in fraternal rejoicings to celebrate a marriage that epitomised the culmination of the policy of conciliation would end in the bloody Massacre of St Bartholomew.[21] When they began on August 17th with the customary *fiançailles* everything was set for the usual mixture of chivalrous combats, masquerades and allegorical shows in which members of rival religious creeds united to honour the crown and pay tribute to the new bride and groom. After the marriage, on the Monday, there was a masquerade in which the king, the Protestants Navarre and Condé and the ultra-Catholic duke of Guise entered the hall on marine chariots encrusted with coral and sea-creatures. Charles IX played Neptune, and the deities descended from their mobile sea-grottoes and danced. This was the mythology of the Fontainebleau and Bayonne fêtes brought indoors. On Tuesday there was a court ball at the Louvre, while on Wednesday there followed an allegorical combat in the Salle de Bourbon of the Louvre, entitled *Le Paradis d'Amour*. This was the most spectacular of all the entertainments that actually took place. Surviving accounts prove that others were planned but never executed because of the disastrous interruption to the festivities.

Le Paradis d'Amour was a development from the enchanted castle combats of the earlier fêtes, but this time with a climax in the dance. From what little we know of it, *Le Paradis d'Amour* is also a crucial moment in the development of the new art of *ballet de cour*. The décor was of the usual scattered variety. Charles IX and his two brothers, Anjou and Alençon, defended the gateway to Paradise, behind which stretched the Elysian Fields, where there resided twelve nymphs and in which revolved a huge model of the heavens. To the left there was the Underworld, with a hell mouth approached by crossing a river in a boat manned by Charon. Into the room came troops of knights in different liveries who fought at the barriers; these, as they were defeated by the brothers, were relegated to

the Underworld. In this almost theological setting the attackers were led by the bridegroom, Henri of Navarre, a fact regarded in retrospect as especially sinister and prophetic of the events that followed. But there was nothing at all unusual in the pattern of the plot, for the royal brothers always had to win, as they had in previous fancy-dress tournaments. This time, however, the dramatic sequence was changed. After the fighting, instead of the usual celebrations to mark the victory of the royal family, Etienne Le Roy, the famous singer, descended from the heavens as Mercury accompanied by Cupid and harangued the royal brothers on the virtues of love. They subsequently led out the twelve nymphs from the Elysian Fields and danced a complicated ballet that lasted for an hour. At the conclusion of this, the imprisoned knights were released (conceivably at the intercession of the nymphs) in allusion to the pacifying power of love instanced in the Navarre-Valois wedding. The entertainment was brought to its close with the customary fireworks. In its mixture of dramatic plot, scenery, singing and dancing it is well on the way to the new form of *ballet de cour*.

On Thursday August 21st there was a *course de bague* in the courtyard of the Louvre. Charles IX and his brothers appeared as Amazons, the Prince de Condé *à l'estradiotte*, the Duke of Guise as another Amazon and Henri of Navarre and his troop as Turks. On August 23rd, the day after, between ten and eleven o'clock in the morning, Admiral Coligny was shot at and wounded from a house, soon after discovered to be one belonging to the Duke of Guise. The panic this produced precipitated the series of events leading to the order for the massacre. Contrary to most of what the policy of Catherine de'Medici had ever stood for, and contrary to the spirit of the Navarre-Valois marriage, the bloody massacre burst on to the scene. Its horrors were immediately perpetrated through the rest of France, leading to a resumption of civil war. Strangely enough, it made virtually no difference whatever to royal policy. Indeed, it is the study of these festivals, with their theme of peace and reconciliation, of a 'politique' triumph, that decisively eliminate any hypothesis that the terrible massacre was at all premeditated: as was quickly realised, it can only have been a ghastly mistake. Catherine renewed her relations with William of Orange and Louis of Nassau against Spain in the Low Countries, and once more refused to publish the decrees of the Council of Trent. The trouble was that the mistake was on such a colossal scale that it shattered Catherine's concept of the role of the French monarchy as liberal leaders against Spanish domination and set back the campaign in the Netherlands. That the massacre was an insane blunder is further confirmed by its occurence at the very moment when Catherine was projecting the most liberal and tolerant policy possible in order that her favourite son, Anjou, should be elected king of Poland.

'Magnificences' for the Polish Ambassadors, 1573

On July 7th 1572, a month before the Navarre-Valois 'magnificences', Sigismund III of Poland died and the Polish Diet met to elect a new king. Poland was unique in Europe in the sixteenth century for being the only country where liberty of conscience was an established fact. It was, therefore, with great difficulty that Catherine's most conciliatory envoy, Jean de Montluc Bishop of Valence, explained away the massacre. On May 9th, 1573 the Polish Diet actually elected Anjou king, but only on condition that he maintained liberty of conscience. Two months later, on July 6th, Charles IX issued the Edict of Boulogne, bringing an end to the war provoked by the massacre and establishing once more liberty of conscience within France. In this way, less than a year after, Catherine was back where she had started. In the light of a crown for Anjou, everything was to be stage-managed as though the massacre had never happened.

One year later, almost to the day, the Polish ambassadors made their entry into Paris. The impression they made in their magnificent costumes, recorded in the Caron Drawing and the Valois Tapestry, was one of barbaric richness and splendour. There seems to have been the usual set of 'magnificences', preceded by Anjou's entry into Paris as king of Poland.[22] This was devised by Jean Dorat and it presented the happy, if totally untrue, picture of the three united brothers, the grief of France at the loss of Anjou, and the heroism of the queen mother, depicted as Pallas, hymned as the mother of kings and bringer of peace. Nor, bravely, were allusions to religion pushed to one side. At the Pont Nostre Dame the City of Paris in her antique guise as Lutetia bearing a crown was oddly cast as Religion with a flaming altar before her 'representant l'affection et zelle que ladite Ville a envers la Relligion, et piété d'icelle tant envers Dieu que le Roy'.[23] Religion was strictly non-denominational and to emphasise the fact verses celebrated the three royal brothers, one a king of France, one a king of Poland while, in the case of the third, there lay another crown beyond the seas, that of England. In that way the programme drew into its conciliatory orbit the negotiations for Alençon to marry Elizabeth I.

The greatest spectacle, however, was the ballet staged by the queen mother herself in the gardens of the Tuileries.[24] Sixteen ladies of the court, including her daughter Marguerite de Valois, then at her most sparkling, were revealed seated on a silver rock attired as the provinces of France. To the most melodious music that had ever been heard, it is recorded, they toured a hall ablaze with flambeaux. The ladies afterwards descended from the rock and danced a spectacular ballet, which lasted for an hour. Not a step was out of place and their intricate movement and patterns, together with their grace, made a profound effect on the audience. Nothing quite like it in the way of sustained choreography had ever been

seen before. Brantôme records that it was 'le plus beau ballet qui fut jamais fait au monde' and the Poles said that 'le bal de France estoit chose impossible à contre faire à tous les rois de la terre'.

Agrippa d'Aubigné records that the court ball that followed continued for most of the night. The feeble woodcut illustrating the official account, Dorat's *Magnificentissimi Spectaculi*, shows something of the appearance of the temporary *salle des fêtes* and, above all, the court ladies arranged in a figure. They are costumed and arranged in two sets of eight and we get a clear idea of the importance of the arena theatre with its tiered seats enabling the onlookers to appreciate the patterns formed by the dancers. In both the Caron Drawing and the Tapestry, the walls of the hall are taken away and we are shown the court ball in action. In the foreground are the Poles in their national dress, while in the background stretch the gardens of the Tuileries. From these sources we learn that the musicians on that occasion were dressed as Apollo and the Muses and also sat upon a rock. *The Ballet of the Provinces of France* included the presentation of symbolic devices, an element from the Bayonne tournament. Its mythology was also that of Bayonne but in its outstanding development in coherence and in the elaboration of the dance element it was already a new form of spectacle.

79

The Triumph of Faith: Henri III in Italy, 1574

Less than a year later, on June 15th 1574, news reached Cracow of the death of Charles IX. The reign of the new king was to be prefaced by a series of festivals glorifying the power of the French monarchy as Anjou, now Henri III, made his way homewards through Italy, a circuitous route chosen to avoid Protestant Germany. These in a sense belong to the saga of Valois *fêtes* because they present us with a view of events in France which is fiercely Catholic, reflecting the ethos of the peninsula as it sank beneath Habsburg domination and the new forms of religious fervour engendered by the Counter Reformation. There is no ambiguity in their presentation of the French king as a loyal servant of the Church of Rome, already famous for his victories over heresy.[25] Perhaps in Venice and a little in Ferrara but certainly not in Mantua we catch flickering allusions to the return of a French monarchy powerful enough to break the Habsburg grip. Nothing, however, flattered these new rulers of petty states more than a visit from the crowned head of an ancient dynasty.

Henri made his entry into Venice seated in the poop of the *Bucintoro*,

80 the state barge. Before San Niccolò on the Lido a triumphal arch, based on that of Septimus Severus, and a loggia designed by Palladio had been erected. The arch was decorated with canvases by Veronese and Tintoretto celebrating the martial exploits of the king as Anjou against the Huguenots with Faith triumphing over the figure of Heresy. The Corinthian columns of the stately loggia were interspersed with statues of the virtues, while within four Victories stood around an altar with a picture of Christ by Tintoretto. The festivities lasted ten days and included banquets, religious ceremonies, a firework display and performances by I Gelosi. The Duke of Ferrara had been present at all of this, so that Henri's entry into the Este city re-echoed the themes of Venice exactly, the king riding through a eulogy of himself entirely in terms of virtues, opening with Religion which included a picture of his battles to defeat the Huguenots. Not to be outshone, the rival Gonzaga court under Duke Guglielmo at Mantua ran through the same repertory in an event which reflected a high point in international prestige for the ducal family. Mantua was a Habsburg satellite with a duchess who was a daughter of the Emperor Ferdinand I, and both she and her husband were deeply committed to the new wave of Catholic devotion. On entering the city Henri would have seen the old Gonzaga device of Mount Olympus; but now Faith stood on its summit and the motto: *Hic semper tuta.*

What are we to make of this burst of homage to the Valois monarchy? In many ways not much, for it was so much empty rhetoric designed to give prestige more to the hosts than to the guest. The themes, however, were anticipatory ones of the mood of the new reign, for Henri III, far more than any of his brothers, was a child of the new piety. At Venice he had been presented with a manuscript containing the statutes of an Order of the Holy Spirit which had been founded in the fourteenth century by Louis of Taranto, King of Jerusalem and Sicily. This was subsequently to inspire, four years later in 1578, one of Henri's avowed channels for introducing the reforms of the Council of Trent into France, the Order of the Holy Spirit.

The Joyeuse 'Magnificences', 1581

Almost a decade separates the 'magnificences' for the Polish ambassadors from those for the wedding of Anne, Duke of Joyeuse, in 1581. These were the years of the reign of Catherine's most gifted and most complex son, Henri III. Intellectual and introspective, he was the

wrong king to rule over a France divided by religion, ruined by civil war and bankrupt. By far the cleverest of Catherine's children, he was seized by alternate bouts of feverish activity and total inertia. As the reign progressed the latter predominated. Prone to morbid suspicion of those round him, he was also a hopeless judge of character and incapable of realizing the consequences of his own actions. The reign opened with the united family disintegrating. On September 15th, 1574 Marguerite and Alençon, who hated his brother, fled from the court. Navarre had already left and now headed the Huguenots. Poor Catherine spent most of her time trying to re-establish concord among her remaining sons and daughter. While the power of the Catholic cause led by the Guise and with support from Spain grew, the crown was becoming even more dangerously isolated; and its position was not helped by the open defiance of Alençon, who now became Anjou. These were years when the crown struggled to preserve government from disintegration, and tried to stop Anjou intervening in the Low Countries and to arrange a marriage for him with Elizabeth I.

The Joyeuse 'magnificences' celebrated the marriage of Henri III's favourite, Anne, Duke of Joyeuse, to Marguerite, sister of Queen Louise of Lorraine.[26] These 'magnificences' were not the conciliatory fêtes of yore, in which Protestant and Catholic knights joined in peaceful chivalrous combat to demonstrate their allegiance to the crown. The Joyeuse 'magnificences' exalted a royal favourite almost into a member of the royal family and represented the crown allying itself closely by marriage to the ultra-Catholic Guise faction. This exaltation alienated the aristocracy and the shocking expenditure of a million écus on the wedding fêtes was bitterly denounced in view of the mounting royal debts and the collapse of ordered government in the provinces. The 'magnificences' occurred during an interval of peace, for on November 26th 1580 the Treaty of Fleix was signed. At the opening of 1581 Henri III had a long illness, after which his eccentricity and immoderation became worse. For the marriage the bride's father, Duke Charles of Lorraine, and his court came to Paris and the fêtes were without doubt the climax of Valois festival art. In the dedication of his Mimes to Joyeuse, de Baïf wrote that he was still trying to collect his wits after so many 'magnifiques théâtres, spectacles, courses, combats, mascarades, ballets, poésies, peintures',[27] which had been specially created in honour of the alliance. Cartels were composed by Ronsard and Desportes, an epithalamion by de Baïf, music by Claude Le Jeune (1528–1600) and decor by Antoine Caron. The king paid the contributors handsomely for their labours and in these fêtes more than in any other we are able to trace the fruits of the poetic and musical programme of the Académie de Musique et de Poésie.

As usual the 'magnificences' extended over a fortnight and were given

on various days by different people. Each day had its own particular colours: one would be white and silver and another silver and pink. Due to conflicting accounts of the entertainments it is difficult to establish exactly when all the events took place and our knowledge of each one varies greatly. They apparently opened on September 19th with a foot-combat presented by the Duc de Mercoeur in the Salle de Bourbon in the Louvre between the king and the duke of Guise, de Mercoeur and de Damville in the subject of Love. The king's party was against Love, and he and his companions entered on a rock clad in black, carnation and green, Love chained at their feet with musicians attired à l'antique, who sang Le Jeune's 'La Guerre', a song sung with menacing gestures telling of the dolours of love. Other knights who came to defend Love had a cartel by Ronsard, and Desportes wrote another for a troop calling themselves the Faithful Knights. On the wedding day there was apparently a course de bague in which the king's troop arrived in white, black and silver, each one preceded by a lance-bearer disguised as a captive king in chains. They were accompanied by six Moors on a camel, who sang 'en langue estrangère'. This was listed on the programme for the fêtes, although we have no evidence that it was actually executed. An epithalamion by de Baïf, however, was certainly performed on the day of the wedding. Two choirs of boys and girls dressed à l'antique led in by Hymen sang verses in hexameters in vers mesurés to musique mesurée by Le Jeune. There was a tourney at night in the courtyard of the Louvre in which knights fought twelve a side in white and yellow. For this 'un théâtre pompeux, & deux braves arcades', one representing the Moon and the other the Sun, had been constructed. The decor apparently included a gigantic representation of the heavens with the planets moving in their courses and the emblems of the French royal house included, foretelling, surprisingly in the circumstances, the happy destiny of the family. Henri III entered 'comme un grand soleil estival',[28] an anticipation of Louis XIV as the Sun King. For another tournament, also in the courtyard of the Louvre, he came in a marine triumph, riding on a great ship floating in a sea full of rocks with musicians dressed as tritons. These sang a song in vers mesurés accompanied by musique mesurée by Le Jeune, which borders on the incantatory. It sang of the peace, happiness and prosperity of France with each verse ending with the same solemn refrain: 'ASTRES HEUREUX TOURNEZ, TOURNEZ CIEUS, TOURNE LE DESTIN'.[29] Never before so forcefully as in this final set of 'magnificences' was the power of art called upon to exercise its influence in averting the disasters surrounding the monarchy.[30]

The Cardinal de Bourbon's river fête recalled that of Bayonne. A vast triumphal chariot had been prepared to bear the court to his residence at the Abbey of Saint-Germain-des-Prés. It was drawn by twenty-four little

ships disguised as sea-horses, tritons, whales, sirens, tortoises, dolphins and other marine monsters, in which were concealed musicians and singers. Unfortunately the great ship refused to move and so the court was forced to go by coach to the cardinal's house, where he presented *'le plus pompeux et magnifique de tous'*,[31] for he had created an artificial garden with flowers and fruits in it as though it were in July or August.

Le Balet Comique de la Reyne

In the midst of all this prodigal expenditure there is mention of the queen mother's fête, of workmen busy preparing a temporary room for its performance. The delays were such that it was never apparently performed, being finally postponed until some subsequent date.[32] Ironically Catherine's life-work in festival was to find expression in the entertainment presented by her daughter-in-law, Louise of Lorraine. *The Balet Comique de la Reyne* was the only one of the Joyeuse 'magnificences' to find itself into print in full with illustrations and music.[33] The text was by La Chesnaye, the music by the Sieur de Beaulieu, the scenery by a certain Jacques Patin, while the whole was planned and directed by Baltasar de Beaujoyeux, who had been responsible for the *Ballet of the Provinces of France* in 1573.

The illustrations evoke the occasion brilliantly. At one end of the **81–3** crowded hall sat the royal family, centring on the king with the queen mother, clearly visible from the rear with her diaphanous mourning veils, to his right. Opposite them, at the far end of the room, was an artificial garden framed by a triple arch of trellis. From the flanking openings issued the chariots and allegorical personages who were to make up the action of the ballet, while in the centre Circe, the wicked enchantress sat enthroned. To the left of the hall was the *voûte dorée*, a star-bespangled cloud at ground level containing groups of musicians and singers. Opposite, to the right, there was a boscage in which sat Pan and behind which was a grotto full of more musicians. Above, but not indicated in the engraving of the scene, there was a cloud suspended from the ceiling.

The moral meaning of the entertainment about to be enacted was the familiar allegorical exposition of the Circe fable as found in one of the standard Renaissance mythological manuals, Natale Conti's *Mythologiae*. Circe, the daughter of Perseus and the Sun, lured men to vice, to a life of the passions that transformed them into beasts. This enchantress thus represented the passions: lasciviousness, drunkenness, cruelty, avarice,

119

ambition, all the vices to which men, devoid of the guidance of reason, are drawn. The action was to be a moral struggle of Virtue versus Vice, of the vanquishing of Vice by the triumph of Reason and the Rational Soul. In short, the ballet was a moral debate on the lines of many we know to have taken place in the Palace Academy during the reign of Henri III.

81 The performance opened with a gentleman escaping from the bondage of Circe and appealing to the king to deliver him. Only a monarch, who had brought about such a golden age, could possess the power needed to destroy her magic. At this point Circe bestirred herself from her garden and issued forth to harangue the royal family in fury and return once more to the far end of the room. The plot of man struggling to free himself from the power of the passions was thus stated in this first encounter. This was to be acted out in a series of *entrées* by various mythological creatures embodying abstract forces that successively tried to vanquish the power of Circe. The first was of water deities. Six tritons and three sirens escorted into the hall a pageant car like a fountain drawn by sea-horses upon which

82
83 sat Queen Louise and her ladies, elaborately bejewelled, as naiads, accompanied by Glaucus and Tethys. The sirens sang a song in *musique mesurée* praising the king and toured the hall. They then escorted the fountain chariot up to the king and a song followed in honour of Queen Louise, succeeded by a second by Glaucus and Tethys complaining of the evils of Circe. Then ten violinists entered the room, the ladies descended from their chariot and danced a ballet of thirteen geometric figures, expressing, we are told, the mysteries of number. These revels were at length rudely interrupted by Circe, who rushed out from her garden and turned the dancers and musicians to stone. Suddenly a clap of thunder was heard and from the cloud above the hall Mercury descended, singing of his role as the messenger of the gods and the teacher to men of science and the arts. The moment recalled that of his arrival a decade before in the ill-starred *Paradis d'Amour*. Mercury carried the juice of the moly herb, which had the power to cure minds that have abandoned virtue. Having been sprinkled with the herb the performers resumed their ballet, only to be turned to stone once again by Circe who mocked the naiads who cherished the ancient Golden Age virtues and led them off, together with Mercury, to be her slaves. The first sequence of the *Balet* ended with the vices triumphant, for man's intelligence manifested in the arts and sciences must be guided by Reason and not by Passion.

In the second part the forces of nature challenged the power of Circe. As before the sequence opened with deities, this time eight satyrs who toured the hall singing a song in praise of Henri III. These were followed by a pageant car like an oak wood in which sat four dryads, who recounted the evils of Circe and called on Pan in his grotto to rescue her slaves.

The scene was now set for the final battle. As in the case of the previous

entrées it began with a new group of characters touring the hall singing in praise of the king. This time it was the four Cardinal Virtues, Prudence, Fortitude, Justice and Temperance, who said that as the king was the embodiment of themselves it was he who would defeat Circe. The Virtues invoked Minerva, Goddess of Reason and Wisdom, who entered in a chariot drawn by dragons and made her progress down the length of hall towards the king escorted by the Virtues. As she arrived the music from the starry vault to the left was of an amazing beauty. Minerva announced that she would vanquish Circe on the king's behalf and invoked her father Jupiter to aid her. Once again there was a tremendous thunderclap and this time the whole cloud slowly descended from the ceiling bearing Jupiter. At this moment the *Balet* reached its musical apogee, for no less than forty musicians and singers in the *voûte dorée* sang:

> *O bien heureux le ciel qui de ses feux nouveaux*
> *Ialoux effacera tous les autres flambeaux*
> *O bien heureux encor sous ces princes la terre*
> *O bien heureux aussy la nauire Francoys*
> *Esclairé de ses feux, bienheureuses leurs loix*
> *Qui banniront d'icy les vices et la guerre.*

The song is of the wisdom and virtue of the kings of France in banishing war and advancing virtue. With the arrival of Jupiter the final assault on Circe began. Pan and the satyrs, the natural powers, under the direction of Minerva and the Virtues, embodying Reason and Wisdom, and aided by Jupiter, the father of the gods, advanced on the garden of the enchantress and broke her power, presenting her magic wand to the onlooking Henri III.

This triumph was celebrated in a ballet of forty geometric figures by the newly released naiads. We have already discussed how the breaking and reforming of the figures expressed the mutation of the elements and seasons, each single figure stating an eternal truth in geometric form. Finally the ladies presented devices to certain of the spectators. Queen Louise gave the king one depicting a dolphin, an allusion to the hoped-for birth of a dauphin.

In this entertainment the *ballet de cour* is fully realized. We can trace in the entertainment imagery and forms from previous sets of 'magnificences' all the way back to Chenonceaux and beyond to late medieval forms of masquerading and mumming. Scattered scenery is of the sort used for indoor combats of the type of *Le Paradis d'Amour*; the element of combat typified in the fight of Virtues and Vices recalls the tradition of jousts; the marine mythology of tritons, sirens and naiads was a familiar ingredient of Valois festivals; pageant cars depicting rocks, trees and fountains were features of late medieval entertainments; choreographed dances had been

imported first from Italy. All these elements were welded together into a coherent harmony of plot and dramatic dénouement in the *Ballet Comique*. The entertainment as a whole also reflects the aims of the academies in reviving both ancient music and dancing. The published texts eulogises its 'varieté, nouveauté' and 'beauté' and bring out the importance of the musical contribution in terms of sheer variety, size and length (it lasted five and a half hours). Although the scenery was scattered, beyond Circe's garden and castle 'on voyoit une ville en perspective', whose focus was the royal dais where sat the principal actor in the drama, the king. And, as in the case of all previous French court spectacle, the real meaning of the ballet was political. It enacted the dramas and dilemma of the French crown. Circe not only represented the passions, she was the evil of civil war that had wrecked the peace of the realm. Through his practice of virtue and under the guidance of reason it was predicted that Henri III would vanquish the phantom of war.

The End of 'politique' magnificence

Nothing could have been more optimistic and, at the same time, further from political reality than the Joyeuse 'magnificences' that were the final glorious swan song of Valois festival art. After them the rule of Henri III descended into endless eccentricities and excesses. The king was surrounded by favourites, indifferent to financial ruin and obsessed by extremes of Counter-Reformation piety. The image of the court during the 1580s became one of riotous extravagance alternating with bouts of wild penitence. The most familiar festival form became that of the religious procession, in which both king and queen appeared in penitential guise, attended by figures of the Virtues, imploring heaven that an heir to the throne be born.[34] This new piety also had an outlet in the Order of the Holy Spirit which Henri had founded at the close of 1578. The loyalty of chivalry in homage to the crown that had formerly found its vehicle in tilts and tourneys now expressed itself in the formation of a closed group of the aristocracy swearing fealty to the king in an association whose overt aim was the propagation within France of the decrees of the Council of Trent.

Henri epitomised a kind of 'politique' stance reconciled to the new Catholicism. The older 'politique' tradition of Catherine lingered on through the early 1580s in the match of Henri's brother, Anjou, to Elizabeth I. By then Anjou was William of Orange's protégé in the Low Countries, cast in the role of the reviver of vanished Burgundian glories. In

the spring of 1581 a splendid embassy arrived in England from France to treat formally for the marriage. This was the occasion of the famous tournament at Whitehall when the 'Four Foster Children of Desire', of which Philip Sidney was one, attempted to storm the 'Castle or Fortress of Perfect Beauty' figured in the queen attended by her ladies seated in the tilt gallery.[35] A year later the nuptials seemed even more imminent when Anjou himself came, and once more the English court arranged a series of chivalrous spectacles in the French manner. As we have seen as at Binche and Fontainebleau a castle with a magician was assailed and taken but, more to the point, the pock-marked Anjou arrived at a barriers chained to a rock with Love and Destiny leading him in.[36] As it was remarked at the time, these were the wedding fêtes without the marriage. Anjou left, still single, for Antwerp, only to die two years later, disgraced, after an attempted *coup d'état*. With his death there was no immediate heir to the French throne, for Henri III still had no children.

The result of this was that the crown was isolated as never before, with a Protestant, Henri of Navarre, as next in succession. In December a Catholic Holy League, sponsored by the Guise family, and in alliance with Spain was formed. For the Guise the continued dalliance of the Valois with the heretic Elizabeth was the ultimate betrayal. Not surprisingly they absented themselves from the last great 'politique' fête of the reign, Henri III's reception of the Order of the Garter early in 1585.[37] This occurred in the aftermath of the assassination of William the Silent. To ultra-Catholic Paris came envoys from the Netherlands offering its sovereignty to the French king and, at the same time, Protestant lords from England seeking to avert this and yet ally both countries in frustrating Spanish domination. So it was that the populace witnessed the extraordinary sight just three years before the Armada was to sail of Protestant knights of the Garter and Catholic knights of the Holy Spirit walking side by side through streets lined 'with the king's guards that no people should trouble the way'. A few days after the last of the great ballets was danced by the king himself, to the amazement of the English who had seen nothing quite like it before. Attired in white and silver swagged with pearls the last Valois king led the twenty-four dancers in a series of figures that spelt out his own name and that of the heretic queen of England.

Alas, this final 'politique' vision was not to be; in March the Holy League became an established fact. Ultra-Catholic and with direct support from Spain, it held that the crown could not be inherited by a heretic and that the true heir was the old Cardinal de Bourbon. With this, darkness begins to enfold the last years of the Valois dynasty. The united family was no more. Marguerite deserted Navarre and joined the League, much to the horror of her mother. In July 1585 Catherine came to terms with the Leaguers in the Treaty of Nemours and, for the first time, the crown

rescinded the edict that had always guaranteed the Huguenots a degree of protection and tolerance for the practice of their faith. Once more there was war. In 1588 the League drove the king from Paris and forced him to summon a meeting of the Estates General at Blois. In December 1588 Henri III made desperate last attempts to throw off the Guise and had both the Cardinal and his brother the duke murdered, an action that canonised them in the eyes of the Catholic Leaguers. Poor Catherine died on January 5th 1589, and her son was assassinated by a Leaguer seven months later. With this darkness falls on what had been the most brilliant and cultivated court in Europe. For several years there was to be no king of France and the kingdom was rent by the worst and most savage of all the wars, that between the heir Henri of Navarre and the Catholic League.

Survival

In the troubled and terrible years that followed the assassination the art of festival almost died. For the transmission of the new art of *ballet de cour* into the next century one must study the simple ballets presented by Henri IV's sister, Catherine, at the little court she held at Béarn. There, in the midst of a war in which it seemed that the French monarchy was about to disappear for ever, ballets were danced before her expressing in simpler terms the same hopes and fears that her namesake in happier days had embodied in her 'magnificences'. On August 23rd, 1592 a ballet was danced at Pau.[38] Four knights, two Béarnais and two French, fought for and in defence of marriage before Madame, a debate stopped by the descent of Mercury, who expressed Jupiter's rage at this world full of strife. The plot was simple in its evolution, with a dance of four nymphs and a triumph of Cupid, Love reconciling the knights, and it closed with predictions of Madame's own marriage, allied to hopes of peace for France and the birth of an heir. As of old the Béarnais and French knights were Protestants and Catholics, and the ballet's theme was reconciliation through love, which would bring longed-for peace once more. It recalled all that Catherine de'Medici's life work in festivals had stood for.

In the *Ballet of Medea*,[39] the year after, a nymph appeared before Catherine and her brother the king, and begged her come to the aid of France who was being cruelly ravaged by a goddess, the enchantress Medea, who revealed herself attended by two Spanish knights, the arms of Spain above her and those of France and Navarre cast down at her feet. Two nymphs entered and danced a ballet until they stopped before Medea

and made a speech bemoaning the Spanish triumph over the *fleur de lys*. Later two French knights consulted a sybil, who prophesied a saviour in the person of Henri IV. A combat followed in which the French knights defeated the Spaniards and led them prisoner before Henri IV, while Medea reluctantly was forced to do obeisance to his sister, Catherine. This victory was expressed in a final ballet by the knights and nymphs. In these poverty-stricken provincial productions with the minimum of scenery, with the fewest possible performers and devoid of the splendour of old, the art of the *ballet de cour* created under the auspices of that genius of the Renaissance court fête, Catherine de'Medici, trickled its lonely course into the next century, eventually to reveal itself in a new glory in the court spectacles of *le Roi Soleil*.

IV

APOTHEOSIS OF A DYNASTY

The Grand Duke Ferdinand and the Florentine 'intermezzi'

Bastiano de'Rossi, in his account of the most celebrated spectacle of the reign of the Grand Duke Ferdinand of Tuscany, the intermezzi of 1589, opens by praising Medicean magnificence. He begins by citing Cosimo Vecchio as an *exemplum* of this virtue, manifested in his numerous public buildings. He then goes on to recall Medici fêtes: the famous *giostra* of Lorenzo the Magnificent, the festivals of Pope Leo X and the marriage festivities of Lorenzo de'Medici and Maddelena of France. When he comes to the grand dukes he sees them, too, as exponents of this virtue in their spectacles and building projects. Cosimo I had created Cosmopolis on the island of Elba, the Fortezza di San Martino in Mugello and the Città del Sole in the Romagna, besides presiding over the splendours of both his son's and his own nuptials. Francesco, his eldest son, followed the tradition laid down by his father. His liberality was manifested in princely villas and in the development of the port of Livorno. His court fêtes were brilliant also, de'Rossi relates, but none is mentioned, for the most famous was the *Sbarra* of 1579 to celebrate his notorious marriage to his mistress, Bianca Cappello, a lady loathed by his successor, his brother, the Grand Duke Ferdinand. To de'Rossi, however, Ferdinand de'Medici's festivals already seemed, two years after his accession, to eclipse all that had gone before, being of an 'unheard-of marvel and wonder'. A funeral oration even more vividly casts this grand duke as the presiding genius over memorable fêtes. Hymning the splendour of his court it proceeds to laud that of

126

... the entertainments, the spectacles, which ... were always grand, always pompous, always marvellous, always regal. ... The superb *apparati*, the pompous shows, the artful devices of inestimable cost, the marvellous spectacles, which not only surpassed the universal expectations of everyone, but the imagination of the most expert, and the most wise, not only could they not conceive such things in their minds before their execution, but having seen them and seen them again, were still unable to. The expense was incredible, the artifice unimaginable, the invention of the noblest. ...

As in the case of Catherine de'Medici, court spectacle was a deliberate part of the policy of the grand dukes of Tuscany.

Medici festivals in the grand ducal period were motivated by different problems from those confronting the Habsburg and Valois dynasties. The Medici were *nouveaux*, and each series of fêtes was designed to enhance the grandeur of this infant dynasty, which due to its role as bankers was able to buy its way into alliances with the ruling houses of Europe. Charles V had restored the Medici to power in 1529 in the person of Alessandro, who was created duke by the emperor in 1536. His successor, Cosimo, remained true to the imperial alliance and for this he was richly rewarded. He was given a Spanish bride, Eleanor of Toledo, daughter of the viceroy of Naples, in 1539; was handed Siena in 1557; and, as a wife for his eldest son, Francesco, received an Austrian archduchess, Joanna, sister to the Emperor Maximilian II, in 1565. This match represented a diplomatic triumph for the Medici family and further consolidated their position as one of the ruling houses of Europe. At the right moment the skilful Cosimo had turned pro-papal and in return had had the title of grand duke bestowed on him by Pius V. Medici rule in the late sixteenth century was therefore directed towards the deliberate suppression of any lingering republican traditions within Florence and the promotion of autocratic principles. Under the influence of Eleanor of Toledo Spanish court etiquette was introduced and society became gradually more feudalised. The new aristocracy, owing their status to the Medici, overshadowed the senators, with a consequent division between those who sought civic as against court honours. The gradual emergence of the Medici as a ruling dynasty owed much to a deliberate artistic policy that was expressed in vast cycles of frescoes within their palaces and villas glorifying events in the family's history, in erecting public monuments and statues in their own honour, and in the periodic staging of stupendous fêtes in which every event in the life of the Medici family was presented as being of universal import.[1]

The Grand Duke Ferdinand

The Grand Duke Ferdinand was Cosimo's fourth son. At the age of fourteen he had been made a cardinal and he held court in Rome until he succeeded his brother in October 1587. While in Rome he had founded the great missionary establishment, the Propaganda, and also accumulated a vast collection of classical antiquities, acquired through the dissolution of the papal collections by Counter-Reformation popes. The collection included the celebrated *Venus de'Medici*, the *Wrestlers*, the *Dancing Faun* and the group of *Niobe and her children*, all of which Ferdinand housed in the Medici villa in Rome, but later, after his accession, transferred to the Uffizi. Ferdinand had hated his brother and bitterly opposed his pro-Spanish policies, so that his accession meant a total *volte-face* in the political attitudes of the state of Tuscany. As cardinal he had always maintained a secret correspondence with Catherine de'Medici, and when he became Grand Duke in 1587 it meant a dramatic reversal of policies from pro-Habsburg to pro-Valois. This, ironically, occurred at a moment when the fortunes of the French royal house were at their lowest ebb. Such a reversal placed Tuscany decisively back amongst the so-called *stati liberi*, those Italian states headed by Venice and Savoy that attempted to maintain some form of independence both politically and ideologically, outside the iron grip of Habsburg dominion and a subservient reactionary papacy. The reign of Ferdinand marked the beginning of the last flickers of Italian liberalism (of which the most famous instance was to be the confrontation of Venice and the Pope over Paolo Sarpi) which were to be such a feature of the decades leading up to the Thirty Years War.

Ferdinand announced the nature of his rule by his *impresa*, a swarm of bees encompassing their queen and the motto *Majestate Tantum*, signifying that his government should be just and temperate and one that would enable his people to lay up wealth as bees stored honey. In a Europe rent by religious war and economic disorder the state of Tuscany under the liberal rule of Ferdinand assumed an important place in European politics in the last two decades of the sixteenth century. The grand dukes remained bankers and although Florentine banking had suffered a severe setback when Spain had declared its bankruptcy in 1580, this had not upset the Medici bank. Central to grand-ducal policy was the creation and enlargement of the port of Livorno, where the grand dukes proclaimed complete religious toleration. To it flocked both Protestant and Catholic English, Huguenots from Marseilles, Portuguese Jews, Flemings, merchants and traders of every nation seeking shelter from the political and religious disorder of their own countries. Together with Genoa, Livorno became the leading port in the Mediterranean at the close of the sixteenth century. Similarly there was an encouragement of agriculture

manifested in the draining of the Valdichiana, and there was a militant naval policy both in the activities of the grand-ducal order, the Knights of St Stephen, in sweeping the infidel from the seas, and in the voyages of discovery, which Ferdinand seriously supported and encouraged. The Medici family were the foremost bankers and traders and their fabulous wealth was reflected in the sumptuous richness of their court. While commerce and agriculture flourished, art and science were promoted. The grand-ducal gardens were the most marvellous in Tuscany, and Ferdinand established a botanical garden in 1593. The ablest physicians were attracted to teach medicine at Pisa, where Galileo was professor of mathematics from 1589 to 1592. In addition, the Medici art collections were thrown open to public view and the architect Bernardo Buontalenti created the Tribuna with its ceiling of mother-of-pearl set in gilded gesso and its pavement inlaid with coloured marbles. The grand duke also collected the rarest manuscripts from Egypt, Persia and Ethiopia for his library and his chapel was staffed by some of the greatest singers and composers of the day. The reign of the Grand Duke Ferdinand was indeed a golden age for Tuscany.

The Entry of Christina of Lorraine into Florence, 1589

As early as the close of 1587 Ferdinand had arranged that he should marry Christina, Catherine de'Medici's grand-daughter, then aged twenty-two. Catherine de'Medici and Henri III sent Monsieur Albin to Florence and maintained the negotiations via Orazio Rucellai. When news reached Madrid of the impending alliance, Philip II was furious and countered with alternative offers of an Austrian archduchess or a princess of Braganza, both of which were promptly rejected by Ferdinand. The king of Spain's annoyance was increased by the duke's demand that Spanish military governors should be relieved of their posts in Tuscany and that the vast debts owing to the Medici bank should be repaid. In October Orazio Rucellai arrived at the French court to conclude the marriage negotiations. Christina came with a dowry of 600,000 crowns, 50,000 in jewels, together with the renunciation of claims on Medicean property by Catherine and a transfer to Christina of the queen mother's rights to the Duchy of Urbino. On the day on which magnificent jewels arrived at the French court for the bride, the duke of Guise was assassinated by order of the king. This, together with the death of Catherine herself on January 5th 1589, delayed the departure of the bride. 'Happy are you, my niece', said

Henri III, 'for you will be in a peaceful land and not see the ruin of my poor kingdom.' On February 27th the *fiançailles* took place at Cheverny and the day after Christina left on her journey. The collapse of royal power was such that an army was needed to conduct the bride and her train in safety to Marseilles, which had declared itself a republic. On April 23rd the flotilla bearing the new grand duchess anchored at Livorno. Travelling via Pisa to the Medici villa of Poggio a Caiano Christina met her husband for the first time and on April 30th the bride made her solemn entry into Florence.

Everything for the Medici depended on the creation of precedent. The first Medici bride to be accorded a triumphal entry was, as we have seen, Eleonora of Toledo, daughter of the Viceroy of Naples, chosen by Charles V as wife for Cosimo I in 1539.[2] In addition to the imperial eulogy (essential as the Medici owed their status as dukes to the emperor) we can trace for the first time a substantial escalation in the creation of a family mythology with paintings celebrating the victories of Giovanni della Bande Nere on a triumphal arch at Prato and an equestrian statue of him by Il Tribolo at San Marco. This, however, was a slight affair compared to the enormous elaboration that took place twenty six years later when a second, far grander bride, Joanna of Austria, sister of the Holy Roman Emperor Maximilian II, entered Florence.[3] In 1565 the status of the Medici was considerably different from what it had been in 1539, so Duke Cosimo instructed Don Vincenzo Borghini, Prior of the Innocenti and a veritable mine of relevant and bizarre erudition, to undertake research into the conventions of the royal entry. Borghini's elaborate report still survives. His main conclusions are that there were three types of entry: the first that of a prince into a city of his own; the second that of a prince into a city belonging to another ruler; and the third an entry in connection with a marriage. The result of this learned discourse was a pattern of themes for the reception of a Medici bride that was to be enacted many times in the next century. Borghini's programme began with an arch dedicated to the city of Florence; next, a decoration to Hymen, god of marriage; then an arch celebrating the bride's own family; then an amphitheatre lauding the groom's family; and finally, three arches expressing the wisdom and magnanimity of Duke Cosimo's rule. This was embodied in an arch devoted to *Religione*, which led on to one on the subject of *Prudenza Civile* closing with *Tranquillità Pubblica* which, in tribute to the Medici, was found to reside in the Palazzo Vecchio.

Borghini's notebooks for this entry provide a unique glimpse into the enormous research and consultation that went on between the duke himself and Vasari, who was in charge of actually supervising the team of architects, sculptors and painters necessary to carry out street decor on this scale. The resulting decorations in the monochrome antique manner, quite

unlike the multi-coloured *tableaux vivants* still customary north of the Alps, show that Florence was still in the vanguard in the successful temporary transformation of a city into a humanist dreamland; its citizens found themselves seemingly wandering through ancient Rome at its apogee. Here the new harmonious architecture of the renaissance related to man the microcosm was seen on a scale never achieved in permanent form. Sadly, no such revealing documentation survives for 1589.

Christina took the same route into Florence as the one taken by Joanna twenty-four years before. The entry this time was arranged under the direction of Niccolo Gaddi, who had total control of *le invenzioni*, which basically elaborated themes begun in the 1565 entry.[4] Pietro Angelio da Barga wrote the inscriptions and verses and a vast team of architects, sculptors and painters laboured upon it. The underlying programme for the street decorations is revealed by Gaddi in his commentary on the last arch, when he writes that the story told was 'the foundation and the restoration of the city of Florence, and its coming to honour and greatness, through such and so many victories, and its coming to its supreme height, and to a royal state'. This entailed a deliberate presentation, or rather distortion, of Florentine history as an inevitable progression from republican rudeness to monarchial perfection, with the Medici presented as the preordained ultimate power on account of their military prowess, civic virtue, munificence and liberality.

The first arch, following the pattern of Joanna's entry, was dedicated to the city of Florence and its history. Scenes included the founding of 84 Florence by the imperial triumvirate of Augustus, Anthony and Lepidus, its second foundation by Charlemagne, the union of Florence and Fiesole leading to a climax in a canvas by Alessandro Allori depicting Florence and her dependants. The city was significantly attired 'in a regal habit, similar to that worn by the grand dukes' and her cloak was embroidered with the Medici arms.

The Medici theme was further developed in the second arch, which celebrated previous Medici marriages and told the story of the present one. In a Europe where it seemed that the French monarchy was at its nadir, Christina was greeted by a huge canvas in the centre of which her grandmother, Catherine de'Medici was seated in splendour surrounded by 85 famous members of the Medici family: Popes Leo X and Clement VII, the Cardinals Ippolito and Giovanni de'Medici, the Duke Alessandro, the Grand Dukes Cosimo and Francesco, arrayed in their robes and wearing ducal crowns, and the whole French royal family, including all to whom they were married, except Philip II of Spain, husband of Catherine's daughter Elizabeth. In this astounding tableau Ferdinand made a public statement of his policy to emphasise that Tuscany was not a Spanish province and exalted his family as equals of the French royal house,

casting Catherine in the role of a kind of grandmother of Europe. Further canvases celebrated previous French marriages, of Catherine to Henri II, and of Duke Charles of Lorraine to Claude of France, while events in this bride's life were also depicted, including her parting from her family and her embarkation from Marseilles.

The exaltation of the Medici by a careful juxtaposition with other grander figures was elaborated on the Ponte Sta Trinità, on which four statues of founders of Florence were erected along with Cosimo Vecchio and Cosimo, the first grand duke. Here the two Medici were presented as 'founders' within this present age. There followed the customary arch dedicated to the bride's family, this time the house of Lorraine, descendants of the crusading king of Jerusalem, Geoffrey of Boulogne, and a decoration tactfully in praise of Charles V (who had restored the Medici to power in Florence) and Philip II (who decidedly did not approve of the marriage) with large paintings of the battles of Linz and Lepanto, to both of which victories against the Turk Duke Cosimo had contributed. As the bride advanced through the streets ever closer to the Palazzo Vecchio the glorification of the groom's family intensified. The virtues of a good ruler that had formed so substantial a part of the 1565 entry were abandoned in favour of outright apotheosis. In one Cosimo and Eleanor were shown as golden statues surrounded by their family. Even the unpopular Francesco was suddenly resurrected and surprisingly depicted as 'a true mirror of the just and temperate life'. Three scenes portrayed the crucial events in Cosimo's life: Pius IV authorising the creation of the establishment of the Order of Stephen; Cosimo organizing the fortification of Tuscan cities; and, as a climax, his creation as Duke on January 9th, 1536.

The decoration before the palace contained the real crux of the entry. One scene showed Cosimo crowned grand duke by Pius V, another Francesco enthroned amid his court and magistrates — a placating gesture towards the city — while in the centre there was perhaps the most significant statement about Medici rule in the entire entry. In the midst of a large canvas sat Tuscany, arrayed in the grand-ducal mantle, her crown being taken away from her by the pagan Etruscan King Porsenna, while
86 Cosimo leant forward to crown her yet again. The Medici grand dukes are here presented as restoring Tuscany to her ancient purity of monarchical rule, made proper because the Medici are monuments to Christian piety whereas Porsenna was one to idolatry. Behind him stood an altar adorned with pagan religious vessels. This extraordinary group was completed by Siena, in a robe embroidered with Medici *palle*, and by Tuscany presenting her sceptre to Florence in a robe 'similar to that of the grand dukes'. In this way, by means of allegorical tableaux and subtle juxtaposition of historical personages, the Medici family, who less than a hundred years before had been one of many rich mercantile families within Florence,

were presented as the heirs of ancient kings, as the equals of the house of Valois, as the preordained saviours of Florence, whose republican period was now viewed as an imperfection and prelude to the perfect rule of Medici autocracy. The decorations in the streets of Florence were no doubt intended to be more meaningful to its inhabitants than to the arriving bride.

The 'intermezzi' of 1589

The court now embarked on a cycle of fêtes that stretched over some three weeks, the climax of which were the celebrated intermezzi of 1589, a landmark in the origins of opera and in the history of theatrical production. As in the case of the *Balet Comique de la reyne*, the intermezzi were produced under the influence of humanist theories concerning music and spectacle and, as in the case of the *Balet Comique* also, they both ended in representing a compromise between the demands of the learned and those of a courtly audience. The music in the *Balet Comique* was strongly in the mood of *musique mesurée à l'antique* promoted by de Baïf's Academy, but it was without regular antique metre and the dance tunes were devoid of any humanist influence at all. None the less the central humanist position in which music was to be the handmaid of poetry and thus recapture ancient 'effects' was the dominant one. In the intermezzi for Christina the same problems were faced and the same solutions reached. In order to understand the intermezzi for Christina, however, we must first reconnoitre back in time to a tradition very different from that of the *ballet de cour*.

The tradition of intermezzi went back to the close of the fifteenth century. These were musical mythological interludes inserted between the acts of court plays and also into other forms of fêtes staged to mark great occasions, ballets, tournaments and other chivalrous *divertissements*. From the start they could be heavily political in intent.[5] At the Medici court these were developed into a major artistic phenomenon with elaborate visual spectacle allied to grandiose vocal and instrumental music. There was a series of seven intermezzi on the occasion of Cosimo's marriage to Eleanor of Toledo in 1539.[6] These were inserted into Antonio Landi's play *Il Commodo* and were written by Giovanbattista Strozzi with music by Corteccia and produced under the direction of Pier Francesco Giamballari. The themes were related to the play but each remained a separate piece unconnected with those before or after it. As the century progressed, and under the impact of late Renaissance humanism, intermezzi were to gain

thematic unity. Those of 1539 took place within the confines of an elaborate perspective stage setting for the comedy. There were classical rustic entrées of shepherds, of sirens, of Silenus and of nymphs who sang songs. Twenty-six years later the intermezzi for *La Cofanaria* with scenery by Giorgio Vasari did not substantially develop this format.[7] Again there was the standard Serlian *prospettiva* for the *commedia*, this time of Florence, and again the *intermezzi* took place within it, the only new effects being the introduction of cloud visions and an extensive use of trapdoors for the entry of demons and for the raising and lowering of props such as mountains. The event was staged within the *Salone del Cinquecento* of the Palazzo Vecchio which, until 1586, was to be the location of all major Medici fêtes and whose temporary decor for such occasions anticipated the ingredients that were to find permanent form in the *Teatro Mediceo*. In 1565 Vasari not only transformed the interior of the hall with a complex symbolic programme in honour of the marriage (even the chandeliers represented popes and emperors) but also 'a uso di teatro antico' with *gradi* for the spectators, a grand ducal box facing the stage, a *porta regia* forming a nascent proscenium arch and a front curtain which dropped. There was also an advance in the *intermezzi* in the introduction of a unity of theme, all being concerned with episodes from the life of Cupid and Psyche, whose union at the close was metamorphosed into that of the onlooking bride and groom, Joanna of Austria and Francesco de'Medici.

Thirty years divide these from the next major series of nuptial *intermezzi* which, if they had been marked by the same blaze of printed publicity as those of 1589, would undoubtedly be regarded as the seminal series. The occasion was the marriage of the Grand Duke Francesco's sister, Virginia de'Medici to Cesare d'Este, duke of Ferrara and it was the first time that the team of 1589, Giovanni de'Bardi together with the court Vitruvian architect-engineer, Bernardo Buontalenti (1536–1608), collaborated in staging six intermezzi for the play *L'Amico Fido*. The cost was stupendous, some 250,000 scudi, and more than four hundred workmen are said to have been involved in the actual production, which was without doubt a major landmark on two counts. The first was the *Teatro Mediceo*, the interior of which we have already glimpsed in Callot's famous etching of it in 1617.[8] This building was the direct ancestor of the baroque theatre, the culmination of a long series of transitory *salle des fêtes*, in the gardens, courtyards and finally the *Sala del Cinquecento* of the Medici palaces. This explains its form, rectangular with the customary *gradi* in a horseshoe shape around three sides facing a raised stage at one end on which could be exhibited scenery of a type that worked from the sight assumption of monocular vision whose centric ray emerged from the eye of the onlooking prince enthroned at the centre point of the main hall.

87

134

A graceful oval staircase linked stage and auditorium. The decision to build a permanent home for such spectacles reflected not only their growing importance as an aspect of rulership but the increasingly complicated nature of such events. For the first time the court fête ceased to be a migratory phenomenon and came to rest in a specially built room within the walls of the palace complex. By the middle of the following century, this was to become an essential ingredient of the apparatus of any baroque court. The Medici were slow in establishing a permanent court theatre. The Este had one in 1528 and the Gonzaga in 1549. We should perhaps qualify that word 'permanent'. The Teatro Mediceo is really a half-way house, for each time that it was utilised it was entirely redecorated and reinstalled even although this probably incorporated seating and machinery kept in store. Moreover the existence of an area designed for utilisation for fêtes did not exclude the continued erection of temporary theatres in other rooms and courtyards of the Medici palaces.

This was a revolutionary step in itself, but the second innovation related to the *intermezzi* themselves.[9] In comparison with their predecessors of the previous half century, this series embodied stupendous advances in engineering technique. Instead, for example, of a cloud being lowered and then pulled up again, it was now possible to blow it from the stage at ground level. There were also major innovations in respect of unity of theme. In the first *intermezzo* Jupiter and the gods celebrated the return of the Golden Age (a cliché of Medici eulogy)[10] through the marriage, and then Jove sent his blessings to earth to inaugurate the new era. In the second the audience was led to the realms of classical hell, where the devils lamented their defeat, and the story was continued in the third, where Spring arrived — in the Golden Age Spring is perpetual — and in the fourth, where the rejoicings of earth were extended to the sea, with Neptune calming the waves and sea-deities singing in praise of the nuptials. Juno, goddess of marriage, showered her blessings in the fifth and the happiness of earth and heaven were localised in the final intermezzo, in which shepherds and shepherdesses in Tuscan costume danced in triumph.

The subject matter was not new but for the first time the whole scene changed before the eyes of the audience. No longer were a few elements pushed, lowered or raised onto the main Serlian set for the comedy but each intermezzo saw the whole visual structure metamorphosed before the eyes of the spectators. There was no lowering of a curtain. The descriptions are all in terms of movement, of clouds floating, gods descending, furies ascending, waves billowing or trees sprouting leaves. Nothing like it had ever been attempted before and although its central motif was the homage of the gods to the bride and groom (a theme familiar from the cavalcade of the gods by Vasari in 1565), its allusions were deeper and richer, reflecting sharply the preoccupations of the

mysterious *Principe dello Studiolo*. The four central intermezzi took the audience in breathtaking manner through the elements: fire (hell), earth (Primavera), water (Neptune) and air (Juno). It was a vision of the magical hermetic universe as it was known to the Florentine neoplatonists from Ficino onwards. It reflected exactly their aspirations, in which it seemed man had set himself in tune with and conquered the elements into submission so that they could pour forth their riches in his service, a theme reechoed in the abstruse schema for Duke Francesco's studiolo in the Palazzo Vecchio. Not only did it encapsulate current Florentine philosophical attitudes but also scientific ones. Buontalenti was aware of the works of Hero of Alexandria, so that the intermezzi must have been conceived too as a triumph of the ressurected scientific feats of classical antiquity. It can be no coincidence that (as we have noted) the publication of Hero's works by Baldi in Italian occurred in the same year as the famous 1589 intermezzi.

The intermezzi of 1589 were a product of the same team.[11] Music was by musicians of the grand-ducal chapel, Cristofano Malvezzi and Luca Marenzio, and three young, advanced composers, Emilio de'Cavalieri, Guilio Caccini (1546–1618) and Jacopo Peri (1561–1633). Cavalieri occupied a special position because Ferdinand had appointed him superintendent of his court fêtes, and although de'Bardi was the most heavily involved he was rather a relic from the reign of the duke's unpopular brother, Francesco. The production was magnificent and cost 30,255 *fiorini*, 4 *lire* and 25 *soldi*. Its technical side was under the direction of Ser Jacopo de'Corsi, who instructed the detachments of men who were stationed at all points backstage: some to trim wicks and refill lamps, others to man the windlasses controlling clouds or to push back and forth shutters within their grooves for scene changes. Two hundred and eighty-six costumes were made, on which work began in October 1588. Two tailors with fifty assistants constructed them, virtually every detail having been specified by Count de'Bardi, and amplified by the designer Buontalenti. Every dress was an archaeological triumph, each attribute being based on a classical source. Unlike 1586 we have a plethora of information not only in the form of manuscript accounts and descriptions but in the surviving designs for both the scenery and costumes. In addition the grand duke must have authorised the exceptional number of official accounts which ensured both its European fame and his own. Even more significant were the sets of engravings by Agostino Caracci (1557–1602), Epiphanio d'Alfiano and Orazio Scarabelli which appeared three years later in 1592. They were to be the fount of Italian baroque scenography as well as influencing the development of the stage north of the Alps, above all the Stuart court masques designed by Inigo Jones *fiorentino*.

On May 2nd 1589 the front curtain in the Teatro Mediceo parted to reveal a Doric temple and above it a cloud, surrounded by rays of light, which slowly descended to the ground. On this rode the Doric Harmony, singing of her descent to mortals and especially to the bride and groom, this 'nuova Minerva' and her 'forte Alcide'. This formed the prologue to Girolamo Bargagli's comedy, *La Pellegrina*, which was acted in the usual Serlian setting, this time a view of Pisa incorporating some of its most important buildings and as usual presented as an image of Medici power over one of the subject cities of Tuscany. The initial statement in the figure of the Doric Harmony was carried to fruition in the first intermezzo which took the form of a representation of the Harmony of the Spheres 88 according to Platonic cosmology, and in particular as described in the tenth book of Plato's *Republic*, The *prospettiva* was suddenly covered with star-spangled clouds. Eight Platonic sirens plus two more of the ninth and tenth sphere sat on clouds telling how they had forsaken the heavens to sing the praises of the bride. On a central cloud sat Necessity on a throne with a diamond spindle of the cosmos between her knees. She was attended by the three Parcae or Fates and they in turn were flanked by clouds bearing the seven planets and Astraea, whose advent on earth signalled the return of the Golden Age (a theme reiterated from 1586 and earlier). Above were twelve heroes and heroines, each pair embodying virtues attributed to the onlooking couple. Both the sirens and the planets joined in a dialogue describing the joy of the cosmos at so auspicious an alliance and as the clouds arose from the lower part of the stage sunlight streamed in, while above night approached. A concluding madrigal expressed hopes of 'glorious heroes' as a result of the match. As the cloud vision faded the stage was filled with sunlight, revealing the *prospettiva* of the city of Pisa.

This extraordinary scene combined a learned public exposition of a programme for musical reform with compliments to the bride and groom. The musical ideas stem from the *Camerata fiorentina dei Bardi*, which was presided over by Giovanni de'Bardi, Conte di Vernio, humanist and maecenas, and which, between the years 1576 and 1582, presented a programme for the revival of Greek tragedy together with the use of music. Within this circle of reformers moved Piero Strozzi who, together with de'Bardi, was one of the closest of Galileo's collaborators in the search 'towards the imitation by song of that which is spoken', a quest that led to the earliest operas. Already in the *Sbarra* of 1579 to celebrate the wedding of Bianca Cappello to Francesco de'Medici this had been introduced into court spectacle.[12] One of the surviving madrigals used on that occasion is one in which a soprano sang a poetic text, following its inflexions to a bass accompaniment.

The first intermezzo on the Doric mode, which, following Plato and

Aristotle, de'Bardi proclaimed to be the most excellent, established that the theme of the intermezzi of 1589 was the re-creation of ancient music, both *musica mundana* and *musica humana*. The opening intermezzo was an expression of *musica mundana* and the six intermezzi as a series elaborated the powers of music with heroic examples from Greek mythology, ending in the sixth with a representation of its gift to mankind. In the second *intermezzo*, the contest between the Muses and Pierides was enacted, set in a garden with orange and lemon trees. After the contest the prize was awarded to the Muses, following which the Pierides turned into magpies to run croaking and chattering from the stage. The main scenic feat of this intermezzo was the huge mountain pulled up from below stage. In the following scene, de'Bardi recreated an ancient Greek musical festival based on a passage in Lucian's *De Salutatione*, in which the people of Delphi sing Pythian songs in honour of Apollo, slayer of the dragon, the mighty battle of which actually took place before the eyes of the spectators. This was performed to music in ancient metric modes and was choreographed in five parts. In this Apollo, god of music, was seen in his role as purger by way of rhythmic dancing of the demons of the human soul. In the fourth intermezzo there was a return to Platonic cosmology and an enchantress summoned up a vision opposite to the first, that is, one of disharmony, a demonic hell scene. In the fifth de'Bardi took another example of the power of ancient music, the story of Arion (closely based on Plutarch's *Moralia*) being rescued by a music-loving dolphin who had heard his playing before he was thrown overboard from a ship. This time Buontalenti conjured up a sea-scene; the great soprano of the day, Vittoria Archelei, appeared as Amphitrite on a shell of mother-of-pearl, drawn by two dolphins, and attended by tritons and naiads who sang a song in praise of the marriage. A galley with a crew of forty entered, and after performing amazing feats, including striking sail in honour of the grand duke, the crew attacked the singing Arion, who jumped overboard. Arion next appeared playing his instrument, singing and floating through the waves on the back of a dolphin. Finally, in the sixth intermezzo, the themes of the spectacle came to a conclusion. As in the first scene, the whole stage was a cloud vision, which parted to reveal an Olympus of some twenty gods and Virtues. The myth to be enacted this time was derived from Plato's *Laws*. Jupiter, taking pity on humans, dispatched Harmony and Rhythm to earth so that man might obtain relief from his burdens through singing and dancing. As they descended, twenty couples in pastoral dress entered, lured by the celestial music, and danced a ballet while singing a song in honour of the bridal couple.

The 1589 intermezzi move on from those of 1586. They vividly reflect a new reign with new policies. In 1586 the harmony of the cosmos was conjured up in tribute to the nuptial couple as it had been so often for

Medici marriages. Three years later the theme was infinitely more erudite, de'Bardi and Buontalenti presenting the onlooking court with a total vision of the elements (air, two and six, earth, three, fire, four, and water, five) and universe in a series of moving visions in affirmation of a philosophical belief in its structure according to number within the Pythagorean-Platonic tradition as exemplified above all on earth by music. The impact on the audience of these astonishing mobile tableaux must have been staggering. What they saw set before them were the most profound beliefs and aspirations of later mannerist society, the tuning of earth to heaven. In this way the 1589 intermezzi seem almost a logical conclusion to the ideological pre-occupations of Valois court *magnificences*; and perhaps this is not surprising in view of the fact that they were staged to celebrate a Medici-Valois alliance. But, unlike their French predecessors, there is nothing disparate about them. Perhaps they deserve to be placed into a broader European political context in addition to the more familiar artistic one. Indeed, preoccupation by scholars with the artistic significance of this event has obscured its political implications. This was a great fête staged by an anti-Habsburg power in the immediate aftermath of the defeat of the Spanish Armada in an Italy dominated by Philip II. Any anti-Habsburg stance had to be made in a veiled and covert way which was capable of more than one reading. The *intermezzi* made use of a cosmology of harmony that crossed all ideological barriers. The printed accounts and the engravings must have carried through Europe not only a message of Medici magnificence but of the pledge of the ruler of Tuscany to a policy of peace and harmony within a European context. The illustrations were significantly issued three years after the event when Medici money was financing the armies of the Huguenot Henri IV in his struggle against the forces of Spain and the Catholic League. Would it be too fanciful to read the intermezzi of 1589 as the embodiment in symbolic terms of the hopes of liberal anti-Habsburg Europe on whatever side of the great religious divide?

But in the long run it was to be Buontalenti's contribution that was to be the most significant.[13] Together with Brunelleschi he must stand as one of the prime figures in the evolution of the renaissance court fête as a visual experience. Brunelleschi stands at the beginning; Buontalenti, as his direct heir through a succession of Medicean Vitruvian architect-engineers, was to carry the quest for re-creating the antique stage to a new final perfection. Born in 1536, he had been trained at the grand-ducal court and was early associated with the Grand Duke Francesco and shared with him a passion for things mechanical and scientific. One of the earliest anecdotes concerning Buontalenti recalls a childhood toy he made, a peep-show with a representation of the heavens together with floating angels. The history of court spectacle, as we have already seen, is closely aligned

to developments in engineering; indeed, one of the earliest applications of the new discoveries in the way of machines was to be to theatrical peep-shows in which a court audience was filled with wonder by being presented with a facsimile of the physical world.

Buontalenti belongs to this ethos of mannerist marvels, designing strange grottoes and automata for Francesco's villa at Pratolino. His temporary *mise en scène* for Medici baptisms, obsequies and marriages elevated the family, by means of visual reference, onto a heroic level. The designs for the 1589 intermezzi are crucial, for they are the earliest mass-disseminated illustrations of what became a norm throughout Europe for theatrical visual experience for the next three hundred years, the proscenium arch behind which receded ranks of side wings, the vista closed by a back-shutter. Such a solution was probably reached in 1586 in the earlier series of intermezzi; for these we have no certain designs, but the Uffizi theatre, the architecture of which assumes such a peep-show arrangement, was built for them. The theme of both sets of intermezzi was harmonious and utopian in their presentation of an ordered Pythagorean-Platonic cosmos. This preoccupation also finds expression in the compositional structure of the sets which, although used as a vehicle for bizarre and exotic manneriest fantasies, always arranged them in an absolutely balanced High Renaissance compositional order (as exemplified by Raphael's *Disputà*). All the sets work on the principle of a receding elliptical curve, the side wings diminishing in size into the distance, and the actors, whether on ground level or in the heavens, arranged to accentuate this. The fact that in these early designs the artist always includes the performers is an indication of his powerful position as the manipulator and director of the overall stage picture. It is significant that this highly artificial means of creating visual experience and controlling its reception by the audience was evolved at a court presided over by a new dynasty ever-anxious to promote itself to new levels of grandeur to conceal its bourgeois origins. Enclosed within the *teatro* of the Uffizi Palace, an audience of some three thousand was to be subject time and again to some amazing spectacle glorifying the Medici in whose eyes all lines of vision met.

This development of the proscenium stage and its machinery at the Medici court, a direct descendant of the *sacre rappresentazioni* devised by Brunelleschi, is a continuous technical evolution which bridges for us the gap between Serlio's *Architettura* (1545) and Niccolò Sabbatini's *Pratica di fabricar scene e macchine ne' teatri* (1637–38), which codifies the mechanics of the baroque stage. We need to place this development within its ideological context, for it emerged as the direct result of particular circumstances. Under Cosimo I there was a desire for Medici splendour and for a re-creation of the antique theatre with its Vitruvian machinery in

the service of the state. By the late 1560s *periaktoi* were used for scene changes during *commedie*. But the real impulse that produced the peep-show stage were the preoccupations of the Grand Duke Francesco. What is so typical and yet so strange is this late mannerist alliance of science and art, when the technical advances of the former are not used initially for any obvious utilitarian ends but indeed for exactly the opposite. The researches, for example, into the chemistry of materials that took place in the Medici *Fonderia* was used to produce objects of luxury: rich porcelain, artificial jewels and exotic tableware in strange natural materials. The astonishing advances in hydraulics were put to use in the gardens and grottoes of the grand duke's fantastic villa at Pratolino to create fountains and to set in motion strange symbolic automata. The scenography of the intermezzi of 1586 and 1589, both the work of the Grand Duke Francesco's architect-engineer, Bernardo Buontalenti, belongs directly to this alliance of science and art; once again, it does not produce anything in the least rational in our terms, but uses instead complicated feats of engineering and dynamics to conjure up for a select aristocratic audience facsimiles of the visible and invisible world, in terms of late renaissance Platonism and the hermetic tradition.

The cult of chivalry: the 'sbarra' and 'naumachia'

All the other entertainments save one were minor and it is noticeable that it is the latter which were staged in the *piazze* of the city or on the river Arno and were hence accessible, like the temporary street decorations, to the ordinary citizens. On May 4th the traditional *calcio* game took place in the Piazza Sta Croce between two teams of fifty on behalf of the grand duke and duchess. Three days later, Easter Sunday, there was a state banquet in the Salone dei Cinquecento with an abundance of music. On the 8th the populace were diverted yet again this time with animal baiting in the Piazza Sta Croce followed on the 10th by running at the quintain. But the most important of these events was the *Sbarra* and the *naumachia* which took place on May 11th in the courtyard of the Pitti Palace.

The intermezzi were entirely a professional performance with actors, singers and musicians. It was not until into the next century that the Medici and members of their court were actually to cast themselves into mute acting roles framed by the powerful emblematics of a series of *intermezzi*. We can see this in Callot's etching of *La Liberazione di Tirreno*

(1617) with its courtly ballet focussing on the grand duke and duchess. In this instance there was a marked contrast with what was customary at the northern courts. Louise de Lorraine, for example, danced in her *Balet Comique* (1581) and Henry, prince of Wales headed a group of noble youths in the masque of *Oberon* (1611). For the Florentine aristocrats the festival event in which they did actually act and assume allegorical roles was the tournament, a northern chivalrous form, already adopted by the Medici at the close of the fifteenth century but assiduously cultivated by them in the ducal period as an expression of the new hierarchical form of court life which its ceremonial display of knights, squires and pages emphasised. For the marriage of Francesco to Joanna of Austria in 1565 there had been the storming of a fortress in the Piazza Sta Maria Novella and in 1569, on the occasion of the birth of their first child, there had been a joust in the Piazza Sta Croce but the real precursor of the 1589 *sbarra* was that staged a decade before in exactly the same setting for the notorious marriage of Francesco to his Venetian mistress, Bianca Cappello.

The 1579 *sbarra* or barriers was a spectacular event and the earliest instance of a complex *tournoi à thème* at the Florentine court.[14] Its debt to the long series at the court of the Este dukes through the 1560s and early 1570s is only too apparent both in its setting and allegorical content. As in the instance I described, *Il Tempio d'Amore* (1565), the architectural environment was the palace courtyard but instead of *gradi* onlookers watched through the arcades around the three sides of the quadrangle looking towards the garden grotto and from the balconies of the floors above. As at Ferrara, the setting was elaborate and it is certain that elements of it were arranged in perspective. The side opposite the grand duchess's viewpoint, which housed the grotto, had three arches, the flanking ones framing marine *prospettiue* while the large central arch was closed off by a curtain which, when drawn, revealed a seascape that included a view of Venice. But we know that there were other additional scenic elements in the arena: Mount Helicon stood to one side, the city of Delphi to the other while, in between, stood the Temple of Apollo. The *thème* concerned the union of Beauty and Fortitude, *Amor et Arma*, complimentary to bride and groom with further allusions to the marriage of the two seas, the Venetian Adriatic and the Florentine Tyrrennian. As in the case of the Ferrarese *tournois à thèmes* there was an overall plot into which the various contending knights could weave their own allegorical guise. The 1579 one, in the courtly vein of *Orlando Furioso*, concerned a valiant knight, Uliterio, who was held captive by the five-headed monster of an enchantress, and of his lady, the Damigella di Dalmatia, who sought succour at the hands of the new grand duchess. The knights, headed by the grand duke himself, arrived on pageant cars, which ranged from a whole mountain which opened to reveal a hunting scene to a Venetian galley

drawn by sea horses and guided by Neptune.

The 1589 *sbarra* was its direct successor and the *cortile* of the Pitti Palace was arranged in exactly the same manner with a ceiling stretched over it, suspended lamps and the scenery concentrated at the grotto end opposite the ducal viewpoint.[15] This time the grotto was overlaid with elaborate architectural features that made up a Turkish castle. As no **94** publication was issued we have to rely on a description and a series of prints to reconstruct its content. This, it is clear, was very much along the lines of 1579 with *carri trionfali* on themes of magic, enchantments and transformations, heavily indebted to *Orlando Furioso* and *Gerusalemme Liberata* and in style lineally descended from those by Vasari for 1565 and those by Gualterotti for 1579. What can be disentangled from the visual evidence indicates a theme of evil enchantment aligned to profane love contrasted with the triumph of chaste love and the virtues in honour of the ducal couple. The enormously complex entry of Don Virginio de'Medici **95** catches the mood and at the same time reflects exactly the high pitch of late mannerist fantasy that these pageant entries sought at times to achieve, evocative of an art as bizarre as that of Arcimboldo (who in fact designed festivals for the Emperor Rudolf II). Don Virginio was preceded into the arena by a mountain on top of which sat an evil enchanter astride a crocodile, the mountain being full of animals that symbolised carnal lust and evil. Then came the knight himself attended by eight nymphs, who presented sonnets to the ladies of the court; he 'appeared to be a Mars'. A more likely characterisation would perhaps be Heroic Love. Pavoni, the diarist describes what followed:

> After him followed a garden which, while it entered the grounds began extending itself around and about, which made, with its beautiful and unexpected view all the surrounding people marvel, nor could they see by what it was transported, appearing as though it moved by enchantment: and in this garden was seen woven, and by a masterly hand made, different kinds of fancies, like ships, small galleys, towers, castles, men on horseback, pyramids, groves, an Elephant, and other animal quadrupeds, and it all was made of greenery; inside of which were heard different sorts of birds, which with the diversity of their singing made a harmony sweet and soft.

The etching shows us an impression (it seems to lack a lot of the details of the verbal description) of this extraordinary spectacle; it was as though a section of the ducal garden at Pratolino had been conjured by magic into the cortile. It depicts what must have been a significant dramatic tableau, in which the mountain of lust was encircled by this garden, celebrating chaste love and by implication the grand duke and duchess. The other entries were no less strange, including another mountain that opened to reveal an inferno, a galley (as in 1579), and a Petrarchan triumph of death and knights astride gigantic geese.

The *sbarra* would have been wholly comprehensible to the new duchess, although Buontalenti's chariots included mechanical effects far more complicated than anything achieved at the Valois court. The final spectacle, the *naumachia*, was, however, a novelty to the Medici court, a deliberate emulation of a festival form of classical antiquity when a Roman amphitheatre could be flooded for a sea encounter. Although water engagements were a familiar ingredient of Valois festivals, all of them made use of existing rivers, canals or lakes. What set the 1589 *naumachia* apart was the technical expertise necessary to suddenly flood the *cortile* five foot deep in water and float onto it eighteen galleys manned by a Christian force which stormed and took the infidel garrison. The theme took up the allusions to Lepanto in the entry, and represented in dramatic form the struggle against the Turks that was a grim reality to the Mediterranean powers.

The 1589 fêtes must occupy a central position in any account of pageantry as an adjunct of power. They represent the apogee of a long Medici policy of aggrandisement in which festival art played a vital role.[16] This can be followed in the multiplication of printed accounts and the decision to issue illustrations of the actual appearance of their marriage festivals.[17] This long series of festival books gradually developed a literary formula to describe such events which embodies a subtle interplay between art and power, the power of the prince to create art and, simultaneously, that art as a direct reflection of his magnificence, liberality and taste and hence his right to rule.

The Marriage of Henri IV and Marie de'Medici, 1600

Three months after these stupendous festivals a Dominican friar assassinated Henri III and the Huguenot Henri of Navarre became in title the next king of France. True to his liberal policies the Grand Duke Ferdinand never wavered in his loyalty to the French crown. It was indeed Medici loans that financed Henri IV's armies in the long war against the forces of the Catholic League and contributed substantially to putting him on the French throne. From the moment of his accession Ferdinand urged upon Henri IV the necessity of his conversion to Catholicism, and the Florentine court acted as mediator between the French king and Rome. Pope Clement VIII considered any proposals by Henri to change his faith merely a ruse to obtain the crown, a shallow event that he would immediately after promptly disclaim. Henri sent the Cardinal de Gondi to

Rome, but being refused admittance the cardinal took refuge at the Florentine court. Under continued pressure from Ferdinand Henri at last agreed to change his faith in April 1593, saying that he would do so after he had defeated the duke of Lorraine; on these grounds he was given four thousand more Swiss mercenaries and a further loan of two hundred thousand crowns by the Medici. Meanwhile Ferdinand opened negotiations with Rome on behalf of the French king by way of the cardinal of Toledo. With the Catholic League holding a General Assembly in Paris to name a Catholic king and with the Spanish ambassador provoking them by proposing the Infanta, Henri's abjuration of Protestantism and reception into the Catholic Church was accelerated, an event that finally happened on July 25th 1593. As Ferdinand had predicted, once the conversion had been achieved, the collapse of the League was only a matter of time, as was also the king's recognition by the pope.

The change in the position of the French monarchy was epitomised two years later in January 1595, when France formally declared war on Spain. Pressure from Ferdinand and from the emperor at last forced the pope to send Henri IV an ambassador. Shortly after that a French ambassador was allowed to proceed to Rome and the long-awaited reconciliation followed. Thenceforth the grand duke's efforts centred on obtaining peace, the result of which was the Treaty of Vervins in May 1598; this, like Câteau Cambrésis in 1559, was a turning-point in the pattern of European politics. Spain and France were both bankrupt and exhausted after years of war. This meant that during the closing decade of the sixteenth century the state of Tuscany came to occupy a unique position within Europe. At peace and rich from banking, from the profits of the corn trade and from the huge development of Livorno as an international port, the grand dukes of Tuscany enjoyed, for a brief period, a position they were never subsequently to attain.

The Treaty of Vervins laid the way open for a final coup of Medici diplomacy, another Medici bride for the French king. The divorce of Henri's wife, the brilliant Marguerite de Valois, in 1599 made possible Ferdinand's long-cherished project of marrying his niece, Marie de'Medici, then aged twenty-five, to Henri IV. This match had been mooted as long ago as 1592 but it was not resurrected until after Henri's conversion to Catholicism. Negotiations began in 1597, by which time Henri owed Ferdinand some 1,747,147 gold crowns. The French demanded a dowry of one and a half million, but in the end accepted 600,000 crowns, 350,000 in cash and the rest deducted from the enormous royal debt. In December 1599 the marriage contract was at last signed.

The official account describing the fêtes for this marriage alliance sets the event within vistas of universal peace of a kind that reflected the

messianic mood that so often surrounded Henri IV.[18] Marie's marriage was made public within Florence on April 30th, the day that Christina had entered the city as a bride eleven years before. Due to various delays the marriage did not actually take place until October 5th, when the Cardinal Aldobrandini, the papal legate, married the couple by proxy in the Duomo. Unlike previous Medici fêtes, these festivals, following the French pattern, were given by various people on different days. The grand duke's contribution was on the day of the wedding itself and took the form of an allegorical banquet in the Salone del Cinquecento of the Palazzo Vecchio, which had been specially decorated for the occasion.[19] On either side of the canopy, beneath which the new French queen sat, were canvases by Jacopo da Empoli in which her marriage was paralleled to that of Henri II to Catherine de'Medici. There was a buffet in the form of a gigantic *fleur de lys* placed between two windows running from floor to ceiling and composed of a display of the legendary collection of Medici plate of gold, silver, crystal and precious stones arranged as a glittering secular tabernacle. The banquet itself was a feast of compliment to the royal couple. One course was in the form of a winter landscape with a hunting scene, another dish was the lion of Florence, which opened to shower forth *fleur de lys* and then change into an eagle. There was a course on the theme of the labours of Hercules in compliment to the warrior bridegroom, and the bride had set before her an equestrian statue of her husband. That statue, together with the other edible sculpture, was the work of Pietro Tacca (1577–1640), the most important of Giovanni Bologna's assistants. Four years later this ephemeral tribute was to take permanent guise when Marie de'Medici ordered an equestrian state of Henri IV for the Pont Neuf in Paris.[20]

Suddenly in the midst of the revelry two luminous clouds began to propel themselves above the heads of the feasters across the length of the Salone, while simultaneously a rainbow, the traditional emblem of peace, vaulted the table at which the young French queen sat. In the clouds rode Juno drawn by peacocks and Minerva pulled by a unicorn. Juno began a contention with her sister goddess by complaining of her appearance at such peaceful nuptials. Minerva replied by gesturing to the rainbow and saying that she in fact brought love and peace. Together they celebrated the virtues of this martial king and ended with predictions of huge expansions of his empire even into the Orient. The dialogue had been written by Battista Guarino and the music was by Emilio de'Cavalieri.

Until the departure of the bride from Livorno fête succeeded fête. On October 6th Jacopo Corsi presented Jacopo Peri's *L'Euridice* with a libretto by Ottavio Rinuccini; on October 7th there was a *palio*; and on the eighth Riccardo Riccardi presented an entertainment in his garden. The official account is unillustrated, and virtually the only festival which is

visually commemorated is that given by the Florentine nobleman, Riccardo Riccardi, in the garden of his villa at Valfonda.[21] This became the subject 97 of a series of frescoes recording the four phases of the entertainment providing us with the only detailed glimpse of a renaissance garden fête that embraced singing, dancing, chivalrous exercises and the chase, a forerunner of a type of festival which was to reach its apogee in the spectacles presented by the later Medici in the amphitheatre of the gardens of the Pitti Palace in the next century. For the occasion the villa courtyard and its pergolas were transformed into an auditorium with Marie de'Medici enthroned in the centre in a box with a sunshade above her. The 'stage' was a broad gravelled path forming a processional route for the performers which had as its 'backcloth' two geometric plantings of trees divided by a central *allée* whose focal point was the royal box. The arrangement makes the point of the connexion between the use of perspective in garden design and in theatres neatly. The first fresco depicts the prologue, the inevitable opening *omaggio* to Marie de'Medici, which took the form of a chariot laden with golden hampers full of sweetmeats fashioned as fruits. This was wheeled in by twelve men and six women in the guise of gardeners, who danced and sang in tribute to music provided by musicians hidden in the nearby trees. The triumphal cars must have made their entrance to spectacular effect, slowly processing up the long *allée* towards the queen. In the next rode Pindarus, the Greek poet who wrote the *Epinacia*, who sang of the public games of antiquity as a preface to a chariot race *à l'antique*. In the third this classical precedent found its lineal descendant in the chivalrous exercises of the Medici court, when the Florentine poet Angelo Poliziano arrived to introduce a *corso al saracino*. Finally we glimpse Diana, goddess of the chase, addressing the queen from her chariot while huntsmen and dogs rush by signalling to the onlooking court the beginning of the hunt. No other source gives us such a powerful and accurate impression of the use and importance of the garden as a setting for *fêtes de cour* in the late sixteenth century.

Peri's *L'Euridice* had six scenes, none of great complexity; Vittoria Archilei sang the name part and Peri himself sang Orfeo. The performance was a landmark in the history of the evolution of opera, being an expression of the Academy's aims of reviving Greek drama and antique singing. Although performed on the occasion of the marriage, there were no reasons especially to relate it in theme to the event.[22]

Without doubt, however, the climax to the series of entertainments was that given by Gabbriel Chiabrera in the Teatro Mediceo. This was Caccini's *Il Rapimento di Cefalo*, with settings by Bernardo Buontalenti.[23] 98 It was the architect's last great court spectacle and is recorded as having 'the most marvellous machines that until now have ever been seen in our times'. Caccini's *Cefalo* was again a triumph of the principles of the

Academy, for in it the composer 'imitated the inflexions of speech, not losing the meaning amidst complex polyphonic music'. The story was not in itself directly related to the marriage, although the official account cites it as an example of heroic virtue; but the opera as a whole was encompassed by a prologue and epilogue which incorporated the most staggering visual effects in celebration of the alliance. It opened with a mountain scene, in the centre of which rose a huge mount some 20 ells high covered with trees and bushes. On its summit stood the winged horse Pegasus, while below sat Apollo and the Muses. Down the hill there gradually descended the figure of Poetry, who advanced downstage and sang the praises of Henri IV and the new queen, predicting, as had the goddesses at the banquet, a mighty destiny. Until now wrongly assigned to the 1589 *intermezzi*, a design for this prologue alone survives to give us an impression of what was regarded as the climax of Buontalenti's stagecraft. The mountain exceeded by 8 ells its predecessor in the second *intermezzo* of 1589, the winged Pegasus soaring up to the full height of the flanking wings.

The opera itself was full of astounding feats of engineering, but the greatest was yet to come. At the close the scene changed to a *gran teatro* in the Doric style with gilded columns and statues which architecturally continued the auditorium, so that the spectators seemed suddenly to find themselves incorporated within the *mise en scène*. Heroes stood on each side of the stage, while from below a vast machine slowly arose bearing Fame in a magnificent chariot, her wings extended and holding an olive branch and a trumpet. Beneath her sat eighteen ladies, representing towns over which the grand duke ruled, headed by the two cities of Florence and Siena, who sang the glories of the present duke. While the chariot gradually ascended into the heavens the machine supporting it sank back below stage, allowing the ladies to alight and salute a huge scarlet lily, emblem of the city of Florence, which blossomed in the background and around which hovered the *palle* of the Medici family.

Marie de'Medici left Florence on October 13th and some days later sailed from Livorno in a squadron of ships furnished by her husband, her uncle, the pope and the Order of St John. Accompanied by her aunt, the Duchess Christina, and her sister, the Duchess of Mantua, Marie landed at Marseilles on November 9th after a stormy journey. Travelling via Avignon to Lyons, into which she made a magnificent entry on December 3rd, she at last married her husband on December 10th, the ceremony being yet again conducted by the papal legate, the Cardinal Aldobrandini. An English pamphlet sums up the whole transaction with tart accuracy: 'Thus much in breefe haue I written vnto you, of our Ladie the French Queenes entrie into our citie of *Lyons*, whom I beseech God to preserue

148

for us, and shortly to send her some issue, which is a thing with all my heart I doe most desire . . .'[24]

The marriage of Cosimo de'Medici, 1608

This high-water mark of Medicean policy was not a success. Shortly after relations between Henri and Ferdinand cooled, notably because the French king refused to settle his debts and because he suddenly made peace with the grand duke's enemy, the Duke of Savoy, ceding him Saluzzo. This did not, however, mean a cessation of Ferdinand's liberal conciliatory policies, but rather reflected the difficulties of his naval policy, for which he needed the help of Spain in his war against the Turks and corsairs, and his desire to receive from the new king, Philip III, the investiture of Siena, which was held from the Spanish crown as a fief. His moderate nature and aversion to the excessive demands of Counter-Reformation popes found expression in his relations with James I of England and in his overt support of Venice in her famous quarrel with the pope over the Servite, Paolo Sarpi. Nonetheless, his desire for peace with Spain was finally settled in 1608 when his son Cosimo married Maria Maddelena, daughter of the Habsburg Archduke Charles of Graz and sister of the queen of Philip III of Spain.

The 1608 fêtes form an interesting epilogue to the reign of Ferdinand, who died a few months later.[25] In the entry of the Habsburg archduchess, Maria Maddelena, into Florence on October 18th 1608 any gestures towards heroic civic history were finally eliminated. This time the programme was that of absolutist rule. As usual the first arch was of the Tuscan order, but the two figures who dominated it were *Imperio de Terra* and *Imperio di Mare*, regal personages expressing the grand-ducal dominion over land and sea. References to the French royal house were omitted and the marriages to be recalled now were those of Alessandro de'Medici to Charles V's daughter, Margaret, and of Francesco to Joanna of Austria.

The decorations were relentlessly dynastic: an arch to glorify the house of Austria, a second in tribute to the bride's mother's family, the Wittelsbachs of Bavaria, a third in honour of the house of Lorraine in salute to Duchess Christina and the inevitable apotheosis of the house of Medici. As in 1589 the fêtes spread over three weeks and were even more elaborate than those for Christina. There was the usual *corso al saracino*, a *calcio*, banquets and religious processions, but four stupendous spectacles surpassed all the other festivities. The first was a court ball interrupted

from time to time by Francesco Cini's *Notte d'Amore*, a series of sudden scenic wonders which took the dancers by surprise every so often and guided them through the passage of a single night in allegorical terms, with visions of Night with its fantastic dreams to dawn. There was a horse ballet (to which we have already alluded) in emulation of the antique, the *Giostra de Venti*, and a river fête, the *Argonautica*. This was staged on the Arno and the most extraordinary and exotic boats had been constructed to bear the knights to the combat. In their design, which in the main was by Giulio Parigi (d.1635), they belong to a line of descent back to Vasari's mascarade of 1565 via Buontalenti's floats for the *sbarra* of 1589. Cosimo came as Jason on a ship based on a Venetian bucentaur and led his forces in the customary victory of an heir-apparent (like the future Philip II at Binche) over all forces, for he landed on an island, vanquished two fire-breathing bulls, two warriors and a dragon, seizing the Golden Fleece from its Temple to present to his bride.

But the climax was the intermezzi to adorn the pastoral, *Il Giudizio di Paride*, with scenery and costumes by Giulio Parigi, a pupil of Buontalenti, who had himself died only a few months before the marriage. These intermezzi pinpoint what can only be described as an increasing tension between the divergent demands of aesthetic creativity and those of political propaganda. So far the exponents of the Florentine *camerata* had been able successfully to marry their aims to reform music with a eulogy of Medici rule. In 1600 the problem had been neatly solved by the intermezzi forming a prologue and epilogue to what was in fact an early opera, Caccini's *Il Rapimento de Cefalo*. There was no such happy relationship eight years later. Into what was regarded as a pedestrian pastoral six intermezzi were inserted by no less than five different authors, all of them bar one overtly political. Only one, the Garden of Calypso, departed from convention and we know that it was regarded by at least the grand duchess as falling short. She complained about the incessant movement of the cloud machines, having seen it during rehearsal; but what probably upset her was its lack of allusion to the Medici, although the return of Ulysses to his wife could perhaps have been meant as an allusion to marital fidelity. All the rest was outright apotheosis along the lines of the state entry.

In the first the Palace of Fame, a fantastic structure made of mirror glass, received the heroic ancestors of both bride and groom after which the structure sank below stage while Fame arose heavenwards. In the second the imperial eagle, with wings outspread, swept down from the clouds to earth bearing the maiden Justice or Astraea on his back while virtues bearing the Medici *palle* sang of a new Golden Age, a hackneyed theme familiar from every previous marriage. In honour of the grand duke's colonial enterprises the Florentine Amerigo Vespucci sailed across

the seas of the Indies on a ship adorned with the lilies of the city, while in a fiery inferno Vulcan's forge was discovered shaping armour for the young Cosimo, whose valour was to be exercised against the barbarous corsairs.

The content of the intermezzi, staccato and unconnected, are inevitably intellectually disappointing. Parigi's settings, however, fall into a slightly different category. In one sense they were not an advance in 1589. They showed little of the astonishing richness of invention and fantasy of Buontalenti and for the most part re-worked his repertory: water (Amerigo 101 Vespucci), air (Astraea), fire (Vulcan) and earth (the Garden of Calypso). They also followed his compositional formula of the elliptical curve making use of the same diminishing side wings, the same central eye-catcher, the same cloud machines and the same deployment of performers both on stage and above it arranged in receding curves or along the line towards the vanishing point in order to emphasise the artificial perspective. What Parigi did was to introduce a strong architectural element which was present in several scenes, most notably the first and last, and also to achieve a much greater sense of infinity than Buontalenti. But although less important in one sense, in another they were destined to be far more so; due to the duke's obsession with giving the event more official publicity than any other Medici marriage, the prints of the settings must have been produced in large numbers. Their influence was European: in the case of Inigo Jones whole sets were copied for use in the Stuart court masques, and they were also pirated and copied in the same way in both Spain and Germany, so that their general influence as scenic types was to last the century.[26] This consistent adaptation and copying reflected not only their powerful artistic influence on the evolution of theatre but also how well this series of scenic types encapsulated the images necessary to express in visual terms absolute power and its opposing forces.

There is one *intermezzo* to which I have not yet referred, the last of the 102 series. In it one senses a stylistic crossroads, as we move out of mannerism into the baroque. In one composite image or diagram the neoplatonic 'ideas' of Ferdinand's rule were realised. Through a trapdoor arose the goddess of Peace enthroned before the Temple of Peace, in itself a building of harmonious classical proportions. Grouped round Peace were the principles of Ferdinand's rule, an interesting assortment: Remembrance of Old Friendship, Love of Country, Security, Faith, Concord, Abundance, Innocence, Justice, Reverence, Natural and Civic Law. These were further supported by fourteen priests, alluding to the piety of the grand duke's rule, which had reached its climax in the negotiations for the transfer of the Holy Sepulchre from Jerusalem to the Capella dei Principi in S Lorenzo. There was yet a further curious assemblage of abstractions of grand-ducal government: Pleasure, Jest, Laughter, Forgetfulness of Injuries

and Trade. Four clouds then appeared carrying the Olympian anti-gods, Bellona, Cybele, Pluto and Neptune, gods of violence and greed but also the means to earthly power. Peace harnessed these forces by letting each serve Cosimo and his bride within their respective spheres, so through them the virtues of Ferdinand's peaceful rule were extended to include war and wealth, sea and land. These deities descended to stage level on their clouds and dismounted to take up their places in tableaux depicting the terrestrial and sub-terrestrial spheres now subservient to the Medici. The rejoicings of earth were taken up to heaven, the clouds above revealing new harmonies culminating in a dance by Light Breezes, who floated in on two clouds from either side. At the court of the grand dukes of Tuscany the theatre had developed into a machine for presenting the realm of neoplatonic ideas made apprehensible and visible. The grand duke and his audience of some three thousand were contemplating the divine ideas of the principles of which on earth he was the living embodiment. From these neoplatonic machines created by the Vitruvian architect engineers of the Medici stemmed the theatre of illusion. This was the true theatre of power at its apogee; but all too quickly it became one of illusion with little reality. As Medici rule under Cosimo II swiftly declined, the festival images offered only the comfort of a distorting glass in which degenerate and weak rulers contemplated an image of power that no longer had substance.

V

ILLUSIONS OF ABSOLUTISM

Charles I and the Stuart Court Masque

Charles I was nine when the Grand Duke Ferdinand died. Sixteen years later, in 1625, he was to marry the duke's grand-daughter, Henrietta Maria, daughter of Marie de'Medici and Henri IV. This couple was to reign over the most brilliant and civilized court in Europe during the third decade of the seventeenth century until the mirage of peace and power they created vanished in a disastrous civil war. England, which had been on the fringes of Renaissance culture since the Reformation, suddenly became a focal point for everything of any importance that was happening within Europe in the arts. The king's agents scoured the Continent for paintings by the great artists of the Renaissance, especially those by the Venetian masters, Titian and Tintoretto. Among their greatest triumphs was the acquisition of the celebrated collection of the Duke of Mantua, including the famous Mantegna cartoons. To the court were attracted artists from abroad, the sculptors Francesco Fanelli and Hubert Le Sueur, the painters Daniel Mytens and Orazio Gentileschi, and above all Van Dyck. Even Rubens, the greatest exponent of the new baroque style, visited Charles's court in 1629. But the presiding genius of this remarkable renaissance was a man whose influence was seminal for the arts in England in whatever sphere he worked, the king's surveyor of works, Inigo Jones. Architect, painter, engineer, designer, connoisseur, collector, author, theoretician, he occupied a key place for nearly half a century at the courts of James I and Charles I. Together with Ben Jonson, Inigo Jones created that most distinctive manifestation of the art of the festival at the Stuart court, the masque.

The Court masque

The masque had a complex lineage back to late medieval disguisings and early Tudor pageants and mummings.[1] The principal factor which conditioned its evolution was its roots in compliment to the monarch. While other types of court entertainment, such as the tournament, went into decline and eventually died out, the masque burgeoned and grew ever more elaborate as a festival form ideally expressive of certain principles of government. The rise and fall of the masque is indeed exactly coincidental with the rise and fall of extreme claims to monarchical divinity. It cannot also be a coincidence that the disparate elements from which it emerged, all already in existence in the sixteenth century, suddenly came together to form this distinctive genre at the moment of the advent of the Stuarts and the official enunciation of the Divine Right of Kings.

Elizabeth I was always the focus for every form of adulation and panegyric in her festivals, but she never articulated such an ideological claim. The Elizabethan ethos stressed the chivalric code, as we have seen, exhibiting the queen to her people as the focus of the loyalty of her knights in her Accession Day Tilts. The Elizabethan monarchy was populist by instinct. It used alfresco shows to deliberate effect to display the monarch to every rank in the kingdom and, as with Charles V and and Catherine de'Medici, the royal progress was a prime instrument of rule. It was only under the Stuarts that exclusivity of access developed sharply, in a manner deliberately affected by the new petty dynasties of Italy. Not only did tournaments cease (the last Accession Day Tilt was in 1619); so eventually did the alfresco shows, there was no state entry after 1604, and there were only two reluctant progresses to Scotland in 1617 and 1633. Even the Order of the Garter ceremonies were transferred to Windsor by Charles I. Festivals were now removed into the confines of the palace in the form of the spectacular court masques staged in temporary theatres erected in the great *salle des fêtes* we know as the Whitehall Banqueting House which, as rebuilt by Inigo Jones, remains to this day. In 1637 a separate Masquing Room was erected, forerunner surely, had the monarchy survived, of a permanent court theatre of the type established in Florence in 1586.

The Stuart masques divide into two phases, the Jacobean and Caroline. From the point of view of art as power it is the latter which provides the most striking evidence. In literary terms, however, it is the former which is far superior because of Jonson's pen. James I admired his work and they became vehicles not only for pyrotechnics of erudition but low comedy and burlesque, elements missing from those staged for the less intellectual and priggish Charles I. The masque was essentially a composite form. This is difficult for us to grasp; we assume the importance of the literary text, because that alone remains today. But, for a contemporary, the primacy of

103

what was sung or spoken did not necessarily follow. As in the case of the Florentine *intermezzi*, it is impossible and pointless to disentangle the contributions of everyone: author, composer, designer, machinist and choreographer. However, the history of the English court masque is dominated by two famous figures who created it as a form, Ben Jonson and Inigo Jones. *The Masque of Blackness* of 1605 is the first of the Stuart masques and *Salmacida Spolia* in 1640 the last. Until 1631, when they finally parted company, Jonson and Jones together produced these annual spectacles of state performed each Twelfth Night and Shrovetide. After their famous quarrel it is usual to regard the masque, as presented by Jones himself, with the assistance of various tame poets, as a decadent form, in which what had been essentially a poetic means of expression became overloaded with pointless visual spectacle. The quarrel of Jones and Jonson was not, in fact, as used always to be assumed, one of the visual versus the verbal. Their trouble lay in the very similarity, and not in the divergence, of their views as to what made up the component parts of a court masque. Both of them printed their own definitions of these spectacles, seemingly different but in reality closely related. In 1631 Jonson wrote: '. . . all representations, especially those of this nature in court, public spectacles, either have been or ought to be the mirrors of man's life'.[2] Jones the year after described them as 'nothing else but pictures with light and motion'.[3]

The great Caroline masques of the 1630s created by Inigo Jones were based, as one would expect, on sound platonic doctrine. Jones in his own commentary to Aurelian Townshend's masque *Tempe Restored* (1632) elaborates his viewpoint when he states that he had designed the costume for Henrietta Maria 'so that corporeal beauty, consisting in symmetry, colour, and certain unexpressable graces, shining in the Queen's Majesty, may draw us to the contemplation of the beauty of the soul, unto which it hath analogy'.[4] Jonson's definition is really not so very different and has the same philosophical basis in platonism. As the masque in his view is a 'mirror', such an object of necessity demands a spectator, and therefore this presupposes that the masque is essentially a visual form. For Jonson, as for Jones, the court is looking at its real self in the court masque, seeing itself as in a mirror. The climax of all these performances is when the masquers themselves are revealed, inhabitants of the realm of neoplatonic ideas, to link with the world of reality before them in the general dancing of the court, fusing idea and reality into one.

Jones's scenery was essentially the action of the masque which its dialogue, songs and dances elucidated and moralised, but first and foremost the masque was a statement made visually by means of engineering. Every stage picture he presented was a symbol composed of a composite series of hieroglyphs. To a neoplatonist such as Jones truths

were best expressed in images, words occupying a lower place in the hierarchy of communication, being only the *name* of an *idea*, image or thing. The masques, therefore, belong directly to the Renaissance tradition of conceptualising abstractions. Jones is a textbook Renaissance neoplatonist of no great originality in his own philosophical assumptions,[5] which were derived from the standard books of reference by Renaissance architects and aesthetic theoreticians, who believed that it was images that *meant* and that words only *explained*. Jonson himself ironically belonged to the same tradition when he wrote: 'The conceits of the mind are pictures of things, and the tongue is the Interpreter of those pictures.'[6] To Jones's direct and uncompromising neoplatonism one must add his discipleship to Serlio's assertion concerning the role of stage machinery as the means to evoke wonder in the minds of spectators and, above all, as a way of expressing the magnificence of monarchs.[7]

To achieve his theatre of ideas Jones, who had visited Italy in the 1590s, introduced to England for the first time perspective stage scenery, although it took the court many years to read this properly. Even in Oxford in 1636 there were still people unable to understand the perspective stage scenery he had designed for the plays on the occasion of the king's visit. A bewildered observer described the side wings as being like bookcases jutting out in a library.[8] This inability to read stage pictures correctly reveals not only the aesthetic backwardness of England but the importance of the collusion of the audience in understanding perspective, and the success of Jones's neoplatonic pictures depended on having an audience that would accept his thought and vision premises. He could not work from the premise of a visually sophisticated audience in the same way as Buontalenti. In 1605, when Jones used perspective in the first of the masques, Jonson's *Masque of Blackness*, one courtier saw only a pageant car with a bevy of sea-monsters standing at one end of the hall, all fish and no sea, as he tartly remarked.[9] It can be no coincidence either that perspective stage scenery was used for court performances only, and that its introduction in England coincides with the serious promotion of the theory of the Divine Right of Kings. Perspective made the ruler the emblematic and ethical centre of every court production and emphasised the hierarchical gradations of court life.

The Stuart masques, even more powerfully than the Florentine *intermezzi*, were platonic 'ideas' made apprehensible by means of symbolic fables and miraculous resolutions. Courtiers were seen as heroes, kings became gods, actions were emblems, all of which demanded a viewer able to read the visual images unfolding before him. Occasionally he was helped by the spoken or sung dialogue; rarely there was a commentary published afterwards in which the hieroglyphs were unravelled for the vulgar. Even if the audience could not understand the frequently recondite

allegories, one must never underestimate the considerable pleasure afforded a Renaissance audience at being in the presence of what Jonson once referred to as 'removed mysteries'.[10] Inigo Jones's work for the Caroline court depended on an acceptance that seeing was believing, that the stage pictures he created had both a philosophical meaning and a moral force, and that in projecting illusions he was at the same time presenting a platonic reality.

The collusion of the spectator was all important, for what he was really called upon to contemplate were mechanical marvels. The incessant use of mystic symbols, spells, incantations and miraculous visions of the celestial world, the glimpses of hell or the sudden arrival of spring in winter might seem magical, but they were magical only if the onlooker wished them to be. Rather, he was admiring man's ability to create these illusions, to present visions of the physical world and then make them suddenly do the impossible. The masque in this sense, besides embodying platonic truth, celebrated the power of the rational mind in controlling the physical world. In it virtues were revealed, and the gods came down to earth, but the ultimate in extraordinary revelations always happened at the climactic moment when the audience itself was about to be included in the unfolding fable by means of ritual dances. All the masques express the power of the monarchy to bring harmony, the rich gifts of nature and the natural world into obedience. All move from initial statements of disorder and cosmic chaos towards revealing king and court abstracted in emblematic form as gods and goddesses, heroes and heroines, sun and stars. Year after year the exchequer poured money into these annual manifestations of harmonious visions of Stuart rule. Unfortunately for Charles I, the illusion of control manifested in these spectacles was unable to bring with it any corresponding reality.

The repertory of pictorial images needed to convey these set ideas was a very limited one: landscape, both wild and tame, the garden, the sea, the Underworld, the storm, the villa, the palace, the street or piazza, classical ruins, the heavens and, very occasionally and within the tradition of the Italian theatre, re-creations of actual places. Every masque makes a visual progress from disorder to order or from order to disorder and back to a higher order again. For Jones there are therefore only two repertories of stage picture. The first are ones of nature untamed and unleashed: tempests, stormy seas, flaming hell scenes, impenetrable forests; the second those evoking earthly and cosmic harmony; elegant villas, piazzas and palaces in the classical style, the safety of a port, the beauty of a garden in full flower, or the virtues of heaven itself in the form of spectacular cloud apparitions and glimpses of stars and planets. For nearly four decades Inigo Jones was presenting the same visual argument on behalf of the Stuart kings.

157

Inigo Jones, it is well known, drew heavily on engravings of scenes created for *intermezzi* at the Florentine court, but there the coincidence ends, for the motives behind the visions evoked by the Medici court were very different from those for the court of England. The first scene in *Albion's Triumph* (1632) was derived from Parigi's *Temple of Peace* in the *intermezzi* for *Il Giudizio di Paride*, and the Indian shore in the *Temple of Love* (1635) was lifted from *Il Nave di Amerigo Vespucci* in the same series, but there the connection ends. Jones had travelled to Italy in 1613–15 in the train of the connoisseur and diplomat, Thomas Howard, Earl of Arundel, and had studied closely, for instance, the Teatro Olimpico at Vicenza; but much of his stagecraft must have been self-invented, even if inspired by information from afar of the visual appearance of Florentine court spectacle. His concept of the role of an architect was directly in line of descent from Brunelleschi and Alberti; as such, inventing and providing machines for court spectacles was as central to his exposition of the role of the Vitruvian architect engineer as designing a permanent building or dealing with fortifications in the Civil War. His early masques used a turning machine, a *machina versatilis* for surprise effects, but from about 1610 onwards he used sliding shutters and side wings, the *scena ductilis*. These were utilised in Prince Henry's masque of *Oberon* (1611), in which **104, 105** rock shutters parted to reveal a fairy palace. By 1613, and probably from the very beginning, Jones had evolved an upper stage for heavenly tableaux, and in 1631 he introduced a fly gallery, allowing the front curtain to go up for the first time and deities to ascend out of sight. Cloud machines he continually elaborated and perfected over the years. In the early masques, for example, he developed the descent of a cloud bearing a chariot gently sloping downwards. By 1631 a cloud could descend to deposit a goddess in a throne on the stage and the cloud itself could be removed. During the 1630s, and again probably earlier, Jones made use of scenes of *relieve*, profiled cut-outs, sometimes three-dimensional, which were placed before the back cloth and revealed from time to time by parting the backshutters. These were often used as set pieces to break the monotony of a court play. The stage for the Stuart court masque was always a very shallow one, as the action took place mainly in the dancing area, which was reached by a combination of steps and slopes. From the evidence of the several hundred drawings that survive we know that Inigo Jones directly supervised the creation of the masques at all points, including the direction of the performers on stage. His drawings sometimes show performers massed as part of the stage picture.

The Divine Right of Kings

The masque is for the monarch and about the monarch in a way more overt and relentless than any festival form we have so far encountered; the more directly so in the reign of Charles I, as the king himself danced the leading part in these annual spectacles of state. Both Jones and the king made every Stuart court masque a vehicle not only for neoplatonic doctrine, but for an exposition of the political theory of the Divine Right of Kings. To understand them we must be familiar with the treatise by the king's father on the rights and duties of a sacred king, the *Basilikon Doron*, which James I had composed for the edification of his eldest son, Prince Henry. The central theme is not a complex one and can be summed up succinctly in the first two lines of the sonnet he wrote for the opening of the book:

> God gives not kings the stile of Gods in vaine:
> For on his throne his Scepter do they sway. . . .[11]

The king is the representative of God on earth and the greatest sin a subject can commit is to raise a hand in opposition. 'Therefore,' James instructed his son, 'you are little GOD to sit on his Throne, and rule over other men.'[12] The arguments on behalf of divine monarchy expounded in this book are more succinctly phrased in a speech James made to Parliament on March 21st 1609:

> The state of Monarchy is the supremest thing vpon earth. For Kings are not onely GODS Lieutenants vpon earth, and sit vpon GODS throne, but even by GOD himselfe they are called Gods. There bee three principall similitudes that illustrates the state of MONARCHIE: One taken out of the word of GOD; and the two other out of the grovnds of Policie and Philosophie. In the scriptures Kings are called Gods, and so their power after a certaine relation compared to the Diuine power. Kings are also compared to fathers of families: for a King is trewly Parens Patriae, the politique father of his people. And lastly, Kings are compared to the head of this Microcosme of the body of Man.[13]

Every masque devised by Inigo Jones is a visual realisation of these principles to its courtly onlookers.

The artistic and scientific knowledge of Inigo Jones in his role as the Vitruvian architect-engineer was to set forth the politico-religious theories of the first two Stuart monarchs. In one of the few statements certainly from Jones's hand in a commentary to *Tempe Restored* (1632), he makes one of the most extreme assertions concerning the nature of royalty to find voice during the period: 'In Heroic Virtue is figured the King's majesty, who therein transcends as far common men as they are above beasts, he being the only prototype to all the kingdoms under his monarchy of

religion, justice, and all the virtues joined together.'[14] In this definition Jones fuses the Divine Right of Kings with early seventeenth-century developments within the *speculum principis* tradition that were to lead in France to the absolutism of Louis XIV. In England they were cut short by the Civil War in 1642.

In tribute after tribute in the years of 'personal rule', the virtues and heroes of the past were not held up — as they had been in medieval and even humanistic mirrors — for imitation and emulation. The Divine Ruler does not need to model himself on examples from classical myth and antique history. In sharp contrast, he surpasses them, and it is his subjects who must study him as the living embodiment of the virtues. The task of Jones as the Vitruvian engineer was to translate into pictures with light and motion what one of the judges in the famous ship-money case involving John Hampden was to express as a legal principle. 'He is the first mover amongst these orbs of ours, and he is the circle of this circumference, and he is the centre of us all, wherein we all as the loins should meet. He is the soul of this body, whose proper act is to command.'[15]

The Caroline Masques

The Caroline masques all relate to the years of Charles's so-called 'personal rule', those eleven years between 1629 and 1640 in which he ruled without parliament, a period subsequently branded by the opposition as the Eleven Years' Tyranny.[16] In March 1629 parliament was dissolved, never to reassemble until the unhappy months of 1640. At home, efforts were made to revivify and expand the antiquated Tudor administrative machinery. Charles found a brilliant statesman in Thomas Wentworth, earl of Strafford, who was entrusted with establishing order in the north and in Ireland, and an efficient cleric in William Laud who, as successively bishop of London and archbishop of Canterbury, set about the radical overhaul of the strange patchwork that made up the Church of England. To understand the masques of Inigo Jones, which are so pure an expression of this decade, it is necessary to forget totally what happened after 1640 and to ignore, for the most part, Puritan opposition attitudes. It is essential to view these productions solely through the eyes of an optimistic king and his surveyor of works as they annually celebrated what they deluded themselves into believing to be the triumphant rule of a monarch by Divine Right.

During the years of personal rule Jones *invented* the myths of the masques. This is quite specifically stated in *Tempe Restored* (1632), where it is written that 'the subject and allegory of the masque, with the descriptions and apparatus of the scenes, were invented by Inigo Jones', and only 'the verses were written by Master Aurelian Townshend'.[17] In the same way in the last of the masques (1640) he is openly credited with 'the invention, ornament, scenes, and apparitions, with their descriptions'.[18] Both these are making explicit what must have been the normal relationship that governed the creation of these spectacles between 1631 and 1640. Although Jones invented the subject matter of the masques, he must have done so in consultation with the king and queen who acted in them.

Although Charles I ascended the throne in 1625, no great series of court entertainments began to be staged until the years of personal rule. By 1631, when the first, Ben Jonson's *Love's Triumph through Callipolis* and *Chloridia*, were staged, the mythology of the court was already fully developed. In these two masques the fundamental statements of Caroline mythology were forcefully made, and all the masques subsequent to them elaborated these preliminary assumptions. *Love's Triumph*,[19] the king's masque, opened with an allegorical representation of the cleansing of the court. Anti-masquers as the distractions and perversions of love were banished from Callipolis, 'the city of beauty and goodness'. This was a preface to the arrival of perfect love in the form of the king as Heroic Love and his courtiers as other forms of exemplary devotion. These voyage to pay tribute to the queen, Henrietta Maria, who was celebrated as a terrestrial manifestation of the neoplatonic ideal of Beauty and Virtue. And here the masque reveals itself as saturated in neoplatonism:

> To you that are by excellence a queen,
> The top of beauty! but of such an air
> As only by the mind's eye may be seen
> Your interwoven lines of good and fair . . .[20]

Such a revelation of love cannot be achieved until the city has been purified, and so a chorus walks about, bearing censers and exorcizing the place. Next the 'prospect of a sea appears', moving the court from the 106 enclosed world of the city and its buildings to vistas of the world of nature. Across the sea floated Charles and his train, a vision that would be read by the court audience not only as an image of love, for Venus arose 107 from the waves, but as a political statement of British sea-power. All British monarchs from Elizabeth I onwards were celebrated as sovereigns of the seas, whether under the allegorical guise of Cynthia or Neptune. Such a picture as the king bestriding the waves in triumph in Callipolis evoked for onlookers innumerable previous images of maritime power

claimed by the Tudor and Stuart kings. Indeed the rule of the latter was to founder on naval policy in the imposition of ship-money.

In a very precise analysis derived from Ficino's *Commentary on Plato's Symposium* Ben Jonson proceeds to define the relationship of the king to the queen:

> For Love without his object is soon gone;
> Love must have answering love to look upon.
> To you, best judge, then, of perfection!
> The queen of what is wonder in the place!
> Pure object of heroic love alone!
> The centre of perfection, sweetness, grace!
> Deign to receive all lines of love in one,
> And by reflecting of them fill this space,
> Till it a circle of those glories prove
> Fit to be sought by beauty, found by Love,
> Where Love is mutual, still
> All things in order move;
> The circle of the will
> Is the true sphere of Love.[21]

In these lines the Caroline court is cast as a circle in the midst of whose unexcepting orbit the queen reigns as a neoplatonic love goddess over the passions. She is the 'centre of proportion' and in her the 'lines of love' meet. From her, as the object of the king's devotion, radiate 'glories' which fill this courtly circle, whose boundary is defined as the royal will. In this way Jonson defines the precepts of absolutist rule, casting the king as supreme sovereign over both intellect and will. The image of the circle, a geometric shape that allows no exceptions to its boundaries, is perhaps the most significant emblem of a new era.

Having established these principles Jones makes his Vitruvian machine mutate to demonstrate the fruits of such a policy. We move visually from earth to heaven, for the clouds above part to reveal 'Euclia, or a fair glory', who celebrates the creation of order and beauty within the cosmos while Neptune in the waves below summons from the deep a rock bearing the Muses. The renaissance of the arts, the best-known aspect of the civilization of the court of Charles I, is a direct manifestation of this triumph of autocratic power. With these emblems of universal harmony and royal power giving birth to the arts set before the eyes of the onlookers, the masquers now join them in the ritual of the revels.

At their close, one final stage picture develops these images of earthly royal policy into abstract neoplatonic ideas. The scene changes to a garden, a vision of nature at its most tamed and cultivated and, at the same time, reflecting reality, for at the same period the royal gardens were being redesigned in the new Italianate style. Once more the clouds above

parted, this time to reveal the divine 'ideas' of which Charles I and Henrietta Maria seated beneath the state were terrestrial reflections — Jupiter and Juno, the king and queen of Heaven, attended by Hymen and Genius, the gods of marriage and generation. They in turn call upon Venus, queen of Love, who descended in a cloud which, when it reached ground level, was whisked away to reveal her enthroned. Love it is that links heaven and earth, and the two queens of Love, Henrietta Maria and Venus, were seen by the assembled court to contemplate each other from opposite ends of the hall. The masque closed with a simple allegory. Within this peaceful garden representing the State of England, a palm tree, the emblem of peace, arose bearing the British crown, while round its trunk were entwined the lily and the rose.

Chloridia, the queen's Shrovetide masque, was complementary to *Love's Triumph*.[22] Its theme was the transformation of Chloris by the love of Zephyrus, the west wind, into Flora, goddess of flowers. The curtain rose to reveal a pleasant landscape of hills and rivers to which this time **108** Zephyrus descended, calling upon Spring and asking that she execute Jove's bidding to make the earth another heaven. This, Spring replied, had already been accomplished by the flowers caused by 'yonder sun', gesturing towards the king seated beneath the state. So in this masque we open where the king's masque finished with a vision of the king's peace, of heaven come down to earth, and move from it through a myth that takes us first to hell, the anti-court, and then to a vision of a higher harmony, the bower of Chloris. Cupid, we are told, is in revolt and, forsaking his mother, has gone to hell, there exciting and stirring up jealousies and other passions among the gods to 'raise a chaos of calamity'. This was depicted in a series of anti-masques that anatomize the ills of the wrong sort of love. A dwarf postillion enters and satirises what is in fact the vicious underworld of the Stuart court, followed by a series of *entrées* in the manner of the French *ballet de cour*, which move from the woes wrought by Cupid — Jealousy, Disdain, Fear and Dissimulation — to the ills caused by Zephyrus upsetting the cosmos with winds, tempests, lightning and thunder. The evils were banished all of a sudden by the command of Juno, goddess of marriage, who again, as in *Love's Triumph*, symbolized the ideal marriage of the king and queen. '. . . the scene is changed into a delicious place figuring the bower of Chloris, wherein an arbour feigned of goldsmith's work, the ornament of which was borne up with terms of satyrs beautified with festoons, garlands and all sorts of fragrant flowers. Beyond all this in the sky afar off appeared a rainbow . . .'[23]

The rainbow symbolises peace, the king's peace, and the masquers led by Henrietta Maria represent the coming of Spring and the banishment of **109** the disharmony of Winter. They celebrate their triumph in a dance, after which the heavens part to reveal Iris and Juno, who tell of the defeat of

Cupid, who now sues for pardon. As in the case of *Love's Triumph*, this vision of nature tamed in the beauties of a garden, the handiwork of man civilizing wild nature, is an image of royal harmony. And as in *Love's Triumph* such benefits lead to a programme for the arts. 'Here out of the earth ariseth a hill, and on the top of it, a globe, on which Fame is seen standing with trumpet in her hand; and on the hill are seated four persons, presenting Poesy, History, Architecture and Sculpture.'[24] A life of virtue leads to heaven, and the arts enable such noble acts to be immortalized. Fame slowly ascended into the clouds, leaving an earth transformed and rich with Juno's gifts: fountains, rivers, the Spring, the star flowers of the nymph Chloris. As Fame arose the hill sank, the heavens closed once more and the focus was shifted down to the dancing area below, where order and harmony were expressed in the dance.

Every year for the next decade, such statements on the royal rule were to be made in the masque, which are the quintessential expressions of the mind of the Caroline court. These all, with one exception, propound the same principles of absolutist rule: power, they say, is love; opposition and rebellion are passions unleashed, both human and cosmological, the king is order, gentle, civilized, nature and peace. The court masques, as devised by Inigo Jones and Charles I through the 1630s, derived from this consistent philosophical position. They were primarily moving images whereby an audience apprehended such moral and political truth. As Jones wrote in the commentary to one: 'corporeal beauty, consisting in symmetry, colour, and certain unexpressable graces . . . may draw us to the contemplation of the beauty of the soul, unto which it hath analogy.'[25] The Caroline masque made the onlooker apprehend the actual physical world round him by contemplating these artificial scenes as a series of images of divine and regal harmony.

Only once, in Shirley's *Triumph of Peace* (1634), offered to Charles by the Inns of Court to make amends for Puritan Prynne's implied attack on the queen in his *Histriomastix*, do we hear a cautious voice of dissent to this confined arcadia so aptly described as a circle by Jonson. Not only did the anti-masques attack certain items in royal policy, but the ultimate triumph was a statement that the royal prerogative could not rule without law.[26] This is a unique instance of the use of an essentially regal art form for advice to the crown on tempering its autocratic policies. What is more revealing is the fact that the king failed to see any criticism of his policies in the masque and in fact ordered a second performance!

'Coelum Britannicum', 1634

Out of the eight masques staged during the period of personal rule until the last *Salmacida Spolia* in 1640, the greatest without doubt is Thomas Carew's *Coelum Britannicum*, performed on Tuesday February 18th 1634, not only on account of the richness of its themes and its almost unbelievable mechanical marvels, but also because Carew's text ranks as magnificent poetry.[27] This masque was danced at the apogee of the years of Charles's personal rule. In the summer of 1633 he had travelled north to his kingdom of Scotland and was crowned king. Although the Calvinist clergy had been shocked by the splendour (or 'popery') of the Chapel Royal, the occasion was to all intents and purposes a triumph. The Scottish bishops had been summoned and charged to compile a version of the English *Book of Common Prayer*, and in August of the same year William Laud was at last appointed archbishop of Canterbury. Immediately measures were taken to prevent Puritans retaining their own ministers and chaplains, by insisting that those who were ordained must hold a benefice within the Established Church. Religious uniformity seemed therefore within grasp, while the judges' decision that year to uphold the royal prerogative over the imposition of ship-money seemed a victory for monarchical principles. All was, however, in reality little more than a postponement of disastrous troubles to come.

Coelum Britannicum is, therefore, a courtly celebration of the triumphs of Stuart absolutist rule. The curtain rose on a scene of the classical ruins **110** of a great city of the Romans or Ancient Britons (the side wings of which were lifted by Jones from a set by Parigi for the 1608 *intermezzi*). Mercury descended and, going up to the queen, announced Jove's intention of transforming heaven into such a pattern of the virtues as was the English court:

> Your exemplar life
> Hath not alone transfused a jealous heat
> Of imitation through your virtuous court —
> By whose bright blaze your palace is become
> The envied pattern of this underworld,
> But the aspiring flame hath kindled heaven. ...
> Th' immortal bosoms burn with emulous fires,
> Jove rivals your great virtues, royal sir,
> And Juno, madam, your attractive graces ...[28]

The speech introduces us immediately to a fundamental thought-assumption of the years of Charles's rule, namely, that the court was a model of the virtues. Its success is such that Jove now wishes to re-create heaven in imitation of this earthly Olympus. Charles and Henrietta Maria followed the precepts of James I in his *Basilikon Doron* in making their

court 'a patterne of goddlinesse and all honest virtues'. Lucy Hutchinson, looking back several years later, describes the ethos of the new court exactly in the memoirs of her husband:

> The face of the court was much changed in the change of the King, for King Charles was temperate, chaste and serious; so that the fools and bawds, mimics and catamites, of the former court, grew out of fashion; and the nobility and courtiers, who did not quite abandon their debaucheries, yet so reverenced the king as to retire into corners to practise them.[29]

Momus, god of satire, now made his entrance, and Jove's plans for the reformation of the heavens were related in a parody of those achieved by Charles I. The purge was narrated before a vast figure of Atlas bearing up the starry sphere of heaven on which all the constellations were placed. It opened with Jove himself admitting to his own reformation of character in renouncing 'all lascivious extravagances and riotous enormities of his forepast licentious life'.

This heralded a new code of sexual morality and the practise of marital fidelity. 'Cupid must go no more so scandalously naked, but it is enjoined to make him breeches, though of his mother's petticoats. Gannymede is forbidden the bedchamber, and must only minister in public. The gods must keep no pages, nor grooms of their chamber, under the age of 25, and those provided of a competent stock of beard.'[30] So in allegorical terms Momus described what Lucy Hutchinson relates as a historical fact, the reestablishment of sexual decency at court and the exile of those who failed to conform, survivals from the depraved reign of the king's father. The virtues of marriage were then exalted. Both Venus and Jupiter, we are told, have returned to their marriage partners and now indulge in conjugal affection. Jupiter indeed 'to eternize the memory of that great example of matrimonial union which he derives from hence, hath on his bedchamber door and ceiling fretted with star in capital letters engraven the inscription of CARLO MARIA'.[31] So the masque follows the pattern of all the others in establishing the perfection of the union of the king and queen, both in their roles as knight and romantic heroine, and as ideal husband and wife.

There then followed a series of anti-masques in which the hideous vices embodied in the licentious Ovidian constellations were expelled in turn from the firmament. One by one the star formations were extinguished from the celestial sphere on stage until it was left in total darkness: 'monstrous shapes . . . of natural deformity' and 'several vices, expressing the deviation from virtue'. Before, however, the new Olympus of the Stuart court can give it new, more virtuous light, various other claimants came forward: Plutus, god of riches; Poenia or Poverty; Fortune and Pleasure. All these were spurned:

> ... we advance
> Such virtues only as admit excess,
> Brave bounteous acts, regal magnificence,
> All-seeing prudence, magnanimity
> That knows no bound, and that Heroic virtue
> For which antiquity hath left no name,
> But patterns only, such as Hercules,
> Achilles, Theseus.[32]

At this point the story took up the opening pictorial statement of the masque, the Ancient British ruins, for the Caroline court was the reviver of these ancient vanished glories, the bringers to perfection of a historical process. They were therefore, at this juncture, bidden to view this less perfect British society, the 'rude, and old abiders here', forerunners of the civilization of the new, reunited Britain: '... a new scene appears of mountains, whose eminent height exceed the clouds, which pass beneath them; the lower parts were wild and woody. Out of this place comes forth a more grave anti-masque of Picts, the natural inhabitants of this isle, ancient Scots and Irish; these dance a Pyrrhica or martial dance'. To the audience these recalled the Britain of antiquity, a preface to a vision of the Stuart imperial *renovatio* which, in the figure of James VI of Scotland and I of England, had reunited the three kingdoms once more into their ancient unity. And now, at this moment, Jones introduced his most spectacular machine to celebrate that most frequent theme of Stuart panegyric, the creation of the Empire of Great Britain. Since the proclamation of 1604 masques, poems, medals, eulogies and inscriptions had sung of the benefits showered on this island by the Stuart resumption of the imperial diadem. The crown as reassumed for this empire was not a new creation but a return to ancient purity, to a time when this island had been ruled by the king's ancestors, the Trojan king Brutus and his descendants. The Vitruvian machine now gave spectacular expression to this achievement of Stuart politics:

> ... there began to arise out of the earth the top of a hill, which by little grew to be a huge mountain that covered all the scene; the underpart of this was wild and craggy, and above somewhat more pleasant and flourishing; about the middle part of this mountain were seated the three kingdoms of England, Scotland and Ireland, all richly attired in regal habits appropriated to the several nations, with crowns on their heads, and each of them bearing the ancient arms of the kingdoms they represented.[33]

At the top sat the Genius of Great Britain with a cornucopia filled with corn and fruits, symbolizing the abundance and peace of Charles's rule. A chorus was summoned of Rivers and Druids, ancient British priests, who spy the darkened sphere but who find a new radiant light to replace it in the virtuous beams shed by the queen. Now the time has come, after the

112 purging and after the vision of a less perfect British civilization, to realize and figure forth the glories of this present age, its fulfilment in Charles I and twelve other great lords who enter as British Worthies, epitomizing a new heroic age of Great Britain reborn. These descended and danced their entry, after which yet again the great machine evoked new wonders and developed in emblematic form the ideals of this new culture:

> The dance being past, there appears in the further part of the heaven coming down a pleasant cloud, bright and transparent; which coming softly downwards before the upper part of the mountain, embraceth the genius, but so as through it all his body is seen; and then rising again with a gentle motion bears up the genius of the three kingdoms, and being past in the airy region, pierceth the heavens, and is no more seen. At that instant the rock with the three kingdoms on it sinks, and is hidden in the earth.[34]

This staggering feat by which Jones enraptured his audience with wonder 'gave great cause of admiration' in the same way as Buontalenti's amazing feats of engineering left members of the Medici court *stupiti*.

Genius during her ascent proclaimed that these British Worthies should adorn the starry firmament, but the kingdoms below begged that they should be allowed to remain and grace the earth. Genius replied that it was not themselves but their fame alone that would kindle new constellations in the heavens. Once more the scene changed, moving from the fastnesses of mountains and wild scenery to a glimpse of the new civilization of the Caroline court:

113
> ... the nearest part showing a delicious garden with several walks and parterres set round with low trees, and on the sides against these walks were fountains and grots, and in the furthest part a palace from whence went high walks upon arches, and above them open terraces planted with cypress trees, and all this together was composed of such ornaments as might express a princely villa.[35]

Nature controlled in the beauties of a Renaissance garden; a vision of a palace built in the new classical style. This is the world of the new gardens, as created by Isaac de Caus at Wilton or the queen's garden at Somerset House, allied to palace building of a type the king longed to realize. At this point, in a setting directly expressing the ideals of the present age and of the benefits of the civilized life made possible by the beneficent rule and example of Charles I, the masquers united with the audience in the revels.

There was yet one more spectacle to come. At the close of the revels, which lasted a great part of the night, Jones took this world of the specific to that of the abstract. He conjured up a diagram of the neoplatonic ideas upon which Charles I based his government:

> ... for conclusion to this masque there appears coming forth from one of the sides, as moving by a gentle wind, a great cloud, which arriving at the

middle of the heaven, stayeth; this was of several colours, and so great that it covered the whole scene. Out of the further part of the heaven begins to break forth two other clouds, differing in colour and shape; and being fully discovered, there appeared sitting in one of them *Religion, Truth*, and *Wisdom*. . . . In the other cloud sat *Concord, Government*, and *Reputation*. . . . These being come down in an equal distance to the middle part of the air, the great cloud began to break open, out of which struck beams of light; in the midst suspended in the air, sat Eternity on a globe. . . .[36]

The identification of these emanations of the royal mind with government policy was emphasised in the distant view of one of the royal palaces, Windsor Castle. Around Eternity shone fifteen stars, one larger than the rest figuring the king. In this final scene came a last compliment, for Windsor Castle was that seat of revived Caroline chivalry, the Order of the Garter, on the reorganisation of whose rites and ceremonies Charles lavished much care and attention.

Conclusion

A study in depth of any of the Caroline masques reveals that no other form gives such a penetrating glimpse into the mind of Charles I. The seriousness and the passionate belief in their remedial efficacy is reflected above all in the closing masques of the reign. They offer overt evidence of the confidence the king and Inigo Jones placed in the effect of these spectacles in staving off the oncoming tide of disaster. In 1635 the famous Rubens canvases were inserted into the ceiling of the Whitehall Banqueting House. No longer could this be used as the court's *salle des fêtes* for fear of the heat of the blazing torches damaging the paintings. They in themselves provided in permanent form a pattern of the neoplatonic ideas hovering above the heads of the court below, just as the masques did in more emphemeral form. But late in 1637 a masquing room had to be built with all speed. The king had something to say and the masque was his mouthpiece. Sir William Davenant's *Britannia Triumphans* (1638), was performed during the ship-money trial and it directly apotheosized the righteousness of the king's naval policy and ended with a vision of the ship-money fleet. Charles as Britannocles, the glory of the western world, was again exhibited as the platonic perfection of kingship.[37]

But alas, by 1638 example of virtue alone was no longer sufficient power to control an increasingly unruly opposition. The thought-tenets of the masque world were beginning to wear thin. By 1640, the year of the

last of the masques, Sir William Davenant's *Salmacida Spolia*, they were almost threadbare.[38] In the weeks of crisis, with an empty exchequer and an appalling political situation, Charles still rehearsed the masque daily, his faith in the efficacy of such spectacles even at that late hour still apparently unshattered. But in this final masque he was no longer cast as triumphant. He is Philogenes, the Platonic king, doomed to reign in adverse times. His power is endurance and his chief virtue patience:

> O who but he could thus endure
> To Live and govern in a sullen age
> When it is harder far to cure
> The people's folly than resist its rage?[39]

114

It was no longer possible for Inigo Jones to reveal to men the Good and expect them tamely to follow it. The final scene was perhaps the most eloquent and touching of all those devised for the Stuart masques. It was a Vitruvian apotheosis, celebrating through architecture and engineering a glory that reality was shortly to deny the Stuart monarchy:

> From the highest part of the heavens came forth a cloud far in the scene, in which were eight persons richly attired representing the spheres. This joining with two other clouds which appeared at that instant full of music, covered all the upper part of the scene; and at that instant, beyond all these, a heaven opened full of deities; which celestial prospect, with the chorus below filled all the whole scene with apparitions and harmony.[40]

Everything that Inigo Jones believed in was woven together in this single emblematic stage scene: the cosmic harmony of the universe was overtly linked with the classical architecture below, which, built according to Renaissance canons, reflected the harmony of the heavens. The clouds bearing the celestial vision actually touched the tops of the buildings linking heaven and earth. It symbolized the harmony of the king's love for the queen and their mutual love for their people. The masque, Jones wrote, was 'the noblest and most ingenious that hath been done here in that kind'.[41] That the audience viewed its message with apprehension may be gathered from Jones's remark that it 'was generally approved of, especially by all strangers'.[42] Or as one member of the court put it even more succinctly: 'myself being so wise as not to see it',[43] thereby testifying less to the dangerous efficacy of apparitions and harmony than to their total irrelevance. This observation struck the death-knell of the power of the art of Inigo Jones. In the end it was to strike the death-knell of the art of the Renaissance court spectacle.

VI

CONCLUSION

By the third decade of the seventeenth century the themes of the Renaissance court fête had moved from a contemplation of cosmic harmony and its reflection in the state to a contemplation of the monarch as the genesis of that earthly and heavenly harmony. The ballets performed by Louis XIII's court, the masques in which Charles I danced, or the *intermezzi* unravelled for the eyes of the later Medici grand dukes gradually ceased to represent an aspiration towards political order and became an expression of its actual fulfilment in the prince. This can be taken as perhaps the significant dividing line in terms of political thought between the Renaissance and the Baroque festival.

All over Europe we can trace this happening as we progress into the opening decades of the seventeenth century. In 1581, in the *Balet Comique de la Reyne*, Henri III waged a war in allegorical terms with the vices and evils besetting his kingdom and was aided by harmonious and celestial powers to victory. In 1641 *Le Ballet de la Prosperité des Armes de France*, a spectacle in the new theatre of the Palais Cardinal equipped with Italianate machinery to achieve multiple scene changes, derived from Inigo Jones, opened with Harmony peacefully hovering in a cloud.[1] The ballet thus began with an accomplished fact, the good and beneficient rule of Louis XIII and his great minister, Cardinal Richelieu. Subsequent to this there was a vision of hell, representing vanquished opposition to royalist policies, and the ballet ended with Olympus descending to praise the king under the guise of the Gallic Hercules. This shift can be traced no less forcefully in the French royal entry. Already, under Henri IV, the programmes for these events had begun to be obsessed with casting the king as the messianic ruler saving his kingdom from the horrors of civil

war and, as *Rex Christianissimus*, destined for even greater victories. By 1622, when his son Louis XIII entered Avignon, the cult had developed so far that the street decorations took the form of a progress by the monarch through emanations of his own mind. The procession wound its way through the royal virtues: the Gateway of Felicity, the Trophy of Wisdom, the Fountain of Justice, and the Theatre of Fortitude and Piety to the Palace of Glory[2] while the image of Eternity graced the facade of the cathedral. The dedication to the account of his entry into Aix-en-Provence in the same year opens with a statement on regal divinity as extreme as any made by or on behalf of the Stuarts: 'Comme les Roys sont les Dieux de la Terre, aussi leur nom doit estre continuellement adoré par des Fastes solemnelles'.[3] Six years later this kind of apotheosis was re-stated with even greater vigour in Louis's entry into Paris in the aftermath of the surrender of La Rochelle. Once again there was a progression through the royal virtues, this time towards an arch dedicated to the eternity of the king's glory, the reward of having reduced the Huguenot stronghold, 'l'ouvrage le plus cyclopéen . . . des temps modernes'.[4] This is the imagery of absolutism, paralleled by developments within contemporary political theory.[5] In short, we have arrived at the thought premises of the festivals of Louis XIV and the Baroque age.

Revamped medieval romance, the imagery of Sacred Empire, of Christianity and classical myth and history provided the absolutist monarch with an encyclopaedia of universally understood symbols with which to promote his rule. In spite of the rise of scientific thought and method by the middle of the seventeenth century, the vitality of such material was remarkable depending as it did largely on a neoplatonic pattern of philosophical assumption, upon an outmoded pre-Copernican cosmology and the whole obsession with secret wisdom within the hermetic tradition which was by then under fierce attack. Nonetheless, the Renaissance court festival handed onto its Baroque successor a repertory of themes and settings that continued to form the staple ingredients of such entertainments until well into the eighteenth century, although in the Age of Englightenment such *fêtes de cour* became increasingly meaningless.[5]

This book inevitably ends, therefore, where another begins, the history of festivals in the century and a half down to the collapse of the *ancien régime* in France in 1789 and in the rest of Europe in the Napoleonic Wars that followed.[6] That remains to be written. Few subjects have suffered so much from the modern compartmentalisation of knowledge as festivals. It has fallen between so many stools, those of the historian of art, literature, ideas and political history. It is noticeable that the first serious attempt to study them, the series of volumes entitled *Les Fêtes de la Renaissance* which appeared from 1959 onwards, failed to overcome this fragmented

approach. They remain collections of studies of particular events looked at in isolation and as an attempt to establish the subject as a coherent discipline may be said to be a failure. One emerges with no overall picture as to what this stupendous development was. Perhaps the study of festivals can never by its very nature ever be a coherent discipline without distortion. I opened this book with one modest objective: to make real to the reader Ménestrier's statement that such festivals were 'Allegories de l'Estat des temps'. I close in the hope that he by now knows precisely what Ménestrier meant by that definition of what was a unique alliance of art and power in the creation of the modern State.

APPENDIX I

A CALENDAR OF MAJOR FESTIVAL EVENTS
AND PUBLICATIONS, 1494–1641

The period covered may be loosely defined as Renaissance, opening with Charles VIII's invasion of Italy in 1494, which signalled a major interplay between north and south, and closing with the political ballet, *Le Ballet de la Prosperité des Armes de France*, 1641, in the incipient baroque style.

An asterisk (*) indicates that a description of an event was published at the time and a dagger (†) that it was illustrated. This gives a useful indication of the development and spread of the genre. It starts off, in the main, in pamphlet form, short and unillustrated, often 'news-letters' by Italian observers, and it is only after the middle years of the century that there is a deliberate expansion in the format. The turning point was the great series of entries of Philip II and Henri II in 1548–50 which prompted major publications on a scale not seen before, that describing the Antwerp entry even being issued in several languages. Very full descriptions with illustrations only became the norm after about 1590 with the long series of folio volumes on the Antwerp entries of Ernest and Albert and Isabella. These, for example, prompted an illustrated description of James I's entry into London in 1604.

The list also gives some insight not only into the distribution of such books but on the range of their subject matter. In the main it is the royal entry which is the subject of nearly every major publication. This explains the often extreme paucity of printed illustrative material on other forms of festival. There is no comparable series of volumes, for example, on either the French *ballet de cour* or the English court masque which, in the case of the former, is a major *lacuna*. In addition their existence depended not only on the attitude of a dynasty to its propaganda but on the resources both in terms of money and of artists capable of recording such occasions. Thus it is no surprise that Antwerp, home of the Plantin press, should have produced by far the most distinguished series of festival volumes. Florence under the Medici grand dukes produced a comparable series reflecting their role as

being in the forefront of using festivals as political promotion for the dynasty. Countries with slim resources, such as Scotland, barely produced a festival literature at all.

1494	Naples: festivals for the coronation of Alfonso II
	Entries of Charles VIII in Italy including Turin, Pavia, Pisa, Florence and Siena
1496	Entry of Joanna of Castile into Brussels
1498	Entry of Louis XII into *Rheims and *Paris
1499	* Entry of Louis XII into Milan
1501	Entry of Catherine of Aragon into London
1501–2	Festivals in Rome and Ferrara for the marriage of Lucrezia Borgia to Alfonso d'Este
1506	Entry of Ferdinand of Spain into Naples
1507	Entry of Louis XII into Pavia
	Entry of Pope Julius II into Rome
	* Entry of Louis XII into Lyons
1509	Entry of Louis XII into Milan
1512	Entry of Massimiliano Sforza into Milan
1513	* Rome: procession and decorations for the 'Possesso' of Pope Leo X
	* Rome: festivals for the granting of Roman citizenship to Giuliano and Lorenzo de'Medici
1514	Entry of Mary Tudor into Paris
1515	† * Entry of Charles V into Bruges
	Entry of Pope Leo X into Florence
	* Entry of François I into Lyons
1517	* Entry of François I into Rouen
1518	Florence: festivals for the marriage of Lorenzo de'Medici, Duke of Urbino to Madeleine de la Tour d'Auvergne
1520	* Festivals at the Field of Cloth of Gold
	* Calais: meeting of Henry VIII and Charles V
	* Entry of Charles V into Antwerp
1522	* Entry of Charles V into London
1526	* Entry of Charles V into Seville
1527	Festivals by Henry VIII for the French ambassadors at Greenwich
1529–30	Coronation of Charles V and entries into Genoa,
	† * Bologna and Mantua
1535–36	Italian tour of Charles V with entries into *Messina, *Naples, *Rome, *Siena, *Florence and Lucca
1536	Florence: festivals for the marriage of Duke Alessandro de'Medici and Margaret of Austria
1539–40	Charles V's journey through France with entries into *Poitiers, *Orléans, *Paris and *Valenciennes
1539	Florence: festivals for the marriage of Cosimo, Duke of Florence and Eleanor of Toledo

1541	† * Entry of Charles V into Milan and Mallorca
1547	Entry of Edward VI into London
1548	† * Entry of Henri II into Lyons
1549	† * Entry of Henri II into Paris
	Mantua: festivals for the marriage of Caterina d'Austria and Francesco Gonzaga, Duke of Mantua
1548–49	Voyage of the future Philip II through Italy, Germany and the Low Countries including entries into *Genoa, *Milan, *Mantua, Trent, *Brussels, Louvain, † *Ghent, Bruges, Lille, Tournai, Arras and † *Antwerp with festivals at Binche
1550	† * Entry of Henri II into Rouen
1551	* Entry of Henri II into Orléans
1553	Entry of Mary I into London
1554	* Entry of Philip II into London
1558	† * Brussels: obsequies for Charles V
1559	* Entry of Elizabeth I into London
	* Paris: festivals for the marriages of François II to Mary Queen of Scots and Marguerite de Valois to the Duke of Savoy
1561	* Entry of Elizabeth of Valois into Toledo
1561	Ferrara: the tournaments *Il Castello di Gorgoferusa and *Il Monte di Ferronia
1563	The Chenonceau 'magnificences'
1564	* The Fontainebleau 'magnificences'
1564–65	* Entries of Charles IX during the Grande Voyage de France including Lyons, Avignon and Tours
1565	* The Bayonne 'magnificences'
	* Florence: festivals for the marriage of Francesco de'Medici to Joanna of Austria
	* Ferrara: the tournament Il Tempio d'Amore
1568	† * Bavaria: festivals for the marriage of Duke Albert V to Renée of Lorraine
1569	* Ferrara: the tournament L'Isola Beata
1570	* Ferrara: the tournament Il Mago rilucente
1571	† * Entries of Charles IX and Elizabeth of Austria into Paris
	* Entry of Anne of Austria into Burgos
1572	London: festivals for the French ambassadors
	Paris: 'magnificences' for the marriage of Henri of Navarre to Marguerite de Valois
1573	Paris: 'magnificences' for the Polish ambassadors and entry of the future Henri III into Paris including the † *Ballet of the Provinces of France
1574	Journey of Henri III through Italy including entries into † *Venice, *Verona, † *Mantua and *Ferrara
1575	* England: 'The Princely Pleasures of Kenilworth'
1578	† * Entry of the Archduke Matthias into Antwerp

1579	† * Florence: *Sbarra* for the marriage of Francesco, Grand Duke of Tuscany and Bianca Cappello
1580s	England: the Accession Day Tilts enter their apogee
1581	London: festivals, including *'The Fortress of Perfect Beauty', for the French ambassadors treating for the marriage of Elizabeth I and the Duke of Anjou
	Paris: 'magnificences' for the marriage of the Duke de Joyeuse including † *'Le balet Comique de la Reyne'
	* Entry of Philip II into Lisbon
1582	Entries of the Duke of Anjou into † *Antwerp, *Ghent and *Bruges
1585–86	Entries of Robert Dudley, Earl of Leicester in the Netherlands including † *The Hague
1586	* Florence: *intermezzi* for the marriage of Virginia de'Medici to Cesare d'Este, Duke of Ferrara
1589	† * Florence: festivals for the marriage of Ferdinand, Grand Duke of Tuscany to Christina of Lorraine
1590	London: Accession Day Tilt and retirement of Sir Henry Lee
1591–92	England: Royal progresses including the † *Elvetham and Ditchley, entertainments in honour of Elizabeth I
1594	Entry of the Archduke Ernest into † *Antwerp and † *Brussels
1595	† * Entry of Henri IV into Lyons
1596	† * Entry of Henri IV into Rouen
1599–1600	† * Entries of the Archdukes Albert and Isabella into Antwerp, Ghent and Valenciennes
1600	* Florence: festivals for the marriage of Henri IV to Marie de'Medici
	† * Entries of Marie de'Medici into Lyons and Avignon
1604	† * Entry of James I into London
1605–40	* The Stuart court masques begin with Jonson's *Masque of Blackness*
1606	Nancy: festivals for the marriage of Henri de Lorraine and Marguerite de Gonzague-Mantoue
1608	† * Florence: festivals for the marriage of Cosimo de'Medici and Magdelena of Austria
	† * Mantua: festivals for the marriage of Francesco Gonzaga and Margherita di Savoia
1610	* Paris: *Le Ballet de Monseigneur le Duc de Vandosme*
1612	† * Paris: carrousel on the Place Royale for the Franco-Spanish marriages
1613	† * London and Heidelberg: festivals for the marriage of the Princess Elizabeth and Frederick, Elector Palatine
1615	* Paris: *Le Ballet de Madame*
1616	† * Florence: the horse ballets, the *Guerra d'Amore* and the *Guerra di Bellezza*

1617	† Florence: *La Liberazione de Terreno e d'Arnea*
	† * Paris: *Le Ballet de la Délivrance de Renaud*
1619	† * Paris: *Le Ballet de Tancrède*
	† * Entry of Philip III into Lisbon
	* The marriage of Christina, Madame Royale, to Victor Amadeus, later Duke of Savoy inaugurates a long series of ballets at the Savoy court
1622	† * Entries of Louis XIII including Avignon, Aix-en-Provence, *Arles and Lyons
1626	* Paris: *Ballet Royal du grand bal de la Douairière de Billbahaut*
1627	† * Nancy: *Combat à la Barrière*
1628	† * Entry of Louis XIII into Paris
	† * Florence and Parma: festivals for the marriage of Odoardo Farnese and Margherita de'Medici with the inauguration of the Teatro Farnese
1631–40	* England: masques of the personal rule of Charles I
1633	* Entry of Charles I into Edinburgh
1635	* Paris: *Le Ballet de la Marine*
	Entries of the Cardinal Archduke Albert into † *Antwerp (*Pompa Introitus Ferdinandi*), † *Ghent and Brussels
1637	† * Florence: festivals for the marriage of Cosimo II, Grand Duke of Florence and Vittoria della Rovere
1639	* Paris: *Le Ballet de la Félicité*
1639	† * Entry of Marie de'Medici into Amsterdam
1641	* Paris: *Le Ballet de la Prosperité des Armes de France*

APPENDIX II

GENEALOGICAL TABLES

The Medici

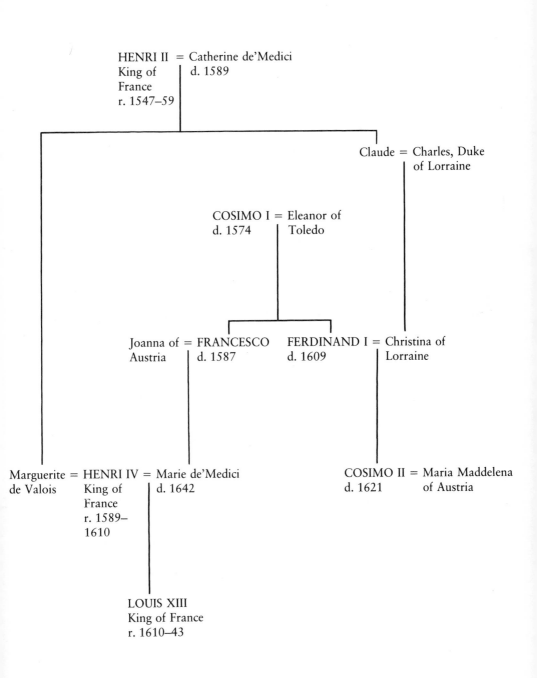

HENRI II = Catherine de'Medici
King of d. 1589
France
r. 1547–59

Claude = Charles, Duke
of Lorraine

COSIMO I = Eleanor of
d. 1574 Toledo

Joanna of = FRANCESCO FERDINAND I = Christina of
Austria d. 1587 d. 1609 Lorraine

Marguerite = HENRI IV = Marie de'Medici
de Valois King of d. 1642
France
r. 1589–
1610

COSIMO II = Maria Maddelena
d. 1621 of Austria

LOUIS XIII
King of France
r. 1610–43

Connections Between the Ruling Houses of Europe

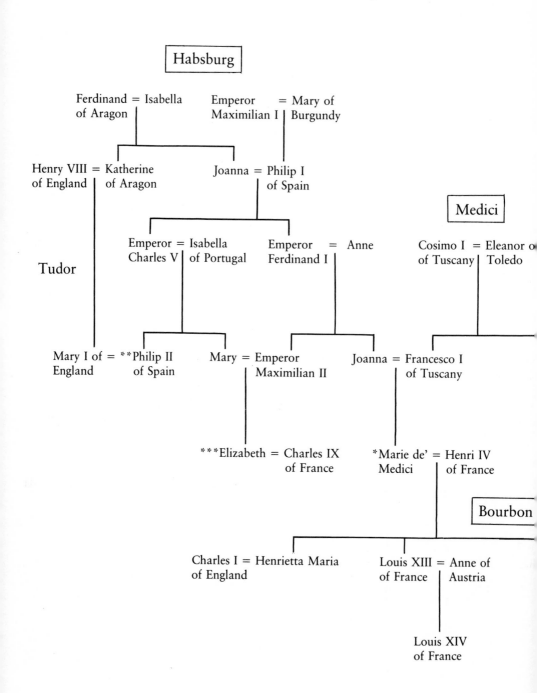

Valois

François I = Claude
of France

Henri II = Catherine de'
of France | Medici

...aude = Charles Charles IX = ***Elizabeth (1) Marguerite = Henri IV = (2) *Marie de'
 Duke of of Austria of France Medici
 Lorraine

 François II = Mary Queen Henri III = Louise of
 of Scots Lorraine

 Elizabeth = **Philip II
 of Spain

...dinand I = Christina
Tuscany

Cosimo II = Maria Maddalena

...hristina = Victor Amadeus I
 of Savoy

 Savoy

Charles Emmanuel II
of Savoy

The Tudors and Stuarts

HENRY VII = Elizabeth of
r. 1485–1509 | York d. 1503

HENRY VIII = (1) Katherine of
r. 1509–47 Aragon
 (2) Anne Boleyn
 (3) Jane Seymour
 (4) Anne of Cleves
 (5) Katherine Howard
 (6) Katherine Parr

Margaret = JAMES IV
 of Scotland
 d. 1513

JAMES V = Mary of Guise
of Scotland | d. 1560
d. 1542

MARY I = PHILIP II
r. 1553–8 King of
 Spain
 r. 1556–98

ELIZABETH I
r. 1558–1603

EDWARD VI
r.1547–53

MARY = (1) FRANCOIS II
Queen of Scots | d. 1560
d. 1587 (2) Lord Darnley
 d. 1567

Anne of = JAMES VI & I
Denmark | r. 1567–1625 Scotland
d. 1619 r. 1603–25 England

Henry
d. 1612

CHARLES I = Henrietta Maria
r. 1625–49 d. 1666

NOTES

Abbreviations

Three collections of essays entitled *Les Fêtes de la Renaissance* are referred to so often that I have used the following abbreviations:

Fêtes I, 1959 = *Les Fêtes de la Renaissance* I, ed. Jean Jacquot, CNRS, Paris 1959

Fêtes II, 1960 = *Fêtes et Cérémonies au Temps de Charles Quint, Les Fêtes de la Renaissance* II, ed. Jean Jacquot, CNRS, Paris 1960.

Fêtes III, 1975 = *Les Fêtes de la Renaissance* III, ed. Jean Jacquot and Elie Konigsen, CNRS, Paris 1975

PART I

I. THE MEDIEVAL INHERITANCE

[1] On fêtes at the Savoy court see: Gino Tani, 'Le Comte d'Aglié et le Ballet de Cour en Italie', *Fêtes* I, 1959, pp. 221–33; Mercedes Viale Ferrero, *Scenografia*, in *Mostra del Barocco Piemontese*, Turin 1963, I, pp. 1–3, nos 6–17; Mercedes Viale Ferrero, *Feste delle Madame Reali di Savoia*, Turin 1965; Cesare Molinari, *Le Nozze degli Dèi*, Rome 1968, pp. 97–104; Margaret McGowan, 'Les Fêtes de Cour en Savoie. L'Oeuvre du Philippe d'Aglié', *Revue d'Histoire du Théâtre* III, 1970, pp. 183–241.

[2] There is no full length study of the royal entry in the middle ages. By far the most useful is the introduction to B. Guénée and F. Lehoux, *Les Entrées royales françaises de 1328 à 1515*, Sources d'Histoire Médiévale, Institut de Récherche et d'histoire des Textes, CNRS, Paris 1968, pp. 8–29. For a comprehensive but now dated general survey of the royal entry in Europe see G. Kernodle, *From Art to Theatre. Form and Convention in the Renaissance*, Chicago 1943, pp. 58–108 and a very useful bibliography, pp. 226–38.

[3] 1431 entry into London. The text is printed, amongst other places, in: *Chronicles of London*, ed. C. L. Kingsford, Oxford 1905, pp. 97–116; *The Minor Poems of John Lydgate*, ed. H. N. MacCracken, Early English Text Society, 1934, pt. ii, pp. 630–48. Studies: Robert Withington, *English Pageantry. An Historical Outline*, Harvard UP, 1918, I, pp. 141–47; J. W. McKenna, 'Henry VI and the Dual Monarchy: Aspects of Royal Political Propaganda, 1422–32', *Journal of the Warburg and Courtauld Institutes* XXVIII, 1965, pp. 145–62; for an interesting re-use in a post-Reformation context, the entry of Edward VI into London in 1547, see Sydney Anglo, *Spectacle, Pageantry and Early Tudor Policy*, Oxford 1969, pp. 284–94.

[4] *Chronicles*, ed. Kingsford, p. 107.

[5] Entry into Rouen. Sources: Charles de Beaupaire, 'Entrée et Séjour du Roi Charles VIII à Rouen en 1485', *Mémoires de la Société des Antiquaires de Normandie* XX, 1853, pp. 279–306; Guénée and Lehoux, *Les entrées royales*, pp. 241–65. Study: E. Konigson, 'La Cité et le Prince: Premières Entrées de Charles VIII (1484–86)', *Fêtes* III, pp. 55–69.

[6] 1515 Bruges entry. Source: *La Tryumphante Entrée de Charles Prince des Espagne en Bruges 1515*, ed. S. Anglo, Teatrum Orbis Terrarum, n.d., incorporating a study. See also I. von Roeder-Baumbach and H. G. Evers,

Versieringen bij Blijde Inkomsten, Antwerp 1943, pp. 40–45; J. Jacquot, 'Panorama des Fêtes et Cérémonies du Règne', *Fêtes* II, pp. 413–18. It is worth referrring here to another earlier rare illustrated royal entry, that of Joanna of Castile into Brussels, 1496, Berlin. Kupf. k.78.D 5.

[7] 1515 Lyons entry. Sources: *L'Entrée de François I, roy de France en la cité de Lyon le 12 juillet 1515*, ed. G. Guigue, Lyons 1899. Another French entry for which there is a visual record is that made by Mary Tudor into Paris in 1514: *Pierre Gringoire's Pageants for the Entry of Mary Tudor into Paris*, ed. Charles Read Baskervill, University of Chicago, 1934.

[8] 1558 London entry. Sources: *The Quenes maiesties passage through the citie of London to westminster the daye before her coronacion*, facsimile ed. by James M. Osborn, New Haven 1960; *Calendar of State Papers, Venetian, 1558–80*, pp. 13–15. Studies: Anglo, *Spectacle*, pp. 344–59; David M. Bergeron, *English Civic Pageantry 1558–1642*, London 1971, pp. 11–23; Richard L. DeMolen, 'Richard Mulcaster and Elizabethan Pageantry', *Studies in English Literature* XIV, 1974, pp. 209–17; David M. Bergeron, 'Elizabeth's Coronation Entry (1559): New Manuscript Evidence', *English Literary Renaissance* 8, 1978, pp. 3–8. It may be useful to add that Anglo, *Spectacle* includes analyses also of the entries of Katharine of Aragon, Edward VI and Mary I into London. For Katharine of Aragon's entry see the same author's 'The London Pageants for the Reception of Katharine of Aragon: November 1501', *Journal of the Warburg and Courtauld Institutes* XXVI, 1963, pp. 58–89; and for a new interpretation Gordon Kipling, *The Triumph of Honour. Burgundian Origins of the Elizabethan Renaissance*, Leiden 1977, pp. 72–95.

[9] See for the most recent reassessment Malcolm Vale, *War and Chivalry: Warfare and Aristocratic Culture in England, France and Burgundy at the End of the Middle Ages*, London 1981, ch. 1. The argument for England is made in Kipling, *The Triumph of Honour*, 1977. See also M. H. Keen, 'Huizinga, Kilgour and the Decline of Chivalry', *Medievalia et Humanistica* VII, 1977, pp. 1–20. These represent the thrust towards reversing the view disseminated by J. Huizinga, *The Waning of the Middle Ages* (first published in 1919), trans. F. Hopman, Harmondsworth, 1965. Its influence has been dominant on the interpretation of late medieval festivals as the expressions of a chivalrous ideal in its death throes. This has coloured the attitude to these festivals in the major works that deal with or touch upon them: R. L. Kilgour, *The Decline of Chivalry as Shown in French Literature of the late Middle Ages*, Cambridge, Mass. 1947 and A. B. Ferguson, *The Indian Summer of English Chivalry*, Durham, North Carolina 1960.

[10] There is no modern history of the tournament. The following all provide useful material for its history during the later middle ages and some go on to cover the renaissance period, although their attitude to such tournaments is invariably dismissive. J. J. Jusserand, *Les Sports et jeux d'exercice dans l'ancienne France*, Paris 1901, pp. 40–154; Viscount Dillon, 'Barriers and foot combats', *Archaeological Journal* LXI, 1904, pp. 276–308; Emile Duvernoy and René Harmand, *Le Tournoi de Chauvency en 1295: étude sur les moeurs chevalresques au xiii^e siècle*, Paris 1905; F. H. Cripps-Day, *The History of the Tournament in England and in France*, London 1918; R. C. Clephan, *The*

Tournament, its Periods and Phases, London 1919; N. Denholm-Young, 'The tournament in the thirteenth century', *Studies in Medieval History prsented to Sir Maurice Powicke*, ed. R. W. Hunt, W. A. Pantin and R. W. Southern, Oxford 1948, pp. 240–68; Sydney Anglo, *The Great Tournament Roll of Westminster*, Oxford 1968, ch. 2; R. Harvey, *Moriz von Craûn and the Chivalric World*, Oxford 1961, pp. 113–216; Richard Barber, *The Knight and Chivalry*, London 1970, pp. 153–88; Vale, *War and Chivalry*, 1981, pp. 62–87.

[11] J. R. Hale, 'Fifteenth and sixteenth-century public opinion and war', *Past and Present* XXII, 1962, pp. 18–33.

[12] B. Castiglione, *The Book of the Courtier*, trans. Sir Thomas Hoby, introduction by J. A. Whitehead, London 1974, p. 19.

[13] On the development of pageantry in medieval tournaments see: Withington, *English Pageantry*, 1918, ch. 2; R. S. Loomis, 'Chivalric and Dramatic Imitations of Arthurian Romance', *Medieval Studies in Memory of A. Kingsley Porter*, Harvard 1939, I, pp. 79–87; Ruth Huff Cline, 'The Influence of Romances on Tournaments of the Middle Ages', *Speculum* XX, 1945, pp. 204–11; Edouard Sandoz, 'Tourneys in the Arthurian Tradition', *ibid.*, pp. 389–420.

[14] On the tournaments of René of Anjou: R. A. Lecoy de la Marche, *Le Roi René: sa vie, son administration, ses travaux artistiques et litteraires*, Paris 1875, II, pp. 146–9; Edgcumbe Staley, *King René of Anjou and his Seven Queens*, London 1912, pp. 134–40, 308–12; Marie-Louyse des Garets, *Un Artisan de la renaissance française au XVe siècle: le roi René; 1409–1480*, Paris 1946, pp. 143–47, 160–64; see also J.-J. Champollion-Figeac, *Les Tournois du roi René*, Paris 1827; G. A. Grapelet, *Les Pas d'armes de la Bergère*, Paris 1828.

[15] No major study exists of Burgundian court festivals but see O. Cartellieri, *The Court of Burgundy*, London 1929, ch. 7; A. Planche, 'Du tournoi au théâtre en Bourgogne. Le pas de la Fontaine des Pleurs à Châlons-sur-Sâone, 1449–50', *Le Moyen Age* LXXXI, 1975, pp. 97–128.

[16] Cartellieri, *Court of Burgundy*, 1929, pp. 130–31.

[17] On Henry VIII's tournaments and the Burgundian connection see: Anglo, *The Great Tournament Roll*, 1968, ch. 3; Anglo, *Spectacle*, 1969, esp. ch. 3; J. G. Russell, *The Field of Cloth of Gold*, London 1969, pp. 104–41; Kipling, *Triumph of Honour*, 1977, pp. 116–36.

[18] Anglo, *The Great Tournament Roll*, 1968, pp. 56–58; S. Anglo, 'The Evolution of the Early Tudor Disguising, Pageant and Mask', *Renaissance Drama*, N.S. i, 1968, pp. 3–44.

[19] For the development in England see E. K. Chambers, *The Medieval Stage*, Oxford 1903, I, ch. XVII.

[20] Cartellieri, *Court of Burgundy*, 1929, pp. 139–50 and p. 263 for sources and studies.

[21] Guénée and Lehoux, *Les Entrées Royales*, 1968, pp. 14–18.

[22] See Roy Strong, 'The Popular Celebration of the Accession Day of Queen Elizabeth I', *Journal of the Warburg and Courtauld Institutes* XXI, 1958, pp. 86–103; partly reprinted in Roy Strong, *The Cult of Elizabeth. Elizabethan Portraiture and Pageantry*, London 1977, pp. 117–28. See also for the

deliberate policy of replacing old religious festivals with royalist ones, S. Anglo, 'An Early Tudor Programme for Plays and other Demonstrations against the Pope', *Journal of the Warburg and Courtauld Institutes* XX, 1957, pp. 176–79.
23 See Louis Adrian Montrose, ' "Eliza, Queene of Shepheardes", and the Pastoral of Power', *English Literary Renaissance* 10, 1980, pp. 153–82.

II REMOVED MYSTERIES

1 Stephen Orgel and Roy Strong, *Inigo Jones. The Theatre of the Stuart Court*, University of California Press, 1973, I, p. 106, ll. 10–18.
2 A. D. Fraser Jenkins, 'Cosimo de'Medici's Patronage of Architecture and the Theory of Magnificence', *Journal of the Warburg and Courtauld Institutes* XXXIII, 1970, pp. 162–70. For an excellent account of *Magnificentia* in relation to one princely house, the Este, see Werner L. Gundersheimer, *Ferrara. The Style of a Renaissance Despotism*, Princeton U.P., 1973, pp. 250–1, 266–7.
3 *The Tempest*, IV.i.59.
4 On hieroglyphics and emblems in the Renaissance see: Ludwig Volkmann, *Hieroglyphik und Emblematik in ihren Beziehungen und Fortwicklungen*, Leipzig 1923; George Boas, *The Hieroglyphics of Horapollo*, New York 1950; Robert J. Clements, *Picta Poesis. Literary and Humanistic Theory in Renaissance Emblem Books*, Temi e Testi, 6, Rome 1960; Mario Praz, *Studies in Seventeenth-Century Imagery*, Rome 1964, esp. ch. i; Albrecht Schoene and Arthur Henkel, *Emblemata. Handbuch zur Sinnbildkunst des XVI und XVII Jahrhunderts*, Stuttgart 1967; Don Cameron Allen, *Mysteriously Meant. The Rediscovery of Pagan Symbolism and Allegorical Interpretation in the Renaissance*, Johns Hopkins, 1970. For England, see Rosemary Freeman, *English Emblem Books*, London 1948. For Alciati see: H. Green, *A. Alciati and his Book of Emblems*, London 1872; Andreae Alciati, *Emblematum Fontes Quatuor . . .*, ed. H. Green, Holbein Society, 1870; *Emblematum Flumen abundans . . .*, ed. H. Green, Holbein Society, 1871; G. Duplessis, *Les Emblèmes d'Alciati*, Paris 1884; Hessel Miederna, 'The Term *Emblemata* in Alciati', *Journal of the Warburg and Courtauld Institutes* XXXI, 1968, pp. 234–50.
5 For the Gallic Hercules see: R. Trousson, 'Ronsard et la légende d'Hercule', *Bibliothèque d'Humanisme et Renaissance* XXIV, 1962, pp. 77–87; M.-R. Jung, *Hercule dans littérature française du XVIe siècle*, Travaux d'Humanisme et Renaissance LXXIX, Geneva 1966, pp. 159–77. For the Gallic Hercules in the 1549 Paris entry see: I. D. McFarlane, *The Entry of Henri II into Paris 16 June 1549*, Medieval and Renaissance Texts and Studies, Center for Medieval and Renaissance Studies, Binghamton, New York 1982, pp. 29–31. For Henry IV see Corrado Vivanti, 'Henry IV, the Gallic Hercules', *Journal of the Warburg and Courtauld Institutes* XXX, 1967, pp. 176–97, esp.

pp. 184 ff.; Margaret McGowan, 'Les Jésuites à Avignon: Les Fêtes au Service de la Propagande politique et Religieuse', *Fêtes* III, 1975, pp. 153–71; André Masson, 'L'Allegorie dans le livre illustré: La Joyeuse Entrée d'Henri IV à Rouen', *Revue française d'histoire du livre* 14, 1977, pp. 3–20.

6 C. A. Marsden, 'Entrées et Fêtes Espagnoles au XVIe Siècle', *Fêtes* II, 1960, p. 407.

7 Victor E. Graham and W. McAllister Johnson, *The Paris Entries of Charles IX and Elizabeth of Austria*, University of Toronto Press, 1974, *passim* in the notes to the texts of the entries.

8 See D. J. Gordon, *The Renaissance Imagination*, ed. Stephen Orgel, University of California Press, 1975, pp. 138–39; for his further use of Valeriano see A. H. Gilbert, *The Symbolic Persons in the Masques of Ben Jonson*, Durham 1948.

9 For *imprese* see Praz, *op. cit.*, ch. 2; Robert Klein, 'La Théorie de l'Expression Figurée dans les Traités italiens sur Imprese, 1552–1612', *Bibliothèque d'Humanisme et Renaissance* XIX, 1957, pp. 320–41.

10 See, for example, Anne-Marie Lecoq, 'La Salamandre dans les Entrées de François Ier', *Fêtes* III, 1975, pp. 93–164. There are remarkably few studies of dynastic devices and their contribution to renaissance monarchical mythology but see: Frederick Hartt, 'Gonzaga Symbols in the Palazzo del Tè', *Journal of the Warburg and Courtauld Institutes* XIII, 1950, pp. 151–88; Earl Rosenthal, ' "Plus ultra"; "Non plus ultra", and the columnar device of the Emperor Charles V', *ibid.* XXXIV, 1971, pp. 383–88; same author, 'The Invention of the Columnar Device of the Emperor Charles V at the Court of Burgundy in Flanders in 1516', *ibid.* XXXVI, 1973, pp. 204–28; Mario Praz, 'The Gonzaga Devices', in *Splendours of the Gonzaga*, exhibition catalogue ed. David Chambers and Jane Martineau, Victoria & Albert Museum, 1981–82, pp. 65–72.

11 Jacques Vanuxem, 'Le Carrousel de 1612 sur la Place Royale et ses Devises', *Fêtes* I, 1956, pp. 191–200, esp. pp. 197 ff.

12 On which see Jean Seznec, *The Survival of the Pagan Gods*, New York 1963; see also Allen, *Mysteriously Meant*, 1970, pp. 201–47; Norma Cecchini, *Dizionario Sinoticco di Iconologia*, Bologna 1976.

13 For the *Genealogia degli Dei* see J. Seznec, 'La Mascarade des dieux à Florence en 1565', *Mélanges d'archéologie et d'histoire*, LII, 1935, pp. 224–43; Seznec, *The Survival of the Pagan Gods*, 1953, pp. 280–82; A. Nagler, *Theatre Festivals of the Medici 1539–1637*, Yale U.P., 1964, pp. 24–34; Anna Maria Petrioli, *Mostra di Disegni Vasariani. Carri Trionfali e Costumi per la Geneologia degli Dei* (1565), Gabinetto Disegni e Stampe degli Uffizi, Florence 1966.

14 D. J. Gordon, 'Ben Jonson's *Haddington Masque*: The Story and the Fable', *Modern Language Review* XLII, 1947 (reprinted in D. J. Gordon, *The Renaissance Imagination*, ed. Stephen Orgel, University of California Press, 1975, pp. 185–93).

15 Nagler, *Theatre Festivals of the Medici*, 1964, p. 34.

16 *Ben Jonson*, ed. C. H. Herford and P. and E. Simpson, Oxford 1941, VII, p. 91.

[17] For an introduction to the study of Renaissance mysteries and the occult see Edgar Wind, *Pagan Mysteries in the Renaissance*, London 1958, ch. 1; Eugenio Battisti, *L'Antirinascimento*, Milan 1962, esp. ch. VII; Frances A. Yates, *Giordano Bruno and the Hermetic Tradition in the Renaissance*, London 1964.

[18] For discussions of images and diagrams see E. H. Gombrich, '*Icones Symbolicae*: the Visual Image in Neo-Platonic Thought', *Journal of the Warburg and Courtauld Institutes* XI, 1948, pp. 163–88 reprinted in *Symbolic Images. Studies in the Art of the Renaissance*, 2nd edn., London 1978, pp. 123–95; Walter Ong, 'From Allegory to Diagram in the Renaissance Mind: A Study in the Significance of the Allegorical Tableau', *Journal of Aesthetics and Art Criticism* XVII, 1959, pp. 423–40. See also S. Orgel and R. Strong, *Inigo Jones. The Theatre of the Stuart Court*, 1975, p. 3.

[19] Sir John Harington, *Orlando Furioso*, London 1591, preface.

[20] Source: Orgel and Strong, *Inigo Jones. The Theatre of the Stuart Court*, 1973, I, pp. 105–14. Study: D. J. Gordon, '*Hymenaei*: Ben Jonson's Masque of Union', *Journal of the Warburg and Courtauld Institutes* VIII, 1945, pp. 107–45; reprinted in Gordon, *The Renaissance Imagination*, 1975, pp. 157–84.

[21] Gordon, *Renaissance Imagination*, p. 168.

[22] Source: *Discours au vray de ballet danse par le roy le dimanche XXIXe jour de Janvier 1617* . . ., Paris 1617, reprinted in Paul Lacroix, *Ballets et Mascarades de Cour de Henri III à Louis XIV*, Paris 1868, II, no. 3, pp. 97–103. Studies: Henry Prunières, *Le Ballet de Cour en France avant Benserade et Lully*, Paris 1914, pp. 115–19, 249–65; Margaret M. McGowan, *L'Art du Ballet de Cour en France 1581–1643*, CNRS, Paris 1963, pp. 101–15, 280.

[23] Virtually every history of the theatre deals with this subject. As a point of departure the reader is refered to Alessandro d'Ancona, *Origini del teatro italiano*, Turin 1891, but amongst recent works, all of which contain varying viewpoints and large bibliographies, there is: G. Kernodle, *From Art to Theatre. Form and Convention in the Renaissance*, Chicago 1943, pp. 174–215; Agne Beijer, 'An Early 16th-Century Scenic Design in the National Museum Stockholm, and its Historical Background', *Theatre Research* IV, no. 2, 1962, pp. 85–155; F. Marotti, *Lo spettacolo dall'umanesimo al manierismo*, Milan 1974; Nino Pirrotta and Elena Povoledo, *Music and Theatre from Poliziano to Monteverdi*, C.U.P., 1982, pp. 283–334. Valuable introductions to the study of perspective in the Renaissance are: John White, *The Birth and Rebirth of Pictorial Space*, Icon editions, 1972; Samuel Y. Edgerton, *The Renaissance Discovery of Linear Perspective*, New York 1975. There is a considerable literature on the emergence of the illusionistic stage and the structure of renaissance theatres for which the reader is referred to Kernodle, *From Art to Theatre*, 1943; the catalogue *La Vie Théatrale au Temps de la Renaissance*, Institut Pédagogique National, 1963; Marie-Françoise Christout, 'Scénographie, art des fêtes, ballet de cour, aux XVIe et XVIIe siècles', *L'Information d'Histoire de l'Art*, 10th year, no. 5, 1965, pp. 200–11.

[24] See Part II, chapter V.

[25] For Brunelleschi and perspective see Carlo Argan, 'The Architecture of Brunelleschi and the Origins of Perspective Theory in the Fifteenth Century',

Journal of the Warburg and Courtauld Institutes IX, 1946, pp. 96–121; R. Wittkower, 'Brunelleschi and Proportion in Perspective', *ibid*. XVI, 1953, pp. 275–91; White, *The Birth and Rebirth of Pictorial Space*, 1972 edn, pp. 113–21; L. Zorzi, *Il Luogo Teatrale a Firenze* (ed. M. Fabbri, E. Garbero Zorzi, A. M. Tofani Petrioli and L. Zorzi), Milan 1975, pp. 11–12; same author's *Il Teatro e la Città, Saggi sulla Scena Italiana*, Turin 1977, pp. 65–68; Carlo Ragghianti, *Filippo Brunelleschi. Un uomo, un universo*, Florence 1977, pp. 139–86; Eugenio Battisti, *Filippo Brunelleschi*, English edn., London 1982, pp. 102–13.

26 Vitruvius, *The Ten Books of Architecture*, trans. Morris Hicky Morgan, Dover 1960, p. 150. For the emergence of the Vitruvian scene see A. Beijer, 'An early sixteenth century scenic design in the National Museum, Stockholm', *Theatre Research* IV, 1962, pp. 85–155; Robert Klein and Henri Zerner, 'Vitruve et le Théâtre de la Renaissance Italienne' in *Le Lieu Théâtre à la Renaissance*, CNRS, 1964, pp. 49–60.

27 Kate T. Steinitz, 'Leonardo Architetto Teatrale e Organizzatore di Feste' in *Letture Vinciani* I–XII, 1960–72, Florence 1974, pp. 249–74, fig. II.

28 There is a large and inconclusive literature on these three pictures including: Richard Krautheimer, 'The Tragic and Comic Scene in the Renaissance: the Baltimore and Urbino Panels', *Gazette des Beaux-Arts* XXXIII, 1948, series VI, pp. 327–46; Piero Sanpoalesi, 'Le Prospettive Architettoniche di Urbino, di Filadelfia e di Berlino', *Bolletino d'Arte*, series iv, XXXV, 1949, pp. 322–37; Alessandro Parronchi, 'La prima rappresentazione della "Mandragola": il modello per l'apparato, l'allegoria', *La Bibliofilia* LXIV, 1962, pp. 37–86; André Chastel, 'Les "Vues Urbaines" Peintes et Théâtre', *Bolletino Centro Internazionale di Studi d'Architettura Andrea Palladio* XVI, 1974, pp. 141–44.

29 *Italian Renaissance Festival Designs*, Elvehjem Art Center, University of Wisconsin, 1973, pp. 26 (7); Donald Oenslager, *Four Centuries of Scenic Invention*, International Exhibitions Foundation, 1974–75, p. 13 (I); *La Scena del Principe*, exhibition catalogue, *Firenze e la Toscana dei Medici nell'Europa del Cinquecento*, Florence 1980, p. 338 (3.1).

30 On the role of the *cortile* as a setting for fêtes and its effect on renaissance palace architecture see André Chastel, 'Cortile et Théatre' in *Le Lieu Théâtrale à la Renaissance*, CNRS, Paris 1964, pp. 41–47.

31 For the 1539 fêtes see: Nagler, *Theater Festivals of the Medici*, 1964, pp. 5–12; Andrew Minor and Bonner Mitchell, *A Renaissance Entertainment: Festivities for the Marriage of Cosimo I, Duke of Florence, in 1539*, Columbia, University of Missouri Press, 1968; Zorzi, *Il Teatro e la Città*, 1977, pp. 94–96, 193–96; Bonner Mitchell, *Italian Civic Pageantry in the High Renaissance*, Biblioteca di Bibliografia Italiana LXXXIX, Florence 1979, pp. 50–54; Pirotta and Povoledo, *Music and Theatre*, 1982, pp. 154–69, 340–6.

32 Helen Purkis, 'La Décoration de la Salle et les Rapports entre la scène et le public dans les mascarades et les intermèdes Florentins, 1539–1608', *Fêtes* III, 1975, pp. 239–51.

33 The best introduction is Bertrand Gille, *The Renaissance Engineers*, London 1966.

34 There is a substantial bibliography on Brunelleschi's contribution to the development of stage machinery. The most important are: Alexander Wesselofsky, 'Italienische Mysterien in einem russische Reisebericht des XV. Jahrhunderts', *Russische Revue* X, 1877, pp. 425–41; Oskar Fischel, 'Eine florentiner Theateraufführung in der Renaissance', *Zeitschrift für Bildende Kunst* LV, 1919–20, 31, pp. 11–20; Virginia Galante-Garrone, *L'Apparato scenico del dramma sacro in Italia*, Turin 1935; D. M. Robb, 'The Iconography of the Annunciation in the Fourteenth and Fifteenth Centuries', *Art Bulletin* XVIII, 1936, pp. 480–526; D. M. Robb, 'L' "Ingegno" del Brunelleschi', *Firenze* XI, 1942, pp. 95–96; P. Turchetti in *Enciclopaedia dello Spettacolo*, Florence–Rome 1954–68, II, cols 1197–99; John R. Spencer, 'Spatial Imagery of the Annunciation in Fifteenth Century Florence', *Art Bulletin* XXXVII, 1955, pp. 273–80; Cesare Molinari, *Spettacoli fiorentini del Quattrocento*, Venice 1961, p. 40; A. P. Blumenthal, 'A newly-identified drawing of Brunelleschi's stage machinery', *Marsyas* XIII, 1966–67, pp. 20–31; A. P. Blumenthal, 'Brunelleschi e il teatro del Rinascimento', *Bolletino del Centro Internazionale di Studi di Architettura Andrea Palladio* XVI, 1974 (1976), pp. 93–104; Zorzi, *Il luogo teatrale*, 1975, esp. pp. 55–69 (nos 1.1–1.40); Ragghianti, *Filippo Brunelleschi*, 1977, pp. 446–57; Battisti, *Brunelleschi*, 1981, pp. 300–307; Pirrotta and Povoledo, *Music and Theatre*, 1982, pp. 290–98.

35 For Leonardo see: E. Solmi, 'La Festa del Paradiso di Leonardo da Vinci e Bernardo Bellincioni (13 gennaio 1490)', *Archivio Storico Lombardo* XXXI, 1904, pp. 75–89; reprinted in *Scritti Vinciani*, Florence 1924, pp. 3–14; M. Herzfeld, 'La rappresentazione della "Danae" organizzata da Leonardo', *Racolta Vinciana* XI, 1920–22, pp. 226–28; Kate Steinitz, 'A Reconstruction of Leonardo da Vinci's Revolving Stage', *The Art Quarterly* XII, 1949, pp. 325–38; C. Pedretti, 'La Macchina Teatrale per l'Orfeo di Poliziano', *La Scala, Rivista dell'Opera*, June, 1956, pp. 52–56, reprinted in Pedretti, *Studi Vinciani*, Geneva 1957, pp. 90–98; C. Pedretti, 'Dessins d'une scène executés par Léonard da Vinci pour Charles d'Amboise (1506–1507)', in *Le Lieu Théâtrale à la Renaissance*, Paris 1964, pp. 25–34; Kate Steinitz, 'Le Dessin de Léonard da Vinci pour la représentation de la Danae de Baldassare Taccone', *ibid.*, pp. 35–40; Kate T. Steinitz, 'Leonardo Architetto Teatrale e Organizzatore di Feste', in *Letture Vinciane* I–XIII, 1960–72, Florence 1974, pp. 249–74; Manfredo Tafuri, *Teatro e Scenografie*, Milan 1978, pp. 26–27.

36 On the medieval tradition see Villard de Honnecourt, *The Sketchbook*, ed. T. Bowie, Bloomington 1959; Pirrotta and Povoledo, *Music and Theatre*, 1982, pp. 356–65.

37 Nagler, *Theatre Festivals of the Medici*, 1964, pp. 44–46; Giovanna Gaeta Bertelà and Annamaria Petrioli Tofani, *Feste e Apparati Medicei da Cosimo I a Cosimo II*, Gabinetto Disegni e Stampe degli Uffizi, Florence 1969, pp. 25–29; Zorzi, *Il Luogo Teatrale*, 1975, pp. 32–33, 100–101 (7.14–18); same author's *Il Teatro e la Città*, 1977, pp. 103–105; same author in *Scena del Principe*, 1980, pp. 336–37.

38 John Orrell, 'The Theatre at Christ Church, Oxford, in 1605', *Shakespeare Survey* 35, 1980, pp. 129–40.

[39] Vitruvius, *ed. cit.*, p. 282.

[40] On which see Gille, *The Renaissance Engineer*, 1966; Giovanni Canestrini, 'Il quattrocento e le macchine', *Civiltà delle macchine*, May, 1954, pp. 16–18; Alfred Chapuis and Edouard Gélis, *Le Monde des Automates*, Paris 1928, pp. 31 ff; Alfred Chapuis and Edmond Droz, *Les Automates*, Neuchâtel 1949, pp. 33 ff, 77 ff; Carlo Ragghianti, 'Lo Spettacolo Automatico', *Critica d'Arte* VIII, no. 45, 1961, pp. 57–65; Eugenio Battisti, *L'Antirinascimento*, Milan 1962, pp. 220 ff; A. G. Drachman, *The Mechanical Technology of Greek and Roman Antiquity*, Copenhagen, Munksgaard 1963, pp. 18 ff and 197–8 on Hero's mechanical theatre.

[41] See Part II, chapter IV. The descent of 1589 *intermezzi* from the Italian scenery and machinery of mystery plays is described in Agne Beijer, 'Vision célestes et infernales dans le théâtre du moyen-âge et de la Renaissance', *Fêtes* I, 1956, pp. 403–17.

[42] *Poetics*, 1453 b.

[43] For a discussion of the place of wonder in Renaissance drama see J. V. Cunningham, 'Woe or Wonder' in *Tradition and Poetic Structure*, Denver 1960; S. Orgel and R. Strong, *Inigo Jones. The Theatre of the Stuart Court*, University of California Press, 1973, I, p. 4.

[44] *The First (etc.) Book of Architecture*, London 1611, f. 24r.

[45] *Ibid.*, f. 24r–26r.

[46] See Stephen Orgel, *The Illusion of Power. Political Theatre in the English Renaissance*, University of California Press, 1975.

III THE SPECTACLES OF STATE

[1] Generally see Robert Payne, *The Roman Triumph*, London 1962, pp. 225–46; Andrew Martindale, *The Triumphs of Caesar in the Collection of HM the Queen at Hampton Court*, London 1979, ch. 4.

[2] W. Weisbach, *Trionfi*, Berlin 1919, pp. 20 ff; see also Paul Schubring, *Cassoni*, Leipzig 1915; G. Caradente, *I Trionfi nel Primo Rinascimento*, 1963.

[3] See V. M. Essling and E. Muntz, *Pétrarque: ses études d'art, son influence sur les artistes*, Paris 1902; A. Venturi, 'Les Triomphes dans l'art representatif', *Revue de l'art ancien et moderne* XX, 1906, pp. 81 ff.

[4] The source for Alfonso's entry into Naples is printed in C. von Fabriczy, 'Der Triumphbogen Alfonsos I am Castel Nuovo zu Neapel', *Jahrbuch der Königlich Preussischen Kunstsammlungen* XIX, 1898, pp. 146–47. See also Jacob Burckhardt, *The Civilisation of the Renaissance in Italy*, trans. S. G. C. Middlemore, n.d., p. 217; Payne, *The Roman Triumph*, pp. 233–34.

[5] For Borso d'Este's entry into Reggio see Burckhardt, *Civilisation of the Renaissance*, p. 215; Payne, *The Roman Triumph*, 1962, pp. 234–36.

[6] Burckhardt, *Civilisation of the Renaissance*, pp. 218–19 with other instances and sources; Bonner Mitchell, *Italian Civic Pageantry in the High Renaissance*, Biblioteca di Bibliografia Italiana, LXXXIX, 1979, pp. 113–14.

[7] See Réné Schneider, 'Le Thème du Triomphe dans les Entrées Solonnelles en France à la Renaissance', *Gazette des Beaux-Arts* IX, 1913, pp. 85–106; Josèph Chartrou, *Les Entrées Solennelles et Triomphales à la Renaissance, 1484–1551*, Paris 1928. For the Cremona entry see Mitchell, *Italian Civic Pageantry*, 1979, pp. 26–27; the Milan entry, pp. 83–85.

[8] For the *Hypnerotomachia Polyphili* see J. W. Appell, *The Dream of Poliphilus*, London 1893; M. T. Casella and G. Pozzi, *Francesco Colonna, Biografia e Opere*, Padua 1959.

[9] *Hypnerotomachia. The Strife of Loue in a Dreame*, trans. R. Dallington, London 1592, f. 82–87v.

[10] For Mantegna's Triumphs of Caesar see Martindale, *The Triumphs of Caesar*, 1979 and bibliography; *Splendours of the Gonzaga*, catalogue, ed. David Chambers and Jane Martineau, Victoria & Albert Museum, 1981–82 (nos 66–71).

[11] For Henri II's entry into Rouen see Margaret McGowan, 'Forms and Themes in Henry II's entry into Rouen', *Renaissance Drama*, new series, I, 1968, pp. 199–251; *L'Entrée de Henri II à Rouen 1550*, introduction by Margaret McGowan, Amsterdam and New York n.d.

[12] For a discussion of the role of these official printed accounts see W. McAllister Johnson, 'Essai de Critique Interne des livres d'entrées Français au XVIe siècle', *Fêtes* III, 1975, pp. 187–200.

[13] See J. Jacquot, 'Presentation', *Fêtes* III, 1975, pp. 16–25; George R. Kernodle, 'Renaissance Artists in the Service of the People. Political Tableaux and Street Theaters in France, Flanders and England', *Art Bulletin* XXV, 1943, pp. 59–64.

[14] John Shearman, 'The Florentine *Entrata* of Leo X, 1515', *Journal of the Warburg and Courtauld Institutes* XXXVIII, 1975, pp. 136–54.

[15] There is a fair amount of literature on Netherlandish entries. For those staged for Charles V and his son, the future Philip II in 1549, see Part II chapter II and notes 18–20 for the bibliography. On entries subsequent to that of 1549 see I. von Roeder-Baumbach and H. G. Evers, *Versieringen bij Blijde Inkomsten*, Antwerp 1949; for the entry of Francis, Duke of Anjou into Antwerp in 1582 see *La Magnifique Entrée de Francois d'Anjou en sa ville d'Anvers ...*, introduction by H. M. C. Purkis, Amsterdam and New York n.d.; no individual studies exist for the Antwerp entries of 1594 and 1599 but they are discussed in the extensive literature on the *Pompa Introitus Ferdinandi* of 1635: Max Rooses, *L'Oeuvre de Peter Paul Rubens* III, 1890, pp. 293, 355–356; M. Varchawskaya, 'Certains traits particuliers de la décoration d'Anvers par Rubens pour l'Entrée triomphale de L'Enfant-Cardinal Ferdinand en 1635', *Bulletin des Musées Royaux des Beaux-Arts de Belgique*, 1967, pp. 269–94; J. R. Martin, *The Decorations for the Pompa Introitus Ferdinandi*, Corpus Rubenianum Ludwig Burchard, XVI, London and New York 1972; Elizabeth McGrath, 'Rubens' Arch of the Mint', *Journal of the Warburg and Courtauld Institutes* XXXVII, 1974, pp. 191–217; same author's 'Le Déclin d'Anvers et les Décorations de Rubens pour l'Entrée du Prince Ferdinand en 1635', *Fêtes* III,

1975, pp. 173–86. For the Ghent entry of that year see: D. Rogger, *Les arcs de triomphe de la Joyeuse Entrée de 1635 et leur décoration picturale*, Ghent [1925]; Carl van de Velde and Hans Vlieghe, *Stadsvieringen te Gent in 1635 voor de Blijde Intrede van Kardinal-Infant*, Oudhiedkundig Museum Abdijvan de Blijloke, Ghent 1969; Hans Vlieghe, 'Two "Poeteryen" by Gaspar de Crayer', *Burlington Magazine* CVIII, 1966, pp. 67–72; Archduke Leopold William's entry into Antwerp, 1648: Hans Vlieghe, 'The Decorations for Archduke Leopold William's State Entry into Antwerp', *Journal of the Warburg and Courtauld Institutes* XXXIX, 1976, pp. 190–98. By 1648 Antwerp was so impoverished that Quellinus's series of arches, for which designs exist, were not erected.

For some important observations on Flemish entries of this period as examples of dialogue between ruler and ruled and for their direct influence in Portugal see George Kubler, 'Archiducal Flanders and the *joyeuse entrée* of Philip III at Lisbon in 1619', *Koninklijk Museum voor Schone Kunsten*, Jaarboek, 1970, pp. 157–211. For the transmutation of the old Burgundian mythology in the North as a result of the Revolt of the Netherlands see R. C. Strong and J. A. van Dorsten, *Leicester's Triumph*, Sir Thomas Browne Institute, Leiden and Oxford 1964. In this instance pageantry builds up Robert Dudley, Earl of Leicester as the reviver of Burgundian splendour.

[16] On Henry VIII and the Field of Cloth of Gold see Sydney Anglo, 'Le Camp du Drap d'Or et les Entrevues d'Henri VIII et Charles Quint', *Fêtes* II, pp. 113–34; Jocelyne C. Russell, *The Field of Cloth of Gold*, London 1969; Sydney Anglo, *Spectacle, Pageantry and Early Tudor Policy*, London–Oxford 1969, pp. 124–69.

[17] *Peacham's Compleat Gentleman*, ed. G. S. Gordon, Oxford 1906, p. 214.

[18] On Elizabethan chivalry and the Accession Day Tilts see Frances A. Yates, 'Elizabeth Chivalry: the Romance of the Accession Day Tilts', *Journal of the Warburg and Courtauld Institutes* XX, 1957, pp. 4–25; reprinted in *Astraea. The Imperial Theme in the Sixteenth Century*, London 1975, pp. 88–111; Roy Strong, *The Cult of Elizabeth. Elizabethan Portraiture and Pageantry*, London 1977, pp. 129–62.

[19] On Henry Prince of Wales and chivalry see E. C. Wilson, *Prince Henry in English Literature*, New York 1946; Strong, *Cult of Elizabeth*, pp. 187–91; Frances A. Yates, *Shakespeare's Last Plays: A New Approach*, London 1975, ch. 1; J. W. Williamson, *The Myth of the Conqueror. Prince Henry Stuart: A Study of 17th-Century Personation*, New York 1978. The last barriers was on the creation of Charles I as Prince of Wales in 1616: see D. S. Bland, 'The Barriers. Guildhall Library MS. 4160', *Guildhall Miscellany* VI, 1956, pp. 7–14.

[20] On the tournament in Italy see M. Tosi, *Il Torneo di Belvedere e i Tornei in Italia nel cinquecento*, Rome 1946; see under 'Torneo' in *Enciclopedia dello Spettacolo*, Rome 1954–62; Elena Povoledo, 'Le Théâtre de Tournoi en Italie pendant la Renaissance', *Le Lieu Théâtrale à la Renaissance*, ed. J. Jacquot, CNRS, Paris 1964, pp. 95–104.

[21] On tournaments at the Este court see A. Solerti, *Ferrara e la corte estense nella seconda metà del secolo decimosesto*, Città di Castello 1900, pp. xxxviii–xxxix,

clii–clxi, clxxvii–cci; see the article on Ferrara in the *Enciclopedia dello Spettacolo*. For a detailed study of *Il Tempio d'Amore*, see the excellent article by Irène Mamczarz, 'Une Fête Equestre à Ferrare: Il Tempio d'Amore (1565)', *Fêtes* III, 1975, pp. 349–72. See also Adriano Cavicchi, 'Il Teatro Farnese di Parma', *Bollettino del Centro Internazionale di Studi Architettura*, Andrea Palladio XVI, 1974, pp. 333–42.

22 There is no full length study of the tournament at the court of Savoy but see Margaret M. McGowan, 'Les Fêtes de Cour en Savoie. L'Oeuvre du Philippe d'Aglié', *Revue d'Histoire du Théâtre* III, 1970, pp. 183–241 esp. 197–98 on the 1650 carrousel.

23 For the *opera torneo* see Cesare Molinari, *Le Nozze degli Dei*, Rome 1968, pp. 67–96; see also under Ferrara, Parma and Firenze, and 'torneo' in *Enciclopedia dello Spettacolo*. In addition to Molinari for *Mercurio e Marte* see Nagler, *Theater Festivals of the Medici*, 1964, pp. 139–61.

24 See Irving Lavin, 'Lettres de Parme (1618, 1627–28) et Débuts du Théatre Baroque', *Le Lieu Théâtrale à la Renaissance*, ed. J. Jacquot, CNRS, Paris 1964, pp. 105–58.

25 For Florentine tilts and tournaments see Part II, chapter IV.

26 Francoise Decroisette, 'Les Fêtes du Mariage de Cosme III avec Marguerite Louise d'Orléans à Florence, 1661', *Fêtes* III, 1975, pp. 421–36.

27 Claude François Ménestrier, *Traité des Tournois, Ioustes, Carrousels, et autres Spectacles Publics*, Lyons 1669, pp. 9–21.

28 For the bibliography of the 1608 fêtes see Part II, chapter IV, note 25.

29 For the two equestrian ballets of 1616, the *Guerra d'Amore* and the *Guerra di Bellezza* see: Ménestrier, *op. cit.*, pp. 174–78; Nagler, *Theater Festivals of the Medici*, 1964, pp. 126–30; G. G. Bertelà and A. Petrioli Tofani, *Feste et Apparati Medicei da Cosimo I a Cosimo II*, Gabinetto Disegni e Stampe degli Uffizi, Florence 1969, pp. 142–49; H. Diane Russell, Jeffrey Blanchard and John Krill, *Jacques Callot: Prints and Related Drawings*, National Gallery of Art, Washington 1975, pp. 66–65; Arthur Blumenthal, *Theater Art of the Medici*, Dartmouth College Museum and Gallery, 1980, pp. 95–109.

30 For the equestrian ballet of 1637 see: Nagler, *Theater Festivals of the Medici*, 1964, pp. 173–74; Ludovico Zorzi, Mario Fabbri, E. G. Zorzi and A. M. Petrioli Tofani, *Il Luogo Teatrale a Firenze*, Florence 1975, pp. 50–51, 152–54 (11.3–11.5).

31 For the Joyeuse 'magnificences' bibliography see Part II, chapter III note 26. Margaret M. McGowan, *Le Balet Comique by Balthazar de Beaujoyeulx 1581*, Medieval and Renaissance Texts and Studies, Binghampton 1982, sig. Aij.

32 Frances A. Yates, *The French Academies of the Sixteenth Century*, London 1947, p. 284 and pl. 28.

33 Ménestrier, *op. cit.*, pp. 167–80.

34 On *La Liberazione di Tirreno* see: Angelo Solerti, *Musica, ballo e drammatica alla corte medicea dal 1600 al 1700*, Florence 1905, pp. 121–24; Nagler, *Theater Festivals of the Medici*, 1964, pp. 131–33; Zorzi, Fabbri, Zorzi and Tofani, *Il Luogo Teatrale*, 1975, pp. 123–25 (8.41–8.46); Russell, Blanchard and Krill, *Jacques Callot*, 1975, pp. 65–67; O. J. Rothrock and E. van Gulick, 'Seeing and Meaning: Observations on the Theatre of Callot's *Primo*

Intermedio', *New Mexico Studies in Fine Arts* IV, 1979, pp. 16–36; Blumenthal, *Theater Art of the Medici*, 1980, pp. 110–17.

35 The history of dance in its practical sense during the Renaissance is remarkably unexplored. On the *ballet de cour* see: Claude François Ménestrier, *Des Ballets anciens et modernes*, Paris 1682 (a book written still in a Renaissance atmosphere); Henri Prunières, *Le Ballet de cour en France avant Benserade et Lully*, Paris 1914; Margaret M. McGowan, *L'Art du Ballet de Cour en France*, CNRS, Paris 1963; Marie F. Christout, *The Court Ballet in France 1615–1641*, New York, Dance Perspectives, no. 20, 1964; same author, *Le Ballet de Cour de Louis XIV*, Paris 1967.

36 Yates, *French Academies*, 1947, p. 249.

37 For ballet at the court of Lorraine see Francois-Georges Pariset, 'Le Mariage d'Henri de Lorraine et Marguerite Gonzague-Mantoue (1606)', *Fêtes* I, pp. 153–86; McGowan, *L'Art du Ballet de Cour*, 1963, pp. 197–99.

38 For the bibliography on ballet at the Savoy court see Part I, chapter I note 1.

39 For *ballet de cour* in Sweden see Agne Beijer, 'La Naissance de la Paix. Ballet de Cour de Réné Descartes', *Le Lieux theatrale à la Renaissance*, CNRS, Paris 1964, pp. 409–22.

40 For the bibliography on the Stuart court masques see Part II, chapter V note 1.

41 *English Masques*, ed. H. A. Evans, n.d., p. 7

42 Stephen Orgel and Roy Strong, *Inigo Jones. The Theatre of the Stuart Court*, University of California Press, 1973, I, p. 283.

43 *Ibid.* I, p. 95.11.272–73.

44 For idea and theory of the dance see Ménestrier, *Des Ballets anciens et modernes*, 1682; McGowan, *L'Art du Ballet de Cour*, 1963, pp. 11–27; John C. Meagher, 'The Dance and the Masques of Ben Jonson', *Journal of the Warburg and Courtauld Institutes* XXV, 1962, pp. 258–77; Sarah Thesiger, 'The *Orchestra* of Sir John Davies and the Image of the Dance', *ibid.* XXXVI, 1973, pp. 277–304. For the use of symbolic figured dances in a *Rappresentazione Sacra* see Marc Fumaroli, 'Le *Crispus* et *La Flavia* du P. Bernardino Stefonio S.J.', *Fêtes* III, 1975, esp. pp. 521–24 and pls I–III.

45 See Part I, chapter II note 20.

46 On *Le Ballet de Monseigneur le Duc de Vendosme . . .* see McGowan, *L'Art du Ballet de Cour*, 1963, pp. 69–84.

47 Orgel and Strong, *Inigo Jones*, 1973, I, p. 407, 11.130–34.

48 Ménestrier, *Des Ballets anciens et modernes*, 1682, pp. 35–36.

49 For a still useful discussion of this see Hélène Leclerc, 'Du Mythe Platonicien aux Fêtes de la Renaissance', *Revue d'histoire du théatre* II, 1959, pp. 109–65.

PART II

I THE IDEA OF MONARCHY

[1] For a general introduction to the idea of Empire see H. Fisher, *The Medieval Empire*, London 1898, pp. 13–47; A. Dempf, *Sacrum Imperium*, trans. Carlo Antoni, Messina 1933; W. Ullmann, *Medieval Papalism*, London 1949, pp. 138–98; Antonino de Stefano, *L'idea imperiale di Frederico II*, Bologna 1952; Robert Folz, *L'Idée d'Empire en Occident du V^e aux XIV^e Siècle*, Paris 1953 and bibliography; E. H. Kantorowicz, *Frederick the Second 1194–1250*, London 1957.

[2] For Charles V and the imperial idea see: K. Brandi, *The Emperor Charles V*, trans. C. V. Wedgwood, London 1939; Menendez Pidal, *Idea imperial de Carlos V*, Madrid 1940; Hans Kohn, *The Idea of Nationalism*, New York 1955, pp. 146–55; Frances A. Yates, 'Charles Quint et l'idée d'Empire', *Fêtes* II, pp. 57–97; partly reprinted in *Astraea. The Imperial Theme in the Sixteenth Century*, London 1975, pp. 1–28.

[3] Erasmus, *The Education of a Christian Knight*, trans. L. K. Born, Columbia U.P., 1936; A. H. Gilbert, *Macchiavelli's Prince and its Forerunners*, Durham, N.C. 1938; see Yates, *Astraea*, pp. 19–20; Pierre Mesnard, 'L'Experience Politique de Charles Quint et les renseignements d'Erasme', *Fêtes* II, pp. 45–56.

[4] *Feste e Archi Triumphali furono fatti nella entrata dell'invittissimo Cesare CAROLO . . . in la nobilissima & fidelissima Cita de Siuiglia A. III. de Marzo .M.D. XXVI*; C. A. Marsden, 'Entrees et Fêtes Espagnoles au XVI^e siècle', *Fêtes* II, 1960, pp. 402–3.

[5] Yates, *Astraea*, 1975, p. 84.

[6] Roy Strong, *Portraits of Queen Elizabeth I*, Oxford 1963, pp. 34–39; John Phillips, *The Reformation of Images: Destruction of Art in England, 1535–1660*, University of California Press, 1973, pp. 119 ff.

[7] Ralph E. Giesey, *The Royal Funeral Ceremony in Renaissance France*, Travaux d'Humanisme et Renaissance, XXXVII, Geneva 1960, esp. pp. 146 ff.

[8] Quoted *ibid.*, p. 5.

[9] For an excellent example of the interlocking of Catholic and imperial imagery derived from Charles V (Golden Age, Astraea, the imperial column *impresa*, etc.) see Philip II's entry into Lisbon, 1581: Alfonso Guerreiro, *Das Festas Que se Fizeram na cidade de Lisboa, na entrada de Rey D. Philippe primeiro de Portugal*, Lisbon 1581.

[10] See Folz, 1953, pp. 171 ff.

[11] See Marc Bloch, *The Royal Touch. Sacred Monarchy and Scrofula in England and France*, London 1973, pp. 195 ff.

[12] Frances A. Yates, 'Queen Elizabeth as Astraea', *Journal of the Warburg and Courtauld Institutes* X, 1947, pp. 27–87; reprinted in *Astraea*, 1975, pp. 29–87.

[13] Harry H. Boyle, 'Elizabeth's Entertainment at Elvetham: War Policy in Pageantry', *Studies in Philology* 68, 1971, pp. 146–66; Jean Wilson, *Entertainments for Elizabeth I*, Cambridge 1980, pp. 96–118; Roy Strong, *The Renaissance Garden in England*, London 1979, pp. 125–26.

[14] *Faerie Queene*, Bk.III, canto III, xlix.

[15] Roy Strong, *The Cult of Elizabeth. Elizabethan Portraiture and Pageantry*, London 1977, pp. 164–85.

[16] *Ibid.*, pp. 151–55; Yates, *Astraea*, 1975, pp. 102–104.

[17] See *L'Ecole de Fontainebleau*, Paris, Grand Palais, 1972–73 (no. 34) and for bibliography; Yates, *Astraea*, pp. 145–46, 222–24.

[18] Yates, *Astraea*, 1975, pp. 122–26.

[19] Corrado Vivanti, 'Henry IV, the Gallic Hercules', *Journal of the Warburg and Courtauld Institutes* XXX, 1961, pp. 176–97; for the Avignon entry see Margaret McGowan, 'Les Jésuites à Avignon. Les Fêtes au Service de la Propagande Politique et Religieuse', *Fêtes*, 1975, pp. 153–63; see also Robert E. Hallowell, 'The Role of French Writers in the Royal Entries of Marie de'Medici', *Studies in Philology* LXVI, 1969, pp. 182–203.

[20] For James I's entry into London see: Sources: John Nichols, *The Progresses, Processions and Magnificent Festivities of King James the First*, London 1828, I, pp. 329–401; *The Dramatic Works of Thomas Dekker*, ed. Fredson Bowers, Cambridge 1964, II, pp. 229–303; Ben Jonson, *Works*, ed. C. H. Herford and P. and E. Simpson, Oxford 1941, VII, pp. 81–109. Studies: Glynne Wickham, 'Contributions de Ben Jonson et de Dekker aux Fêtes du Couronnement de Jacques Ier', *Fêtes* I, 1956, pp. 279–83; Per Palme, 'Ut Architectura Poesis', *Acta Universitatis Upsaliensis, Figura*, new series, I, pp. 95–107; David M. Bergeron, 'Harrison, Jonson and Dekker: The Magnificent Entertainment for King James (1604)', *Journal of the Warburg and Courtauld Institutes* XXXI, 1968, pp. 445–48; same author, *English Civic Pageantry, 1558–1642*, London 1971, pp. 71–88; Graham Parry, *The Golden Age Restor'd. The Culture of the Stuart Court, 1603–42*, Manchester U.P., 1981, pp. 1–20; Jonathan Goldberg, *James I and the Politics of Literature*, Johns Hopkins U.P., 1983, ch. i. Generally on Stuart imperialism see Roy Strong, *Van Dyck, Charles I on Horseback*, London 1972, pp. 45–57; same author's *Britannia Triumphans. Inigo Jones, Rubens and Whitehall Palace*, London 1980, pp. 16 ff.

[21] For this see R. J. W. Evans, *Rudolf II and His World*, Oxford 1973, pp. 15–22.

[22] See Werner L. Gundersheimer, *Ferrara. The Style of a Renaissance Despotism*, Princeton U.P., 1973, pp. 278–81.

II IMAGES OF EMPIRE

¹ For the sources for the 1539 fêtes see Part I, chapter II note 31.

² The festivals of the reign of Charles V were the subject of a major conference in 1955 and the volume of papers published as a result form the basis for much of this chapter: *Fêtes et Cérémonies au Temps de Charles Quint, Les Fêtes de la Renaissance*, ed. Jean Jacquot, II, CNRS, 1960. Referred to as *Fêtes* II, 1960.

³ I omit from this chapter a discussion of Charles V's journey through France in 1539–40 and his visit to England in 1522. The French entries were without exception medieval in character and forced in allegorical content. For an account of these the reader is referred to V. L. Saulnier, 'Charles Quint traversant la France: ce qu'en dirent les Poètes Français', *Fêtes* II, 1960, pp. 207–33; Jacquot, *ibid.*, pp. 433–40. For England see Sydney Anglo, 'The Imperial Alliance and the Entry of the Emperor Charles V into London: June 1522', *Guildhall Miscellany* 11, 4, 1962, pp. 131–35; and the same author's *Spectacle, Pageantry and Early Tudor Policy*, Oxford 1969, pp. 170–206.

⁴ The fundamental reference work for the festivals staged for Charles V while in Italy is Bonner Mitchell, *Italian Civic Pageantry in the High Renaissance*, Biblioteca de Bibliografia Italiana, LXXXIX, Florence 1979. This lists under city and entry both the sources and studies. I include here for convenience references to any important study of a particular entry. For a general survey see André Chastel, 'Les Entrées de Charles Quint en Italie', *Fêtes* II, 1960, pp. 197–206; Jacquot, *ibid.*, pp. 418–33.

For Bologna see: Gaetano Giordani, *Della venuta e dimora in Bologna del Sommo Pontifice Clemente VII. per la coronazione di Carlo V. imperatore celebrata l'anno MDXXX, cronaca con note, documenti ed incisioni*, Bologna 1842; Sir William Stirling Maxwell, *The Entry of the Emperor Charles V into the City of Bologna on the Fifth of November MDXXIX, Reproduced from a Series of Engravings on Wood Printed at Venice in MDXXX*, 1875; the same author's *The Procession of Pope Clement VII and the Emperor Charles V after the Coronation of Bologna on the 24th February, MDXXX, Designed and Engraved by Nicolas Hogenberg . . .*, 1875; Vicomte Terlinden, 'La Politique Italienne de Charles Quint et le "Triomphe de Boulogne" ', *Fêtes* II, 1960, pp. 29–43; Jacquot, *ibid.*, pp. 418–25; Mitchell, *Italian Civic Pageantry*, 1979, pp. 19–25.

⁵ Genoa: W. Vitzthum, 'The Sir Anthony Blunt Collection', *Master Drawings* III, 1965, pp. 405–406; Jacquot, *Fêtes* II, 1960, p. 441; Mitchell, *Italian Civic Pageantry*, 1979, pp. 60–61; *La Scena del Principe* in *Firenze e la Toscana dei Medici nell'Europa del Cinquescento*, Florence 1980, p. 347 (4.6).

⁶ Mantua: Jacquot, *Fêtes* II, 1960, pp. 426–27; Frederick Hartt, *Giulio Romano*, Yale U.P., 1961, I, pp. 105–106, 148–50, 157–58, 269–71; II, pl. 523; Mitchell, *Italian Civic Pageantry*, 1979, pp. 68–69.

⁷ For Lyons see G. Guigue, *La magnificence de la superbe et triumphante entree de la . . . cité de Lyon faicte au . . . roy Henry deuxiesme . . .*, Société des Bibliophiles Lyonais, Lyons 1927; study: V. L. Saulnier, *Maurice Scève*, Paris 1948, I, pp. 328–70.

[8] For Paris see I. D. McFarlane, *The Entry of Henry II into Paris 16 June 1549*, Medieval and Renaissance Texts and Studies, Binghamton, N.Y. 1982: the former includes the text and a study but other studies are: V. L. Saulnier, 'L'Entrée de Henri II à Paris et la Revolution Poètique de 1550', *Fêtes* I, 1956, pp. 31–58. For the influence of these entries on the numerous ones made by Henri II during his reign see Denis Gluck, 'Les Entrées Provinciales de Henri II', *L'Information d'Histoire de l'Art* 10th year, no. 5, 1965, pp. 215–18.

[9] For Giulio Romano see Hartt, 1961.

[10] For these designs see *L'Ecole de Fontainebleau*, Grand Palais, Paris 1972, nos 187–93; see also Bengt Dahlbaeck, 'Survivances de la Tradition Médiévale dans les Fêtes Françaises de la Renaissance', *Fêtes* I, 1956, pp. 397–404.

[11] Messina: Jacquot, *Fêtes* II, 1960, pp. 429–30; L. Ravelli, *Polidoro da Caravaggio*, Bergamo 1978, pp. 192–96; Mitchell, *Italian Civic Pageantry*, 1979, pp. 76–78; *La Scena del Principe*, 1980, p. 348 (4.10).

[12] Naples: Jacquot, *Fêtes* II, 1960, pp. 430–31; Mitchell, *Italian Civic Pageantry*, 1979, pp. 101–104.

[13] Rome: Gugliemmo de Angelis d'Ossat, 'Gli archi trionfali ideati dal Peruzzi per la venuta a Roma di Carlo V', *Capitolium*, anno XVIII, 1943, pp. 287–94; Gustavo Giovannoni, *Antonio San Gallo il giovane*, Rome 1959, I, pp. 309–12; II, pls 327–31; Jacquot, *Fêtes* II, 1960, p. 431; L. Fiorani and others, *Riti, ceremonie, feste e vita di popolo nella Roma dei Papi*, Bologna 1970, pp. 144–47; *La Scena del Principe*, 1980, p. 348 (4.11–13).

This technique of re-dressing the arches from antiquity with new inscriptions was used in 1597 for a translation of relics, see Richard Krautheimer, 'A Christian Triumph in 1597', in *Essays . . . presented to Rudolf Wittkower*, ed. D. Fraser, H. Hibbard and M. J. Lewine, London 1967, pp. 174–78.

[14] Siena: Jacquot, *Fêtes* II, 1960, pp. 431–33; Mitchell, *Italian Civic Pageantry*, 1979, pp. 36–38.

[15] Florence: Jacquot, *Fêtes* II, 1960, p. 433; Mitchell, *Italian Civic Pageantry*, 1979, pp. 46–48.

[16] Milan: Jacquot, *Fêtes* II, 1960, p. 442; Mitchell, *Italian Civic Pageantry*, 1979, pp. 89–91; *La Scena del Principe*, 1980, p. 348 (4.15). During the same tour he made an entry into Mallorca, for which an illustrated account was printed: see Santiago Sebastian, 'La exaltación de Carlos V en la arquitectura mallorquina del siglo XVI', *Mayurqua, Miscelánea de Estudios Humanísticos* V, 1971, pp. 99–113.

[17] See T. E. Laurenson, 'Ville Imaginaire. Décor Théatral et Fête', *Fêtes* I, 1959, pp. 425–29; Marcello Fagiolo, 'Effimero e Giardino: il Teatro della Città e il Teatro della Natura', in *Il Potere e lo Spazio* in *Firenze e la Toscana dei Medici . . ., op. cit.*, 1980, pp. 31–42.

[18] The fullest and most accessible source describing all the entries and fêtes of the tour is Calvete de Estrella, *Le Tres-Heureux Voyage fait par . . . Don Philippe fils du grand empereur Charles Quint*, Société des Bibliophiles de Belgique, no. 16, Brussels 1884. See also, for a survey and analysis, Jacquot, *Fêtes* II, 1960, pp. 440–55.

[19] Antwerp: C. Scribonius, *Le Triumphe d'Anvers, faict en la susception du Prince Philips, Prince d'Espaigne*, Anvers 1549; studies: A. Corbet, 'L'Entrée du Prince

Philippe à Anvers en 1549', *Fêtes* II, 1960, pp. 307–10; Jacquot, *ibid.*, pp. 455–67.

20 See Marcel Lageirse, 'La Joyeuse Entrée du Prince Philippe à Gand en 1549', *Fêtes* II, 1960, pp. 297–306; Leo van Puyvelde, 'Les Joyeuses Entrées et la Peinture Flamande', *ibid.*, pp. 287–96.

21 For Binche see: Estrella, *Voyage* III, pp. 100–33; studies: Albert van der Put, 'Two Drawings of the Fêtes at Binche', *Journal of the Warburg and Courtauld Institutes* III, 1939, pp. 49–57; Daniel Devoto, 'Folklore et Politique au Château Ténébreux', *Fêtes* II, 1960, pp. 311–28; Daniel Devoto, 'Un Divertissement de Palais pour Charles Quint à Binche', *ibid.*, pp. 329–42.

22 See Part II, chapter II, pp. 105–106 and note 6.

23 *Ibid.*, p. 124 and note 36.

24 Ditchley: Frances A. Yates, *Astraea. The Imperial Theme in the Sixteenth Century*, London 1975, pp. 104–11; Jean Wilson, *Entertainments for Elizabeth I*, Cambridge 1980, pp. 119–42.

25 Stephen Orgel, *The Jonsonian Masque*, Harvard U.P., 1965, pp. 8–18.

26 *The Works of Dr Thomas Campion*, ed. A. H. Bullen, London 1889, p. 213.

27 Brussels: *Les Obsèques ... de l'Empereur Charles ...*, Paris 1559; study: Jacquot, *Fêtes* II, 1960, pp. 467–73.

28 E. Borsook, 'Art and Politics at the Medici Court. I: The Funeral of Cosimo I de'Medici', *Mitteilungen des Kunsthistorischen Institutes in Florenz* XII (I–II), 1965, pp. 31–54; G. C. Bertelà and Annamaria Petrioli Tofani, *Feste e Apparati Medicei da Cosimo I a Cosimo II*, Gabinetto Disegni e Stampe degli Uffizi, Florence 1969, pp. 30–37, 200–201. For the whole subject and bibliography see Annamaria Petrioli Tofani, 'La Scena Ecclesiastica', in *La Scena del Principe*, 1980, pp. 385–92.

29 See John Harris, Stephen Orgel and Roy Strong, *The King's Arcadia. Inigo Jones and the Stuart Court*, Arts Council Exhibition, 1973, pp. 135–36 (240–41) and p. 222 for bibliography.

30 See Appendix I.

III 'POLITIQUE' MAGNIFICENCE

1 Brantôme, *Oeuvres Complètes*, ed. P. Merimée, Paris 1890, X, p. 76.

2 Victor E. Graham and W. McAllister Johnson, *The Royal Tour of France by Charles IX and Catherine de'Medici. Festivals and Entries, 1564–6*, University of Toronto Press, 1979, pp. 57–67.

3 Frances A. Yates, *The Valois Tapestries*, London 1959. Previous literature: N. Ivanoff, 'Les Fêtes à la Cour des Dernier Valois après les tapisseries flamande du Musée des Offices à Florence', *Revue du seizième siècle* XIX, 1932–33, pp. 96–101; the following all by J. Ehrmann, 'Caron et les tapisseries de Florence', *Revue des Arts*, 1952, pp. 27–30; 'Les Tapisseries des Valois du

Musée des Offices à Florence', *Fêtes* I, 1956, pp. 93–100; 'Caron et les tapisseries de Valois', *Revue des Arts*, March, 1956, pp. 9–16; 'Dessins d'Antoine Caron pour les tapisseries des Valois du Musée des Offices à Florence', *Bulletin de la Société de l'Histoire de l'Art Français*, 1956, pp. 115–25; 'Drawings by Antoine Caron for the Valois Tapestries', *Art Quarterly* XXI, no. 1, 1958, pp. 47–65. Other studies: P. Francastel, 'Figuration et spectacle dans les Tapisseries des Valois', *Fêtes* I, 1956, pp. 101–5; *L'Ecole de Fontainebleau*, Grand Palais, 1972, nos 43–44, 462.

4 For the Academy and its revival of 'ancient' music, poetry and dancing see: Frances A. Yates, *The French Academies of the Sixteenth Century*, London 1947, ch. III. See also various articles by D. P. Walker, 'The Aims of Baïf's Académie de Poésie et de Musique', *Journal of Renaissance and Baroque Music* I, 1946, pp. 91–100; 'The Influence of Musique Mesurée à l'antique particularly on the Airs de Cour of the Early Seventeenth Century', *Musica Disciplina* II, 1948, pp. 144–47; 'Claude Le Jeune and Musique Mesurée', *Musica Disciplina* III, 1949, pp. 150–70; Claude Le Jeune, *Airs*, ed. D. P. Walker, Rome 1951. See also McGowan, *L'Art du Ballet de Cour*, pp. 16–17.

5 This almost lost set of 'magnificences' is referred to in N. M. Sutherland, *The French Secretaries of State in the Age of Catherine de'Medici*, University of London Historical Studies X, 1962, p. 136 with a reference to Comte Boulay de la Meurthe, 'Entrée de Charles IX à Chenonceau', *Mémoires de la Société archéologique de Touraine* XLI, 1900, pp. 151–89 (not seen).

6 For the Fontainebleau 'magnificences' the most important sources are printed in Graham and McAllister Johnson, *The Royal Tour*, 1979. These are Abel Jouan, *Recueil et Discours du Voyage du Roy Charles IX*, Paris 1566, for which see pp. 75–76 and *Le recueil des Triumphes et Magnificences qui ont estez faictes au Logis de Monseigneur le Duc Dorleans . . .*, reprinted, pp. 147–69. Contemporary memoirs give a somewhat muddled account: Brantôme, *Oeuvres Complètes*, Paris 1873 edn., VII, p. 369; *Les memoires de Messire Michel de Castelnau, Seigneur de Mauvissière*, ed. J. Le Laboureur, Paris 1731, I, pp. 167–68. Studies: H. Prunières, *Le Ballet de Cour en France*, Paris 1914, pp. 45, 50; P. Laumonier, *Ronsard poète lyrique*, Paris 1909, pp. 219–21; H. Prunières, 'Ronsard et les fêtes de cour', *Revue musicale*, 1924; P. Champion, *Ronsard et son Temps*, Paris 1925, pp. 207–11; H. Chamard, *Histoire de la Pléiade*, Paris 1939–40, III, pp. 7–12; Yates, *French Academies*, 1947, pp. 251–53; same author's *Valois Tapestries*, 1959, pp. 53–54.

7 Graham and McAllister Johnson, *The Royal Tour*, 1979, p. 168.

8 For the *Grande Voyage* see Graham and McAllister Johnson, *The Royal Tour*, 1979, pp. 3–22, 170–290, 381–89. They print all the texts for the entries.

9 Vital de Valois, *L'Entrée de Charles IX à Lyons en 1564*, Lyons, p. 50.

10 Graham and McAllister Johnson, *The Royal Tour*, 1979, p. 196.

11 For the Bayonne 'magnificences' the sources are printed in *ibid.*, pp. 284 ff. The most important source is the official account, *Recueil des Choses notables qui on esté faites à Bayonne, à e'entreveuë du Roy Treschrestien Charles neufieme de ce nom . . .*, reprinted, pp. 328–86. They miss, however, an English account: *Calendar of State Papers, Foreign, 1564–65*, p. 398 (1229). Studies: Yates,

French Academies, pp. 253–54; same author's *Valois Tapestries*, 1959, pp. 55–60; Graham and McAllister Johnson, *The Royal Tour*, 1979, pp. 30–57.

12 *Ibid.*, p. 356.

13 *Ibid.*, p. 372.

14 *Ibid.*, p. 377.

15 What follows is based on the discussion in *ibid.*, pp. 57–67.

16 The basic sources for the entries are: Simon Bouquet, *Bref et Sommaire recueil de ce qui a esté faict, & l'ordre tenüe à la ioyeuse & triumphante Entree de tres-puissant, tres-magnanime & tres-cretien Prince CHARLES IX de ce nom Roy de France, en sa bonne ville & cite de Paris ...*, Paris 1572; *Registres des Délibérations du Bureau de la Ville de Paris*, ed. P. Guérin, Paris 1891, VI esp. pp. 238–43. For studies see Frances A. Yates, 'Poètes et Artistes dans les Entrées de Charles IX et de sa Reine à Paris en 1571', *Fêtes I*, 1956, pp. 6–91; and variations on this by the same author: *La ioyeuse Entrée de Charles IX Roy de France en Paris*, 1572, facsimile reprint, Amsterdam and New York, 1974, pp. 6–40; *Astraea. The Imperial Theme in the Sixteenth Century*, London 1975, pp. 127–48; Victor E. Graham and W. McAllister Johnson, *The Paris Entries of Charles IX and Elizabeth of Austria 1571*, University of Toronto Press, 1974.

17 Graham and McAllister Johnson, *Paris Entries*, 1974, pp. 28–29 emphasise the role of Bouquet, which the manuscript evidence supports, as against that of Ronsard and Dorat.

18 *Ibid.*, p. 118.

19 *Ibid.*, p. 217.

20 J. Nichols, *Progresses of Queen Elizabeth I*, London 1823, p. 305.

21 The main sources for the fêtes for the Navarre-Valois wedding are: *Memoires de l'Estat de France sous Charles IX*, Middleburg 1578, pp. 262–71; Agrippa d'Aubigné, *Histoire Universelle*, Paris 1889 edn., III, p. 303. For studies see: Prunières, *Ballet de Court*, 1913, p. 705; same author's 'Ronsard et les fêtes de cour', *Revue Musicale*, May 1924, pp. 40–2; Yates, *French Academies*, 1947, pp. 254–5; Yates, *Valois Tapestries*, 1959, pp. 61–7.

22 For the entry see *Régistres*, ed. Guérin, *op. cit.* VIII, pp. 82–124.

23 *Ibid.*, p. 120.

24 On the ballet of the Provinces of France see: Jean Dorat, *Magnificentissimi spectaculi, a regina Regnum matre in hortis suburbanis editi in Henrici Regis Poloniae invictissimi reunciat gratulationem: descriptio*, Paris 1573; Brantôme, *Oeuvres*, 1873 edn., pp. 371–72; d'Aubigné, *Histoire Universelle*, 1889 edn., IV, p. 178; studies: Prunières, *Ballet de Cour*, 1914, pp. 55–7; Yates, *Valois Tapestries*, 1959, pp. 67–70; McGowan, *Ballet de Cour*, 1963, pp. 41–2.

25 The most comprehensive treatment of the Italian tour together with the sources is P. de Nolhac and A. Solerti, *Il Viaggio in Italia di Enrico III*, Turin 1890. The main events were: entry into Padua: *Le Feste e Trionfi Fatti nella Nobilissima città di Padoa nella feliciss. venuta, e passagio di Henrico III*, Venice 1574; entry into Treviso: *I gran Trionfi fatti nella nobil Citta di Treviso, nella Venuta del christianissimo Re di Francia, & di Polonia. Henrico Terzo*, Venice 1574; entry and festivities in Venice: Nolhac and Solerti, *op. cit.*, pp. 94–112; sources

and references in the extensive literature on Palladio can be found in *Architettura e Utopia nella Venezia del Cinquecento*, Venice, Palazzo Ducale, 1980 (nos 148–50, 157–59); Howard Burns and others, *Andrea Palladio 1508–1580*, Arts Council Exhibition, 1975, pp. 149–50 (nos 264–66); entry into Ferrara: Nolhac and Solerti, *Viaggio*, pp. 171–9; 321–33 entry into Mantua, *ibid.*, pp. 180–93, 333–37; *Entrata del Christianiss. Re Henrico III. di Francia, et di Polonia nella Citta di Montova . . .*, Venice 1574; Blaise de Vignère, *La Sompteuse et magnifique entrée du Roy Henri III de ce nom, Roy de France et de Pologne, grand Duc de Lithuanie etc. en la cite de Mantoue, avec les portraits des choses les plus exquises*, Paris 1576 (this includes eight engravings of the arches and other temporary effects).

26 The literature on the Joyeuse 'magnificences' (other than the *Balet Comique*) is virtually exclusively by Frances A. Yates. The main sources are: programme in Bibliothèque Nationale, Fonds Français, 15,831, f. 90, printed by Yates in *Astraea*, pp. 169–72; *Journal de L'Estoile pour le Règne de Henri III*, ed. L. R. Lefèvre, Paris 1943, pp. 274 ff.; and an important source not used by Yates, Abel Dèsjardins, *Négociations Diplomatiques de la France avec la Toscane*, Paris 1872, IV, pp. 394, 400, 402, 404–5, 406–7. For studies by Yates see 'Poésie et Musique dans les "Magnificences" au Mariage du Duc de Joyeuse, Paris 1581', *Musique et Poésie au XVIe Siècle*, Centre Nationale de la Récherche Scientifique, Paris 1954, pp. 237–63; *French Academies*, pp. 237–38; *Valois Tapestries*, 1959, pp. 82–88; *Astraea*, 1975, pp. 149–72.

27 J.-A. de Baif, *Œvvres en rime*, ed. C. Marty-Leveaux, Paris 1881–90, V, p. 5.

28 J. Dorat, *Oeuvres poètique*, ed. C. Marty-Leveaux, Paris 1895, p. 23.

29 *Ibid.*, p. 29.

30 Yates, *Astraea*, 1975, p. 158.

31 L'Estoile, *Journal*, 1943 edn., p. 274.

32 Yates, *Astraea*, 1975, p. 172 note 4 states that nothing is known about this entertainment but see Dèsjardins, *op. cit.*, pp. 404–5 which refers to a temporary room being built which indicates a festival along the lines of the 1573 ballet, and pp. 406–7, where the event was postponed as the room was not finished.

33 Sources: Baltasar de Beaujoyeux, *Balet Comique de la Reyne faict aux nopces de Monsieur le Duc de Joyeuse . . .*, Paris 1581; facsimile with introduction by Margaret McGowan, Medieval and Renaissance Texts and Studies, 6, Binghamton, N.Y. 1982; studies: Prunières, *Ballet de Cour*, 1913, pp. 82–94; Yates, *French Academies*, 1947, pp. 236 ff.; Yates, *Valois Tapestries*, 1959, pp. 82–86; Margaret McGowan, *L'Art du Ballet de cour en France*, Paris 1963, pp. 37, 42–47; Yates, *Astraea*, 1975, pp. 165–67.

34 Frances A. Yates, 'Dramatic Religious Processions in Paris in the late Sixteenth Century', *Annales Musicologiques* II, 1954, pp. 215–62; Yates, *Astraea*, pp. 173–207.

35 The sources are listed in E. K. Chambers, *The Elizabethan Stage*, Oxford 1923, IV, pp. 63–64, except for F. von Raumer, *History of the Sixteenth and Seventeenth Centuries illustrated by Original Documents*, London 1835, II, pp. 431 ff.; the most recent edition of the basic text is in Jean Wilson, *Entertainments for Elizabeth I*, 1980, pp. 61–85.

[36] Source: *Les Memoirs de Monsieur le Duc de Nevers*, Paris 1665, I, pp. 555–57; study: Yates, *Valois Tapestries*, 1959, pp. 91–3.

[37] Roy Strong, 'Festivals for the Garter Embassy at the Court of Henri III', *Journal of the Warburg and Courtauld Institutes* XXII, 1959, pp. 60–70; Yates, *Astraea*, 1975, pp. 194–96.

[38] Source: *Le Ballet des Chevaliers François et Béarnois représenté devant Madame à Pau le 23e jour d'Aoust 1592* reprinted in Paul Lacroix, *Ballets et Mascarades de Cour de Henri III à Louis XIV*, Geneva 1868, I, pp. 89–107; study: McGowan, *L'Art du Ballet de cour*, 1963, pp. 54–58.

[39] *Ballet de Madame de Rohan*, reprinted in Lacroix, *op. cit.* I, pp. 117–42; study: McGowan, *L'Art du Ballet de cour*, 1963, pp. 58–61.

IV APOTHEOSIS OF A DYNASTY

[1] The development by the Medici of their use of festivals for political ends under Cosimo I is discussed in Michel Plaisance, 'La Politique Culturelle de Côsme I^{er} et les Fêtes Annuelles à Florence de 1541 à 1550', *Fêtes* III, 1975, pp. 133–52.

[2] The sources for and studies of the 1539 entry are listed in Bonner Mitchell, *Italian Civic Pageantry in the High Renaissance*, Biblioteca di Bibliografia Italiana, LXXXIX, 1979, pp. 50–54. Most of the literature deals with the marriage entertainments but for the entry see *A Renaissance Entertainment: Festivities for the Marriage of Cosimo I, Duke of Florence, 1539*, ed. Andrew C. Minor and Bonner Mitchell, University of Missouri, 1968; Henry W. Kaufmann, 'Art for the Wedding of Cosimo de'Medici and Eleanora of Toledo (1568)', *Paragone* XXI, 1970, pp. 52–67.

[3] For the 1565 entry see: Sources: Domenico Mellini, *Descrizione dell'Entrata della Serenissima Regina Giovanna d'Austria* . . ., Florence 1566; G. B. Cini, *Descrizione dell'Apparato fatto per le Nozze dell'Illustrissimo ed Eccellentissima Don Francesco de'Medici Principe di Firenze e di Siena e della Serenissima Regina Giovanna d'Austria* in *Le Opere di Giorgio Vasari*, ed. G. Milanesi, Florence 1882, VIII. Studies: P. Ginori Conti, *L'Apparato per le nozze di Francesco de'Medici e di Giovanna d'Austria*, Florence 1936; E. Pillsbury, 'Drawings by Vasari and Vincenzo Borghini for the Apparato in Florence in 1565', *Master Drawings* V, 1967, pp. 281–83; Giovanna Gaeta Bertelà and Annamaria Petrioli Tofani, *Feste e Apparati Medicei da Cosimo I a Cosimo II*, Gabinetto Disegni e Stampe degli Uffizi, Florence 1969, pp. 18–20, 197–98; Anna Maria Testaverde Matteini, 'Una fonte iconografica francese di Don Vincenzo Borghini per gli apparati effimeri del 1565', in *Il Teatro dei Medici* in *Quaderni de Teatro* II, no. 7, 1980, pp. 135–44; *La Scena del Principe*, exhibition in *Firenze e la Toscana dei Medici nell'Europa del Cinquecento*, Florence 1980, Palazzo Medici-Riccardi, 1980, p. 349 (4.26–4.27).

[4] For the 1589 entry the printed sources are listed in Tofani, *Feste et Apparati Medicei*, pp. 205–6. There were no less than six publications of varying length, one in French. The most fully illustrated and comprehensive official record is Raffaello Gualterotti, *Descrizione del regale apparato per le Nozze Della Serenessima Madama Cristina di Lorena Moglie del Serenissimo Don Ferdinando Medici III Gran Duca di Toscana . . .*, Florence 1589. Studies: Vera Daddi Giovannozzi, 'Di alcune incisioni dell'Apparato per le Nozze di Ferdinando de'Medici e Cristina de Lorena', *Rivista d'Arte* XXII, 1940, anno XII, pp. 85–100; Bertelà and Tofani, *Feste e Apparati Medicei*, 1969, pp. 68–72, 75–77 (33–35); Arthur R. Blumenthal, *Theater Art of the Medici*, Exhibition catalogue, Dartmouth College Museum and Galleries, University Press of New England, 1980, pp. 3–7 (1–2); *La Scena del Principe*, 1980, p. 352 (4.33–4.41).

[5] Bonner Mitchell, 'Les Intermèdes au service de l'Etat', *Fêtes* III, 1975, pp. 117–31. There is no detailed history of renaissance intermezzi but see the résumé, Elena Povoledo, 'Intermezzo', *Enciclopaedia dello Spettacolo*, Rome 1954–62, VI, pp. 572–76; Helen Purkis, 'Le origini dell'intermezzo in Italia', *Convivium, Anno XXV*, n.s., 1957, pp. 479–83.

[6] For the bibliography for the 1539 fêtes see Part II, chapter II note 30.

[7] For the 1565–66 fêtes see: Nagler, *Theatre Festivals of the Medici*, 1964, pp. 15–21 and p. 13 note 1 for sources; Bertelà and Tofani, *Feste e Apparati Medicei*, 1969, pp. 19–20, 197–98 for sources; L. Zorzi, *Il Luogo Teatrale a Firenze* (ed. M. Fabbri, E. Garbero Zorzi, A. M. Tofani Petrioli and L. Zorzi), Milan 1975, pp. 31–36, 93–98, 7.1–10; Elvira Garbero, 'Il Salone del Cinquecento in Palazzo Vecchio' in *La Scena del Principe*, 1980, pp. 323–24, 2.1–8; N. Pirrotta and E. Povoledo, *Music and Theatre from Poliziano to Monteverdi*, C.U.P., 1982, pp. 176–82, 348–54.

[8] On the *Teatro Mediceo* see: D. Heikamp, 'Il Teatro Mediceo degli Uffizi', *Centro internazionale di Studi di Architettura 'Andrea Palladio'*, Vicenza, XVI Corso Internazionale di Storia dell'Architettura, Lezione del 18 settembre 1974, pp. 323–32; Piero Roselli, 'I Teatri dei Medici', *Bollettino degli ingegneri* XXII, 1974, n. 7, pp. 3–12; Zorzi, *Il Luogo Teatrale*, 1975, pp. 36–42, 105, 8.–8.2.; Ludovico Zorzi, 'Il Teatro Mediceo degli Uffizi e il Teatrino detto della Dogana', in *La Scena del Principe*, 1980, pp. 355–60.

[9] For the 1586 *intermezzi* see: S. Fortuna, *Le Nozze di Virginia de'Medici con Cesare d'Este*, Florence 1869; Nagler, *Theatre Festivals of the Medici*, 1964, pp. 58–69 and p. 59 note 1 for sources; Cesare Molinari, *Le Nozze degli Dei*, Rome 1968, pp. 13–25; Bertelà and Tofani, *Feste e Apparati Medicei*, 1969, pp. 56–61, 204 for sources; Zorzi, *Il Luogo Teatrale*, 1975, pp. 37–39, 109–110, 8.4–5; Pirrotta and Povoledo, *Music and Theatre*, 1982, pp. 207–12, 365 ff.

[10] For Medici and golden age see Harry Levin, *The Myth of the Golden Age in the Renaissance*, Indiana U.P., 1969, pp. 38–41.

[11] For the 1589 intermezzi see; Aby Warburg, *I Costumi teatrali per gli Intermezzi del 1589: i disegni di Bernardo Buontalenti e il 'Libro di conti' di Emilio de Cavalieri*, 1894; Hélène Leclerc, 'Du mythe platonicien aux fêtes de la Renaissance: "L'Harmonie du Monde", Incantation et Symbolisme', *Revue*

d'histoire du théatre, 1952, series 2, 11th year, pp. 106–49; F. Ghisi, 'Un aspect inédit des intermèdes de 1589 à la cour medicéene', *Fêtes*, I, 1956, pp. 145–52; D. P. Walker, 'La Musique des intermèdes florentins de 1589 et l'humanisme', *ibid.*, pp. 133–44; D. P. Walker, *Les Fêtes du Mariage de Ferdinand de Medicis et de Christine de Lorraine, Florence, 1589, I, Musique des Intermèdes de 'La Pelligrina'*, Paris 1963; Nagler, *Theatre Festivals of the Medici*, 1964, pp. 72–89 and p. 70 note 1 for sources; Molinari, *Le Nozze degli Dei*, 1968, pp. 25–34; Bertelà and Tofani, *Feste e Apparati Medicei*, 1969, pp. 78–84 (37–41), 206 for sources; Zorzi, *Il Luogo Teatrale*, 1975, pp. 110–116, 8.6–20; Diane DeGrazia Bohlin, *Prints and Related Drawings by the Caracci Family: A Catalogue Raisonné*, National Gallery of Art, Washington 1979, pp. 266–71 (153–54); Ludovico Zorzi, 'Figurazione pittorica e figurazione teatrale', in *Studi dell'arte italiana, I, Questione e Metodi*, Turin 1979, pp. 454–55; Franco Berti, 'Studi su alcuni aspetti del diario inedito di Girolamo Seriacopi e sui disegni buontalentiani per i costumi del 1589' in *Il Teatro dei Medici, Quaderni di Teatro* II, no. 7, 1980, pp. 157–68; Franco Berti, 'I Bozzetti per i costumi' in *La Scena del Principe*, 1980, pp. 361–63, 5.14 a–n.; Blumenthal, *Theater Art of the Medici*, 1980, pp. 7–13 (3–5); Pirrotta and Povoledo, *Music and Theatre*, 1982, pp. 213–66, 365 ff.

12 For the *Sbarra* of 1579 see: H. Edwards, 'The Marriage of Francesco de'Medici and Bianco Cappello', *Art Institute of Chicago Quarterly* XLVI, no. 4, 1952, pp. 62–67; Leo Schrade, 'Les Fêtes du Mariage de Francesco dei Medici et de Bianca Cappello', *Fêtes* I, 1956, pp. 107–30; Nagler, *Theatre Festivals of the Medici*, 1964, pp. 49–57 and p. 49 note 1 for sources; Bertelà and Tofani, *Feste e Apparati Medicei*, 1969, pp. 45–55, 202 for sources; Zorzi, *Il Luogo Teatrale*, 1975, pp. 131–35, 9.4–19.

13 For Buontalenti see Ida Maria Botto, *Mostra di Disegni di Bernardo Buontalenti (1531–1608)*, Gabinetto Disegni e Stampe degli Uffizi, XXVIII, 1968; 'Bernardo Buontalenti: Gli intermedi e la Scena Mutevole' in *Illusione e Prattica Teatrale*, exhibition catalogue by F. Mancini, M. T. Muraro and Elena Povoledo, Venice 1975, pp. 4–48. For the context of Buontalenti see Luciano Berti, *Il Principe dello Studiolo. Francesco dei Medici e la fine del Rinascimento fiorentino*, Florence 1967, ch. VI, esp. pp. 125–31.

14 For the 1579 *sbarra* see note 12 above.

15 On the 1589 *sbarra* and *naumachia* see: Nagler, *Theatre Festivals of the Medici*, 1964, pp. 91–92; Zorzi, *Il Luogo Teatrale*, 1975, pp. 136–39, 9.20–36; P. D. Massar, 'A Set of Prints and a Drawing for the 1589 Medici Marriage Festival', *Master Drawings* XIII, no. 1, Spring, 1975, pp. 12–23; *La Scena del Principe*, 1980, p. 318, 1.51–52; Blumenthal, *Theater Art of the Medici*, 1980, pp. 17–27 (8–13).

16 This is vividly traced also in a series of festivals not discussed here, the temporary decors erected for state obsequies and baptisms. See the important series of articles by Eve Borsook, 'Art and Politics at the Medici Court', *Mitteilungen des Kunsthistorischen Institutes in Florenz* XII, XIII and XIV, 1965, 1967 and 1969 which deal with the obsequies of Cosimo I, Philip II and Henri IV and the baptism of Filippo de'Medici. These also feature in Bertelà and Tofani, *Feste e Apparati Medicei*, 1969, *passim*. Also relevant is R. and

M. Wittkower, *The divine Michaelangelo. The Florentine Academy's Homage on his Death in 1564*, London 1964.

17 For the evolution of Medici festival books see Cesare Molinari, 'Delle nozze medicee e dei loro cronisti', in *Il Teatro dei Medici, Quaderni di Teatro*, anno II, no. 7, 1980, pp. 23–30.

18 For the 1600 festivals the main official source is Michelangelo Buonarotti, *Descrizione della Felicissime Nozze della Christianissima Maestà di Madama Maria Medici Regina di Francia e di Novarra*, Florence 1600. For studies with further sources covering all the festivals see: Angelo Solerti, *Musica, Ballo e drammatica alla Corte Medicea dal 1600 al 1637*, Florence 1905, pp. 23–27; Nagler, *Theatre Festivals of the Medici*, 1964, pp. 93–100; Molinari, *Le Nozze degli Dei*, 1968, pp. 42–49; Bertelà and Tofani, *Feste e Apparati Medicei*, 1969, pp. 96–101; Zorzi, *Il Luogo Teatrale*, 1975, pp. 117–18, 8.25; Blumenthal, *Theatre Art of the Medici*, 1980, pp. 27–30; Sara Marmone, 'Feste e spettacoli a Firenze e in Francia per le nozze di Maria de Medici con Henrico IV', *Quaderni di Teatro* II, no. 7, 1980, pp. 206–28.

19 For a list of contemporary sources on the banquet in addition to those in the previous note see Marmone, 'Feste e spettacoli', p. 216 note 29; see also *La Scena del Principe*, 1980, pp. 330–33 (nos 2.29–36).

20 Katherine J. Watson, 'Sugar Sculpture for Grand Ducal Weddings from the Giambologna Workshop', *Connoisseur* 199, Sept. 1978, pp. 20–26.

21 *La Scena del Principe*, 1980, pp. 320–22 (nos 1.59–63).

22 For further contemporary sources see Marmone, 'Feste e spettacoli', p. 217 note 32. The scenery was almost certainly by Ludovico Cardi da Cigoli: see Cesare Molinari, 'L'Attività teatrale di Ludovico Cigoli', *Critica d'arte* VIII, no. 47, pp. 62–7; no. 48, pp. 62–9, and Pirrotta and Povoledo, *Music and Theatre*, 1982, pp. 238–41.

23 See in addition bibliography listed in L. Zorzi, *Il teatro e la città*, Turin 1977, p. 217 notes 143 and 144.

24 *A true Discourse of the whole of the occurrences in the Queenes voyage ...*, trans. E. A., London 1600.

25 For the 1608 festivals see: Solerti, *Musica, Ballo e Drammatica*, 1905; Nagler, *Theatre Festivals of the Medici*, 1964, pp. 101–18 and p.101 note 1 for sources; Bertelà and Tofani, *Feste e Apparati Medicei*, 1969, pp. 102–27 (52–80), 214–17; Molinari, *Le Nozze degli Dei*, 1968, pp. 58–66; Zorzi, *Il Luogo Teatrale*, 1975, pp. 118–21 (8.26–36); A. M. Testaverde, '1608: L'ingresso in Firenze di Maria Maddalena d'Austria. Notizie e documenti inediti sugli artisti apparatori', *Città e Regione*, 8–9, 1979 (not seen); *La Scena del Principe*, 1980, p. 367 (5.15–16), 399 (9.52–74); Blumenthal, *Theater Art of the Medici*, 1980, pp. 30–86 (15–43).

26 On Parigi's influence on Inigo Jones see chapter V note 1 section IX for bibliography; for Germany see A. M. Nagler, 'The Furttenbach Theatre in Ulm', *The Theatre Annual* XI, 1953, pp. 44–69; B. Hewitt, *The Renaissance Stage: Documents of Serlio, Sabbattini and Furttenbach*, Coral Gables, Florida 1958, pp. 178 ff.; for Spain see under Cosimo Lotti in *Enciclopaedia dello Spettacolo* VI, Rome 1959, cols 1672–1673.

V. A ROYALIST ARCADIA

[1] The literature on the court masque down to 1972 is listed in *Twentieth Century Criticism of English Masques, Pageants and Entertainments, 1558–1642*, ed. David M. Bergeron. For convenience I categorize the most important literature under various aspects:

I. *General*
Paul Reyher, *Les Masques Anglais*, Paris 1909; M. S. Steele, *Plays and Masques at Court during the Reigns of Elizabeth, James I and Charles I*, New Haven 1920; E. K. Chambers, *The Elizabethan Stage*, Oxford 1923, I, ch. V, VI and entries on individual masques under authors in other volumes; Enid Welsford, *The Court Masque*, Cambridge 1927; Allardyce Nicoll, *Stuart Masques and the Renaissance Stage*, London 1938; G. E. Bentley, *The Jacobean and Caroline Stage*, Oxford 1941–68, entries on individual masques under authors; T. M. Parrott, 'Comedy in the Court Masque', *Renaissance Studies in honor of Hardin Craig*, Iowa 1941, pp. 236–49; Jean Jacquot, 'Le Reine Henriette-Marie et l'influence français dans les spectacles à la cour de Charles Ier', *Cahiers de l'Association Internationale des Etudes Françaises*, No. 9, June, 1957; M.-T. Jones Davies, *Inigo Jones, Ben Jonson et le Masque*, Paris 1967; *A Book of Masques in Honour of Allardyce Nicoll*, ed. T. J. B. Spencer, Cambridge 1967; M. Lefkowitz, *Trois Masques à la Cour de Charles I^{er} d'Angleterre*, CNRS, Paris 1970; Gordon Parry, *The Golden Age Restored*, London 1981, pp. 40–63, 184–203.

II. *The Masque Stage and Scenery*
L. B. Campbell, *Scenes and Machines on the English Stage during the Renaissance*, Cambridge 1923; Richard Southern, *Changeable Scenery*, London 1952; Glynne Wickham, *Early English Stages 1300 to 1660* I, *1576–1660* II, London and New York, 1972.

III. *The Whitehall Banqueting House*
Per Palme, *Triumph of Peace. A Study of the Whitehall Banqueting House*, Stockholm 1956; John Charlton, *The Banqueting House, Whitehall*, London, HMSO, 1964; Roy Strong, *Britannia Triumphans. Inigo Jones, Rubens and Whitehall Palace*, London 1980.

IV. *The Jonsonian Masque*
C. H. Herford, P. and E. Simpson, *Ben Jonson*, Oxford 1925–52, VIII, X; D. J. Gordon, 'The Imagery of Ben Jonson's *Masques of Blacknesse and Beautie*', *Journal of the Warburg and Courtauld Institutes* VI, 1943 reprinted in D. J. Gordon, *The Renaissance Imagination*, ed. Stephen Orgel, University of California, 1975, pp. 134–56; D. J. Gordon, '*Hymenaei*: Ben Jonson's Masque of Union', *Journal of the Warburg and Courtauld Institutes* VIII, 1945 reprinted in *The Renaissance Imagination*, op. cit., pp. 157–84; E. W. Talbert, 'The Interpretation of Jonson's Courtly Spectacles', *PMLA* LXI, 1946, pp. 454–71; same author's 'Current Scholarly Work and the Erudition of Jonson's *Masque of Augurs*', *Studies in Philology* XLIV, 1947, pp. 605–624;

D. J. Gordon, 'Ben Jonson's *Haddington Masque*; The Story and the Fable', *Modern Language Review* XLII, 1947 reprinted in *The Renaissance Imagination*, *op. cit.*, pp. 185–93; A. H. Gilbert, *The Symbolic Persons in the Masques of Ben Jonson*, Durham, N. Carolina 1948; D. J. Gordon, 'The Intellectual Setting of the Quarrel between Ben Jonson and Inigo Jones', *Journal of the Warburg and Courtauld Institutes* XII, 1949 reprinted in *The English Imagination*, pp. 77–101; W. Todd Furniss, 'Ben Jonson's Masques' in *Three Studies in the Renaissance*, New Haven 1958; John C. Meagher, 'The Dance in the Masques of Ben Jonson', *Journal of the Warburg and Courtauld Institutes* XXV, 1962, pp. 258–77; Stephen Orgel, *The Jonsonian Masque*, Cambridge, Mass. 1965; John C. Meagher, *Method and Meaning in Ben Jonson's Masques*, Notre Dame 1966; Scott McMillin, 'Jonson's Early Entertainments: New Information from Hatfield House', *Renaissance Drama*, new series, I, 1968, pp. 153–66; *Ben Jonson. The Complete Masques*, ed. Stephen Orgel, Yale U.P., 1969; Gail Kern Paster, 'Ben Jonson and the Uses of Architecture', *Renaissance Quarterly*, 1974, pp. 306–20; Stephen Orgel, *The Illusion of Power. Political Theater in the English Renaissance*, University of California, 1975; Leah Sinanoglou Marcus, '"Present Occasions" and the Shaping of Ben Jonson's Masques', *English Literary History* 45, 1978, pp. 201–25; same author, 'The occasion of Ben Jonson's *Pleasure Reconciled to Virtue*', *Studies in English Literature* 19, 1979, pp. 271–93; Norman Council, 'Ben Jonson, Inigo Jones and the Transformation of Tudor Chivalry', *English Literary History* 47, 1980, pp. 259–75.

V. *Studies of other masques*
D. J. Gordon, 'Le "Masque Memorable" de Chapman', *Fêtes* I, 1956, pp. 305–15; reprinted in translation in *The Renaissance Imagination*, pp. 194–202; Stephen Orgel, 'Inigo Jones's Persian Entertainment', *AARP* 2, 1972, pp. 59 ff.

VI. *Inigo Jones*
Peter Cunningham, *A Life of Inigo Jones*, London 1848; J. A. Gotch, *Inigo Jones*, London 1928; John Summerson, *Inigo Jones*, London 1966; Roy Strong, 'Inigo Jones and the Revival of Chivalry', *Apollo* LXXXVI, 1967, pp. 102–7; John Harris, Stephen Orgel and Roy Strong, *The King's Arcadia: Inigo Jones and the Stuart Court*, Arts Council Exhibition catalogue, 1973; Roy Strong, 'Inigo Jones, *Vitruvius Britannious*' in *From Donne to Marvell*, New Pelican Guide to English Literature, ed. Boris Ford, 1982, pp. 171–86.

VII. *Designs for the masques*
P. Simpson and C. F. Bell, 'Designs by Inigo Jones for Masques and Plays at Court', *Walpole Society* XII, 1923–24; Roy Strong, *Festival Designs by Inigo Jones. An Exhibition of Drawings for Scenery and Costume for the Court Masques of James I and Charles I*, International Exhibitions Foundation, 1967–68; Stephen Orgel and Roy Strong, *Inigo Jones. The Theatre of the Stuart Court*, University of California Press, 1973.

VIII. *Music in the masques*
John P. Cutts, 'Jacobean Masque and Stage Music', *Music and Letters*, July

1954, XXXV, 3, pp. 185–200; J. P. Cutts, 'Original Music to Browne's Inner Temple Masque and other Jacobean Music', *Notes and Queries*, May 1954, new series, 1, 5, pp. 194–95; J. P. Cutts, 'Le Rôle de la Musique dans les Masques de Ben Jonson et notamment dans *Oberon* (1610–11)', *Fêtes* I, 1956, pp. 285–303; A. J. Sabol, *Songs and Dances for the Stuart Masque*, Providence, Rhode Island 1959; M. Lefkowitz, 'New Facts concerning William Lawes and the Court Masque', *Music and Letters*, October 1959, pp. 324–30; M. Leftkowitz, 'The Longleat Papers of Bulstrode Whitelocke', *Journal of the American Musicological Society*, Spring 1965, pp. 42–60; A. J. Sabol, 'New Documents on Shirley's Masque "The Triumph of Peace"', *Music and Letters*, January 1966, pp. 10–26.

IX. *Italian influences on Jones's stagecraft*
Enrico Rava, 'Influssi della scenografia italiana pre-barocca e barocca in Inghilterra . . .', *Antichità viva* VIII, no. 3, 1969, pp. 42–45; G. Pelligrini, 'Inigo Jones's Fiorentino', in *La Scena del Principe*, exhibition catalogue, Florence 1980, pp. 375–82.

[2] Orgel and Strong, *Inigo Jones*, 1973, I, p. 405 ll.1–3.
[3] *Ibid.* II, p. 480 ll.49–50.
[4] *Ibid.* II, p. 483 ll.361–64.
[5] See the section by Gordon Toplis on 'The Sources of Jones's Mind and Imagination' in Harris, Orgel and Strong, *The King's Arcadia*, 1973, pp. 61–3.
[6] *Discoveries*, l.2128.
[7] For all this see Orgel and Strong, *Inigo Jones*, 1973, I, ch.I.
[8] Letter quoted by Herford and Simpson, *Jonson* X, pp. 410–11.
[9] Orgel and Strong, *Inigo Jones* I, p. 89.
[10] *Ibid.* I, p. 106 l.18.
[11] *Political Works of James I*, ed. C. H. McIlwain, Cambridge, Mass. 1918, p. 3.
[12] *Ibid.*, p. 12.
[13] *Ibid., loc. cit.*
[14] Orgel and Strong, *Inigo Jones* II, p. 483 ll.356–60.
[15] Quoted S. R. Gardiner, *History of England 1603–1642*, London 1884, VIII, p. 275.
[16] This account of the Caroline masque is based on the only full length discussion of them in Orgel and Strong, *Inigo Jones* I, ch. IV.
[17] *Ibid.* II, p. 483 ll.365–67.
[18] *Ibid.* II, p. 734 ll.489–90.
[19] For *Love's Triumph* see Bentley, *Jacobean and Caroline Stage* IV, pp. 651–53; Herford and Simpson, *Jonson*, pp. 454–61; Orgel and Strong, *Inigo Jones* I, pp. 53–56, 405–15.
[20] Orgel and Strong, *Inigo Jones* I, p. 406 ll.66–69.
[21] *Ibid.*, pp. 406–7 ll.118–33.
[22] For *Chloridia* see Bentley, *Jacobean and Caroline Stage* IV, pp. 636–38; Herford and Simpson, *Jonson* X, pp. 680–96; Orgel, *Jonson*, pp. 462–72; Orgel and Strong, *Inigo Jones* I, pp. 56–57; II, pp. 419–50.
[23] Orgel and Strong, *Inigo Jones* II, p. 421 ll.163–67.
[24] *Ibid.*, p. 422 ll.228–31.

[25] *Ibid.*, p. 483 ll.361–64.

[26] *Ibid.* I, pp. 64–66.

[27] On *Coelum Britannicum* see Bentley, *Jacobean and Caroline Stage* III, pp. 108–10; Rhodes Dunlap, *The Poems and Masque of Thomas Carew*, Oxford 1949, pp. 151–85, 273–83; Nicoll, *Stuart Masques*, 1938, pp. 101–4; Orgel and Strong, *Inigo Jones* I, pp. 66–69; II, pp. 567–97.

[28] Orgel and Strong, *Inigo Jones* II, p. 571 ll.60–68.

[29] *Memoirs of the Life of Colonel Hutchinson*, London 1906, p. 69.

[30] Orgel and Strong, *Inigo Jones* II, p. 572 ll.250–56.

[31] *Ibid., loc. cit.*, ll.275–79.

[32] *Ibid.*, p. 576 ll.666–73.

[33] *Ibid.*, p. 577 ll.687–94.

[34] *Ibid.*, p. 578 ll.960–67.

[35] *Ibid.*, p. 579 ll.1016–21.

[36] *Ibid.*, p. 580 ll.1051–72.

[37] For *Britannia Triumphans* see Bentley, *Jacobean and Caroline Stage* III, pp. 199–200; Nicoll, *Stuart Masques*, 1938, pp. 114–16; Lefkowitz, *Trois Masques*, 1970, pp. 171–243; Orgel and Strong, *Inigo Jones* I, pp. 71–72; II, pp. 661–703.

[38] For *Salmacida Spolia* see Bentley, *Jacobean and Caroline Stage* III, pp. 213–15; Nicoll, *Stuart Masques*, 1938, pp. 117–26; *Book of Masques*, 1967, pp. 339–70; Orgel and Strong, *Inigo Jones* I, pp. 72–5; II, pp. 729–85.

[39] Orgel and Strong, *Inigo Jones* II, p. 731 ll.196–99.

[40] *Ibid.*, p. 734 ll.458–64.

[41] *Ibid., loc. cit.* ll.487–88.

[42] *Ibid.*, ll.486–87.

[43] *Ibid.*, p. 729.

Postscript

Since going to press *The Court Masque*, ed. David Lindley, Manchester U.P., 1984, has appeared with a valuable bibliography down to that year, pp. 185–94.

VI. CONCLUSION

[1] Source: Paul Lacroix, *Ballets et mascarades de cour de 1581 à 1652*, Paris 1870, pp. 33 ff.; studies: Margaret McGowan, *L'Art du Ballet de Cour en France 1581–1643*, CNRS, Paris 1963, pp. 186–90; Agne Beijer, 'Une Maquette de Décor récemment retrouvée pour le "Ballet de la Prospérité des Armes de France" dansé à Paris le Février 1641' in *Le Lieu Théâtrale à la Renaissance*, CNRS, Paris 1964, pp. 377–403.

[2] For the Avignon entry see *La voie du lait, ou le chemin des héros au palais de la gloire, ouvert à l'entrée triomphante de Louis XIII, roi de France et de Navarre, en la cité d'Avignon, le 16 novembre 1622*, Avignon 1623; study: Margaret McGowan, 'Les Jésuites a Avignon. Les Fêtes au Service de la Propagande Politique et Religieuse', *Fêtes* III, 1975, pp. 164–71.

[3] Jean de Galoup de Chastueil, *Discours sur les arcs triomphaux dressés en la ville D'Aix*, Aix 1624.

[4] Jean Baptiste de Marchault, *Eloges et discours sur le triomphante reception du Roy*, Paris 1629.

[5] See Pierre Walter, 'Jean Louis de Balzac's *Le Prince*. A Revaluation', *Journal of the Warburg and Courtauld Institutes* XX, 1957, pp. 215–47 and, on triumphs, note 40.

[6] For the dissemination of scenic types down to the end of the *ancien régime* see Per Bjurström, *Giacomo Torelli and Baroque Stage Design*, Stockholm 1961, pp. 196–211. By 1681 Ménestrier was able to codify scenery into eleven types of set.

INDEX

Mythological, biblical and other characters who appear in the festivals are printed in italic.

Illustrations

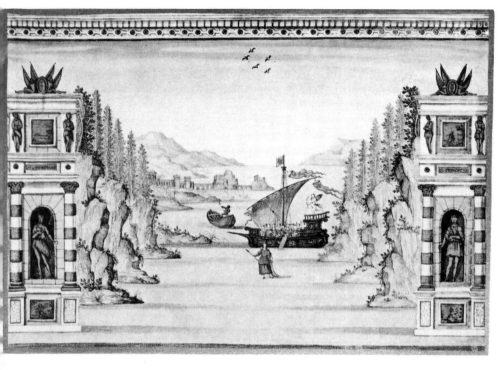

1. Scene from the ballet *Hercole e Amore*, 1640: the Duchess of Savoy's daughter arrives on a ship.

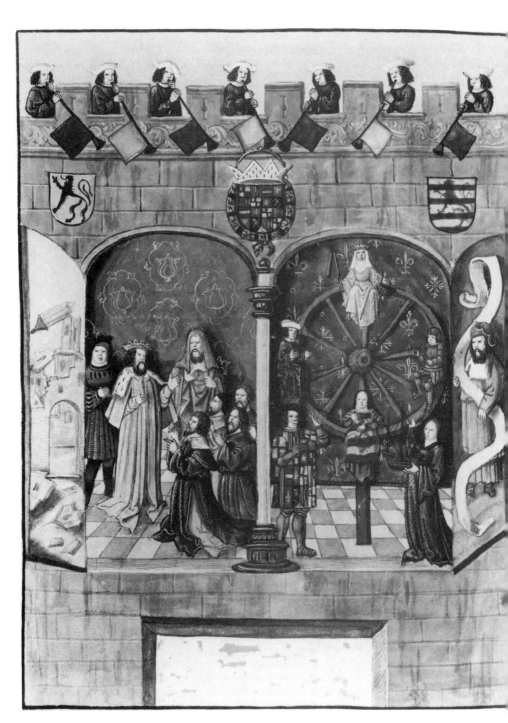

2. Charles V's entry into Bruges, 1515. Artaxerxes promises to restore Jerusalem; Charles topples Fortune from her wheel.

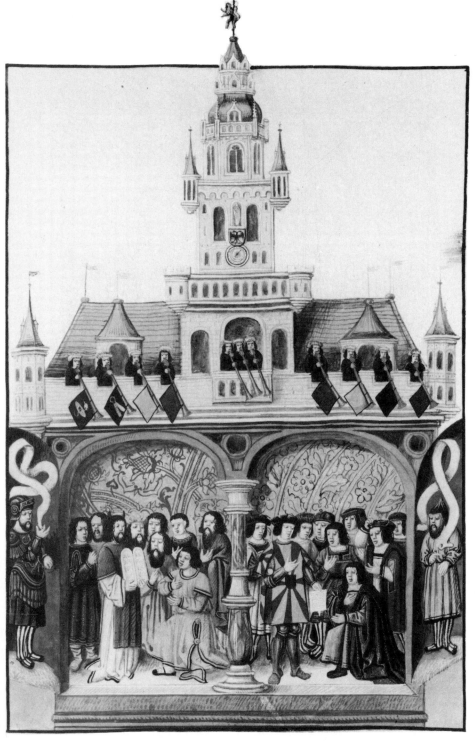

3. Charles V's entry into Bruges, 1515. Moses delivers the Tables of the Law; Louis of Nevers grants privileges to the city.

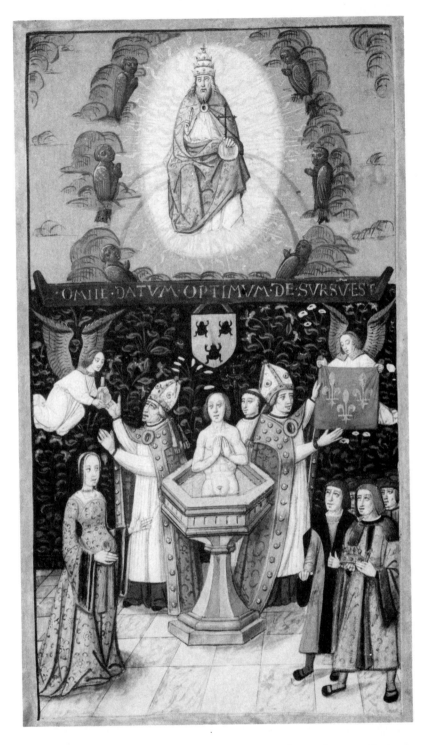

4. François I's entry into Lyons, 1515. Royal unction recalled: the baptism of Clovis with angels delivering holy oil and the *fleur de lys*.

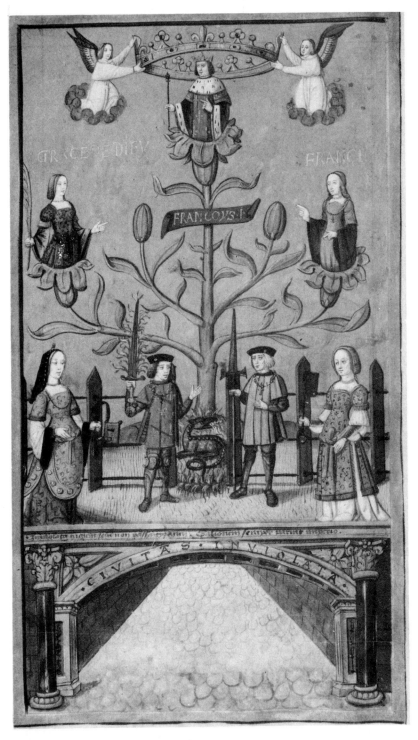

5. François I's entry into Lyons, 1515. A giant fleur de lys bearing François I, crowned by angels, flanked by *Grâce de Dieu*, and France with Lyons and Loyalty standing below.

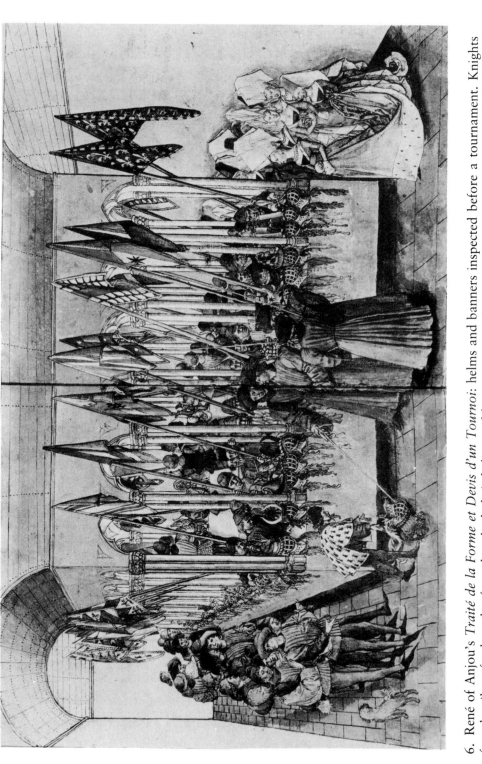

6. René of Anjou's *Traité de la Forme et Devis d'un Tournoi*: helms and banners inspected before a tournament. Knights found guilty of a breach of conduct had their helms and banners removed.

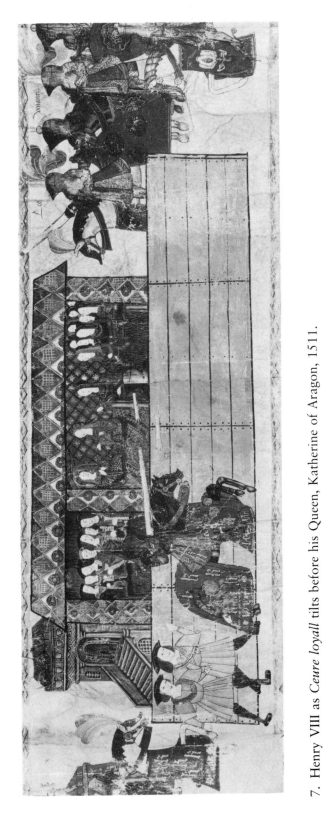

7. Henry VIII as *Ceure loyall* tilts before his Queen, Katherine of Aragon, 1511.

8. An early sixteenth century indoor entertainment. A couple begin to dance flanked by torchbearers and musicians.

ELOQVENTIA FORTITV
dine præstantior.

Arcum leua tenet, rigidam fert dextera clauam,
 Contegit & Nemees corpora nuda leo.
Herculis hæc igitur facies? non conuenit illud,
 Quod uetus & senio tempora cana gerit.
Quid q̃ lingua illi leuibus traiecta cathenis,
 Quîs fissa facili allicit aure uiros.

9. The Gallic Hercules in Alciati's *Emblemata*, 1531.

Above left
10. François I as the Gallic Hercules enslaving, by his eloquence, the four estates of the realm. Arch for the entry of Henri II into Paris, 1549, with his crescent-moon device held by supporters (see pl. 12).

Above right
11. Henri IV as Hercules. Obelisk erected for his entry into Rouen, 1596.

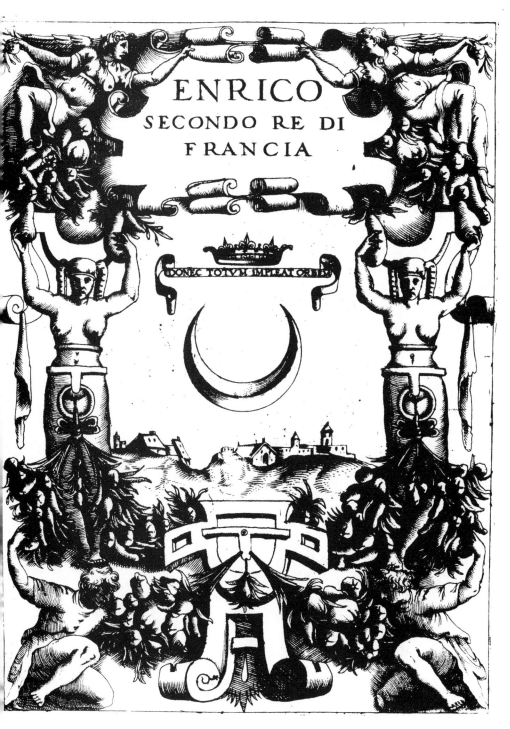

12. *Impresa* of Henri II. The crescent-moon and the motto: *Donec totum impleat orbem* (see pl. 10).

13. The Assyrian Apollo in Vincenzo Cartari's *Le Imagini colla sposizione degli dei degli antichi.*

14. Design by Giorgio Vasari for a chariot bearing the Assyrian Apollo in *La Genealogia degli Dei*, a triumphal procession to mark the marriage of Francesco de'Medici, 1566.

I.

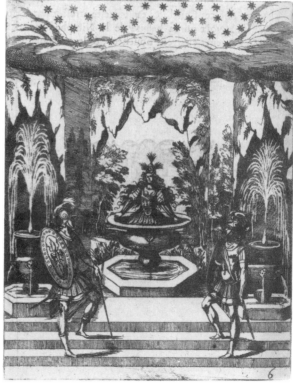

6

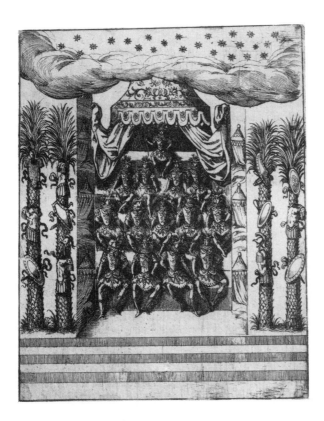

Left, above
15. *Le Ballet de la Délivrance de Renaud*, 1617:
the Demon mountain with Louis XIII as the
demon of Fire.

Left, below
16. *Le Ballet de la Délivrance de Renaud*, 1617:
the enchanted garden of Alcina. A nymph attempts
to seduce two soldiers.

Above
17. *Le Ballet de la Délivrance de Renaud*, 1617:
the finale: Louis XIII triumphs in the guise of the
crusader Godefroy attended by his knights.

18. Sketch by Leonardo da Vinci for a Vitruvian street scene, c.1496–97.

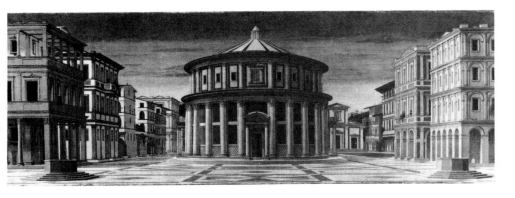

19. An ideal architectural composition related to re-creations of the Vitruvian scene, late 15th century.

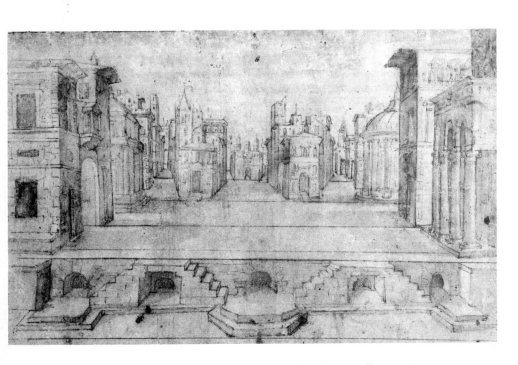

20. Vitruvian scene attributed to Bastiano 'Aristotile' da Sangallo, c.1535.

fi faranno di groſſo cartone , ò pur di tauola ſottile, ben ombreggiate, & tagliate intorno, poi ſi
metteranno alli ſuoi luoghi:ma ſiano talmente diſcoſte,& lontane che gli ſpettatori non le poſſi-
no vedere per fianco. In queſte Scene, benche alcuni hanno dipinto alcuni perſonaggi, che rappre-
ſentano il viuo, come ſaria vna femina ad un balcone , ò dentro d'una porta , etiandio qualche
animale : queſte coſe non conſiglio che ſi faccino, perche non hanno il moto & pure rappreſenta-
no il viuo : ma qualche perſona che dorma a buon propoſito, ouero qualche cane, ò altro anima-
le che dorma , perche non hanno il moto . Ancora ſi poſſono accommodare qualche ſtatue , ò
altre coſe finte di marmo, ò d'altra materia, ò alcuna hiſtoria, ò fauola dipinta ſopra un muro,
che io loderò ſempre ſi faccia coſi. Ma nel rappreſentare coſe viue, le quali babbino il moto : nel
l'eſtremo di queſto libro ne tratterò , & darò il modo come s'habbino a fare.

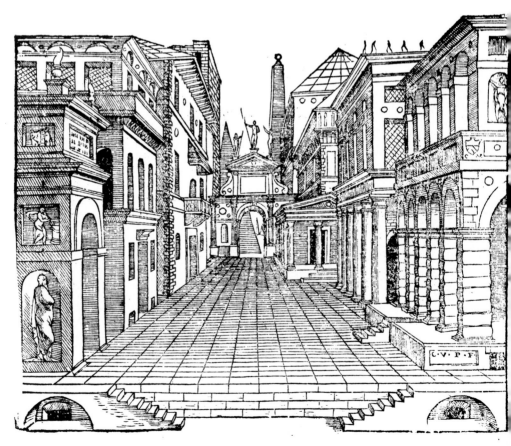

21. The Tragic scene from Serlio's *Archittetura*, 1545.

Della Scena Comica.

Qu anto alla difpofitione de' Teatri, & delle Scene circa alla pianta io ne ho trattato quì
dietro: hora delle Scene in profpettiua ne tratterò particolarmente, & perche (come io diffi)
le Scene fi fanno di tre forti, cioè la Comica per rapprefentar Comedie : la Tragica per le Tragedie, & la Satirica per le Satire : quefta prima farà la Comica, i cafamenti della quale voglio-
no effere di perfonaggi priuati, come faria di cittadini, auocati, mercanti, parafiti, & altri
fimili perfone : Ma fopra il tutto che non ui manchi la cafa della ruffiana, nè fia fenza hofta-
ria, & uno Tempio ui è molto neceffario, per difporre li cafamenti fopra il piano, detto fuo-
lo : io ne ho dato il modo più a dietro, sì nel leuare i cafamenti fopra i piani, come nella pian-
ta delle Scene, maffime, come & doue fi dee porre l'Orizonte. Nientedimeno accioche l'huo-

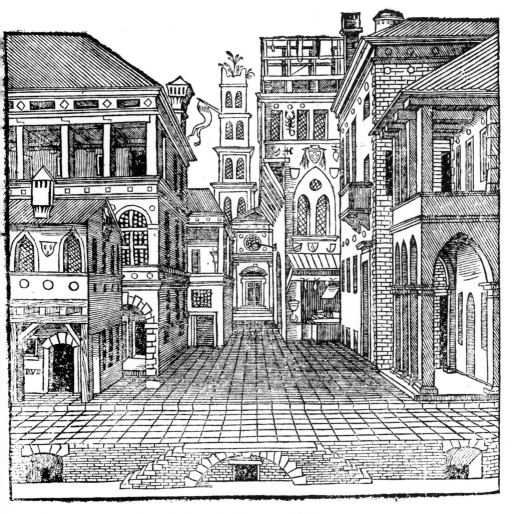

22. The Comic scene from Serlio's *Archittetura*, 1545.

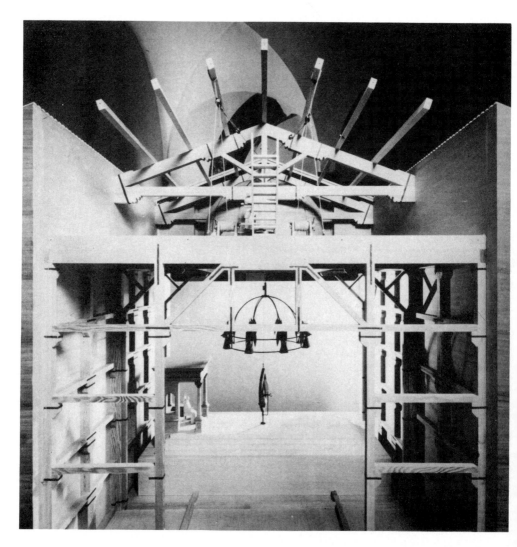

23. Conjectural reconstruction of Brunelleschi's *apparato* for S. Felice in which the Angel of the Annunciation in a mandorla descended and reascended to God the Father.

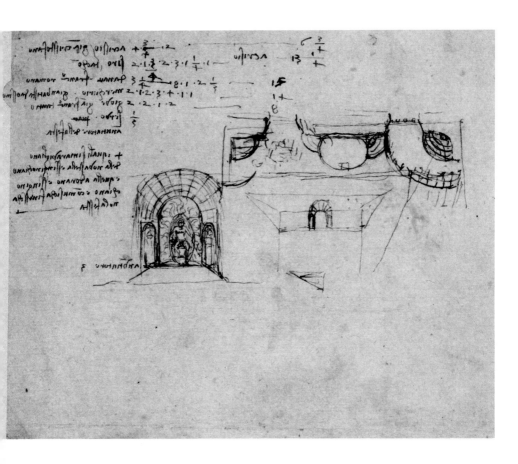

24. A ground plan by Leonardo da Vinci for the play *Danae* with a sketch for a celestial apparition, 1499.

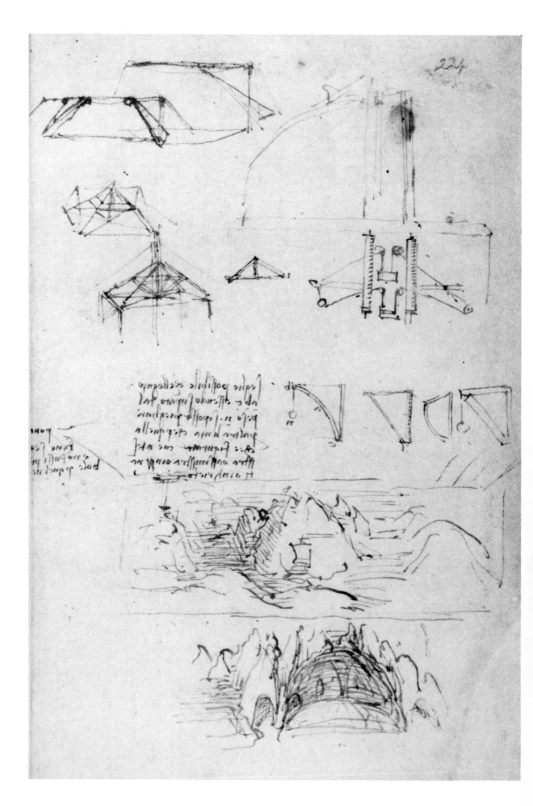

224

Ma lasciando hora da parte il trattare della differeza che è tra le scene Tragiche, Comiche, & Satiriche, per esserne stato scritto a bastanza da altri, & esser fuor del proponiméto nostro, diremo solaméte in que-sto luogo come si faccino le scene, che si girano, & si varij in vn tratto senza che li spettatori se ne auueg-ghino, tutta la pittura, & della sembianza d'vna contrada, si rimuti in vn'altra, ò in vn paese di villa. Di che veggasi in quetta figu-

ra il modo che si tiene. Sia
la linea A B, la piáta della
parete, & si voglia variare
ella parete nel recitare del
a Comedia, ponian caso
tre volte: si taráno tre pa-
rete diuerse, attaccandole
in sieme, le quali forme-
ranno vn corpo simile ad
vn Prisma, ò vna colonna
triangolare, che habbia
nelle sue estremità da ca-
po & da piedi due triango
li equilateri, la cui basa, ò
pianta, farà il triangolo
A B C, & saranno queste
tre parete fatte di regoli
di legno forti con le loro
trauerse, cóficcandoui so-
pra la tela per poterla di-
pingere, & nel centro M, di questa basa triangolare vi farà fitto vn perno, & così nella parte di sopra all'
incontro del punto M, vn altro, che siano fermati in buone spranghe di legno, acciò che in essi si giri tut-
to il corpo, il quale douerrà toccare nel palco solamente attorno il punto M, & il resto star libero, ac-
ciò si possa ageuolmente girare. Si faranno parimente così anco le case di rilieuo tutte di forma triango-
lare, acciò che hauendo la prima faccia della scena L A B G, seruito ponian caso nel primo atto, si possa
in vn tratto girare, & far comparire vn altra contrada: per che doue è la parete A B, si volgerà la B C, &
così anco delle case di rilieuo si girerà nella parte dinanzi la H A, la K I, la D E, & F G, & à due de gl'altri
M 2 interme-

26. Diagram illustrating the classical device of *periaktoi* from Ignazio Danti's *Le
due regole . . .*, 1583.

Left

25. Sketches by Leonardo da Vinci for stage machinery for a production of
Poliziano's *Orfeo*, 1490 or 1506/7.

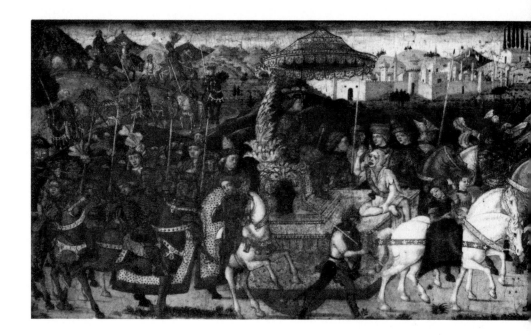

Above
27. The Triumph of Scipio Africanus. Cassone chest, mid 15th century.

Right
28. The Triumph of Fame from a 1488 edition of Petrarch's *I Trionfi*.

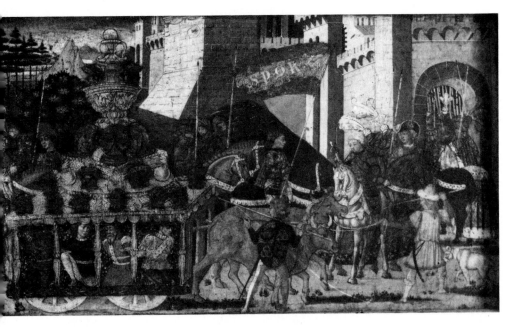

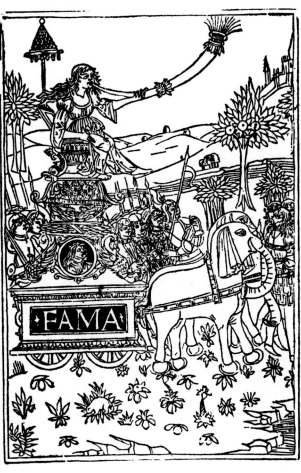

29. Alfonso the Great enters Naples, 1443.

30. Triumphal procession with Leda and the Swan from Francesco Colonna's *Hypnerotomachia Poliphili*, 1499.

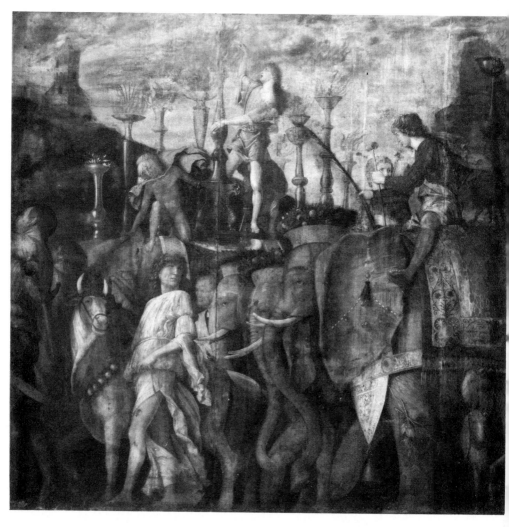

31. Andrea Mantegna, *The Triumphs of Caesar*, c.1486–92: the elephants.

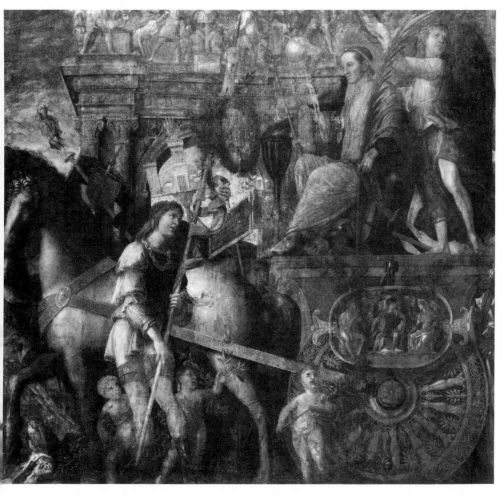

32. Andrea Mantegna, *The Triumphs of Caesar*, c.1486–92: chariot bearing
Caesar.

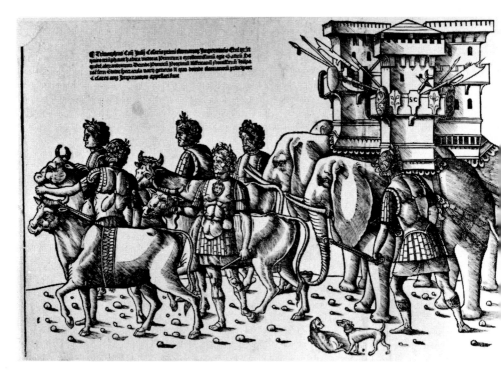

33. Jacopo da Strasbourg after Mantegna, 1503: the elephants.

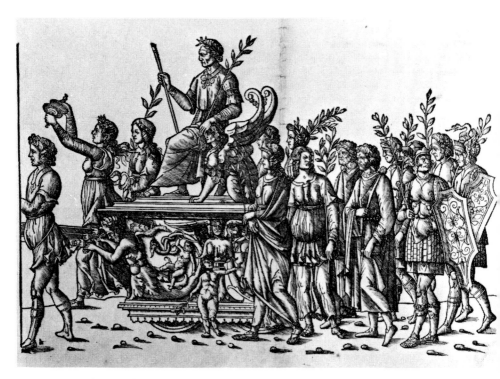

34. Jacopo da Strasbourg after Mantegna, 1503: chariot bearing Caesar.

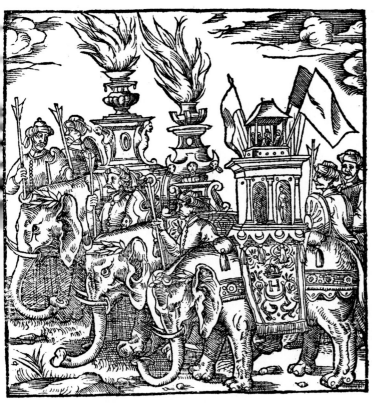

35. Henri II's entry into Rouen, 1550: the elephants.

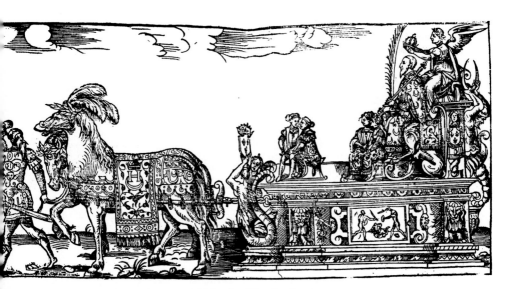

36. Henri II's entry into Rouen, 1550: the King's chariot.

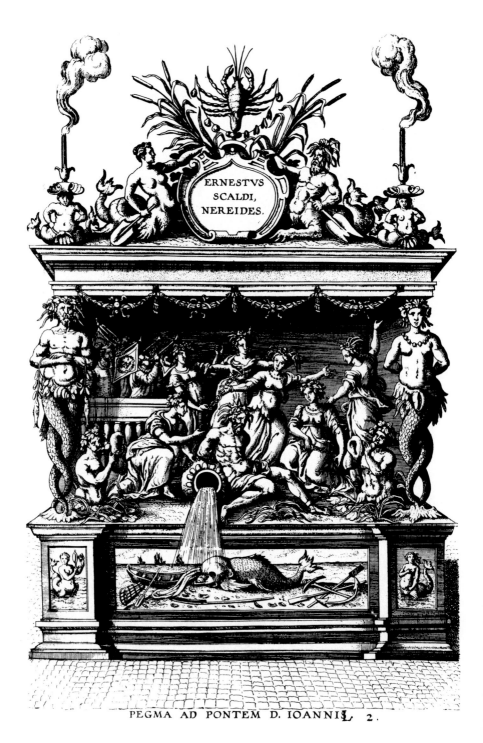

ERNESTVS
SCALDI,
NEREIDES.

PEGMA AD PONTEM D. IOANNIS. 2.

37. The Archduke Ernest's entry into Antwerp, 1594. Pageant depicting the reopening of the River Scheldt.

38. The Cardinal Archduke Ferdinand's entry into Antwerp, 1635: sketch by
Rubens for a pageant depicting the departure of Mercury.

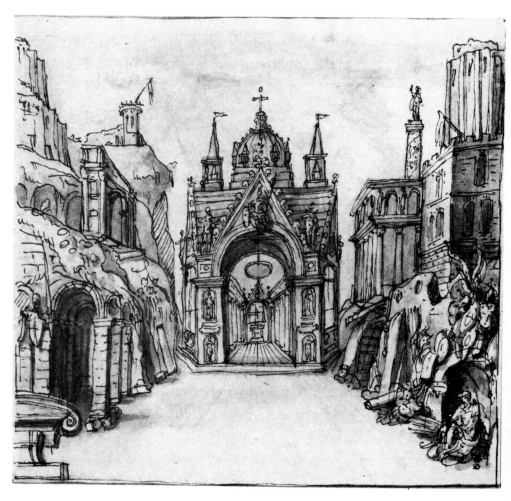

39. Lady Chivalry languishing in her cave awaits rescue at the hands of Henry, Prince of Wales. Inigo Jones's setting for Ben Jonson's *Barriers*, 1610.

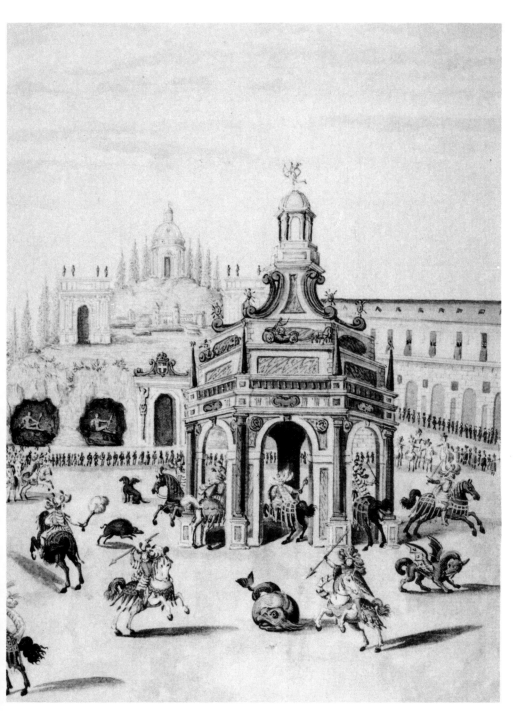

40. *Gli Hercoli Domatori de Mostri et Amore Domatore de gli Hercoli*: a
tournament at the court of Savoy, 1650, with old-fashioned scattered scenery (detail).

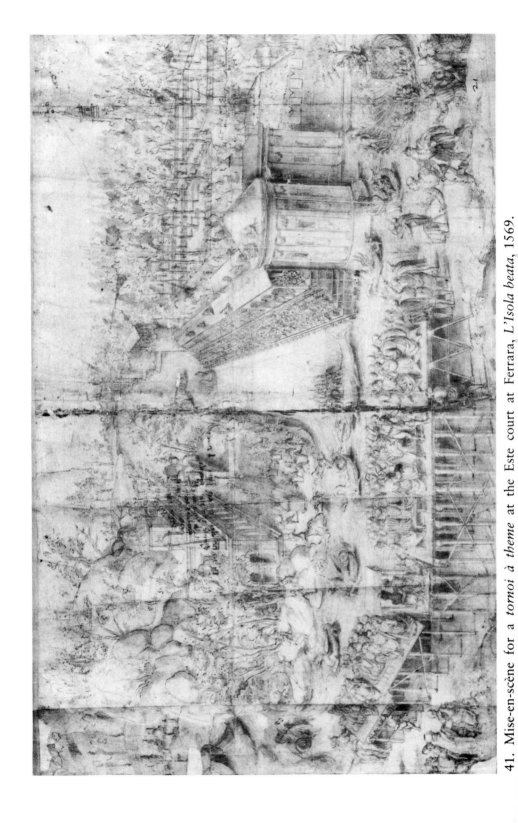

41. Mise-en-scène for a *tornoi à theme* at the Este court at Ferrara, *L'Isola beata*, 1569.

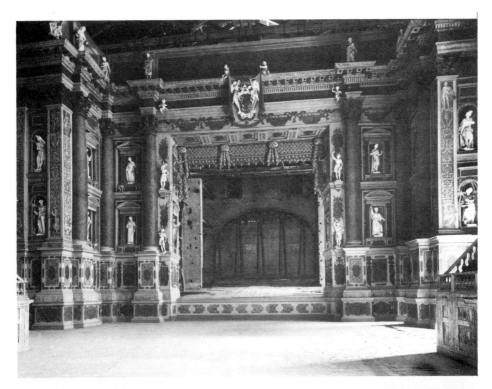

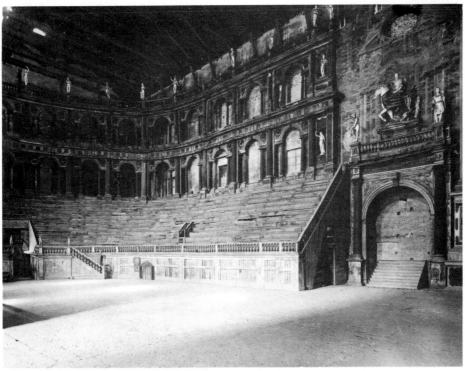

42–3. The Teatro Farnese, Parma, built in 1618–19 and inaugurated in 1628.

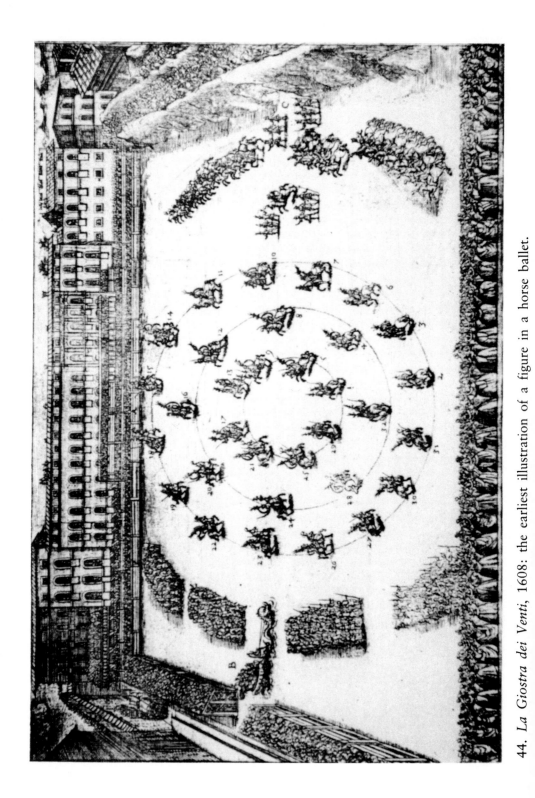

44. *La Giostra dei Venti*, 1608: the earliest illustration of a figure in a horse ballet.

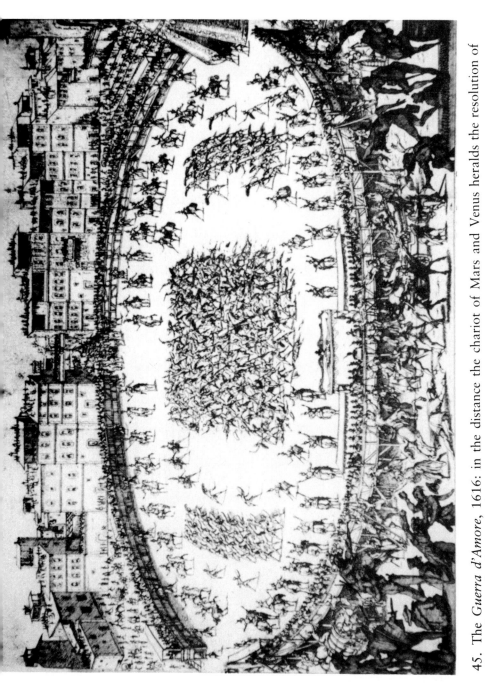

45. The *Guerra d'Amore*, 1616: in the distance the chariot of Mars and Venus heralds the resolution of the conflict in the foreground.

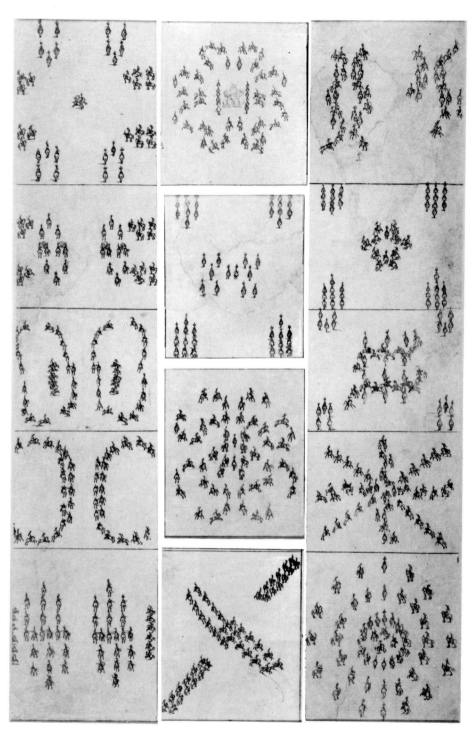

46. Figures danced in an equestrian ballet in the Boboli Gardens in 1637.

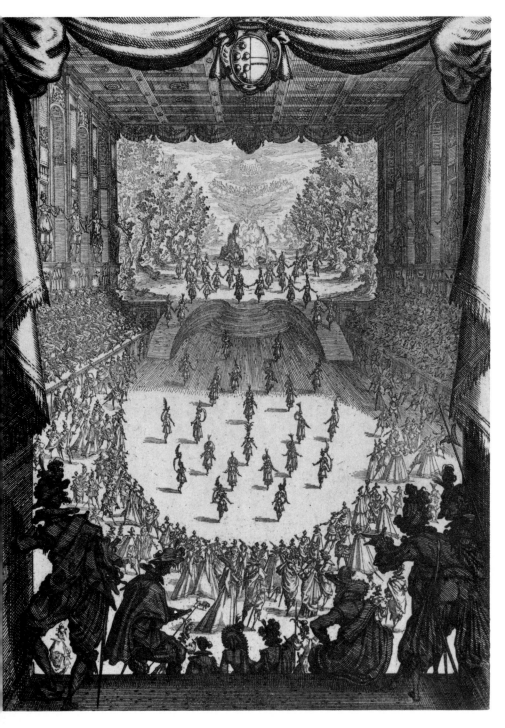

47. A figure in a ballet in the Teatro Uffizi, 1617. The spectators look down on two concentric circles of dancers focussed on the Grand Duke and Duchess.

De ceſte premiere figure ils en formoiẽt vne ſeconde, repreſentant auſſi vn autre caractere dudit Alphabet, poincté de meſme nombre, lequel ſignifioit,

AMBITIEVX DESIR.

Et apres ceſte ſeconde, ils en faiſoient vne troiſieſme d'vn autre caractere, ſignifiant

VERTVEVX DESSEIN.

Et puis ceſte quatrieſme qui ſignifioit,

RENOM IMMORTEL.

Les ſuſdites figures ſe moquoient chacune d'vne cadance entiere, tournant ou retournant en leur meſme place: puis apres ces quatre, les viollons ſonnoient la ſeconde partie du ballet, & les cheualiers d'vn

E iiij.

autre pas plus gay & plus releué preſque du tout à capriolles, ils rentroient d'vn bel ordre en la cinquieſme figure, repreſentant auſſi vn caractere, poincté du nombre ſuſdit, ſignifiant

GRANDEVR DE COV-
RAGE.

Et de la cinquieſme à ceſte ſixieſme, qui ſignifioit

PEINE AGREABLE.

Puis la ſeptieſme ſignifiant,

CONSTANCE ES-
PROVVEE.

Et la huitieſme ſignifioit

VERITE' COGNEVE.

Above

48 and 49. *Le Ballet de Monseigneur le Duc de Vendosme*: symbolic figures danced in a ballet at the French court, 1610.

Right, above

50. The Elvetham Entertainment, 1591: Elizabeth I celebrated as Cynthia, the moon-goddess, Empress of the Seas.

Right, below

51. Henri IV's entry into Rouen, 1596: the King astride the terrestrial globe vanquishes War and is crowned by Opportunity and Prudence.

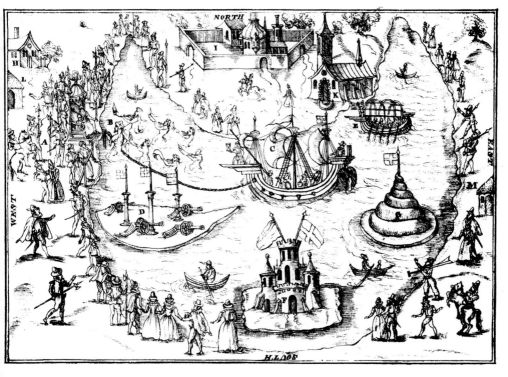

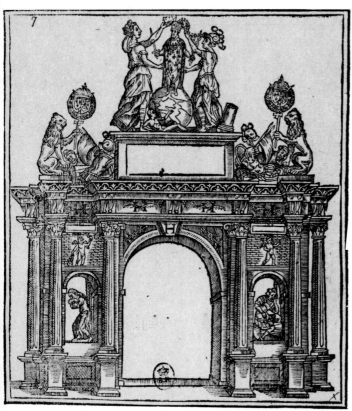

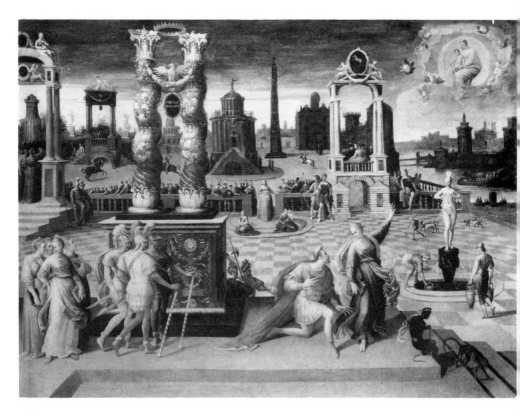

Above
52. Antoine Caron, *The Emperor and the Sybil*, c.1570. The Emperor Augustus, probably an idealised Charles IX, is shown a vision of the Christ Child by the Tiburtine Sibyl against a view of Paris as *Nova Roma*.

Right
53. James I's entry into London, 1604: arch welcoming James I as Emperor of Great Britain and the bringer of Astraea.

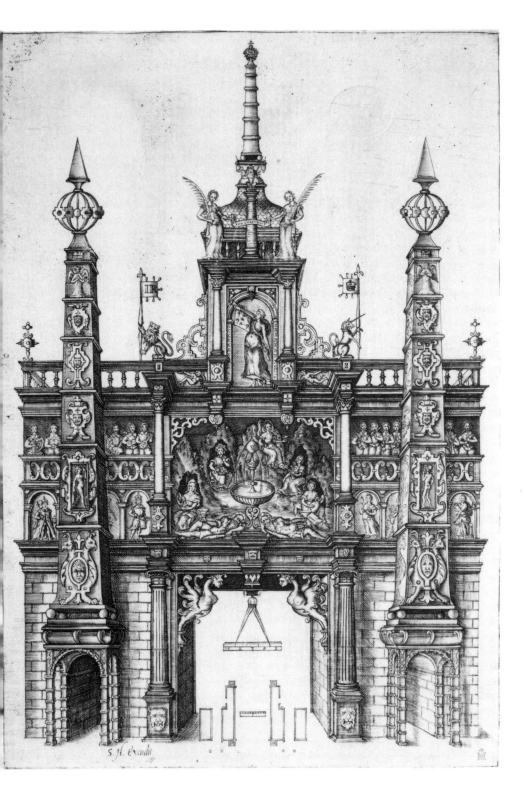

S. H. Excudit

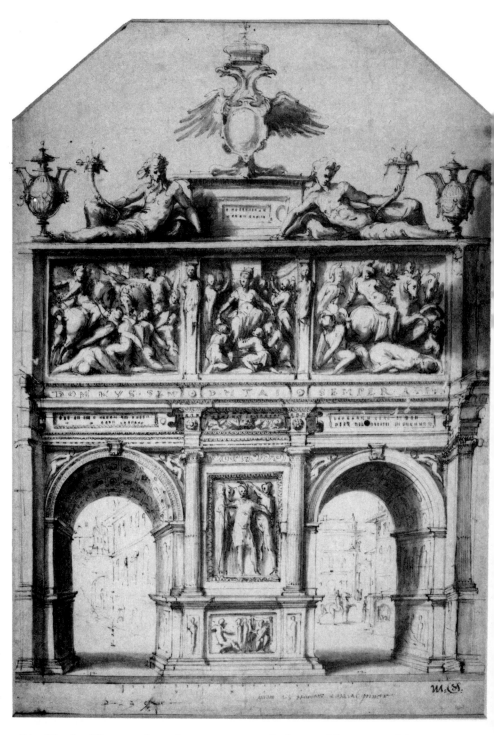

54. Charles V's entry into Genoa, 1529: arch designed by Perino del Vaga.

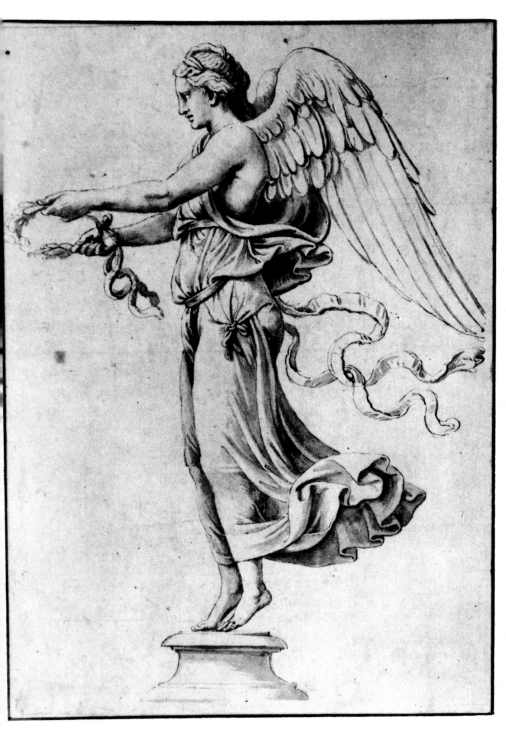

55. Charles V's entry into Mantua, 1530: column designed by Giulio Romano.

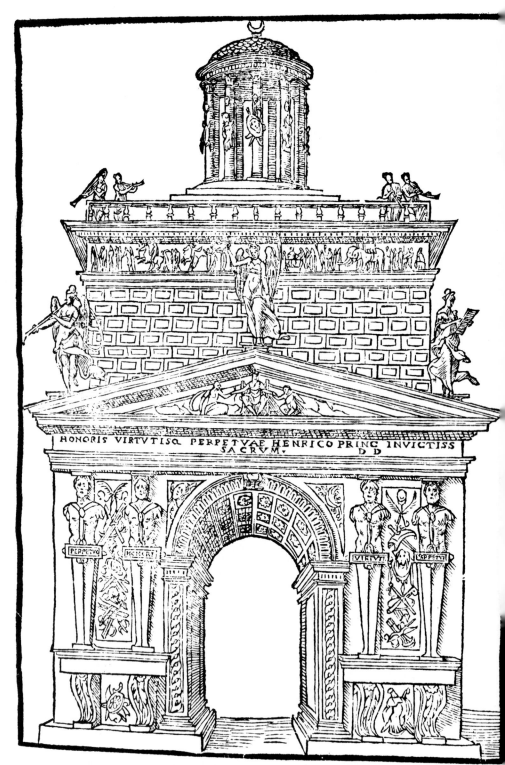

56. Henri II's entry into Lyons, 1548: Henri II's entry was the earliest in France in the antique style.

57. Henri II's entry into Paris, 1549: the second in the antique style.

58. Charles V's entry into Messina, 1535: project for a decoration by Polidoro da Caravaggio with the imperial arms flanked by the Emperor's *impresa* of the columns of Hercules.

59. Charles V's entry into Rome, 1536: the arch of Constantine with indications of the addition of inscriptions.

Above
60. Charles V's entry into Rome, 153
arch designed by Antonio da Sangallo
surmounted by Roma.

Left
61. Charles V's entry into Milan, 1541
arch possibly designed by Giulio Roman
with an equestrian statue of the Empero

62. Philip II's entry into Ghent, 1549: arch in the corinthian order;
Charlemagne nominates Louis the Pious as his heir.

Above
63. Philip II's entry into Antwerp, 1549: Charles V and Prince Philip bear up the world.

Left
64. Philip II's entry into Antwerp, 1549: God the Father crowns Prince Philip.

Right
65. Philip II's entry into Antwerp, 1549: arch with mannerist cartouches and strapwork.

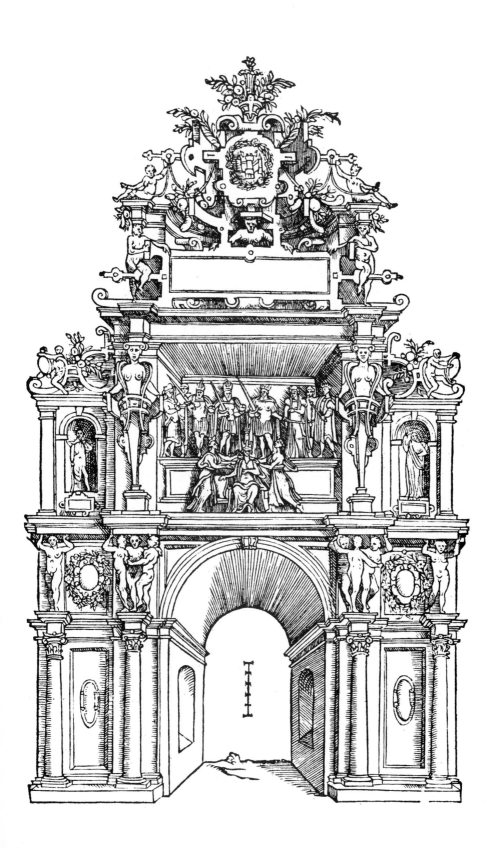

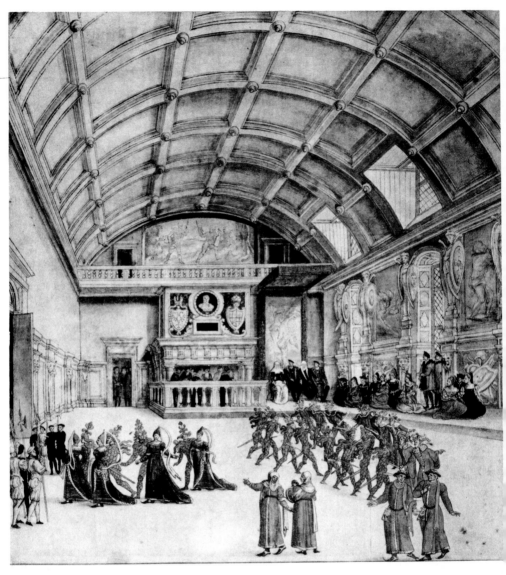

66. Festival at Binche, 1549: wildmen interrupt a court ball and abduct ladies.

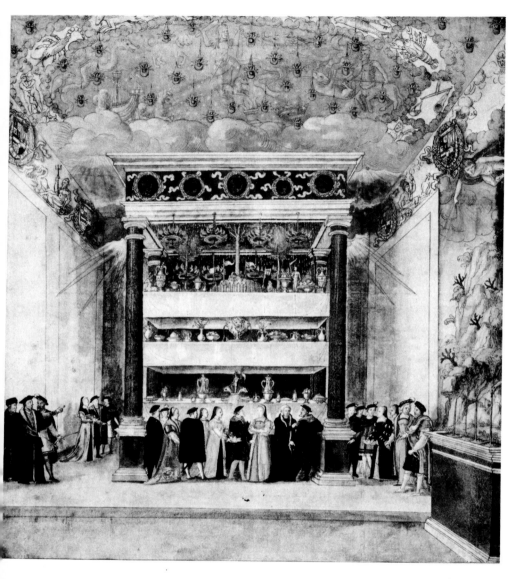

67. Festival at Binche, 1549: the banquet in the enchanted chamber, where the
table gradually descended revealing the courses.

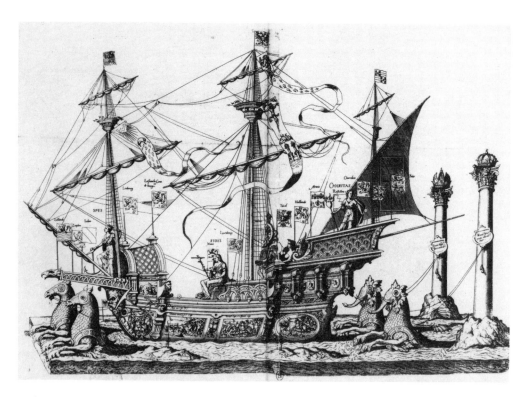

Above

68. Obsequies for Charles V at Brussels, 1558: allegorical ship manned by the Theological Virtues in the procession.

Right, above

69. Catafalque for Cosimo I, Grand Duke of Tuscany, 1574.

Right, below

70. Catafalque designed by Inigo Jones for James I, King of Great Britain, 1625.

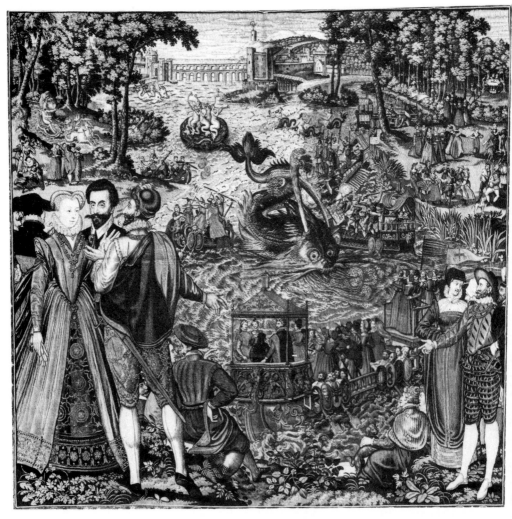

71. One of the eight Valois Tapestries. Woven in the Low Countries later than the events they record, they present French court festivals at a remove. This one depicts one of the Bayonne 'magnificences' (see pl. 74).

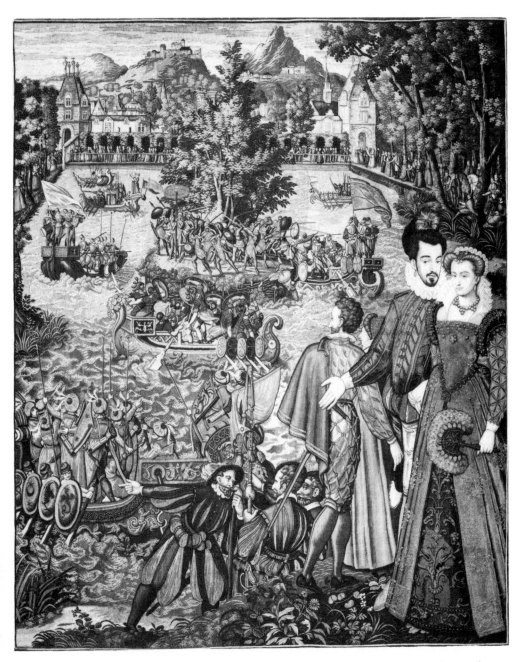

72. One of the Valois Tapestries depicts what may be a distant reflection of one of these 'magnificences', an attack on an island on the palace lake at Fontainebleau.

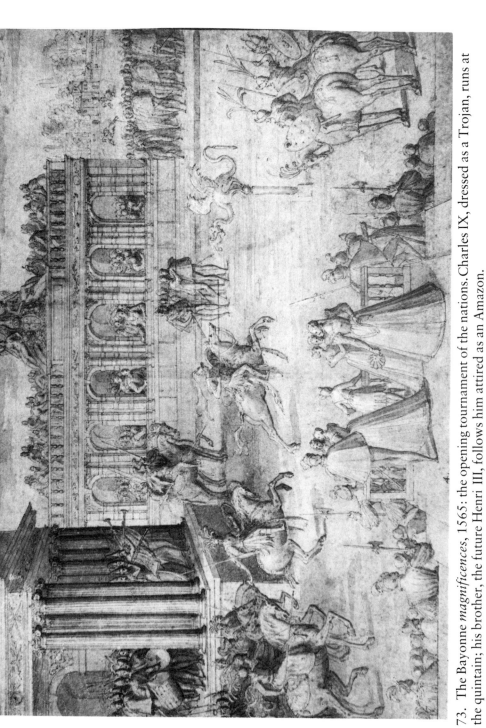

73. The Bayonne *magnificences*, 1565: the opening tournament of the nations. Charles IX, dressed as a Trojan, runs at the quintain; his brother, the future Henri III, follows him attired as an Amazon.

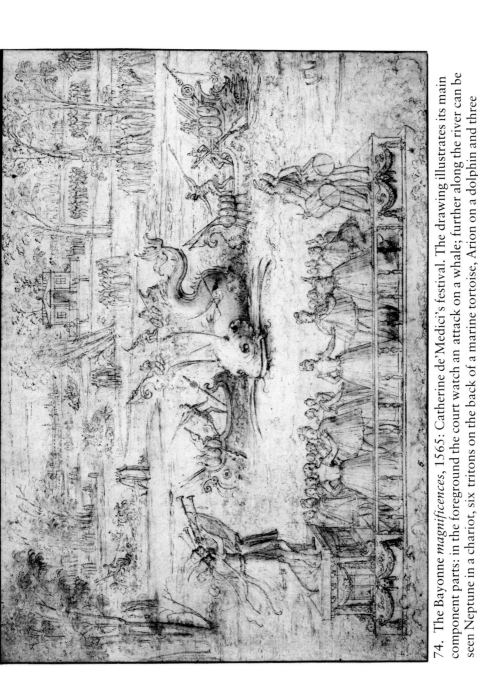

74. The Bayonne *magnificences*, 1565: Catherine de'Medici's festival. The drawing illustrates its main component parts: in the foreground the court watch an attack on a whale; further along the river can be seen Neptune in a chariot, six tritons on the back of a marine tortoise, Arion on a dolphin and three sirens. To the right, on an island, shepherds and shepherdesses dance and, in the middle distance stands a banqueting house.

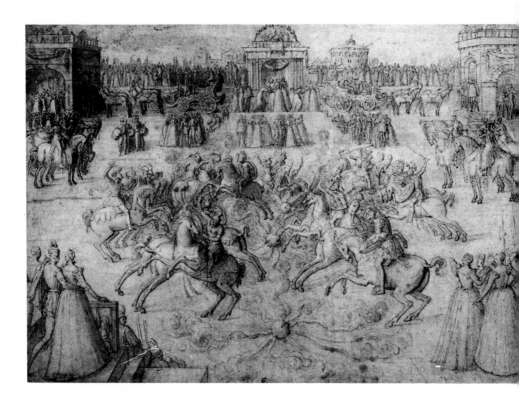

Above

75. The Bayonne *magnificences*, 1565: the tourney of the Knights of Great Britain and Ireland. The drawing combines elements from the opening and close of the tournament. In the distance stand the two chariots bearing Heroic Virtue and Venus, goddess of Love, while in the foreground the final melée takes place in which fireballs were tossed amidst the combatants.

Right, above

76. Charles IX's entry into Paris, 1571: the arch at the Pont Nostre Dame for the King's entry. Charles IX and his brother as the stars Castor and Pollux promise calm after storms to the ship of the French state, emblem also of the city of Paris.

Right, below

77. Elizabeth of Austria's entry into Paris, 1571: the same arch re-dressed for the Queen's entry with figures representing 'The Rape of Asia' prognosticating a vast empire for the child of this union.

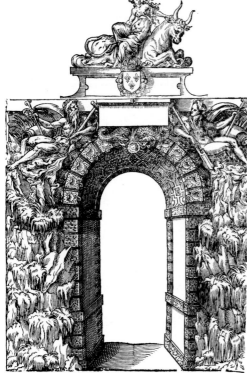

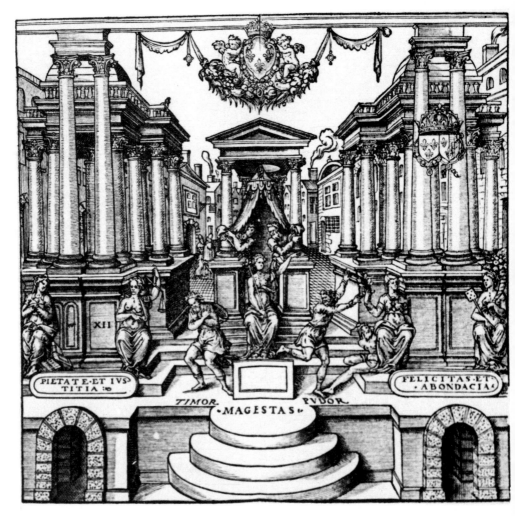

Above
78. Charles IX's entry into Paris, 1571: Serlian perspective near l'Apport de Paris or Châtelet with the King's device of twin columns as emblems of Piety and Justice flanking the figure of Majesty.

Right
79. *Magnificences* for the Polish ambassadors, 1573: contemporary woodcut of the ballet in which sixteen court ladies, including Marguerite de Valois, are arranged in a figure.

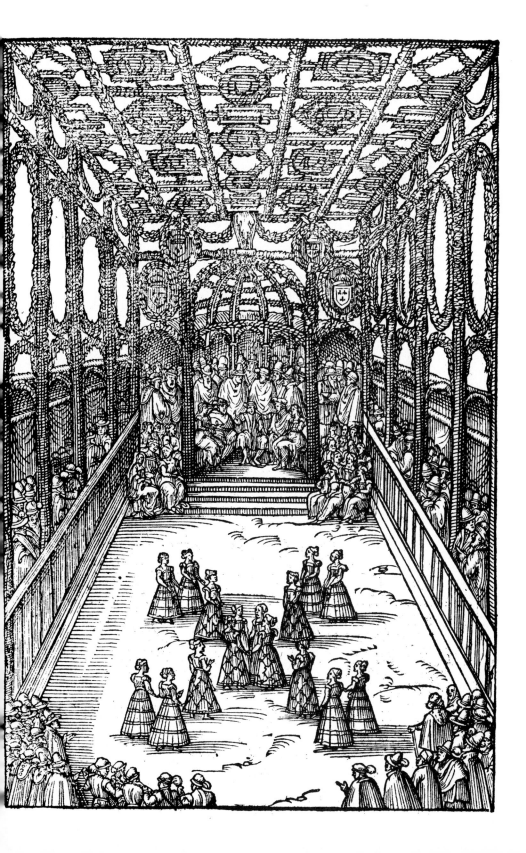

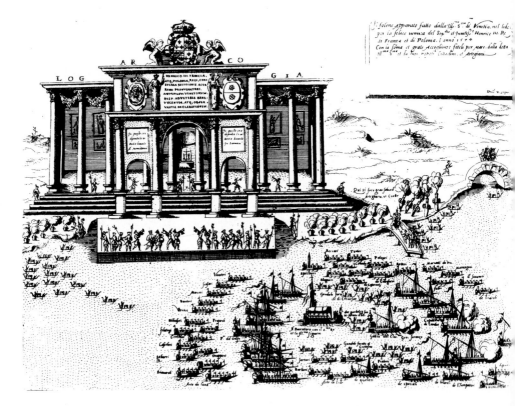

Above

80. Henri III enters Venice, 1574. A triumphal arch leads onto a loggia on the Lido, both designed by Andrea Palladio, the former adorned with paintings by Tintoretto and Veronese.

Right

81. *Le Balet Comique de la Reyne*, 1581: the Salle de Bourbon of the Louvre at the opening of the ballet. Henri III with his mother, Catherine de'Medici, to his right, faces Circe and her enchanted garden.

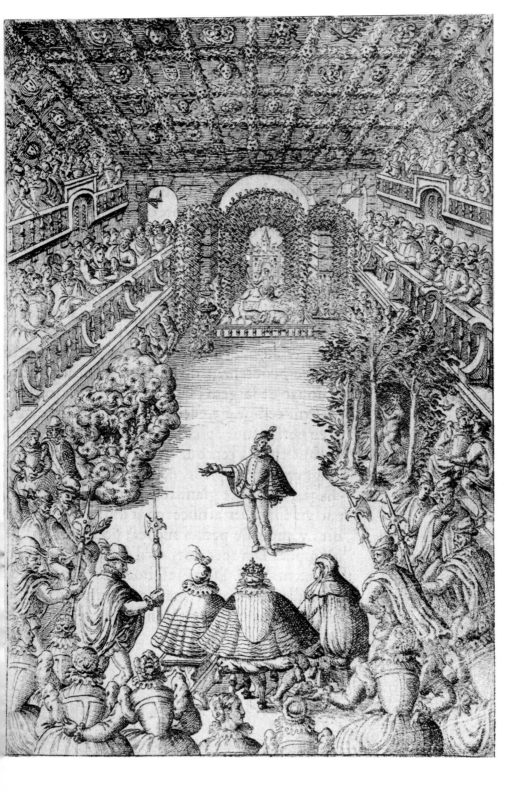

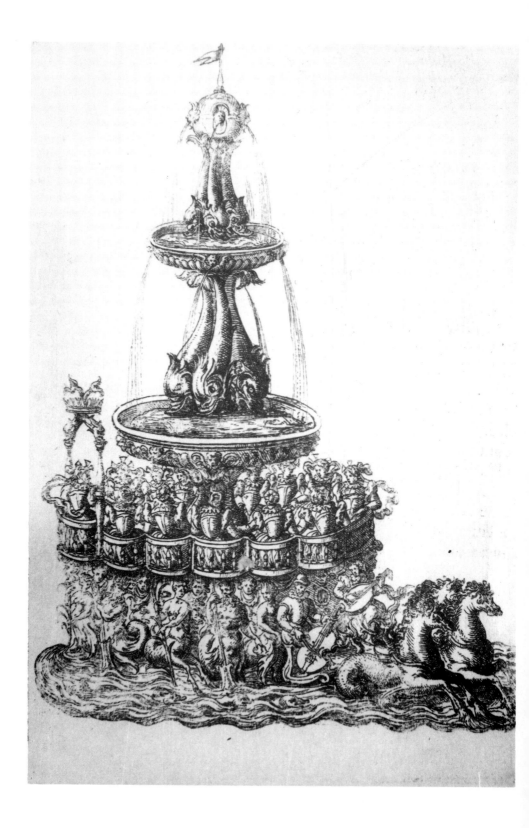

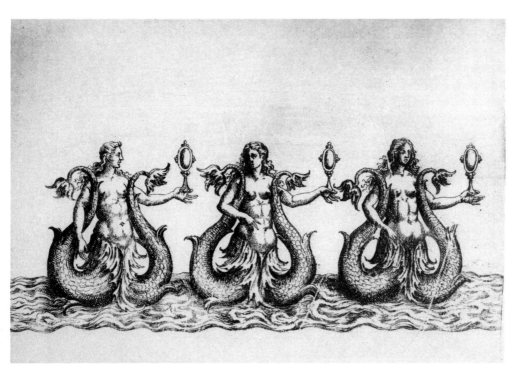

83. *Le Balet Comique de la Reyne*, 1581: the sirens which escorted the Fountain chariot.

Left
82. *Le Balet Comique de la Reyne*, 1581: the Fountain chariot bearing Louise of Lorraine and her ladies on a balcony with musicians below. The chariot can be seen entering the arena at the back left in pl. 81.

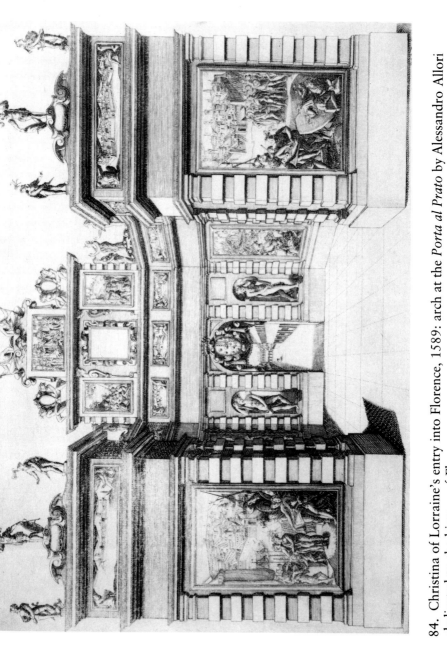

84. Christina of Lorraine's entry into Florence, 1589: arch at the *Porta al Prato* by Alessandro Allori dedicated to the history of Florence.

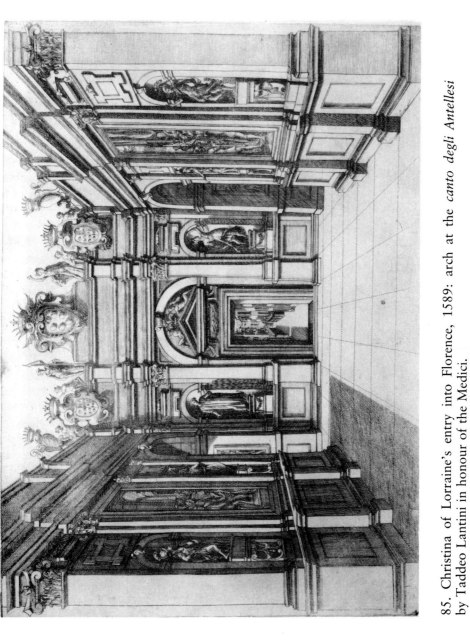

85. Christina of Lorraine's entry into Florence, 1589: arch at the *canto degli Antellesi* by Taddeo Lantini in honour of the Medici.

86. Christina of Lorraine's entry into Florence, 1589: part of the decoration outside the Palazzo Vecchio: Cosimo I crowns Tuscany with a grandducal diadem.

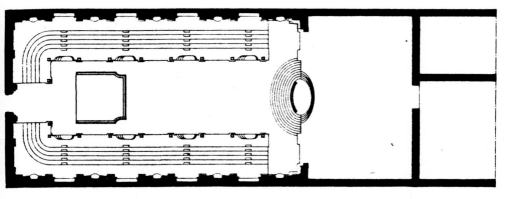

87. The *Teatro Mediceo*: conjectural groundplan with the *gradi* arranged in a horseshoe and the ducal box opposite steps leading up to the stage.

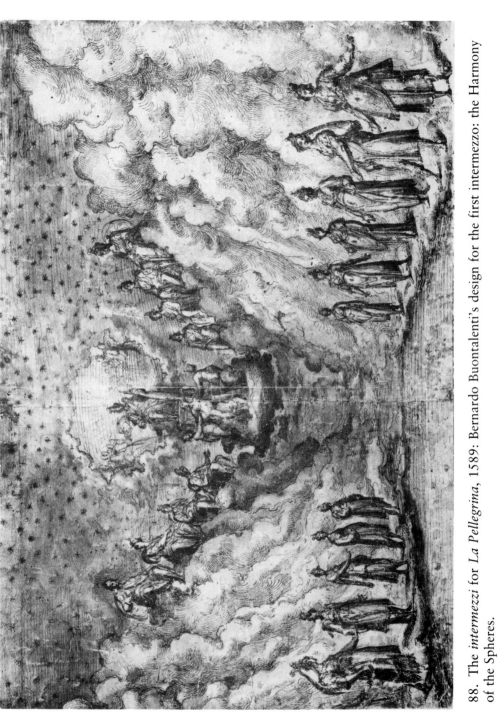

88. The *intermezzi* for *La Pellegrina*, 1589: Bernardo Buontalenti's design for the first intermezzo: the Harmony of the Spheres.

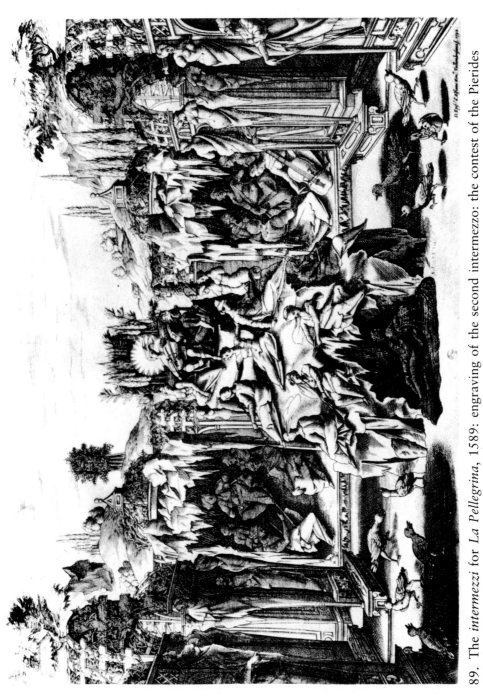

89. The *intermezzi* for *La Pellegrina*, 1589: engraving of the second intermezzo: the contest of the Pierides and the Muses.

90. The *intermezzi* for *La Pellegrina*, 1589: engraving of the third *intermezzo*: Apollo slaying the Python.

91. The *intermezzi* for *La Pellegrina*, 1589: engraving of the fourth intermezzo: the Inferno.

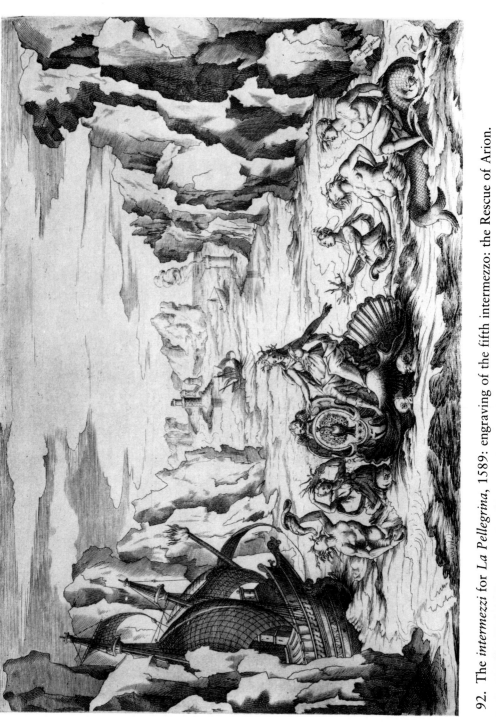

92. The *intermezzi* for *La Pellegrina*, 1589: engraving of the fifth intermezzo: the Rescue of Arion.

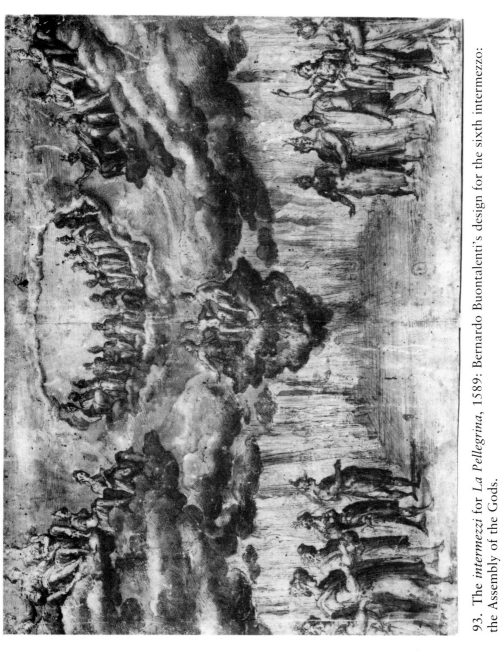

93. The *intermezzi* for *La Pellegrina*, 1589: Bernardo Buontalenti's design for the sixth intermezzo: the Assembly of the Gods.

94. The *sbarra* at the Pitti Palace, 1589: entry of the Duke of Mantua and Don Pietro de'Medici in a chariot drawn by a dragon.

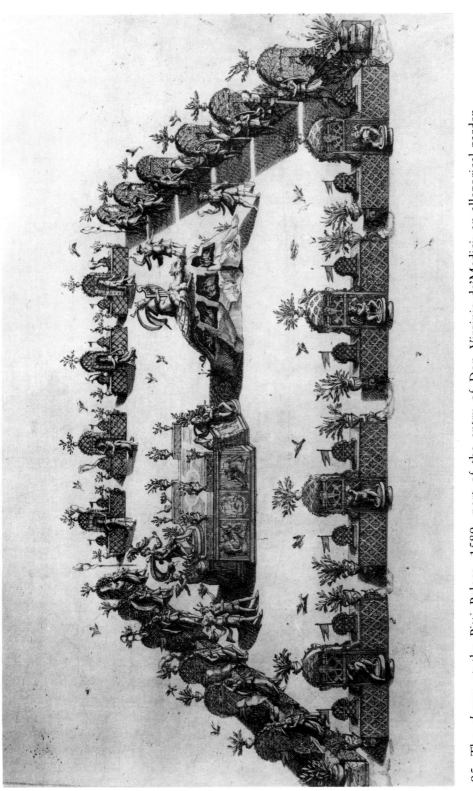

95. The *sbarra* at the Pitti Palace, 1589: part of the entry of Don Virginio de'Medici: an allegorical garden with singing birds.

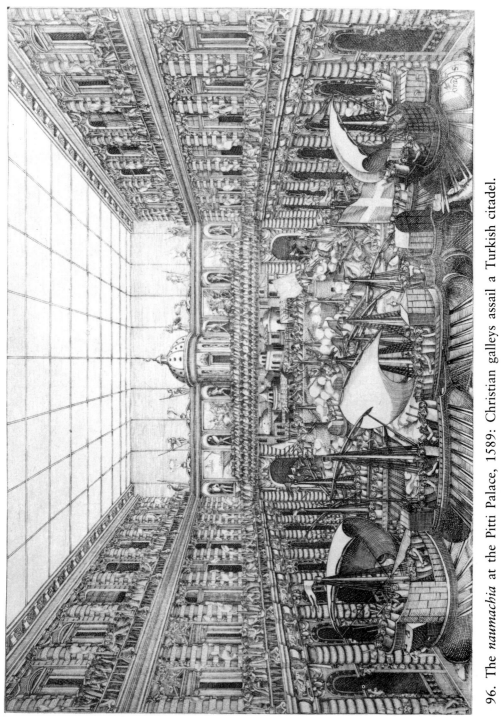

96. The *naumachia* at the Pitti Palace, 1589: Christian galleys assail a Turkish citadel.

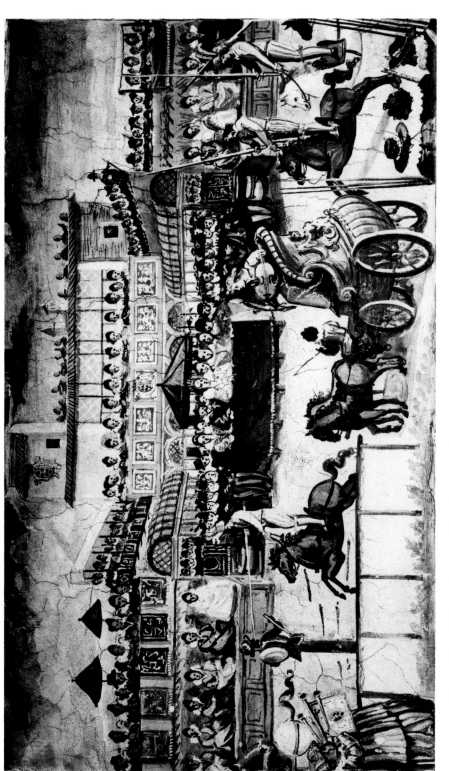

97. Fête in the garden of the Palazzo Valfonda, 1600: *the corso al saracino.*

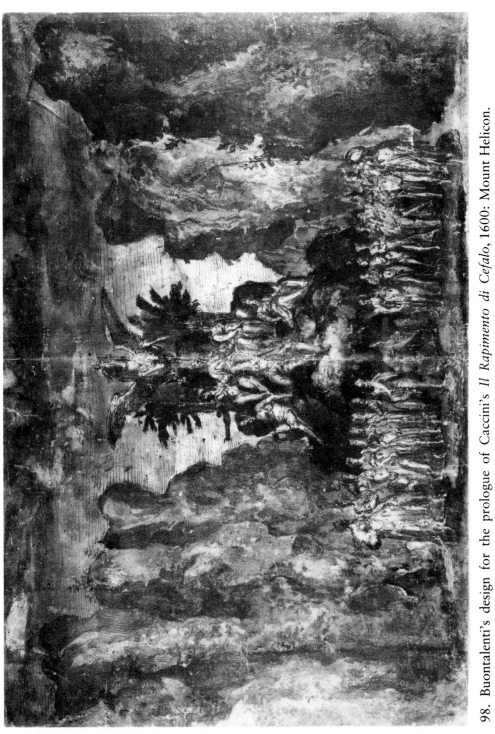

98. Buontalenti's design for the prologue of Caccini's *Il Rapimento di Cefalo*, 1600: Mount Helicon.

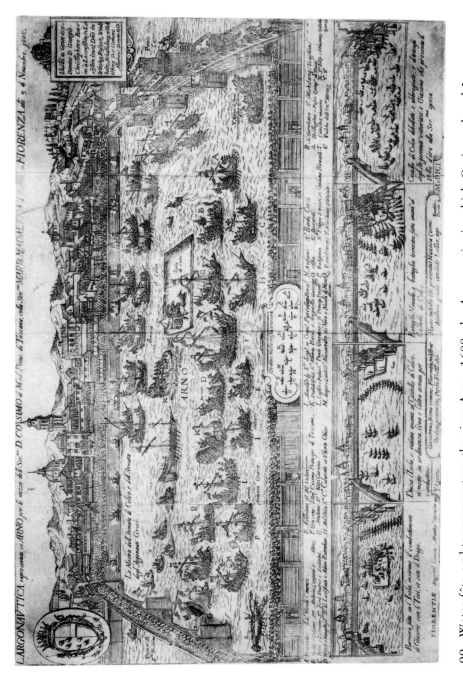

99. Water fête and tournament on the river Arno, 1608: the *Argonautica* in which Cosimo played Jason.

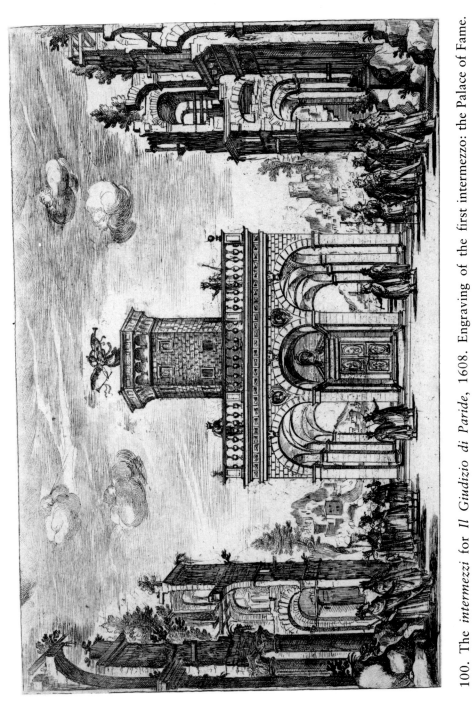

100. The *intermezzi* for *Il Giudizio di Paride*, 1608. Engraving of the first intermezzo: the Palace of Fame.

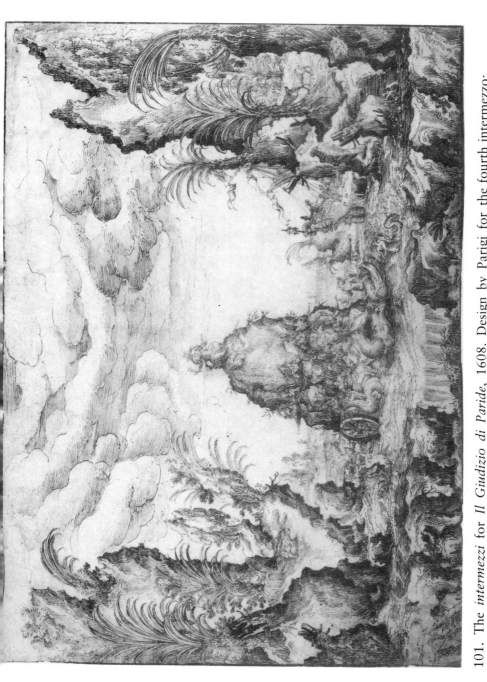

101. The *intermezzi* for *Il Giudizio di Paride*, 1608. Design by Parigi for the fourth intermezzo: Amerigo Vespucci.

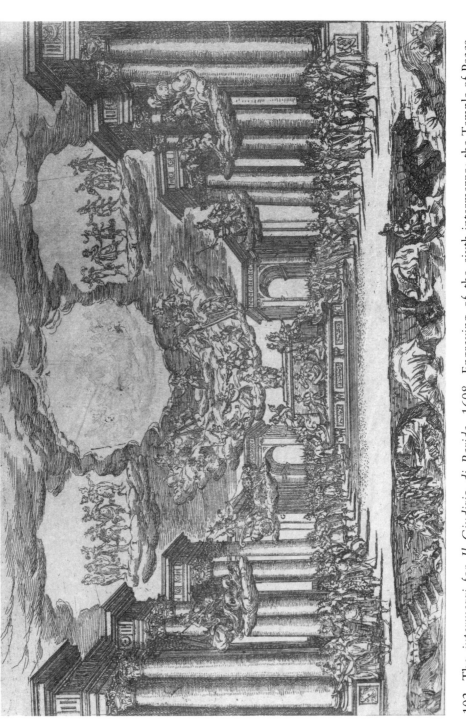

102. The *intermezzi* for *Il Giudizio di Paride*, 1608. Engraving of the sixth intermezzo: the Temple of Peace.

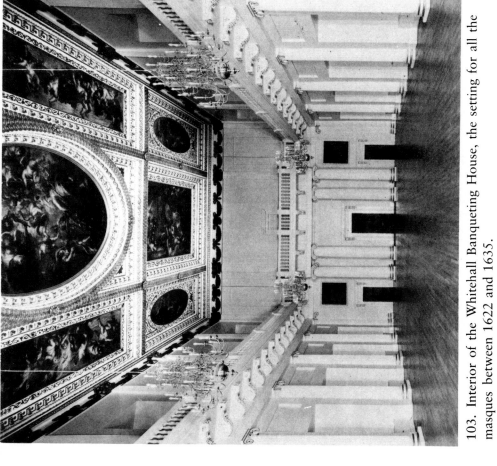

103. Interior of the Whitehall Banqueting House, the setting for all the masques between 1622 and 1635.

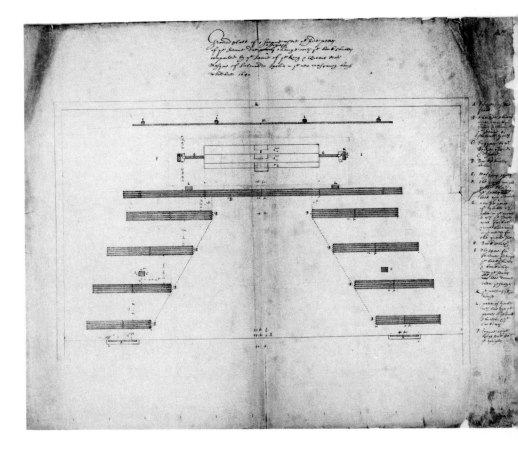

Above

104. Groundplan for *Salmacida Spolia*, 1640, showing the grooves in which the backshutters and side wings, arranged in steep perspective, ran both when on and off stage. At the back there is a tiered bench on which the queen and her ladies had descended.

Right

105. Elevation for *Salmacida Spolia*, 1640, showing the grooves for both side wings, back shutters and cloud borders with a winch below stage controlling ascents and descents of deities and, at the back, the tiered bench of the queen's cloud machine both elevated and at ground level.

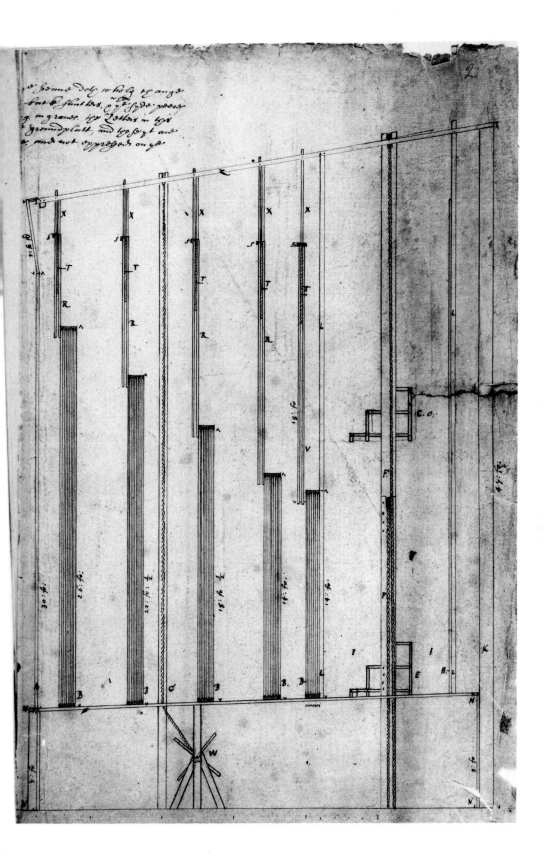

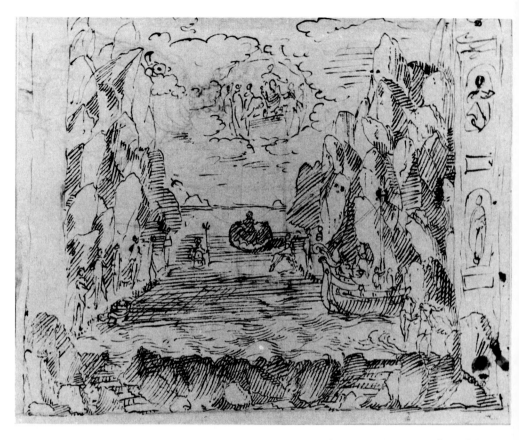

106. Sketch by Inigo Jones probably for the sea triumph in *Love's Triumph*, 1631, in which Charles I and the masquers can be seen arriving in a ship to the right.

107. Design for the cloud bearing Venus in *Love's Triumph*, 1631. Jones has sketched in the supporting battens. The cloud, having reached stage level, was removed.

108. The opening scene in *Chloridia*, 1631: 'pleasant hills planted with young trees, and all the lower banks adorned with flowers'.

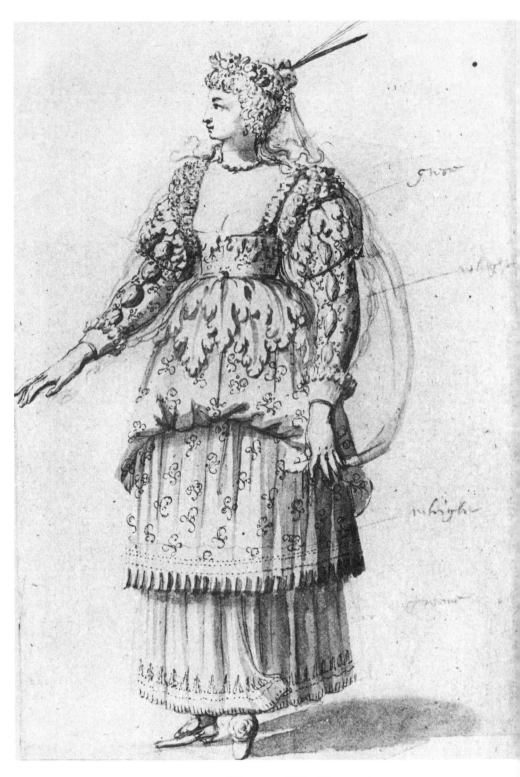

109. Henrietta Maria's costume as Chloris in *Chloridia*, 1631.

110. *Coelum Britannicum*, 1634: the opening scene, a great city of the ancient Romans or civilised Britons in ruins.

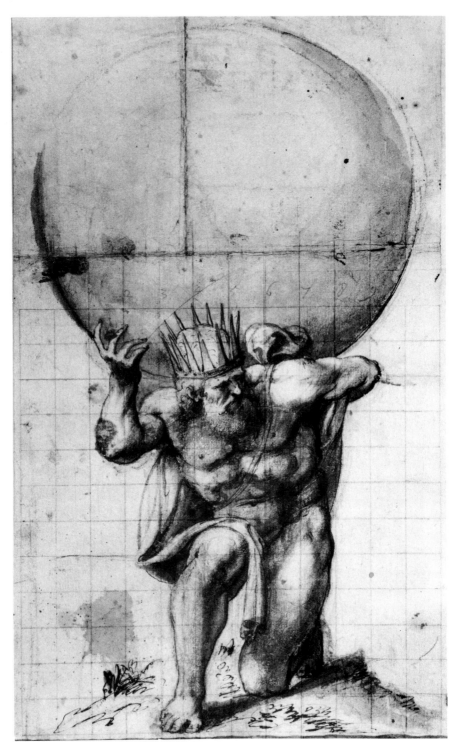

111. *Coelum Britannicum*, 1634: Atlas, a cut out figure, bearing a sphere on which the constellations were depicted in lights.

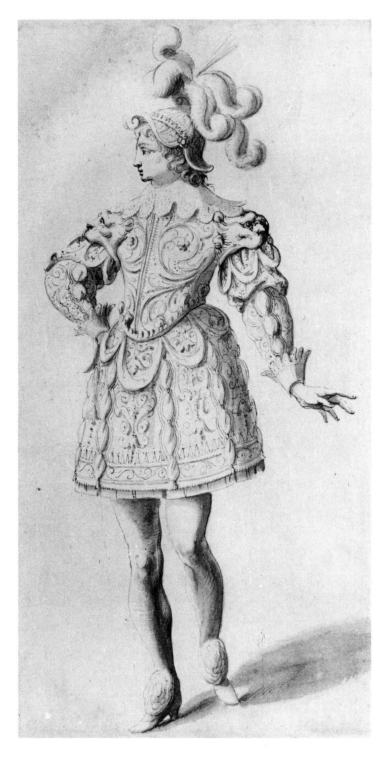

112. *Coelum Britannicum*, 1634: Charles I as an Ancient
British Hero.

113. *Coelum Britannicum*, 1634: a princely villa, a vision of a Caroline ideal.

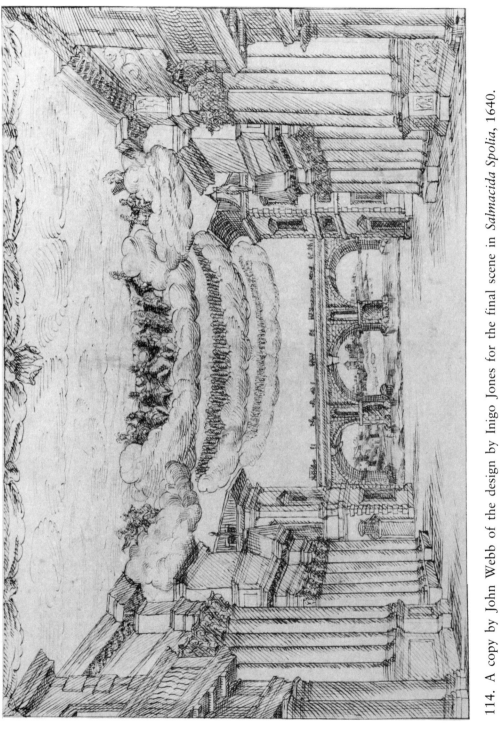

114. A copy by John Webb of the design by Inigo Jones for the final scene in *Salmacida Spolia*, 1640.

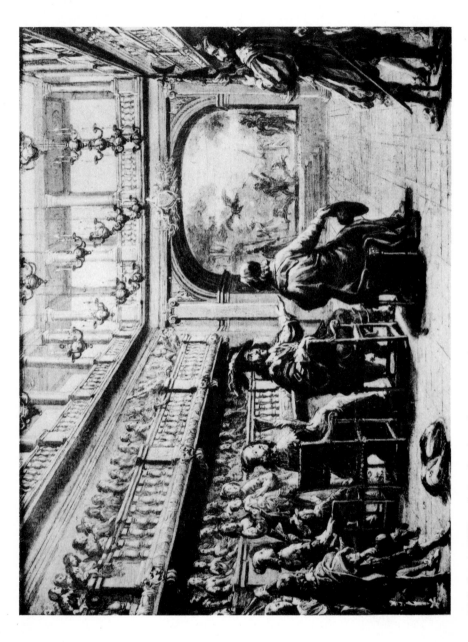

115. Louis XIII and Cardinal Richelieu watch *Le Ballet de la Prospérité des Armes de France* in the new *salle des machines* in the Palais Cardinal, 1641.